THE RUSSIAN ... READER

Volume Two

The Thaw to the Present

CULTURAL SYLLABUS

Series Editor:
MARK LIPOVETSKY (University of Colorado Boulder)

ACADEMIC
STUDIES
PRESS

THE RUSSIAN CINEMA READER

Volume Two

The Thaw to the Present

EDITED BY RIMGAILA SALYS

BOSTON / 2013

Library of Congress Cataloging-in-Publication Data:
A catalog record for this book as available from the Library of Congress.

ISBN 978-1-61811-321-4 (paperback)
ISBN 978-1-61811-376-4 (electronic)

Cover design by Ivan Grave
On the cover: Scene from *Ninth Company*

Published by Academic Studies Press in 2013
28 Montfern Avenue
Brighton, MA 02135, USA

press@academicstudiespress.com
www.academicstudiespress.com

CONTENTS

LIST OF ILLUSTRATIONS

PREFACE

The *Russian Cinema Reader* is intended both for History of Russian Cinema and Russian Culture courses which emphasize film. The two volumes consist of period surveys and individual chapters on widely taught films (plus a few that I think *should* be taught), all of which are available with English subtitles. The period surveys provide historical context, outline genres, themes and emblematic aesthetic markers for each era, and give brief information on important films and directors not included in the reader. The chapters on individual films consist of general information on directors' careers, followed by commissioned essays and published criticism (both excerpts and complete essays) intended as starting points for class discussion, with suggested further readings appropriate to undergraduates. All film introductions without an author attribution were written by me. Except for Tengiz Abuladze's *Repentance*, a Georgian film which influenced the direction of Russian cinema, films of the former Soviet republics have not been included in the collection.

Readers will notice an unavoidable discrepancy in transliteration and formatting between newly commissioned and previously published material. Apart from accepted western spellings such as Tolstoy, Yeltsin, Meyerhold, Tarkovsky and Mosfilm, Russian names and terms in new essays have been transliterated according to the simplified Library of Congress system. To facilitate searching, bibliographic entries are cited in the same system. By necessity, the original editing, citation format and transliteration have mostly been retained for previously published essays.

For students who have not taken an introductory film studies course, Timothy Corrigan's *A Short Guide to Writing about Film* (Longman, 2012; also Kindle edition) is a useful text which covers film terminology, different approaches to writing about cinema, sources for research and guidelines for writing and formatting papers. The Yale Film Studies Film Analysis website 2.0 (http:// classes.yale.edu/film-analysis/) is an excellent resource for basic terms relating to mise-en-scène, cinematography, editing, sound

and analysis, accompanied by illustrations and short clips. The most recent, comprehensive studies of Russian cinema are Birgit Beumers, *A History of Russian Cinema* (Oxford and New York: Berg, 2009) and N.M. Zorkaia, *Istoriia sovetskogo kino* (St. Petersburg: Aleteiia, 2005). A recent reference work is Peter Rollberg, *Historical Dictionary of Russian and Soviet Cinema* (Lanham, MD: The Scarecrow Press, Inc., 2009). All the films included in the reader are available from Russian or American distributors.

This reader would not have been possible without the expertise and generosity of the authors of the period introductions and newly commissioned essays, as well as the good will of authors who gave permission to include their published essays. I have learned from and been inspired by their work; this reader is intended to share their insights with students interested in Russian culture and film. I owe special thanks to Philip Rogers and Mark Leiderman for their unwavering support and advice, to Tim Riggs of the University of Colorado at Boulder who produced images for the reader, as well as to Kira Nemirovsky and her staff.

Rimgaila Salys
Boulder, 2013

ACKNOWLEDGMENTS

Beumers, Birgit. *"Brat/ Brother."* In *The Cinema of Russia and the Former Soviet Union*. Ed. Birgit Beumers. London and New York: Wallflower Press, pp. 233-41. © 2007, Columbia University Press. Reprinted with permission of the publisher.

Beumers, Birgit. *Burnt by the Sun*. London-New York: I.B. Tauris, 2000, pp. 65-6, 69-72, 92-3, 96-8. Reprinted by permission of the author.

Beumers, Birgit. *"Tarkovsky's Return, or Zvyagintsev's Vozvrashchenie."* *Rossica*, No. 14 (Spring 2004), pp. 61-3. Reprinted by permission of the author.

Beumers, Birgit, ed. *Directory of World Cinema. Russia*. Bristol, UK and Chicago: Intellect, 2011, pp. 43-45. Reprinted by permission of Intellect Press.

Bird, Robert. *Andrei Tarkovsky: Elements of Cinema*. London: Reaktion Books, 2008, pp. 68-9, 162-63. Reprinted by permission of the author.

Horton, Andrew, and Michael Brashinsky. *The Zero Hour: Glasnost and Soviet Cinema in Transition*, pp. 111-17. © 1992, Princeton University Press. Reprinted by permission of Princeton University Press.

Johnson, Vida T., and Graham Petrie. *The Films of Andrei Tarkovsky: A Visual Fugue*. Bloomington and Indianapolis: Indiana University Press, pp. 142, 145-47, 149-50, 151-53, 155. © 1994. Reproduced with permission of Indiana University Press in the format Other Book via Copyright Clearance Center.

Kaganovsky, Lilya. "The Cultural Logic of Late Socialism," *Studies in Russian and Soviet Cinema*, 3.2 (2009), pp. 185-86, 193-97. Reprinted by permission of Intellect Press.

Larsen, Susan. "National Identity, Cultural Authority, and the Post-Soviet Blockbuster: Nikita Mikhalkov and Aleksei Balabanov." *Slavic Review* 62.3 (Autumn, 2003), pp. 495-98. Reprinted by permission of *Slavic Review*.

Mikhailova, Tatiana and Mark Lipovetsky. "Flight Without Wings: The Subjectivity of a Female War Veteran in Larisa Shepit'ko's *Wings* (1966)." In *Embracing Arms: Cultural Representation of Slavic and Balkan Women in War*. Ed. Helena Goscilo with Yana Hashamova. Budapest-New York: Central European University Press, 2012, pp. 88-90, 91-102, 104-05. Reprinted by permission of the editors.

Monastireva-Ansdell, Elena. "Redressing the Commissar: Thaw Cinema Revises Soviet Structuring Myths." *The Russian Review* 65.2 (2006), pp. 239-48. © 2006, John Wiley and Sons. Reprinted by permission of Wiley and Sons.

Prokhorov, Alexander. "Soviet Family Melodrama of the 1940s and 1950s. From *Wait for Me* to *The Cranes Are Flying*." In *Imitations of Life: Two Centuries of Melodrama in Russia*. Edited by Louise McReynolds and Joan Neuberger. Durham and London: Duke University Press, pp. 214-25. Copyright, 2002, Duke University Press. All rights reserved. Republished by permission of the copyright holder. www.dukepress.edu

Prokhorov, Alexander. "*Brilliantovaia ruka/ The Diamond Arm*." In *The Cinema of Russia and the Former Soviet Union*. Ed. Birgit Beumers, pp. 129-37. © Columbia University Press. Reprinted with permission of the publisher.

Vicks, Meghan. "Andrei Zviagintsev's *The Return* (*Vozvrashchenie*, 2003)." in *KinoKultura* 32 (2011). Reprinted by permission of the author.

Woll, Josephine, and Denise J. Youngblood. *Repentance*. London and New York: I.B. Tauris, 2001, pp. 75-86. Reprinted by permission of Denise Youngblood.

IMAGE CREDITS

Fig. 100, 102 Courtesy of Intercinema

PART FOUR

CINEMA OF THE THAW 1953–1967

Alexander Prokhorov

Ironically, the era named the Cold War by the West, Russians titled the Thaw. The Russian name of the period comes from the title of Il'ia Ehrenburg's 1954 novel, the publication of which signaled a change in Soviet cultural politics after Stalin's death. In 1956, Nikita Khrushchev denounced the cult of Stalin in his Secret Speech at the Twentieth Party Congress. Because literature served Soviet culture as its most authoritative form of artistic production—and the most informed of new directions the Party was adopting—changes in literature translated into new cultural policies in other art forms. Cinema was by no means the first to experience the cultural Thaw, both because film production required a greater investment of time and resources and because, despite Vladimir Lenin's famous dictum that cinema was "the most important of all arts," film art stood below literature in the hierarchy of Soviet arts.

While Stalin's death usually marks the beginning of the Thaw era in Soviet culture, historians identify several key events that marked the end of the Thaw in the mid-late 1960s. In 1964 Nikita Khrushchev's colleagues in the Party leadership orchestrated a palace coup, voted him out of office and declared a change in the USSR's political course. In a symbolic gesture, Leonid Brezhnev restored the Stalin-era title of General Secretary of the Communist Party, the title he held for the next eighteen years. In 1966, the KGB arrested Andrei Siniavskii and Yuli Daniel for publishing their prose abroad and expressing in it views that differed from officially approved ones. The trial of writers for their aesthetic and political beliefs brought back traumatic memories of Stalin-era show trials. In 1968 the Warsaw Pact troops invaded Czechoslovakia and deposed the reformist government of Alexander Dubček, who had sought to build "socialism with a human face"—a socialist society that respected human rights, embraced freedom of the press and

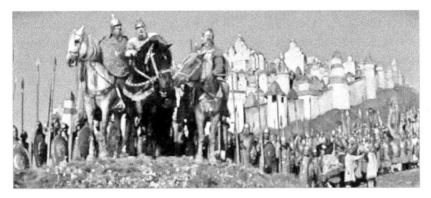

Fig. 75. Il'ia Muromets

political pluralism. While these events created an oppressive atmosphere in Soviet society, I would like to argue that, in Soviet cinema specifically, the political clampdown started with the creation by the KGB's newly appointed chief Yuri Andropov of the Fifth Main Administration for Ideological Subversion (1967). The First Department of this Administration was responsible for policing the Soviet artistic intelligentsia, filmmakers among others. By the mid 1970s, this new KGB unit and the Ministry of Cinema (Goskino) had established very close state control over the minds and deeds of Soviet filmmakers.

The last years of Stalin's rule came to be known as the time of cine-anemia (*malokartin'e*), the sharp decrease in film production due to strict ideological control over the industry and relatively low financing of film production and exhibition. After Stalin's death in 1953, the industry received more resources and was decentralized. While in 1951 only 9 feature films were released, by 1967 the industry produced more than 130-150 films per year.[1] Studios adopted new technologies and began producing widescreen films with stereo soundtracks. In 1955 the first movie theater with a wide screen and stereo equipment opened in downtown Moscow. On 16 November 1956 *Il'ia Muromets*, the first widescreen feature film, premiered at the Khudozhestvennyi movie theater (Fig. 75).

[1] Sergei Zemlianukhin and Miroslava Segida, *Domashniaia sinemateka. Otechestvennoe kino 1918-1996* (Moscow: Dubl' D, 1996), 6.

Three directors, Ivan Pyr'ev, Mikhail Romm and Sergei Gerasimov, introduced key changes into the production of films, the ideological climate in the filmmakers' community and training of the new generation of filmmakers. In 1954, Pyr'ev became the head of the Mosfilm Studio. Following Hollywood studio models, he divided Mosfilm into production units. Led by artistic directors, these units received a degree of artistic autonomy and no longer were required to report every office supply purchase to the Central Committee and industry authorities. Pyr'ev's decentralization of Mosfilm provided the blueprint for other Soviet studios.

Pyr'ev hired and mentored young filmmakers who became industry leaders during the Thaw and beyond. Having realized that the industry needed "fresh blood" and that VGIK (the State Film Art Institute) did not provide a sufficient number of cinema professionals, he established his own filmmakers' school at the studio in 1956. The school became an independent institution of higher learning, VKSR (The School for Scriptwriters and Directors) in 1960. It provided a second degree in filmmaking for professionals who already had a university degree and who wanted to work in the film industry. Among Pyr'ev's students and protégés were the famous film directors Grigorii Chukhrai, Alexander Alov and Vladimir Naumov, Eldar Riazanov, Leonid Gaidai, Georgii Danelia, Igor Talankin and many others.

Mikhail Romm led a workshop at VGIK that trained a new generation of filmmakers, including Andrei Tarkovsky, Andrei Konchalovsky, Vasilii Shukshin, Nikita Mikhalkov and many others. These filmmakers reintegrated Soviet cinema into the global art cinema community in the 1960s and 70s, after its virtual isolation during Stalin's rule. Romm's colleagues at VGIK, Sergei Gerasimov and Tamara Makarova, trained many actors (Nonna Mordiukova, Galina Pol'skikh, Nikolai Rybnikov) and directors (Sergei Bondarchuk, Lev Kulidzhanov, Tat'iana Lioznova, Kira Muratova) who filled the new positions in the growing film industry. While heading one of the creative units at the Gorky Film Studio (the second biggest studio in Moscow), Gerasimov was the studio's de facto director and helped his students to begin their careers. At his studio he allowed Alexander Askol'dov to make *Commissar* (1967).

And after the Central Committee banned the film and ordered the destruction of all the film stock related to the "anti-Soviet" picture, Gerasimov personally saved the negative of Askol'dov's masterpiece.[2] The worldwide screening of *Commissar* during Gorbachev's Perestroika signaled the demise of state censorship in Soviet cinema.

In 1957, Pyr'ev and Romm established the Organizing Committee in charge of establishing the Filmmakers' Union. While the creation of the Union of Soviet Writers in 1934 led to greater state control of the authors under Stalin, the same move during the Thaw established the guild that provided film industry workers with increased autonomy from the state and party institutions in charge of film production and censorship. With its transitory title and fluid structure, The Organizing Committee existed from 1957 until 1965 and was in tune with the ambiguities and contradictions of Thaw culture. When in 1965 the filmmakers finally established their Union, the organization became more bureaucratic, anticipating the ossifying stability of the Stagnation era.[3]

In the 1950s and 60s the film press became an important presence in Soviet popular culture. Until 1953, the only Soviet film journal in print was *Art of Cinema (Iskusstvo kino).* Under Nikita Khrushchev

[2] Interview with Irina Shilova (Pittsburgh 1999). There seem to be various candidates for the role of saving *Commissar* from the flames. I chose this story as one less commonly told. Evgenii Margolit indirectly confirms Shilova's account. He notes that Gerasimov mentored Askol'dov and *Commissar* was produced in the studio unit led by Gerasimov. The director supported both the film and its author as well as he could ("he took an active and sympathetic interest in the fate of the film and its author," 44). In 1975 Gerasimov and Rostislav Pliatt wrote to the Central Committee of the Communist Party requesting the release of the film and the rehabilitation of its director. Neither the fate of the film nor that of Askol'dov changed after this desperate attempt to restore justice. For further information, see Evgenii Margolit, "Askol'dov, Aleksandr Iakovlevich," in *Kino Rossii. Rezhisserskaia entsiklopediia*, Vol. 1, Ed. Lev Roshal' (Moscow: NII Kinoiskusstva, 2010), 42-44.

[3] Notably, before the Union of Filmmakers was established in 1965, The Central Committee of the Communist Party removed from the Union's Organizing Committee the independent and outspoken Pyr'ev. Pyr'ev was a problematic figure for the Party and artistic establishment because he constantly challenged the status quo.

the nature of the Soviet film press changed dramatically. While still funded by the state, *Art of Cinema* became a journal for the intelligentsia and filmmaking community to discuss matters of cultural politics. In 1957 a veteran of the 1920s constructivist movement, Solomon Telingator, redesigned the cover and layout of the journal. The first 1957 issue opened with a new section titled "Round Table" in which critics and filmmakers discussed their professional concerns. At this first round table, Sergei Iutkevich encouraged his colleagues to begin thinking about cinema as art, implying that previously cinema had served primarily as a vehicle for state propaganda. In 1959 *Art of Cinema* published Viktor Nekrasov's article "Words Great and Simple" that compared two trends in Soviet cinema: the epic (read Stalinist) and the anti-monumentalist. Nekrasov called for the cinema to represent human experience, rather than that of great leaders. The article became a manifesto for anti-Stalinist filmmakers, just as six years earlier Vladimir Pomerantsev's article "On Sincerity in Literature" had become an anti-Stalinist manifesto for Soviet writers.

In the same spirit of return to the lively cultural life of the 1920s, the fan magazine, *Soviet Screen* (*Sovetskii ekran*), was revived to address and elicit responses from average moviegoers. The magazine not only informed viewers of new films, but also published viewers' letters, and even allowed them to vote on the most popular films of the year. This dialogic model was a major departure from the one-way-street cultural policies of the Stalin era. *Soviet Screen* had the layout of a western-style magazine, with large color publicity photos of Soviet and international stars. In 1957 Sovexportfilm began publishing a cinema magazine, *Soviet Film* (*Sovetskii fil'm*), in English, French, German and Spanish to target international moviegoers. Not surprisingly, Vladimir Pozner Sr.,[4] a former Hollywood executive, used his expertise in setting up these new film magazines.

[4] Vladimir Pozner Sr. was born in Russia. After the Revolution his family moved to Europe. In France he worked for the European division of MGM. After the Nazis occupied France, he moved to the US, where he worked in the Hollywood studio system and headed the Russian Section of the film department of the US Department of War (1943). Pozner was a communist

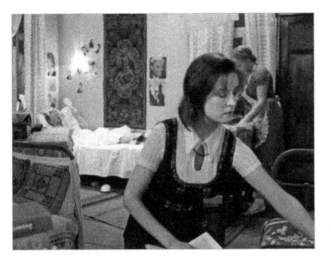

Fig. 76.
The Dorm Room

Soviet Screen's color publicity photographs had a tremendous impact on the everyday life of Soviet people. They began decorating their apartments and dorm rooms with photos of film stars. To create a 1950s atmosphere in *Moscow Does Not Believe in Tears* (*Moskva slezam ne verit,* 1979), director Vladimir Men'shov chose photographs from *Soviet Screen* for the walls of dorm rooms as the most memorable feature of the period's interiors (Fig. 76).

In the 1950s Soviet cinema renewed contacts with other national film industries and international film markets. In the last years of Stalin's rule the USSR began importing Indian films. Indian melodramas, such as the 1951 *Awaara*[5] (starring Raj Kapoor), captured the imagination of Soviet moviegoers by their exotic settings and overtly melodramatic plots catering to popular tastes, instead of the tastes of the Soviet film censor. Cultural authorities were happy to collect high revenues for these relatively inexpensive imports. In the 1950s the Soviet Union also imported genre films from France and Italy. During the Thaw, Soviet filmmakers began

sympathizer and at the beginning of the Cold War had to move first to East Germany and later to the USSR. During the Thaw, Pozner Sr. played a major role in the destalinization of the Soviet film industry. See below.

[5] In Russian the film was titled *Brodiaga* (*Tramp*).

making co-productions, first with the countries of the Eastern Bloc and later with India, France and Italy.

In the second half of the decade, festivals of Italian and French cinema allowed viewers in Moscow and Leningrad (now St. Petersburg) to discover Italian neorealist cinema and, later, cinema of the French New Wave.[6] The first "Week of French Cinema" was held in October 1955 and the "Week of Italian Cinema" was held in October 1956. The key event in the process of reintegration of Soviet cinema into international film culture was the revival of the Moscow International Film Festival in 1959.[7] The festival occurred biannually until the fall of the Soviet Union and alternated with the other Eastern Bloc film festival in Karlovy Vary. The on-and-off scheduling of the Moscow Film Festival was in tune with the Thaw's seasonal rhythms: temporary warm winds of cultural openness followed cultural freezes, only to be followed again by new, albeit brief, periods of liberalization of the cultural climate.

[6] Italian Neorealism (ca. 1942-52) rejected fascist middle-class melodramas (the so-called "white telephone" films), instead striving to confront audiences with the gritty reality of poverty and unemployment in post-war Italy. Neorealism eschewed literary adaptations, emphasizing slices of everyday life. Non-professional actors were preferred, along with natural dialogue and even regional dialects. A documentary style dominated, including location shooting (rather than studio work), natural light and hand-held camera. Rossellini's *Roma, città aperta* (*Rome, Open City*, 1945) and De Sica's *Ladri di biciclette* (*The Bicycle Thieves*,1948) are classic examples of the movement.

French New Wave directors acknowledged their debt to Neorealism. The New Wave movement of the late 1950s-early 60s emphasized the primacy of the auteur, the mise-en-scène and contemporary discourse, while rejecting classical narrative, seamless editing and the use of star actors. The New Wave sought a sense of spontaneity, preferring location shooting, fast editing, including jump cuts and unmatched shots, and the avoidance of establishing shots. Examples are Truffaut's *Les quatre cents coups* (*The 400 Blows*) and Resnais' *Hiroshima mon amour* (both 1959).

[7] The Moscow Film Festival opened in the newly built Shockworker (Udarnik) movie theater in 1935. Sergei Eisenstein was the president of the Main Competition Jury. The major prize winners were the Vasil'ev Brothers for their feature *Chapaev* (1934), René Clair for *The Last Billionaire* (1934) and Walt Disney for his animation films.

Originally the festival had one first prize. Soviet cultural administrators tried to award it to the Soviet film and this was usually the case. During the third (1963) festival, this led to a major scandal. In the wake of Soviet advances in arts and technology, especially Sputnik and the launching of the first manned flight into space in 1961, the festival attracted many major stars. Federico Fellini brought his new film *8 1/2* (*Otto e mezzo*), and the jury led by Grigorii Chukhrai decided to award the first prize to Fellini's film. However, Party authorities pressured the jury into awarding the prize to the socialist realist feature about innovative methods of gas pipeline construction *How Do You Do, Baluev!* (*Znakom'tes', Baluev!* dir. Viktor Komissarzhevskii, 1963). In protest, international jury members threatened to leave the festival. Eventually, with Nikita Khrushchev's blessing and despite the fact that he fell asleep during the screening of Fellini's picture, *8 1/2* received the first prize. After the controversy over the award, which Soviet authorities perceived as a fiasco, the decision was made to award three first prizes: one for a Soviet film, one for a western film and one for a third-world feature. Arguably, this non-competitive model removed suspense from the competition and signaled the coming of the period of stability and status quo, which Gorbachev-era commentators would call the Stagnation era.

Stylistically and ideologically, two historical events were at the center of most politically significant films of the era: The October Revolution and the Great Patriotic War. During the last years of Stalin's rule, both events became absorbed into the monumental biography of the Great Leader and Father. After 1953, the story of the October Revolution morphed from the story of how Lenin prepared the arrival of the true leader, Stalin, into the tragedy of a self-reflexive protagonist torn between personal desires and responsibility to the communal cause. Often such a story takes a tragic turn when a woman has to sacrifice a child, her beloved, and even life itself for the community. Semen Freilikh's article about Grigorii Chukhrai's film *The Forty First* (*Sorok pervyi*, 1956) carried the telling title "The Right for Tragedy" and announced the new approach to the story of Soviet origins.

In the best films about the Revolution, the tale of a tragic protagonist falling for the cause and larger community was carefully intertwined with the narrative of the nuclear family that experiences the revolutionary upheaval. The narrator with whom the viewer was supposed to identify can be a son of the tragic father figure and the contemporary of the viewers. The most successful film about the Revolution and Civil War made according to this blueprint in the 1950s, *The Communist* (*Kommunist*, Iulii Raizman, 1958), follows this family melodrama structure and effectively implicates the individual viewer in the myth of the Revolution as the story of a family overcoming the challenges of modernity.

A similar narrative structure appears in the Thaw adaptations of Shakespeare's tragedies released at the time: *Othello* (*Otello*, Sergei Iutkevich, 1956) and *Hamlet* (*Gamlet*, Grigorii Kozintsev, 1964). These films deal metaphorically with Soviet society's rethinking of its revolutionary past and the intellectual's role in it. When they watched the Danish prince declaiming his soliloquies, Thaw intellectuals (or the "people of the sixties," as they called themselves) felt themselves sons and daughters of the tragic hero who preserves his or her individual integrity and confronts those who claim that everyone should conform with the rules of Elsinore.

By the 1960s, the ideals of the Revolution as the Soviet intelligentsia understood them included the right of the individual to express one's own opinion and reservations about sacrificing the individual either for the cause of the state or the social class. Notably, even films about Lenin made in the 1960s portray the leader of the Revolution as an incarnation of this intelligentsia's ideals (*Lenin in Poland, Lenin v Pol'she*, Sergei Iutkevich,1966). After Innokentii Smoktunovskii played Hamlet in Kozintsev's film, the actor was asked to play Lenin as a self-reflexive, tolerant intellectual in two pictures about the October Revolution, *On the Same Planet* (*Na odnoi planete*, Il'ia Olshvanger, 1965) and *The First Visitor* (*Pervyi posetitel'*, Leonid Kvinikhidze, 1966).

Just as the Revolution and, especially, the Civil War became reinterpreted as tragic experiences, the way White Army officers and soldiers were represented was changing too. They ceased being one-dimensional villains and became complex and often tragic

characters. Lieutenant Govorukha-Otrok from Chukhrai's *Forty First* was the first complex White Army character in Soviet cinema; by the 1960s, the White officer, a decent human being who serves the wrong cause, had become a stock character of Soviet cinema. Given the Russian predilection for melodramas with unhappy endings, films about doomed White officers became popular with moviegoers and altered popular memory of the October Revolution. Notably, by the late 1960s major Soviet stars coveted the roles of the White anti-heroes, not the positive Red heroes. For example, in the 1968 feature *Two Comrades Were Serving* (*Sluzhili dva tovarishcha*, Evgenii Karelov), the rising star of Soviet cinema and theater, Vladimir Vysotskii, received the role of lieutenant Brusentsov. After several tragic turns of the plot involving stunning horses and beautiful women, the White Army officer chooses to put a bullet through his forehead instead of emigrating from his beloved Russia.

In the late 1950s the myth of the Great Patriotic War started taking shape and would soon overshadow the story of the October Revolution as a myth of origins. Denise Youngblood notes that late Stalinist films about the Great Patriotic War celebrated it "as national triumph, but the war as national tragedy remained virgin territory for directors."[8] During the Thaw, war films visualized an event that defined the Soviet people as a community and implicated individuals in the story of national tragedy and triumph.

In the films about World War II filmmakers began experimenting with film form and taboo topics. In their narration and style, Thaw filmmakers chose three main directions: (1) reviving the traditions of the 1920s avant-garde, (2) incorporating neorealist aesthetics into their film style and (3) depicting the war through the lens of art cinema narration. Mikhail Kalatozov and his cameraman, Sergei Urusevskii, revived the constructivist tradition of the 1920s in their *Cranes Are Flying* (*Letiat zhuravli*, 1957) and won the *Palme d'Or* at the Cannes Film Festival, the only one thus far in the history of Russian cinema. Marlen Khutsiev in *Two Fedors* (*Dva Fedora*, 1956),

[8] Denise Youngblood, 117, in Further Reading.

Chukhrai in *Ballad of a Soldier* (*Ballada o soldate*, 1959) and Bondarchuk in *Fate of a Man* (*Sud'ba cheloveka*, 1959) also embraced the neo-realist tradition. Their films played a major role in the destalinization of Soviet cinema but had only relatively modest success at international film festivals because Neorealism was over as an artistic movement in Europe by the time Soviet filmmakers engaged with this tradition. At home, however, these pictures constituted an essential part of Russo-Soviet collective memory of the war.

Soviet art cinema filmmakers of the 1960s used war as a pretext to practice modernist cinematic narration, i.e. episodic structure, focus on the individual character (often via her or his dreams and fantasies), self-reflexive uses of cinematic form, symbolic rather than realist linkage of images. Such films as *Ivan's Childhood* (*Ivanovo detstvo*, Tarkovsky, 1962), *Peace to Him who Enters* (*Mir vkhodiashchemu*, Alov and Naumov, 1961), *Clear Skies* (*Chistoe nebo*, Chukhrai, 1961) and *Wings* (*Kryl'ia*, Larisa Shepit'ko, 1966) subvert many commonplaces, not only of Stalinist but also of neorealist cinema. For example, neorealist films depict the child as the epitome of innocence, not implicated in the crimes of the past (fascism in Italy and Stalinism in the Eastern Bloc countries). In contrast, the child hero in *Ivan's Childhood* has a unique vision of the world because of his trauma. This child, however, promises no redemption. Tarkovsky's masterpiece can be read as a film polemicizing with the neorealist tradition and examining the issues of visual narration and commemoration from a position similar to that of Alain Resnais in *Hiroshima mon amour* (1959). Soviet art cinema films about the war invent a new hero — one who is estranged from traditional social institutions, such as the family, work community, military unit, or society at large. Not surprisingly, many Soviet art cinema films about the war were censored and had only limited domestic distribution. These films, however, gained critical acclaim at international film festivals and restored the prestige of Soviet cinema on the international festival circuit.

While historical-revolutionary and war films of the Thaw revised the key political myths of Soviet culture, the film comedy legitimated private life. Comedies broadened the limits of the permissible and visualized previously taboo sides of Soviet life:

the domestic sphere, individual desire, the anarchic body and socially disruptive behavior (alcoholism, street violence, private entrepreneurship and even sexual aggression). Often a film that belonged to a serious Soviet genre, such as the historical-revolutionary film, would include comic episodes or secondary comic characters who introduced taboo themes. For example, in *Probation Period* (*Ispytatel'nyi srok*, Vladimir Gerasimov, 1960), a film about Soviet secret police agents fighting for the Revolution, the positive hero is paired with a comic foil. The lead character (played by Oleg Tabakov) follows the socialist realist maturation plot. In the course of the film, the protagonist overcomes his excessive humanity towards the enemy and turns into a ruthless Cheka agent emulating his senior colleagues. His partner (played by Viacheslav Nevinnyi) is a comic foil who erroneously models himself on western dime novel private eyes, instead of emulating Soviet secret police role models. Nevinnyi's character animates the boredom of the socialist realist tale. While viewers approved the positive hero's selfless service to the cause of the Revolution, they could also vicariously enjoy the comic foil's exaggerated macho style and his insatiable desire for fashionable clothing, good food and big guns.

Under the wing of Pyr'ev, Riazanov made *Carnival Night* (*Karnaval'naia noch'*), a 1956 remake of Grigorii Aleksandrov's *Volga-Volga* (1938), that established the genre of the New Year film, a subgenre of Russo-Soviet comedy. Alyssa DeBlasio argues that the main features of this genre include "release and screening dates that coincide with the New Year; time imagery representing the transition from one stage of life to the next; the presence of fairy-tale motifs; ... and the emphasis on private rather than public space."[9] The New Year film legitimated private life, established the New Year as a nuclear family-oriented annual holiday and defined the time of this holiday as the moment for carnivalizing the traditional hierarchy of Soviet values, the state's supremacy over individual and domestic concerns.

[9] Alyssa DeBlasio, 43, in Further Reading.

Leonid Gaidai revived slapstick comedy, the film genre representing and rechanneling via laughter the trauma of modern life's overstimulation. In his films Gaidai disrupts the narrative continuity inherited from Stalinism and subjects his characters to a barrage of shocks and jolts. His viewers appreciated the long forgotten thrills and spectacle of crashes, explosions, fights and chases. Highly stylized, carrying the genre memory of chapbooks and circus entertainment, these films depicted a life in which all the taboos and, most importantly, the hypocritical pretenses of Soviet life were suspended. The villains indulge in excessive (by Soviet standards) consumerism: international travel, dinners in restaurants, driving private cars. And Russian entertainment cannot be complete without excessive libations! Gaidai's films explore not only consumption but also the illegal production of hard liquor (*Moonshiners, Samogonshchiki,* 1962). In this popular utopia even doctors recommend that their patients treat their high blood pressure with cognac instead of boring pills (*The Diamond Arm, Brilliantovaia ruka,* 1969).

But next to this world of forbidden pleasures, Gaidai depicts comic situations that border on horror, a horror often based on the inversion of gender hierarchy. In *The Diamond Arm,* the male protagonist experiences nightmares after the scenes in which women assert their power. In one such comic/horrific scene a female gangster assaults the protagonist physically and sexually. When the protagonist faints, he sees an exploding bra clasp and a female monster, who combines the features of the female gangster and the female superintendent of his apartment building.

Gaidai considered himself a genre filmmaker, but film historians remember him now as a film auteur. Like the famous French director Jacques Tati, he created a cinematic world in which the filmmaker-magician ultimately rules. Gaidai even invented an alter ego, the naïve, bumbling and good-hearted student Shurik. Shurik has education but lacks power in a world ruled by street thugs and corrupt bosses. However, through cunning, incredible luck and visual gags constructed by his ultimate magic helper, the director, Shurik overcomes the comic villains.

Gaidai is also important for the period because his films became the record ticket sellers of the 1960s, three of the 10 top grossing films in the history of Russian cinema: *The Diamond Arm* in third place with 76.7 million tickets sold; *Kidnapping Caucasian Style* (*Kavkazskaia plennitsa*, 1967) in fourth with 76.5 million tickets, and *Operation Y* (*Operatsiia Y*, 1965) in seventh with 69.6 million tickets. His comedies made film administrators think not only about ideological propriety but also about the fact that films can bring in a lot of cash. Not surprisingly, Gaidai collaborated closely with the Experimental Creative Unit (*Eksperimental'noe tvorcheskoe ob''edinenie*) ETO, a film studio designed to overhaul the economics of the Soviet cinema and the dismantling of which brought the cinematic Thaw to final closure.

In the early 1960s, Grigorii Chukhrai and the former American studio executive Vladimir Pozner Sr. decided to change the economic basis of the Soviet film industry by making filmmakers' and studios' incomes dependent on ticket sales. The ETO studio was created in 1965, at the time when Aleksei Kosygin proposed similar reforms in the Soviet economy. The experiment proved that the new model was highly effective. Production costs went down and many ETO films became top ticket sellers. The ETO threatened the economic foundation of the essentially feudal Soviet system in which filmmakers, like serfs, were attached to their studios and received from the state regular but low pay, no matter how successful the results of their labors with audiences. Moreover, ETO projects brought new narrative models into the Soviet genre system. Vladimir Motyl' and Nikita Mikhalkov embraced the genre of the western. Edmond Keosaian worked in the genre of crime thriller. Finally, Gaidai made several highly successful comedies at ETO. Stylistically, many of these films established irony and parody as new double-voiced narrative models, alternatives to the monologism of the socialist realist genre system. In 1976 the State Committee on Cinematography (Goskino) recognized the economic success of the experiment but decided to close the studio. One of the reasons was the studio's preference for entertainment genres at the expense of historical-revolutionary and topical films about the political issues of the present. The Goskino leadership rejected the

option to reform the film industry from within and, after the fifteen years of Stagnation, in 1991 the industry collapsed, together with the rest of the Soviet economy.

While the end of the Thaw era was a gradual and contradictory process of artistic and economic evolution, the controversy around Tarkovsky's *Andrei Rublev* (1967-1971) provides a valuable insight into the changing sensibilities and values of the communities involved in the production and dissemination of Soviet cinema. The film itself bears Thaw-era values, while the history of its release is about the ideological ambiguities of the coming Stagnation era. In short, *Rublev* serves as a bridge text linking two periods of Soviet film history.

Tarkovsky began thinking about the picture in 1961, co-authored the script with Andrei Mikhalkov-Konchalovsky and published it in *Art of Cinema* under the title "The Passion according to Andrei." The film itself represents an artful exercise in modernist narration. In the course of 215 minutes, the filmmaker celebrates both his unique vision and the individual as the ultimate measure in ethical and aesthetic debates. Tarkovsky examines the artist and his relationship to power. Like many Thaw era texts, such as Boris Pasternak's *Doctor Zhivago*, the film revives the reading of Christian narratives and symbolism as an alternative to official Soviet mythology.

The film's release and exhibition history represents the crisis of the Thaw-era approach to the administration of cultural production, specifically cinema. The end of the Khrushchev era, with its rhetoric of reviving Leninist revolution after the Stalin cult, blurred ideological priorities for cultural administrators and censors. Nationalist concerns began to compete with Soviet, supra-national ones. Party officials mixed their criticism of Tarkovsky for his lack of a Marxist class approach to the Russian Middle Ages with accusations that he hated the Russian people and had made an anti-Russian film.[10] Through *samizdat* and *tamizdat*, dissident critics

10 P. N. Demichev (presumably, according to Valerii Fomin), "Otzyv o fil'me *Andrei Rublev*, podgotovlennyi v TsK KPSS, 1967," in Valerii Fomin,

broadened the interpretive community of the film. While *Rublev* was attacked by Party censors from the left, it was also attacked by religious thinkers from the right. Alexander Solzhenitsyn criticized Tarkovsky's film for its exploitation of violence, lack of historical and emotional authenticity (*neserdechnost'*) and lack of genuine Christian spirit.

Cultural administrators also had to take into account Tarkovsky's international status and festival organizers' interest in his new film. Soviet cultural officials could not simply dismiss their international partners because Soviet cinema had become integrated into the European art cinema process and specifically, the festival circuit. As a result, *Andrei Rublev* was not officially banned, but was not released for a broader audience either. In the USSR *Rublev* premiered at the Filmmakers' Club (*Dom Kino*) in 1967, but was de facto shelved for the next five years. Soviet film administrators did not ban the film from being shown at international film festivals but they delayed its release to the Cannes Film Festival until 1969. Thanks to the efforts of the same Soviet film officials, the film was not part of the official competition at Cannes and was screened at 4 a.m. The audience, however, received *Rublev* enthusiastically and it won the FIPRESCI Award. Only after the film's international triumph, and under pressure from such influential figures as Grigorii Kozintsev and Dmitry Shostakovich, did an abridged version of *Rublev* see limited domestic release in 1971. Only 277 copies of *Rublev* were shown in a nation of 250 million people and, as Tarkovsky recollects, not a single poster advertising the film was seen on Moscow streets. The Stagnation era model of ideological control was not about ubiquitous fear, mass terror or the promise of communist utopia; rather it was about limiting access to information and the continual harassment of those few, like Tarkovsky, who did not give up and continued exercising artistic agency.

146-47, in Further Reading; S. Surnichenko, "Otzyv Vladimirskogo Obkoma KPSS o fil'me A. Tarkovskogo *Andrei Rublev*. 17 iiulia 1969 g.," in Fomin, 147-48.

FURTHER READING

Anninskii, Lev. *Shestidesiatniki i my.* Moscow: SK SSSR/Kinotsentr, 1991.

Binder, Eva, and Christine Engel, eds. *Eisensteins Erben: Der sowjetische Film vom Tauwetter zur Perestrojka (1953-1991).* Innsbruck: Innsbrucker Beiträge zur Kulturwissenschaft, 2002.

Budiak, L. M., ed. "Glava IX. Ottepel' (Shestidesiatye)." In *Istoriia otechestvennogo kino,* 380-426. Moscow: Progress-Traditsiia, 2005.

DeBlasio, Alyssa. "The New-Year Film as a Genre of Post-war Russian Cinema." *Studies in Russan and Soviet Cinema* 2, no.1 (2008): 43-61.

Etkind, Alexander. "Mourning the Soviet Victims in a Cosmopolitan Way: Hamlet from Kozintsev to Riazanov." *Studies in Russian and Soviet Cinema* 5, no. 3 (2012): 389-409.

Fomin, Valerii, ed. *Kinematograf ottepeli: Dokumenty i svidetel'stva.* Moskva: Materik, 1998.

Graffy, Julian. "Film Adaptations of Aksenov: the Young Prose and the Cinema of the Thaw." In *Russian and Soviet Film Adaptations of Literature, 1900-2001: Screening the Word,* edited by Stephen Hutchings and Anat Vernitski, 110-15. London: Routledge-Curzon, 2005.

_____. "Scant Sign of Thaw: Fear and Anxiety in the Representation of Foreigners in the Soviet Films of the Khrushchev Years." In *Russia and Its Other(s) on Film: Screening Intercultural Dialogue,* edited by Stephen Hutchings, 27-46. NY: Palgrave Macmillan, 2008.

Kapterev, Sergei. *Post-Stalinist Cinema and the Russian Intelligentsia, 1953-1960: Strategies of Self-representation, De-Stalinization, and the National Cultural Tradition.* Saarbrücken: VDM Verlag, 2008.

Margolit, Evgenii. "Introduction." *Thaw Cinema.* CD-ROM. Artima Studio. Executive Director of the Project, Nancy Condee. Washington, DC: The Ford Foundation and NCEEER; Pittsburgh: REES, 2002.

Martin, Michel. *Cinéma soviétique: de Khrouchtchev à Gorbatchev.* Lausanne: L'Age d'homme, 1993.

Pontieri, Laura. *Soviet Animation and the Thaw of the 1960s: Not Only for Children.* New Barnet, UK: John Libbey and Company, 2012.

Prokhorov, Alexander. *Unasledovannyi diskurs: paradigmy stalinskoi kul'tury v literature i kinematgrafe ottepeli.* St. Petersburg: Akademicheskii proekt, 2007.

Shilova, Elena. *...i moe kino.* Moscow: NII Kinoiskusstva/Kinovedcheskie zapiski, 1993.

Troianovskii, Vitalii, ed. *Kinematograf ottepeli. Kniga pervaia.* Moskva: Materik, 1996.

------, ed. *Kinematograf ottepeli. Kniga vtoraia.* Moskva: Materik, 2002.

Troshin, A., N. A. Dymshits, S. M. Ishevskaia, V. S. Levitova, and N. I. Nusinova, eds. "1953-1969." In *Istoriia otechestvennogo kino. Khrestomatiia,* 426-519. Moscow: Kanon, 2011.

Woll, Josephine. *Real Images: Soviet Cinema and the Thaw.* London and New York: I.B. Tauris, 2000.

Youngblood, Denise. "The Thaw, 1956-1966." In *Russian War Films,* 107-41. Lawrence: University of Kansas Press, 2007.

THE CRANES ARE FLYING

Letiat zhuravli

1957

97 minutes

Director: **Mikhail Kalatozov**

Screenplay: **Viktor Rozov, based on his play** *Vechno zhivye* **(*Forever Alive*)**

Cinematography: **Sergei Urusevskii**

Art Design: **E. Svidetelev**

Composer: **Moisei Vainberg**

Sound: **I. Maiorov**

Production Company: **Mosfilm**

Cast: **Tat'iana Samoilova (Veronika), Aleksei Batalov (Boris), Vasilii Merkur'ev (Fedor Ivanovich), Aleksandr Shvorin (Mark), Svetlana Kharitonova (Irina), Valentin Zubkov (Stepan), Konstantin Nikitin (Volodia), Antonina Bogdanova (Grandmother)**

As a young man, Georgian-Russian director Mikhail Kalatozov (born Kalatozishvili, 1903-73) learned his craft on the job—editing, filming, acting, writing screenplays—at Tbilisi film studios. He achieved prominence with *Salt for Svanetia* (*Sol' Svanetii,*1930), a visually sophisticated documentary about a mountain tribe that not only obtains the salt needed for life when the government builds a road, but is liberated from religious and economic oppression by Soviet power. After the banned *Nail in the Boot* (*Gvozd' v sapoge*, 1931), which supposedly slandered the Red Army, and an historically "incorrect" script for *Shamil*, Kalatozov was unable to make films until 1939. In 1941 he shot *Valerii Chkalov*, a successful socialist

realist biopic about the most famous Soviet test pilot. The iconic Thaw film *The Cranes Are Flying* was the high point of Kalatozov's career, the only Soviet film to win the *Palme d'Or* at Cannes. *The Unsent Letter* (*Neotpravlennoe pis'mo*, 1959) and *The Red Tent* (*Krasnaia palatka*, 1969) were later successes, while the ideological *I am Cuba* (*Ia—Kuba*, 1964), which initially flopped in the USSR and Cuba, acquired cult status after its rediscovery by Coppola and Scorsese.

Cranes was the result of Kalatozov's creative partnership with cinematographer Sergei Urusevskii (1908-74), whose emotional, subjective filmic style corresponded to Kalatozov's own inclinations, as demonstrated in *Salt for Svanetia*. Both men had been influenced by the modernist experimentation of the 1920s avant-garde: Urusevskii had studied with Rodchenko, and playwright-poet Sergei Tret'iakov had coauthored with Kalatozov both the scripts for *Salt for Svanetia* and *The Blind Girl* (*Slepaia*), the failed film from which the director created *Salt*.

Cranes takes up the experience of Russians on the home front during World War II. Veronika and Boris are happily in love, but are suddenly separated when he volunteers for army service. When Veronika's parents are killed in a bombing raid, she is taken in by Boris's family, the Borozdins. During another bombing, Veronika is raped by Boris's draft-dodging cousin, Mark. Although she still believes Boris is alive, Veronika soon marries Mark and is evacuated to Siberia with the Borozdin family. Both Veronika and Fedor Ivanovich, Boris's father, gradually realize the extent of Mark's villainies and Veronika leaves him. When Boris's unit returns at the end of the war, Veronika learns that he is dead. She weeps as others celebrate, then distributes the flowers she brought for Boris to the crowd, and walks away with Fedor Ivanovich.

Cranes has an hourglass structure with two deaths at the center: Veronika's spiritual demise from rape and Boris's physical death from a sniper's bullet. The two sections of the film are unified through both internal and bridging symmetries. In part one, both Boris and Veronika dive into bed at dawn; Boris punches Volodia and Veronika slaps Mark; Mark's shoes are connected to Boris's boots through montage. Among the bridging symmetries across the two parts of the film are the long tracking shots of departure

to war and return, cranes flying in formation and love scenes (actual or implicit) on the embankment between Veronika and Boris, Veronika and Mark, and finally, Volodia. Part one is more dramatic with subjective cinematography, while part two reveals, in more conventionally filmed scenes, the consequences for Veronika of the central deaths—from guilt to renewal and ultimate reconciliation.

As an emblematic work of Thaw cinema, *Cranes* both deconstructs the grand narratives of Stalinist film and contravenes its stylistic principles. While the spatial vector of many Stalinist films moved from the country's margins to Moscow as the sacred center, Boris and Veronika already inhabit paradise (the early park scenes near the Kremlin) and must depart. The strong human father replaces mythical Father Stalin. From beginning to end, Fedor Ivanovich is the family's pillar of strength and perhaps most proximate to the director's point of view—from his sarcastic comment about fulfilling and overfulfilling the plan to his refusal to judge Veronika's actions. The heroes of *Cranes* are not stakhanovites, but ordinary, good people. Even the villain is not evil incarnate, but rather cowardly and opportunistic: until Veronika rushes into his arms for protection, Mark does not dare make advances.[1] The classically proportioned faces of Stalin era heroes and heroines (acted by Liubov' Orlova, Sergei Stoliarov, Nikolai Bogoliubov and others) give way to the irregular, mobile features of Veronica and Boris. With her angular features and slanted eyes, Tat'iana Samoilova resembles an Audrey Hepburn-like gamine.

The Thaw also begins to redefine the relationship of the individual to the collective. The film validates private emotion as no less important than public commitment. Veronika has no profession. She is neither worker nor intellectual; her entire life is focused on those she loves. During Stepan's public speech about the joys of

[1] Kalatozov frames his own milieu of arts people (the pianist Mark, the actress Monastyrskaia, the theatre impresario, even initially the harmonica-playing amateur, Volodia, who is linked to Mark through montage) as hedonistic and frivolous, in contrast to the professional class of engineers and doctors who act selflessly during wartime.

victory, Veronika weeps over her private tragedy. *Cranes* argues that it is acceptable to live one's own life, even if it is an unhappy one, as opposed to the obligatory happiness of civic commitment. The socialist realist hero who has achieved consciousness exudes reason, calm and restraint. To modern audiences, the hyper-emotional acting and music of *Cranes* may seem excessive; to Thaw audiences accustomed to the hypocrisies of Stalin era film, the expression of strong emotion denoted sincerity. If socialist realist film was concerned with conquering nature for economic reasons, *Cranes* begins a rapprochement with the natural world. Although the cranes in Grigorii Aleksandrov's *The Radiant Path* (*Svetlyi put'*, 1940) are visually isomorphic with the birds of Kalatozov's film in that the formation begins and ends both films, their signification is radically different. The wedge formation of the Stalin era film denotes the stakhanovite leader at the head of the collective, while in *Cranes* the birds returning in spring signify rebirth, renewal and joyful life, and the birds themselves, reputed to mate for life, denote loyalty and fidelity.

Finally, Thaw cinema replaces the dominant word of Stalinist cinema with image, and for Urusevskii—highly subjective image, as in his opening shots of Moscow: "The whole point is to show [things] in a new way, so that the familiar city turns out to be unfamiliar."[2] His cinematography is dynamic and lyrical: disorienting high, low and canted angles, hand-held camera, extreme closeups, chiaroscuro lighting and long tracking shots—all a radical break with the static, neutral style of Stalinist film. Mise-en-scène is symbolic: the three staircases of life; the water truck that throws cold water on Veronika's naïve dreams, as she looks up at the cranes and declaims a children's poem about them; the Mark-Veronika relationship conveyed graphically by sharp objects—the double row of "porcupine" anti-tank barriers the couple traverses after Veronika's phone call; the broken glass (Veronika's broken life) under Mark's shoes, as he carries her to bed in anti-bridal ritual.

2 Urusevskii, quoted in Maiia Merkel', *Ugol zreniia* (Moscow: Iskusstvo, 1980), 21. For detailed analysis, see the following essay by Alexander Prokhorov.

From the beginning, Veronika is boxed in by the patriarchal order. It is only in the early "blackout" scene with Boris that she wins a playful wrestle, repeatedly declaring "I've won!" From this point on, she loses. Veronika wants to enter the architecture institute; Boris tells her she will not get in. She plans to work at the factory, but is prevented by the trauma of her parents' deaths. Emotionally damaged, she is unable to fend off Mark. Her resistance declines from attempted escape to ladylike slaps to a passivity or faint (I reject what is happening to my body) that could be read from the traditional male point of view as acquiescence. (Her excessive "nos" really mean "yes.") There is an unresolved tension in the filmic presentation of the rape that supports such ambiguity. *Cranes* presents three violent events: the rape, Boris's death, and Veronika's suicide run. Only the rape is essentially devoid of female point-of-view shots. (There are two quick shots of Mark's frenzied eyes.) The rape is depicted instead with the camera alongside Veronika. The point of view may be sympathetic, but it is completely externalized, eliding the interiority of the subject, and thereby opening up the possibility of differing interpretations of her actions. Veronika herself views the rape and subsequent marriage as a betrayal on her part, and proceeds to enact the female self-punishment characteristic of American melodrama.[3]

In the course of the film, Veronika unsuccessfully attempts romantic love, sexual payment for security (marriage to Mark) and motherhood. In the end she is reconciled to her new reality, first by giving away the flowers intended for Boris to other returning soldiers, and then by walking away encircled by the protective arm of Fedor Ivanovich, the paternal authority figure of the film. It is through this stock ending of the melodramatic mode that women reassure themselves about their place in the patriarchal order. Once again, Veronika has become a daughter.

[3] Kalatozov was exposed to American film when he served as representative of the Soviet cinema industry in the United States from 1943-45.

RECONFIGURING THE WAR AND THE FAMILY TROPES IN THAW-ERA HOMEFRONT MELODRAMA

Alexander Prokhorov

The Cranes Are Flying underscores the dominant narrative of home-front melodrama during the Thaw: the reconstitution of the nuclear family around the trauma of irrecoverable loss generated by war. Unlike the melodramas of the era that primarily focus on the reconstitution of the troubled family, *Cranes* shifts the focus to the war experience of the most powerless and sinful member of the community: the unfaithful woman.[1]

In Thaw-era home-front melodrama, war's significance as the cause of loss and instability becomes an ambiguous signifier because the victimizer is usually not an external enemy but a sadistic "us." Kalatozov's melodrama reconfigured the war trope inherited from Stalinism, transforming the ideological confrontation between "us" and "them" into a conflict between the female protagonist and the war equated with familial "us." War victimizes the disempowered, orphaned, and fallen Veronika. Her individual feminine experience becomes the locus of Thaw-era values.

Films of the Thaw period emphasized the visualization of the protagonist's sufferings. The resurrection of visual expressivity in post-Stalinist film made camera work critical for Thaw-era filmmaking, and Kalatozov owes much of the success of *Cranes* to his cameraman Sergei Urusevskii.[2] My discussion of *Cranes* concentrates

[1] The most representative family melodramas of the Thaw period are *Big Family* (Kheifits, 1953), *The Unfinished Story* (Ermler, 1955), *The House I Live In* (Kulidzhanov and Segel, 1957), *Ekaterina Voronina* (Anninskii, 1957), and *My Beloved* (Kheifits, 1958).

[2] In Russian film histories, as well as in the works favoring an auteur approach in general, the director is usually mentioned as the main author of the film. The only exceptions are 1920s avant-garde film and Thaw-era cinema. Two famous cameramen of the Thaw period are Sergei Urusevskii, who worked

on the elements of its structure that contributed to post-Stalinist reimagining of both the war and the family tropes: the protagonist's characterization through the uses of mise-en-scène and camera, the personalized temporality of war, and the family structure.

Cranes not only problematizes the conventions of Stalinist melodrama, but also defines the protagonist, Veronika, against the background of ideal Stalinist womanhood, as envisioned by views during the Thaw. Veronika's foil, Boris's older sister Irina, incarnates this ideal: she is articulate, reason-driven, sexually repressed, and dressed in a military uniform. Kalatozov, however, presents Irina's model of femininity as unfit for the Thaw's envisioned new deal. The military uniform, a low masculine voice, and military body language are presented as a gender mismatch. Irina's father even complains that in being a successful surgeon his daughter made only one mistake—she was born a female. The primacy of reason at the expense of emotionality is presented by the filmmakers as Irina's deficiency of sensitivity. Moreover, Irina's repressed sexuality is channeled into sadistic energy, used to torment the victim-protagonist of the film.

Visual Style and Expressive Mise-en-Scène

The expressive mise-en-scène of *The Cranes Are Flying* makes visible the protagonist's inner suffering, which supports Mary Ann Doane's argument that the distinctive feature in the structure of the melodramatic character is "the externalization of internal emotions

with Kalatozov, and Vadim Iusov, who collaborated with Andrei Tarkovskii. Sergei Urusevskii's contribution to Soviet cinema is usually discussed within the context of reviving the tradition of the 1920s avant-garde film. See Iurii Bogomolov, *Mikhail Kalatozov: Stranitsy tvorcheskoi biografii* (Moscow: Iskusstvo, 1989), 157-61; Antonin Liehm and Mira Liehm, *The Most Important Art: Soviet and East European Film after 1945* (Berkeley: University of California Press, 1977), 199-200; and Maiia Merkel', *Ugol zreniia: Dialog s Urusevskim* (Moscow: Iskusstvo, 1980), 32.

Intelligentsia of the Thaw period also associated avant-garde film with black-and-white film stock, and late Stalinist film with excessive use of color. This was the other reason that many Thaw-era family melodramas avoided color and used avant-garde film techniques to convey melodramatic excess.

and their embodiment within the mise-en-scène."[3] In characteristic family melodrama fashion, Veronika's body is especially important, because she, unlike the Stalinist ideal female, has a weak command of language.[4] Tania Modleski notes that "many of the classic film melodramas from the 30s through the 50s are peopled by . . . women possessed by an overwhelming desire to express themselves . . . but continually confronting the difficulty, if not the impossibility to realize the desire."[5] This observation accurately describes the dilemmas confronting Veronika, who cannot give form to her sufferings through language and painfully searches for alternative channels of self-expression. At the beginning of the film, Veronika either asks questions or speaks in incomplete sentences. The best example of her inarticulateness is a song about cranes, which Veronika sings at the beginning of the film.

> The long-billed cranes
> Are flying overhead,
> Gray ones, white ones,
> Ships in the skies.[6]

In this fragment, the narrative or facts fade into irrelevance, as the value of mood and emotion replaces them.

Veronika lacks the paternal source of discourse available to Stalinist women. All the males who could potentially empower her with their ideologically impeccable logos disappear from the

[3] Mary Ann Doane, "The Moving Image: Pathos and the Maternal," 285, in *Imitations of Life: A Reader on Film and Television Melodrama*, ed. Marcia Landy (Detroit: Wayne State University Press, 1991).

[4] Marcia Landy and Amy Villarejo point out that a "mute quality" is one of the major characteristics of melodrama: "The verbal language is inadequate to the affect that melodrama seeks to communicate" (Landy and Villarejo, *Queen Christina* [London: British Film Institute, 1995], 27).

[5] Tania Modleski, "Time and Desire in the Women's Film," 537, in *Film Theory and Criticism*, ed. Gerald Mast, Marshall Cohen, and Leo Braudy (NY: Oxford University Press, 1992).

[6] Viktor Rozov, "Alive Forever," in *Contemporary Russian Drama* (NY: Pegasus, 1968), 24.

narrative. Veronika loses her biological father and her fiancé in the first months of the war. The discourses offered by the other two male characters, Mark and Fedor, are corrupt. Mark is unfaithful and constantly lies to Veronika. When Fedor Ivanovich pronounces his diatribe against unfaithful women, he adopts the official discourse and pushes Veronika toward a suicide attempt—after his speech Veronika decides to jump off the bridge under a train.[7]

Being inept at verbal language, Veronika retreats to the language of emotional bodily gesture, which the film promotes to the status of natural language.[8] Body language provides the most efficient way to convey the inner self. Tellingly, at the beginning of the film Veronika and Boris agree on the time of their next date by using fingers instead of words (Fig. 77): more precisely, Boris speaks while Veronika uses her hands.

Other characters who share the protagonist's sincerity also favor emotional gesture over corrupt, reason-driven speech. When Fedor, for example, tries to explain why his son has to go to war he cannot find the appropriate words, and he starts crying and drinks a shot of alcohol. When Boris's friend Volodia jokes about the likelihood of Veronika's being unfaithful to him, Boris also abandons words and uses his fists as a means of communication. When Volodia realizes that he mistakenly has told Veronika about Boris's death, speech fails him, and instead he kisses her wet hand covered with soap.

Although Veronika's bodily gestures create a sincere discourse beyond the corrupt word, Veronika's body also becomes a major site of war trauma, conveyed through two major elements of mise-en-scène: lighting and the color of her clothing. Veronika's clothes create a polarized realm of white and black. The two colors signal

7 As Richard Stites notes, it was a literary reference that "no Russian could miss" (Stites, *Russian Popular Culture: Entertainment and Society since 1900* [Cambridge: Cambridge University Press, 1992], 141).

8 Discussing the reactions of Diderot and Rousseau to the Enlightenment crisis, Peter Brooks notes: "Gesture appears in the *Essai* to be a kind of pre-language, giving a direct presentation of things prior to the alienation from presence set off by the passage into articulated language" (Brooks, "The Melodramatic Imagination," 66, in *Imitations of Life*).

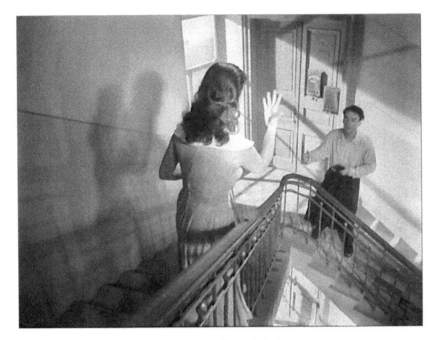

Fig. 77. Veronika and Boris

the protagonist's fall and resurrection as parts of the hyperbolized melodramatic world, where, according to Peter Brooks, every dress change "has little to do with the surface realities of a situation, and much more to do with the inner drama in which consciousness must purge itself and assume the burden of moral sainthood."[9] Veronika's black-and-white clothes serve as the ultimate surface signifier exteriorizing her inner conflict.

Kalatozov's second mode of inscribing visual trauma on Veronika's body is through his use of lighting. In *Wait for Me* the bright light on Liza's face and blonde hair underscores her fidelity and perseverance amid the darkness of war, whereas the onset of war in *Cranes* covers the face of the protagonist in shadows. The shadows emphasize her vulnerability and anticipate the brutality of war. Once the war begins, the bright high-key lighting disappears from the film.

[9] Brooks, "The Melodramatic Imagination," 53.

During Boris and Veronika's last meeting, shadows envelop them and only their eyes are highlighted by bright patches (Fig. 78). The ominous potential of shadow receives full realization in the rape scene, when the flashes of bomb explosions cast grotesque shadows on the protagonist's body. The rape experience is visualized as patches of black on Veronika's face, in a conflation of national and bodily invasion. The thinner and lighter shadows in the second part of the film signal Veronika's gradual recovery from the rape of war. The concluding scene, however, represents but does not resolve the contradiction between personal loss and common victory. The high-key, bright light shining over the celebratory crowd contrasts with the darkness of Veronika's eyes and hair.

To represent the protagonist's emotional state, Kalatozov employs Vsevolod Pudovkin's notion of "plastic material," that is, "those forms and movements that shall most clearly and vividly express in the images the whole content of the idea."[10] In *Cranes* such plastic material carries extraordinary emotional weight. For example, the stuffed squirrel that Boris gives to Veronika, whose nickname is "Squirrel," materializes the characters' emotional state (love, grief) or implies the generation of intense emotions (signaling betrayal, resurrection). Passed on to Veronika as Boris's birthday gift to her, the squirrel transforms into a symbol of their love after his departure. After Mark rapes and then marries Veronika, he steals the squirrel and presents it as a birthday gift to his mistress, thereby transforming the squirrel into an antithetical symbol, that of betrayal. When the stuffed squirrel is returned to Veronika and she belatedly reads the birthday card from Boris hidden inside it, the stuffed toy (an extremely antimonumental object) comes to symbolize the promise of Veronika's resurrection.

A distinctive feature of Thaw-era melodrama's setting, and that of *Cranes* in particular, is the subordination of space to the temporality of lateness, separation, and loss. *Cranes* is radically different in this respect from Stalinist works that favor spatial metaphors of war. In

10 Vsevolod Pudovkin, *Film Technique and Film Acting* (NY: Grove Press, 1949), 55.

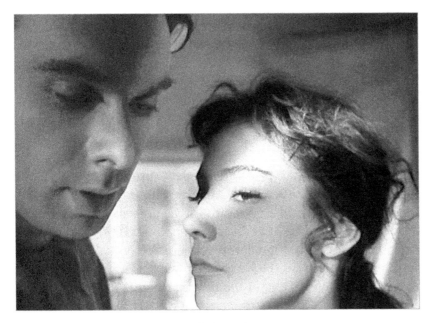

Fig. 78. The Last Meeting

the war-era melodrama *Wait for Me* (*Zhdi menia,* dir. Alexander Stolper, 1943), Liza searches for her husband on a map in a room where numerous portraits depict Stalin with maps and battle plans. By contrast, Thaw-era homefront melodrama allows time "out of joint" to dominate the space of the film. War becomes a time of personal tragedy instead of an epic space for a monumental battle.

Temporality dominates space, starting from the initial frame showing the film's title, which appears against the background of the clock on the main Kremlin tower. Clock sounds and images constantly remind the viewer about war as a time of loss. The clock chime of the radio foreshadows the announcement of war. When viewers hear the radio signal, they see Boris's empty chair at the family table. The family clock ticks deafeningly when Veronika opens the door into the abyss of her apartment, which has been destroyed by a bomb.

If time signifies the personal tragedy of war, then Veronika's recovery from the trauma is conveyed through the images of the protagonist transgressing the spatial borders that separate her from other people. To represent visually the protagonist's ordeal,

Kalatozov favors two types of spatial composition within the film's shots: a space marked by dividing and separating lines and borders, and a space dominated by the protagonist's motion across them. The divided space appears more often in the first part of the film until Veronika's suicide attempt (note, for example, the farewell scene shots, where the prison-like bars of the steel fence separate Boris and Veronika).

The film contrasts such divided frames and claustrophobic rooms with transitional spaces, in which the protagonist experiences radical transformations. Mikhail Bakhtin has argued that "on the threshold ... the only time possible is crisis time, in which a moment is equal to years."[11] The crisis/threshold chronotope precisely characterizes the emotional intensity of Veronika's existence in the transitional spaces. Her arrival in such a space indicates her extreme emotional state and the drastic change in her life. Among various types of such spaces, two are of decisive importance for the construction of the protagonist and her relationship to the war: bridges and staircases.

A bridge serves as the space of psychological/spiritual transition to Veronika's resurrection and reconciliation with the losses of war. Veronika comes to the bridge to save the life of an orphan and thereby saves her own soul. At film's end, Veronika crosses the bridge in an attempt to come to terms with her loss. Likewise, the three stair sequences provide transitional spaces in which characters experience the unavoidability of war suffering en route to their eventual salvation. The stairs spatially symbolize the death-shadowed time of war as the inversion of life's temporality. Consequently, the living characters move counterclockwise— that is, against the time of war—while the dead characters move clockwise, in tune with the temporality of death. Significantly, both Boris and Veronika favor an ascending motion, associated with a reconstitution of their "moral sainthood."[12] Stairs belong to

11 Mikhail Bakhtin, *Problems of Dostoevskii's Poetics* (Minneapolis: University of Minnesota Press, 1984), 169-70.

12 Brooks, "The Melodramatic Imagination," 53.

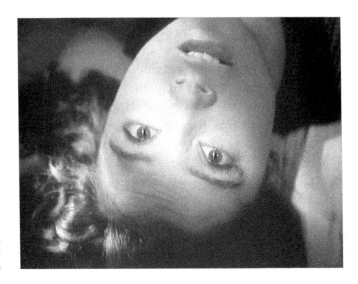

Fig. 79.
World Turned
Upside Down

the vertical axis of Thaw-era melodrama, linking the earthly and heavenly worlds.

The camera's primary function in *Cranes,* like that of the mise-en-scène, is to create the melodramatic protagonist. If mise-en-scène employs the protagonist's excessive bodily gestures to represent the sincerity and uniqueness of her emotions, then the camera employs close-ups for the same end. Close-up shots focus mainly on Veronika. They foreground and validate the sufferings of the most disempowered and marginalized member of the film's social and family hierarchy—a raped orphan. Moreover, to obliterate the significance of the background, cinematographer Urusevskii often used short-focused lenses and blurs the background of his close-ups.[13]

The camera emphasizes the intensity of Veronika's emotions by tilting her face in the frame, disrupting the tonal homogeneity of the image with shadows and placing an obstacle between the

[13] Several critics identify short-focused optics as a distinctive feature of the film's style. See Leonid Kosmatov, "Sovershenstvuia khudozhestvennuiu formu," *Iskusstvo kino* 12 (1957): 26; Neia Zorkaia, *The Illustrated History of Soviet Cinema* (London: Hippocrene Books, 1989), 212; and Bordwell and Thompson, *Film Art: An Introduction* (NY: McGraw-Hill, 1997), 216.

protagonist's face and the viewer's gaze. An upside-down close-up indicates the destruction of peace-time norms and hierarchies (Fig. 79). Urusevskii presents through a carnivalesque close-up the ultimate trauma of the protagonist as Mark rapes her.

The close-ups conveying emotional excess also serve an important narrative function. They break the linear flow of the narrative and usually frame sequences designed to evoke pathos. For example, the sequence of Veronika's rape and Boris's death opens with a close-up of Veronika's face and ends with a close-up of Boris in the throes of death. His dead eyes acquire a glass-like quality, echoing the image of broken glass on the floor of the room where Veronika was raped. Serving as a framing device of the sequences dominated by extreme feelings, close-ups emphasize emotional intensity as the distinctive trait of the protagonist.

To convey the intensity of the protagonist's emotions, Urusevskii also employs extremely long tracking or panning shots.[14] For example, he structures the concluding scene, in which Veronika runs to see Boris's friend Stepan, from whom she learns about her beloved's death, as a combination of radically extended tracking shots of Veronika. The temporal excessiveness of the tracking shots underscores Veronika's passionate hope, while the abrupt cut to a close-up of her and Stepan visually captures her despair when she learns about Boris's death. To impede the narrative flow and to intensify the emotional excess of the episode, the filmmakers also use real time in their long tracking shots, the effect of which is described here by critic Vitalii Troianovskii: "The extra-long tracking shot filmed in real time goes on and on. And you suddenly feel choked up from your proximity to another's soul."[15] If the close-ups emphasize the authenticity of suffering, then the length of the takes underscores the scope of individual trauma.

14 Russian works on Urusevskii's art call these long takes *superpanorama*, no matter whether they are pans or tracking shots. See Maiia Merkel', *Ugol zreniia*; and Vitalii Troianovskii, "*Letiat zhuravli* tret' veka spustia," *Kinovedcheskie zapiski* 17 (1993): 54.

15 Troianovskii, "*Letiat zhuravli* tret' veka spustia," 54.

Finally, the third important camera device is the use of unconventional angles, extremely high and low, to represent the protagonist's psychological state. In the introductory part of the film, high-angle crane shots suggest the scale of the lovers' happiness through the openness and expanse of space. Shifts to low-angled shots focusing on the couple foreground the significance of their togetherness. With the beginning of the war, the high-angled shots gradually disappear and the closed form conveys the claustrophobic nature of Veronika's space. She lives in the attic, where the camera's eye is always confronted with objects blocking the view, thereby creating an aura of entrapment.

High-angled shots reappear only at the very end of the film, which closes with a crane shot of the protagonist. These shots return Veronika to the peaceful life established at the beginning of the film. The camera here serves as a deus ex machina that tries to bring the film to a happy closure and to symbolize Veronika's coming to terms with her tragedy. Moreover, the concluding high-angled shot—where the camera becomes a sort of eye in the sky—and the reappearance of the paternal figure (Fedor) emphasize the restoration, if only partial, of the patriarchal order that presumably will protect Veronika in the future. The protagonist's emotional state, however, hardly coincides with the camera's attempts to regain the space of innocence. In the words of Linda Williams, *Cranes* "begins, and wants to end, in a space of innocence."[16] But Veronika never lets the old space of innocence be unambiguously restored.

The Rhetoric of "Too Late"

Mary Ann Doane points out that "the 'moving effect' of melodrama is tied to a form of mistiming, a bad timing, or a disphasure."[17] Soviet home-front melodrama of the 1950s in general, and *The Cranes Are Flying* in particular, redefined the nature of Soviet time by

16 Linda Williams, "Melodrama Revised," 65, in *Refiguring American Film Genres*, ed. Nick Browne (Berkeley: University of California Press, 1998).

17 Doane, "The Moving Image," 300.

foregrounding the temporality of the protagonist's losses and her powerlessness in the face of time's irreversibility. The melodramatic mistiming was a departure from the temporality of Stalinist culture, which favored a teleological vision of great historical time: the inevitable progression of history toward the triumph of communism. Existing in such a temporality, the characters were supposed to create features of the future in the present, by, for example, overfulfilling production plans and thus being several months or years ahead of schedule.

Cranes also shifted the direction of Soviet temporality; instead of overcoming the future, the film's protagonist seeks reconciliation with her past. Thaw-era melodrama shifts the focus from official state time to personal, individual time; more precisely, the film dramatizes the conflict between personal and state time. *Cranes* opens with a tilted shot of the frame of the clock on the Kremlin tower. This is the first visual clue to the film's concern with personal time. The narrative confirms the discrepancy between state time and the characters' personal time: at 4 a.m. on June 22, the Kremlin clock simultaneously chimes the end of Boris and Veronika's date and the beginning of war.

State time and the lovers' personal time are out of emotional tune throughout the film. Two events—the beginning of the war and the hard-won victory at its end—delineate state time. Boris and Veronika miss the official announcement of the outbreak of war because of their long rendezvous. They are also emotionally displaced vis-à-vis the moment of victory because Boris is killed and Veronika's irrecoverable loss prevents her from joining the general festivities.

Boris and Veronika are not only out of sync with state time, but also are never able to synchronize their personal times. The only moment when the lovers' personal clocks tick together is during the last morning of peace. With the outbreak of war, the rhetoric of "too late" takes over the characters' personal time. The traumatic separation of the two lovers starts with Veronika's lateness, first to the farewell party, then to the site of the recruits' departure, and culminates in the scene of Boris's death, where the last thing that Boris sees is himself arriving late to his wedding to Veronika.

The alternative to this temporality of belatedness and loss is the temporality of new beginnings, which derives much of its symbolism from the Christian notion of resurrection. Although it does not suspend the notion of loss and lateness, this temporality provides hope for rebirth. The rebirth chronotope occurs at the center of the narrative four times in scenes of extreme emotional intensity. The first two such scenes consist of miraculous coincidences—a distinct feature of melodramatic narrative. When Veronika chooses to save the life of an orphan instead of committing suicide, the saved boy's name, improbably, turns out to be Boris. Similarly, when Veronika is betrayed by Mark she finds a note from her dead fiancé, its message articulated by his "posthumous" voiceover, wishing her a happy birthday. Boris's greetings fall not on Veronika's actual birthday, but close to Christmas Day—the moment of Veronika's spiritual rebirth.

The two miracles in *Cranes* are followed by two naturalized metaphors of rebirth. First, spring returns to the town where Veronika is staying during the war. Second, at the very end of the film, the cranes—birds that abandon Russia in winter—return to postwar Moscow.

By defining its dominant temporality as the personal time of the protagonist's loss and rediscovery of hope, *Cranes* rejects the Stalinist overcoming of the present so as to project it into the future. Veronika's personal time reasserts, in Brooks's words, "the need for some version of the Sacred and offers further proof of the irremediable loss of the Sacred in its traditional, categorical unifying form."[18] Thaw-era home-front melodrama conceived of the resacralization of time as a personal reconciliation with the losses of the war.

In addition to destabilizing the structure of the nuclear family, *Cranes* complicates the family's hierarchy by contradictions in the construction of the father's masculinity. The major contradiction arises from the juxtaposition of the official paternity discourse of the state and the discourse of the small family's paternal authority, Fedor. Official paternity is represented most often through acoustic

[18] Brooks, "The Melodramatic Imagination," 61.

devices, especially radio announcements. Of the two central radio messages in the film, the first announces the outbreak of war (thereby linking the official discourse with war), and the second assures listeners that nothing special has happened at the front— right after the episode where Boris falls victim to enemy fire. The incompatibility between the tragedy of Boris's death and the tone of the official news lays open the contradiction between the personal experience of war and the perception offered by the radio, the mouthpiece of the state. Similarly, Stepan's official speech at the end of the film contrasts with Veronika's silent mourning. Stepan's offscreen, upbeat voice is at diametric odds with the close-ups of Veronika's wordless anguish.

Fedor, in contrast to state paternity, avoids and even ironizes the style of official speeches, as he does at the farewell dinner before Boris's departure. His paternal discourse mirrors Veronika's melodramatic sincerity, as he stumbles through his toast and resorts to tears. The closing scene shows Fedor as silent as Veronika, connecting him emotionally with her trauma of war and contrasting with the conventionality of Stepan's loud public speech.

Such a splintering of paternity affects the meaning of both the war and the family tropes. *Cranes* identifies the "big family" of "us" with the war forces that brutalize the individual. State paternity is part and parcel of the murderous "us," as opposed to the paternity of the small family. Home-front melodrama does not resolve the conflict between state paternity implicated in war and small-family paternity attempting to intercede on behalf of the victimized protagonist. It represents the conflict and suspends judgment.[19] The small family with a melodramatic emotional father provided one of the first proto-private spaces as an alternative to the totalitarian national family of the Stalinist era. This space, like the protagonist, celebrates its virtue through its vulnerability and suffering.

[19] Zorkaia, *The Illustrated History of Soviet Cinema*, 212.

Further Reading

Condee, Nancy. "Veronica Fuses Out: Rape and Medium Specificity in *The Cranes are Flying.*" *Studies in Russian and Soviet Cinema* 3, no. 2 (2009): 173-83.

Cooke, Brett. "Acquaintance Rape in Kalatozov's *The Cranes are Flying.*" In *O Rus! Studia litteraria slavica in honorem Hugh McLean*, edited by Simon Karlinsky et al., 69-80. Oakland, CA: Berkeley Slavic Specialties, 1995.

Shrayer, Maxim. "Why are the Cranes Still Flying?" *Russian Review* 56 (1997): 425-39.

Woll, Josephine. *The Cranes are Flying.* London-New York: I.B. Tauris, 2003. [This is the most detailed study of the film.]

BALLAD OF A SOLDIER

Ballada o soldate

1959

88 min.

Director: **Grigorii Chukhrai**

Screenplay: **Valentin Ezhov, Grigorii Chukhrai**

Cinematography: **Vladimir Nikolaev, Era Savel'eva**

Art Design: **B. Nemechek**

Composer: **M. Ziv**

Sound: **V. Kushenbaum**

Production Company: **Mosfilm**

Cast: **Vladimir Ivashov (Alesha Skvortsov), Zhanna Prokhorenko (Shura), Antonina Maksimova (the mother), Evgenii Urbanskii (Vasia)**

Grigorii Naumovich Chukhrai (1921-2001) was born in Melitopol', in the Ukrainian SSR and was part of the Soviet generation that came of age while serving in World War II and developed as professionals during the liberal Thaw. A wounded and decorated war veteran, Chukhrai studied filmmaking after the war at the Soviet State Film School in Moscow (VGIK) with two of the Soviet Union's major filmmakers, first Sergei Iutkevich and later Mikhail Romm, who told his students to "be yourselves." Back in Ukraine, he worked as an assistant director at the Kiev Film Studio, where another stalwart of the Soviet screen, the director Mark Donskoi, helped him realize his dream of going back to work in Moscow by buying the financially struggling young filmmaker a suit! Chukhrai's first feature, *The Forty-First* (*Sorok pervyi*, 1956) was a remake of Protazanov's 1927 silent film, a love story between Civil War enemies following the Russian Revolution: despite their forbidden love, whose eroticism

lit up the Soviet screen, the Red female captor and sniper must, in the end, shoot her White prisoner, her forty-first victim.[1] Recognized at Cannes with a Special Jury Prize, the film foreshadowed the success of Chukhrai's next feature, *Ballad of a Soldier*, which made a triumphant tour of the international festival circuit in 1960, earning many prizes in such far-flung places as Cannes, San Francisco, London, Teheran and winning the Lenin Prize at home. Chukhrai made several other well-received films in the 1960s and 1970s, including *Clear Skies (Chistoe nebo*, 1961*)*, the story of a Soviet pilot who survives Nazi imprisonment only to be accused back home of being a spy, reflecting the fate of many prisoners of war who ended up in Stalinist camps in the darkest post-war years. Chukhrai put a human face on the war and is still best known as the director of *Ballad of a Soldier*, a Thaw-era classic and audience favorite, and also as the head of the Experimental Film Unit at Mosfilm, founded during the Thaw to encourage young talent.

Ballad of a Soldier is based on the wartime personal experience of the director himself and is a reaction to the late Stalin-era monumental epics which glorified the war and the collective sacrifice of the citizenry. In searching for an authentic representation of the war, Chukhrai introduces a human scale and humane aesthetic typical of Thaw-era films and focuses on the individual's contribution to the war effort—the small and selfless acts of kindness, bravery and generosity. In a 1962 interview in *Film Culture* Chukhrai described making the film in memory of friends who had died in the war:

> Since this film was devoted to my dear friends, I wanted it to be as they were—simple, dutiful, and humble.... Since I knew them and loved them as living men, I described Aliosha (the hero) as a living man, too.... I tried to avoid all unnecessary effects, montages, camera angles. A soldier before anything else, is a man.... That is how I experienced the war. The character of Aliosha was born out of long meditations on the theme, a result of a long creative search.

[1] Both films were adaptations of Boris Lavrenev's 1924 novella of the same name.

Ballad of a Soldier, then, is the deceptively simple story of Alesha, a 19-year-old youth (Chukhrai's age when he was called up for wartime service) who becomes a war hero when he accidentally disables two tanks and, instead of accepting a medal for his bravery, asks for a leave to fix the roof on his mother's village house. (Chukhrai actually talked to a young soldier who had destroyed two tanks without realizing how he had done it.) The film records the hero's journey home, which at every turn is delayed by his instinctive desire to help people he meets on the way. As Alesha rides the many trains home, he meets a cross section of the mostly behind-the-lines population, dealing with the war's many losses and deprivations, including, most importantly, Shura, a young woman surreptitiously riding the rails. The train is not only the vehicle for Alesha's personal encounters, but also a modern metaphor for the journey of life and, in the Soviet Union, for the transformational changes that occurred there in the twentieth century. The train, including the propaganda agit-trains, outfitted with printing presses and projectors, was the means of bringing the Revolution to the far reaches of Russia. They were essential to the Soviet industrializing project and were used for moving, willingly or not, large populations over a huge land mass. In the film, repeated close-up tracking shots of their moving wheels imply progress, literally helping the hero on his way. The enclosed train car with its bales of hay and expressionistic luminous lighting becomes a safe haven, a cocoon that isolates and nurtures, albeit too briefly, Alesha and Shura's budding relationship. But the outdoor long shots of the burnt-out landscape that the train traverses record the wartime destruction surrounding the heroes, raising doubts about their future.

Ballad is framed by voice-over narration about a simple soldier who dies in the war, while on the screen we see his mother, dressed in black, walking along a lonely country road. Both at the beginning and end of the film, he will be called a "Russian soldier," marking his commonality with all the other soldiers who sacrificed their lives, and also emphasizing his ethnic, Russian identity rather than his state-imposed Soviet identity. This downplaying of "Sovietness" was typical of Thaw-era films. Although we know from the film's beginning that our hero is dead, from the moment the camera closes

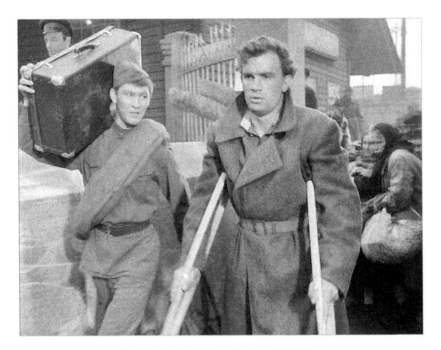

Fig. 80. Alesha Helping the Invalid Soldier

in on his mother's face and then dissolves to German tanks on a battlefield where Alesha is fighting, we forget his eventual fate and become intimately involved in his young life. As the narrator tells us, not even his mother knew what his life was like after he left home. We root for him, when, shaking with fear and closing his eyes, he manages to destroy the tanks that are almost upon him. This early battle sequence in the film, marked by rapid cutting and energetic camerawork, including a symbolic roll-over shot (war turns the world literally upside down) is Chukhrai's only nod in the film to the bold cinematic experimentation so typical of the times. What follows is deceptively simple, realistic cinematography that highlights in many close-ups and mid-shots the human contact and emotion in the film. Chukhrai is not afraid to get the camera uncomfortably close to record human love or anguish, a technique he shared with other Thaw-era filmmakers. The careful staging and framing, the use of slight, low-angle shots of the heroes, the circular group shots of the soldiers on the train, the dynamism of the camera movements, of the lighting and the editing, visually

reflect the youthful energy of its heroes, as well as the release of Thaw-era cinematography from the Stalinist strictures of Socialist Realism. The well-crafted dialogue—humorous, poignant, or often both—seems to be delivered not by actors playing a part but by human beings living the experience. Thaw-era directors sought to reject the hypocrisy and political-moral certainty of Stalinism by emphasizing *sincerity* in the emotional register of their films.

One of the film's major themes, male soldiers' wartime concern about the faithfulness of wives left back home, is introduced in both a deadly serious and also comic encounter on Alesha's first train ride. He helps a moody veteran, unforgettably played by Evgenii Urbanskii, the Marlon Brando of the Soviet screen, who, having lost a leg—and his masculinity, he thinks—is afraid to return to his wife for fear that she might reject him (Fig. 80). Despite losing the leg, Urbanskii's hero is full of pent-up passion, which is released in the later clutching embrace with his wife. As the two men ride the train, they both hear typical soldiers' talk with explicitly sexual references from a self-admittedly ugly, pockmarked guy who brags about satisfying another man's wife. The invalid is pained to hear such a story, while the hero laughs along with the soldiers. The clearly virginal Alesha is faced from the beginning of his journey with the messy wartime complexities of adult human relationships. But ever present is also the easy camaraderie of soldiers, who good-naturedly rib him for being a "hero," or ask him for a favor, to deliver, at the expense of not washing themselves, the last two cakes of the troop's soap to a soldier's wife. Alesha dutifully delivers the soap, only to discover that the wife has been unfaithful. Acting with the moral certainty of youth, he demonstratively takes back the soap and instead gives it to the soldier's ailing father, comforting him with invented stories of the soldier's bravery. But unlike films made during the war that would have condemned unfaithful wives to scorn and death if they had consorted with the enemy, this film, like its famous predecessor, *The Cranes Are Flying*, allows the viewer to have a modicum of understanding for human failings.

Alesha's moral behavior does not change as a result of his experiences: from beginning to end he is scrupulously honest and honorable, willing to stand up for what is right. When he comes

across Shura on the train, he is, despite her fears and made-up story of a wounded fiancé, a perfect gentleman: their innocent, blossoming, never-to-be-realized love is the film's central loss, other than, of course, the loss of his own life. Alesha is clearly heroic in his natural goodness, moral certainty and quiet bravery: he manages to stand up to the bully sergeant guarding the train and later rescues passengers on a bombed-out train. But there are no unambiguous villains in the film, only, as is typical of Thaw films, more or less frail human beings, often inviting the viewer's sympathy. Alesha's journey allows the filmmaker neither to comment overtly upon nor to judge human beings and their actions, but simply to present, as Chukhrai himself notes, truthful portraits of wartime existence and wartime loss.

As viewers we quickly become so invested in the characters' fates through frequent use of mid-shots, close-ups, dynamic camera and emotional lighting, that we earnestly hope, for example, that Alesha and Shura will declare their love. And even though the two never exchange even so much as a kiss, their simultaneously innocent and erotically-charged feelings literally light up the screen. Besides rejecting the pompous patriotic rhetoric and monumental, panoramic battle-scene shots of the late Stalinist period, Chukhrai, like other Thaw directors, also rejects the sexless, puritanical screen representation of love, reclaiming the body and a youthful, healthy sexuality. Instead of using the professional actors that he had originally cast, he picked two young, unknown acting students: a long-haired, round-faced Slavic beauty to match the prototypical blond, open-faced and boyishly handsome Russian everyman. In one of the film's most poignant scenes, Alesha imagines Shura's luminous eyes, full lips and billowing hair, superimposed over the symbolic white Russian birch forest that the train is actually passing as, now separated forever, they finally exchange their formerly unspoken expressions of love.

This sequence, along with the silent scene, shot in extreme close-up, of Alesha and his mother's wrenching embrace in their final, momentary meeting (his good Samaritan acts have left no time to fix the roof) even today invite a powerful emotional response in the audience that leaves hardly a dry eye in the theater. At the

time, the film was a cathartic experience for a generation of viewers in the Soviet Union and abroad, who had experienced wartime deprivation and loss. (With the millions of World War II civilian and military casualties, every Russian family lost someone in the war.) The film combines unabashed emotion, visual simplicity, yet also visual dynamism and beauty, with a highly romantic musical theme and often expressionistic lighting. It transcended the Cold War political rhetoric of the 1960s with the believable innocence and natural goodness of the youthful heroes and the universality of its message: love of mother, girl, fellow soldiers and countrymen, the story of goodness begetting goodness, and common sacrifice and loss in trying times. Yet the film does not shy away from examining human frailty in war, and Alesha learns much about life in his travels and has his first real experience of love. All this makes his fate even more tragic: his path to manhood and maturity is forever blocked by his premature death.

The film was awarded a special Jury Prize at Cannes for its "high humanism and outstanding quality." Writing at the time, *New York Herald Tribune's* Paul Beckley called it "the finest film I have seen from today's Russian cameras; it introduces a director of genius, and two actors of great charm and brilliance; … the editing … is rhythmic, alive and above all economical…; the range of meaning in his picture, encompassing a nation at war and an incredible range of human portraits, is immense…. The photography is exceptional, clean, strong, luminous… one of the ten finest films of 1960."

Vida Johnson

Further Reading

Woll, Josephine. "Ballada o Soldate/Ballad of a Soldier." In *The Cinema of Russia and the Former Soviet Union*, edited by Birgit Beumers, 99-107. London: Wallflower Press, 2007.

LENIN'S GUARD

Zastava Il'icha

Completed 1961, released 1965 in censored version titled *I Am*
 Twenty; **original director's cut released 1989**
189 minutes
Director: **Marlen Khutsiev**
Screenplay: **Marlen Khutsiev and Gennadii Shpalikov**
Cinematography: **Margarita Pilikhina**
Music: **Nikolai Sidel'nikov**
Production Company: **Gorky Film Studio**
Cast: **Valentin Popov (Sergei Zhuravlev), Marianna Vertinskaia
 (Ania), Stanislav Liubshin (Slavka), Nikolai Gubenko (Kol'ka
 Fokin), Petr Shcherbakov (Chernousov), Andrei Konchalovsky
 (Iurii), Andrei Tarkovsky ("Turnip," jerk at the party),
 Nikolai Zakharchenko (Friend), Bella Akhmadulina, Evgenii
 Evtushenko, Rimma Kazakova, Robert Rozhdestvenskii, Boris
 Slutskii, Mikhail Svetlov, Andrei Voznesenskii as themselves**

Like Alexander Pushkin, Marlen Khutsiev (1925—) played a major role in integrating the subjects of a vast Eurasian empire into European culture. And also like the nineteenth-century poet, Khutsiev seems at times banal to western critics because his ways of seeing (neorealist and auteurist) are too familiar to European cinephiles. However, Khutsiev was instrumental in giving post-Stalinist viewers the new visual language that allowed them to identify themselves as individuals who shared a common visual idiom with world cinema of the time. Perhaps that is why Pushkin, the creator of Russia's literary language, is Khutsiev's favorite poet, and why he has always dreamt of making a film about him.

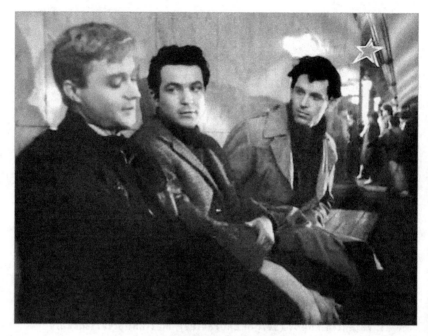

Fig. 81. Sergei, Slavka, Kol'ka

Khutsiev has consistently broken new ground in Soviet cinema. As a result, he has made few films, many of them with a difficult release history. In his 1957 *Spring on Zarechnaia Street* (*Vesna na Zarechnoi ulitse*), together with Petr Todorovskii (director of photography) and Felix Mironer (scriptwriter), he successfully adopted neorealist aesthetics to depict Soviet life. Khutsiev completely overhauled the visual and aural worlds of Soviet cinema in order to focus on the everyday life of the Russian provinces and their non-heroic inhabitants. Like the neorealists, Khutsiev used non-professional actors next to professional ones. Instead of an epic musical score written for a non-diegetic symphony orchestra and professional singers (a staple of Stalinist cinema), he used diegetic guitar and the non-professional individual voices of his actors. This new sound created an atmosphere of authenticity and immediacy unfamiliar to the Soviet viewer of the time. His next film, *Two Fedors* (*Dva Fedora,*1959), challenged the received wisdom about the heroic myth of World War II and was one of the first films about the daily grind of the late Stalinist era.

Khutsiev's *Lenin's Guard* established auteurism as the new film practice of Soviet cinema. While *Lenin's Guard* is a poetic film about the hopes of the Thaw, *July Rain* (*Iiul'skii dozhd'*, 1967) creates an atmosphere of disappointment and disillusionment. Through the story of a couple's breakup, the filmmaker comments on the end of Soviet utopianism and the rise of both individualism and its darker side—alienation. *It Was in May* (*Byl mesiats mai*, 1970) is not well remembered but was an important statement about the multiplicity of memories of World War II. In a society where the heroic myth of victory was on the rise as the official story of origins of the Brezhnev-era leadership, the film came across as a dissonant voice by a filmmaker who undoubtedly had seen Alain Resnais's *Night and Fog* (1955). Khutsiev continues making films in post-Soviet Russia. Since 2003 he has been working on an art house picture about the relationship between Anton Chekhov and Leo Tolstoy. He notes that in Soviet times it was easy to make a film but hard to release it, but that now, even for a living classic, it is hard to get sufficient funding to make a film, especially an art house picture.

Lenin's Guard (or *Il'ich's Gate*) is Khutsiev's visual poem about Thaw-era Moscow. The film's title refers to a working class neighborhood east of downtown Moscow, *Il'ich's Gate* (*Zastava Il'icha*). The area is named after Lenin but refers to the revolutionary leader via his patronymic (Il'ich, the son of Il'ia), evoking one of the key themes of the film: continuity of individual and national stories with Lenin as the true father of the revolutionary spirit. The Russian word "*Zastava*" means both "gate" and "guard." At the beginning of the film viewers see three revolutionary red guards on the streets of post-revolutionary Moscow. Later we see three soldiers in World War II uniform walking the streets of modern day Moscow. There is a living link between these ghosts from the times of epic wars that shaped Soviet identity and the characters in the main narrative of the film: three friends living in modern day Moscow—Sergei, Slavka and Kol'ka (Fig. 81). They come of age and try to understand the meaning of the past: the Revolution, the Great Patriotic War, and the Stalinist purges. For each of the three, the relationship to the past is an individual and unique experience, not a state-sponsored story one has to follow.

Inspired by Khrushchev's destalinization, Khutsiev depicts Soviet rituals as meaningful events that create a genuine sense of collective identity. Two key scenes in the film (the May Day parade and the poetry reading at the Polytechnic Museum) evoke two fundamental myths of Soviet origins (the story of the October Revolution and martyrdom and victory in the Great Patriotic War). The great past is alive in the ideals and aspirations of the three working class friends. Sergei and his girlfriend Ania attend both events and their personal story becomes part of the communal experience. Josephine Woll points out that "On May Day, climaxing the first half of the film, people throng the streets in joyous celebration of the Soviet utopia, the scene one of stunning harmony between individuals and society"[1] (Fig. 82).

Khutsiev favors the documentary potential of film as a medium and downplays its illusionist power. He shot actors against the background of real events in order to give his film a documentary look. For example, we know the exact date when film production began because the filmmaker started shooting his picture at an actual May Day parade in Moscow on 1 May 1961.

Many characters in Khutsiev's film play themselves such as, for example, the famous Thaw poets Bella Akhmadulina, Evgenii Evtushenko, Rimma Kazakova, Robert Rozhdestvenskii, Boris Slutskii, Mikhail Svetlov and Andrei Voznesenskii. Some performers are not professional actors and play representatives of their social circle rather than specific characters. Near the film's end, the working class protagonist attends a party organized by Ania's friends, who belong to the Soviet elite. In this scene, Andrei Konchalovsky and Andrei Tarkovsky play not individual characters but rather social types. They appear as spoiled brats from the Soviet ruling class. In a similar vein, Khutsiev chose Valentin Popov for the lead role because his acting career had working class origins: Popov began performing at the ZIL Auto Works amateur theater. Finally, even the names of Sergei's friends coincide with the names of the actors who play their parts: Kol'ka is played by Nikolai Gubenko;

1 See Josephine Woll, "Being 20, 40 Years Later," in Further Reading.

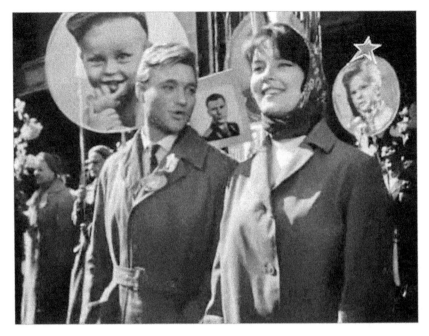

Fig. 82. May Day

Slavka (Ivan in the original script) is played by Stanislav Liubshin. The filmmaker consciously blurs the line between actuality and staged scenes.

In order to create an atmosphere of freedom and give his film a quasi-documentary look, Khutsiev and his director of photography unchain the camera. Margarita Pilikhina combines handheld camera with complex mobile long takes. She observes rather than guides characters. If accidental people or events materialize in the background, interfering with the main action, she does not use editing to erase the aleatoric aspects of shot composition. While camerawork seemed to showcase primarily the director and cinematographer's craft, the visual style of the film became a political statement about present-day urban modernity beyond the constraints of ideological dogma.

Three social issues brought up in the film raised censors' eyebrows. First, Khutsiev depicts the KGB as an institution associated above all with human baseness and the dictator's crimes. In one of the scenes, Nikolai's boss tries to recruit him as a secret

police informer. In disgust, Kol'ka rejects the offer, viewing it as a survival of Stalinist times. Second, the director presents Soviet society as plagued by class divisions and ruled by Stalin's heirs. Ania's father is a party functionary who lectures Sergei about the necessity of Stalin's methods. The filmmaker depicts the children of this elite as enjoying a life of privilege and despising their own people and their sacrifices. Third, Khutsiev dared to propose a plurality of interpretations of the Soviet historical past. In the film, multiple fathers from the Stalin era have different visions of its meaning. The new generation is not homogeneous either. In a symbolic scene at the film's end, Sergei meets the ghost of his father, who was killed during the war. When Sergei asks him how to live, his father tells him that he cannot advise him because he died much younger than Sergei is now. Sergei must come up with his own meaning of life instead of following his father's prescriptions. This scene enraged the Soviet leader Nikita Khrushchev because he saw it as undermining the ideological unity of Soviet society, splitting it along generational lines. Moreover, the Soviet leadership was disturbed by the film's celebration of individual agency as an alternative to state-enhanced uniformity of thinking.

The story of the film's production and release highlights the key ideological turns in the history of late Soviet culture. With his neorealist scriptwriter Felix Mironer, Khutsiev started working on the picture in 1959. Soon he realized that he needed a different collaborator, a contemporary of his characters, who better expressed the spirit of the era. In September 1960 he hired Gennadii Shpalikov, at the time a student from VGIK's Scriptwriting Department. The film was completed during the height of the destalinization campaign in 1961 and had the influential backing of Ekaterina Furtseva, Soviet Minister of Culture. Khutsiev was allowed to go beyond the budgeted 90 minutes and make a three hour-long art cinema film. During preliminary screenings for the filmmaking community, colleagues praised the film as a major artistic accomplishment. Notably, Viktor Nekrasov recollects that Andrzej Wajda saw the film with him and was impressed by Khutsiev's virtuoso filmmaking. One of the leaders of the Soviet filmmakers' community, Mikhail Romm, told the filmmaker simply: "Marlen, you've justified

your existence on this planet." Not surprisingly, the conservative backlash against the intelligentsia in 1963 touched Khutsiev's film too. Khrushchev himself criticized the film during his meeting with Soviet intellectuals on 8 March 1963. Khutsiev was told to cut many scenes in which, according to the censors, young people were either too pessimistic or unruly. The episode of the poetry reading evening was among the scenes to be removed. While Khutsiev was struggling with the censors, his major critic, Khrushchev, was himself voted out of office in 1964, and the new leadership decided to release a censored version of the film. Ironically, the last footage that Khutsiev had to remove just before the premiere in January 1965 was the shots of Khrushchev himself. The film appeared under the title *I am Twenty* four years after its completion and after many other filmmakers had already taken advantage of the new quasi-documentary style invented by Khutsiev.[2]

During perestroika, Soviet filmmakers led the movement for dismantling political censorship in art and the mass media. The Fifth Congress of the Filmmakers' Union established the Conflicts Commission with a mandate to release films banned for political reasons. Among the key films that have made an impact on the evolution of Soviet film language and had been disfigured by Soviet censors, the commission mentioned Khutsiev's masterpiece. In 1989 the director's cut was released in Moscow under the original title. In the ultimate poetic justice, the film that changed Soviet film language during the Thaw played a major symbolic role in abolishing political censorship in the Soviet Union during perestroika.

Alexander Prokhorov

[2] Other filmmakers used Khutsiev's discoveries mostly for commercial ends and much less successfully. Among Khutsiev's imitators are Georgii Daneliia with his *I Walk around Moscow* (1963) and El'dar Riazanov with his *Give me a Complaint Book* (1964).

FURTHER READING

Chernenko, Miron. *Prosto Marlen.* Moscow: Kinogil'diia, 2000.

------. *Marlen Khutsiev: tvorcheskii portret.* Moscow: Soiuzinformkino, 1988.

Khutsiev, Marlen. "Vstrecha s Marlenom Khutsievym. 21 July 2011." http://seance.ru/blog/khutsiev/ (accessed 15 December 2012).

Khlopliankina, Tat'iana. *Zastava Il'icha: sud'ba fil'ma.* Moscow: Kinotsentr, 1990.

Prokhorov, Alexander. "The Myth of the 'Great Family' in Marlen Khutsiev's *Lenin's Guard* and Mark Osep'ian's *Three Days of Viktor Chernyshev.*" In *Cinepaternity: Fathers and Sons in Soviet and Post-Soviet Film,* edited by Helena Goscilo and Yana Hashamova, 29-50. Bloomington: Indiana University Press, 2010.

Woll, Josephine. "Being 20, 40 Year Later. Marlen Khutsiev's *Mne dvadtsat' let (I'm Twenty,* 1961)." *Kinoeye: New Perspectives on European Film* 1, Issue 8 (10 December, 2001). http://www.kinoeye.org/01/08/woll08.php#2 (accessed 30 November 2012).

------. *Real Images: Soviet Cinema and the Thaw,* 142-50. London: I.B. Tauris, 2000.

Zak, Mark. "Zastava Il'icha." In *Rossiiskii illiuzion,* 351-56. Moscow: Materik, 2003.

WINGS

Kryl'ia

1966

85 minutes

Director: **Larisa Shepit'ko**

Screenplay: **Natal'ia Riazantseva, Valentin Ezhov, Larisa Shepit'ko**

Cinematography: **Igor' Slabnevich**

Art Design: **Ivan Plastinkin**

Composer: **Roman Ledenev**

Sound: **Ol'ga Upeinik**

Production Company: **Mosfilm**

Cast: **Maiia Bulgakova (Nadezhda Petrukhina), Zhanna Bolotova (Tania), Pantaleimon Krymov (Pasha), Leonid D'iachkov (Mitia), Sergei Nikonenko (Sergei Vostriakov), Rimma Markova (Shura), Vladimir Gorelov (Igor'), Evgenii Evstigneev (Misha)**

Director and screenwriter Larisa Shepit'ko (1938-1979) studied at the State Film Institute under Aleksandr Dovzhenko and Mikhail Romm. Kirgizfilm Studio produced her diploma film, *Torrid Heat* (*Znoi*, 1963), which dealt with the conflict between an older and younger man who clash over the best way to run a collective farm—a typical Thaw era plot. *The Homeland of Electricity* (*Rodina elektrichestva*, 1967), based on a short story by Andrei Platonov and set in the aftermath of the Civil War, portrayed starving villagers who are given hope by a young Komsomol. The film was banned and released only during perestroika. Shepit'ko's three major films, *Wings*, *You and I* (*Ty i ia*, 1971, severely mutilated by censors), and *The Ascent* (*Voskhozhdenie*, 1976), all deal with situations of

individual existential crisis: the postwar plight of a former woman fighter pilot; a gifted doctor's betrayal of self by abandoning medical research for an easier life and his realization of the necessity to return to his life's work; a partisan and army officer's life and death choices between loyalty and betrayal in Nazi captivity during World War II. *The Ascent,* which won prizes in Russia and abroad, established Shepit'ko's international reputation. But her promise as an innovative woman director was never fulfilled: she died, along with five members of the film crew, in a car accident during the early days of filming *Farewell (Proshchanie),* based on Rasputin's novella. The film was completed by her husband, Elem Klimov.

Wings is a subtle film whose emotional complexities cannot be adequately conveyed in a summary. The basic plot relates the experience of Nadezhda Petrukhina, who spent the happiest days of her life, both professionally and personally, as a fighter pilot during World War II and in love with her fellow pilot, Mitia. Some twenty years later she has become the unpopular principal of a vocational training school and the estranged adoptive mother of Tania, who has recently moved out to live with an older lover. Mitia's death in battle has crippled Petrukhina emotionally and she rejects Pasha, the museum director friend who has been in love with her for years. A series of bitter revelatory experiences—her failed relationship with her daughter; her inability to help a difficult student, Vostriakov; her stunted love life; her realization that, with her "unwomanly" former profession, uncompromising sense of duty and inability to adapt to ordinary life, she is a misfit and "museum exhibit" in 1960s Soviet society—lead her to seek freedom in the skies and release in death, as she flies one last time.

From Interviews

"The most interesting thing in cinema is not the discovery of some sort of horizons, but the discovery of the human being." [...]

(Intervier's question: They often say that you have a "male hand." How do you feel about this?)

"Romm is the one who, after *Wings,* wrote that I have a male hand. I'm convinced that there's nothing of copying a male hand

in my work. I make my films as a woman. There is genuine cinema and ladies' needlework. Ninety percent of our cinema is ladies' needlework; men do it wonderfully too."[1]

"After seeing *Wings*, my mother decided that I had been spying on her then, possibly when I was even not yet on this earth. That was the illusion she had, that was her reaction to the fact that the film turned out to have both detached testimony and a certain cruelty, again on the part of a generation that was trying to judge the preceding one. [...] We tried to analyze Petrukhina's life from the point of view of this person's everyday rights. Our heroine tried to live according to her conscience, but each time the era put forward to her its own criteria and norms. And she responded sincerely to this. She constantly found herself in a tense mise-en-scène in relation to herself, the time, society. She reacted very attentively to social demands. She fulfilled these demands sincerely, but the time was changing, and appraisals of life positions—her own and those of her contemporaries—were, naturally, revised. But there is only one human being. You can revise an appraisal, but can't revise a life. [...] You can't cross out what has been lived by means of revision or reinterpretation. Everything remains. This is an irreversible process; its imprint and summation is the given, concrete face, if not of the generation as a whole, then of this representative of the generation. And the critics didn't start a conversation about precisely this; it is precisely here that I felt the lack of an analytical, objective approach to our film. I'm not ashamed to say that we took into account the complexity of the problem before us and, guided by this, we worked out our own system of analysis in the film."[2]

[1] Larisa Shepit'ko, "Kogda nam ne naprasnyi...," 27 January 1979 interview, in *Larisa*, ed. E.G. Klimov (Moscow: Iskusstvo, 1987), 170, 173.

[2] "Poslednee interv'iu," L. Rybak, in *Larisa*, 181-82.

FLIGHT WITHOUT WINGS
THE SUBJECTIVITY OF A FEMALE WAR VETERAN IN LARISA SHEPIT'KO'S *WINGS*

Tatiana Mikhailova and Mark Lipovetsky

The protagonist of *Wings*, Nadezhda Petrukhina (brilliantly played by Maia Bulgakova), does not appear to be the victim of social repression. A former wartime pilot and a highly placed provincial official, she is not only the principal of a vocational school (*professional'no-tekhnichskoe uchilishche*) but also a deputy in the City Soviet. The film makes no mention of her forced expulsion from the profession of pilot, though it plays a very powerful role as the cause of her unrest. Characteristically, during a discussion of Shepit'ko's film in *Iskusstvo kino* (*The Art of Film*) in 1966, a former wartime pilot, A. Poliantseva, who called *Wings* a harmful film that depicts an atypical heroine, for some reason justified Petrukhina's retirement by referring to her serious injury—an injury never mentioned in the film.[1] Poliantseva's very comments nonetheless testified to a different category of injury: the *traumatic* effects of alienation from one's wartime self, experienced not only by Petrukhina, but also by her real-life critic, with a similar biography.

In the film, however, Petrukhina is seemingly respected by men and women alike, as evident in the scenes at the local beer pavilion: Petrukhina is gladly invited along with the men and receives special treatment from the female bartender, Shura. At the local air club that she had attended before the war, she is also greeted with respect. Her portrait hangs in the city museum along with photographs of those who perished heroically fighting in the war— including Petrukhina's love, Mitia Grachev (Leonid D'iachkov). She has a grown-up daughter, though adopted. Moreover, her male suitor, Pavel ("Pasha") (Panteleimon Krylov), director of the local

1 See "*Kryl'ia*: Podrobnyi razgovor," *Iskusstvo kino* 10 (1996): 15–18.

museum, is so devoted to Petrukhina that in one sequence she has only to whisper his name after he leaves her apartment to have him return. (That "miraculous power," tellingly, fails to work with her daughter, Tania, whose departure from her mother's "domain" is irrevocable.) The only sign of gender repression—and an important one—surfaces in an episode where the heroine, tired of peeling potatoes (a task she performs in a rough, "masculine" rather than in a skillful, "feminine" manner) decides to go to a restaurant: "Why does a person have to peel potatoes on Sunday?" only to find herself refused entrance without a male escort after 6 pm. Perceived as an indecent oddity in the culture of the Thaw, an independent woman is excluded, both symbolically and literally here, from its ready-made social structures.

Scholars describe the transformations of gender culture in the sixties as a paradoxical amalgam of contradictory tendencies: while some state and societal practices stimulated gender equality in terms of women's professional and social growth, others augmented the double burden, stipulating responsibility for housework and childcare as women's major patriarchal role. As Susan E. Reid notes, "The relation between the Khrushchev state and society was not totalitarian; it was, nevertheless, paternal and patriarchal. And, as in other forms of modern welfare paternalism, the main objects of control and definition were women and children."[2] *Wings* fully reflects the ambivalence of gender changes in the Thaw period. On the one hand, Petrukhina belongs to a small stratum of women in positions of political authority. According to Barbara Engel, "At the end of Khrushchev's rule, in 1964, the proportion of women in positions of genuine political authority still barely exceeded 4 percent."[3] On the other hand, Petrukhina's social suffocation directly reflects the tightening of social conventions that make her

[2] Susan A. Reid, "Women in the Home," in *Women in the Khrushchev Era*, ed. Melanie Ilič, Susan Reid, and Lynne Attwood (Houndmills, Basingstoke, Hampshire: Palgrave Macmillan, 2004), 156.

[3] Barbara Engel, *Women in Russia, 1700–2000* (Oxford: Oxford University Press, 2004), 235.

more and more irrelevant to her social environment.[4] Her inability to find "a place of her own" partially explains the film's finale, which we read as implying Petrukhina's suicide.

[...] One cannot help noticing that dramatic overtones dominate in the film, and that the deconstruction of the Soviet heroine fuses with a deep compassion for Petrukhina, whose cultural and social irrelevance testifies not only to the failure of Soviet ideological models, but mainly—as we would like to argue—to the irretrievable loss of specific gender subjectivity that appears to be inseparable from the war experience and the impossibility of creating an alternative gender identity. We would like to emphasize the gender aspect of this trauma, which, we argue, lies in the failure of new female identities offered by the "normal" life of the Thaw period, to secure for Petrukhina a degree of freedom and dignity that she apparently enjoyed during wartime. The novelty of *Wings* stems from the complete internalization of its focal conflict, which Shepit'ko situates within Petrukhina's subjectivity. The clash between the self shaped by wartime experience and postwar "mobilization," on the one hand, and her attempts to become a "normal" (i.e., socially acceptable) woman, on the other, resides at the film's conceptual center.

4 A drama very similar to that undergone by wartime female pilots, and specifically by Petrukhina, unfolded a few years after the release of *Wings*, in relation to female cosmonauts. According to Nikolai Kamanin's diaries, "Summoned to the Central Committee in 1968, Tereshkova was appalled to discover the future they had in mind for her. Five years after her flight she was still working for the space programme, was studying at the Zhukovskii Military Aviation Academy, and fully intending to qualify as an engineer. Though Kamanin had attempted to steer her towards a life of public service, she continued to be entranced by space. Above all, the worldwide struggles of the women's movement simply did not interest her. When the Politburo duly rubber-stamped the decision without her consent she was devastated. Sitting in floods of tears in Kamanin's flat, there was nothing even he could do but lend a sympathetic ear: 'She kept coming back again and again to the same theme, "I've lost everything"—space, the academy, flying, and her family, her daughter'" (Sue Bridger, "The Cold War and the Cosmos: Valentina Tereshkova and the First Woman's Space Flight," in *Women in the Khrushchev Era*, 235–6).

Petrukhina's "military" or, rather, "mobilized" personality manifests itself in many details and scenes. Of particular importance are her commanding, gruff manner of speech, her unbendingly straight back, and her official appearance—conveyed by her unchanging black suit and white blouse, which function as a uniform. Petrukhina's representative status is established in the film's opening sequence, which shows her being outfitted at a tailor's, the back of her head, with its almost masculine haircut, turned toward the viewers, so that her face is invisible. After a theatrical entrance, the tailor takes her measurements, then announces: "A standard size 12" ("Standartnyi sorok vos'moi"), thereby immediately inscribing her case as ordinary, and not unique. However, the camera's movements produce an effect that appears somewhat contradictory to the statement of the heroine's typicality: the film opens with a shot of an urban crowd moving along the street, then the camera moves back and we see the same crowd through a large window. As the camera moves further back, we see Petrukhina completely separated from the crowd, not seen by it or seeing it, as she is standing behind the wall of a dressing room with her face turned away from the viewer. We see her face only at the end of the scene. Thus, though average, one of many, she is at the same time isolated, cut off from "the masses"; her typicality paradoxically combines with her loneliness. No wonder that in the

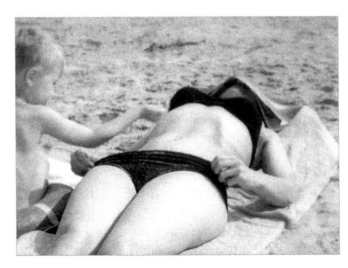

Fig. 83.
Nadia
on the Beach

film's finale, the *standard* outfit, tailored for her in the first scene, transforms into a torturous restraint when, with an awkward smile, Petrukhina tries to climb into the cockpit of an airplane—tangibly and painfully revealing the conflict between Petrukhina's social identity and her constricted self.

In the film's beginning, after a series of the heroine's "official" appearances (as a deputy of the local Soviet, as a school principal), we also see another Petrukhina, relaxing at the beach. The official outfit is removed, and the camera slowly slides along her body, surprisingly young and beautiful in an open swimsuit (Fig. 83), thus contrasting with her image at the tailor's. Yet, as in the scene with the tailor, her face is hidden, covered by a magazine with photographs of cosmonauts—the sixties' replacement for the earlier Soviet cult of pilots. This loaded visual image unmistakably communicates the obliteration of Petrukhina's embraced identity. From the outset we see her subjectivity split between the sexless "suit" (the official or public self) and the feminine "body" (her private self, supposedly encouraged in the cultural atmosphere of the Thaw). The paradox lies in the fact that *both* selves deprive her of herself, of her face, superseded by the impersonal signs of the power discourse that corresponds to her venerated yet awkward position as a former war heroine whose photograph hangs in a museum.

Both Petrukhina's rigidity and her irrelevance are painfully revealed during her visit to her daughter, Tania (Zhanna Bolotova), who left her mother's home for her 37-year-old university professor. Although this motif remains unelaborated in the film, an attentive viewer might detect a deeper conflict behind the awkward mother/daughter relationship. The fact that Tania lives with her university professor suggests the young woman's yearning for a strong paternal presence, for an authority figure, which Petrukhina cannot be. The irrelevance of Petrukhina's authority for Tania—i.e. for the generation of the Thaw—becomes obvious in the following scene, when, unable to communicate with Tania's unofficial husband and his intellectual friends, Petrukhina loudly proposes having a drink, praises the apartment in impersonal, newspaper-style phrases, cuts the cake she has brought with graceless, "masculine" gestures, and finally bombards Tania's husband with tactless questions

delivered as though at an interrogation. Although this scene is usually viewed as testimony to Petrukhina's "military" self, it is evident that Petrukhina "overplays" her part, like a bad actress: her self-parodic performance actually reflects and exaggerates the stereotypical perception of her as a rough, sexless veteran — a perception apparently shared by Tania and her circle. However, the awkward effect produced by Petrukhina proves the opposite: that this stereotypical "identity" is as narrow and artificial for her as the suggested identities of a "party bureaucrat" or a "domestic woman." In short, here, as elsewhere, she cannot assimilate, cannot fit into a social group comprising mutually supportive members. She remains outside any recognized system of self-identification.

In a later conversation with Tania, when the daughter comes to visit her at home, Petrukhina acknowledges her own irrelevance. She characteristically explains her roughness by her wartime past: "Rough and unsophisticated [...] Army grunt. Unfit for cultured circles" ("Seraia, neobuchennaia [...] Soldatnia. Neprilichno privesti v intelligentnuiu kompaniiu"). Yet, immediately afterwards, in reaction to her daughter's suggestion that she leave her job and start a new life, Petrukhina delivers an angry monologue about her sense of duty, rooted in wartime experience and extended to the postwar period: "Let others do that — I never knew these words [...] [I always went] where I was ordered to, without thinking. I worked for myself and for others." Subsequently, she adds: "Feel pity for me, do you? Well, don't. You'd do better envying me" ("Pozhalela? A ty menia ne zhalei. Ty luchshe mne pozavidui"). This riposte evokes a thematic intertext: the poem "My generation" ("Moe pokolenie," 1945) by the famous war poet Semen Gudzenko: "No need to pity us, since we wouldn't have pitied anyone either" ("Nas ne nuzhno zhalet', ved' i my b nikogo ne zhaleli [...]"). Though several Soviet critics, such as V. Kardin, have characterized Petrukhina as a blindly obedient Stalinist,[5] in this episode Shepit'ko clearly emphasizes the

5 See V. Kardin in *"Kryl'ia,"* 12–15. A similar interpretation of the film's protagonist as a Stalinist in the Thaw environment was indirectly promoted by Shepit'ko herself in one of her last interviews — during the ban on direct discussion of Stalinism, which was in effect in the 1970s and early 1980s. See

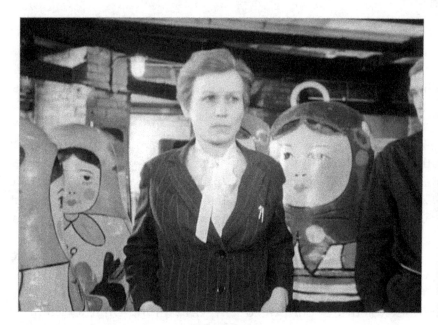

Fig. 84. Matryoshkas

wartime roots of the heroine's sense of duty, suggesting a fusion of independence, brutality and responsibility, rather than a simple subjugation to orders.

Although Petrukhina's soldier-like lifestyle is responsible for her emphatically "unwomanly" manners, Shepit'ko blurs rather than justifies the opposition between "warrior" identity and femininity. First, Petrukhina's memories of the war revolve above all around her beloved and her girlfriends. Second, her professional service to society in her present life entails the duties of a school principal. It is Tania's suggestion that she leave this job ("Leave your hoodlums") that causes Petrukhina's genuine indignation. Official decree alone assigns the meaning of a social service to what is basically and traditionally the patriarchal function of an adult woman as mother. This paradoxical blend of social duty with patriarchal femininity

L. Rybak, "Poslednee interv'iu," 181-82, in *Larisa: Kniga o Larise Shepit'ko*, ed. Elem Klimov (Moscow: Iskusstvo, 1987). This view also surfaces in an article by Armen Medvedev, "Drugie i Nadezhda Petrukhina," in the same collection (261-66).

is ironically underscored by the episode in which circumstances force Petrukhina to play a giant matryoshka—a symbol of fecund maternity—in a school dance performance (Fig. 84). Once again, much as in the sequence of Petrukhina's conversation with Tania and her friends, this episode strikes the viewer by its ironic artificiality: Petrukhina has to be carried on stage and supported by her students throughout the number. Moreover, the fact that she, the school principal, substitutes for a student originally slated to play the part results from her failure as a pedagogue, as a "mother figure." Consequently, such a performance of maternity only reinforces Petrukhina's unsuitability for this venerated—albeit patriarchal—form of gender identification.

Petrukhina's failure as a mother figure on both the private and the social front constitutes the key element in her crisis. Fulfillment of the maternal function is precisely what could safely establish her in the prevailing patriarchal disposition of gender. Simultaneously, that function serves as a test of her professional competence, and the scenario of professional self-realization is vital for the Soviet rhetoric of gender equality. However paradoxically, maternity offers the perfect channel for the internalization of the patriarchal gender model as a social (soldier-like) duty, and vice versa. Yet Petrukhina fails in both directions. Her daughter leaves permanently, her departure presumably caused by Petrukhina's insensitive attack when Tania falls in love with her professor. Though Petrukhina's acknowledged earlier fear that Tania would learn about being adopted proves groundless, all her efforts to establish close relations with her daughter end in their mutual alienation ("Alien, no matter what"/ "vse ravno chuzhaia").

Tania's departure in the personal sphere of the family is paralleled (in the professional arena) with the disappearance of one of Petrukhina's students, Vostriakov (played by the young Sergei Nikonenko), whom Petrukhina unhesitatingly expels from the college for his refusal to apologize to a female fellow student. When Vostriakov, having being beaten by his father and having wandered around for two days without food and shelter, returns to the college and delivers a formal apology, Petrukhina tries to "reach out" to him, only to hear him cry, "I hate you!" Though on the surface both

Tania's and Vostriakov's alienation and hatred for Petrukhina appear unprovoked by her, such is not the case, for her commanding style, on the one hand, and her independence and unbending confidence, on the other, make her a "bad mother," at least from a patriarchal standpoint.

In any case, after Vostriakov's words Petrukhina takes a nose dive: maternity, as the only valid bridge between her private and public selves, collapses, leaving her subjectivity in shambles. Hereafter Petrukhina attempts, without success, to reinvent herself within the paradigm of traditional femininity. After leaving the college, she sees a man in a pilot's uniform and suddenly metamorphoses from a rigid bureaucrat into an attractive woman, taking off her jacket and unbuttoning her blouse, only to be ignored by him. This scene is followed by a beautiful, if excessively sentimental scene in which she walks along the street with a handful of cherries, as if offering her sexuality to the entire world. When she tries to wash the cherries, however, there is no water in the faucet. The onset of a rainstorm not only washes the fruit, but also turns her eyes to the sky—triggering the memory of her wartime love, when she and her beloved were both pilots. The symbolism of this scene is quite transparent: the water absent in the faucet and descending from the sky obviously serves as a metaphor for life (evoking the traditional Russian trope of revivifying water [*zhivaia voda*] so common in folklore). Real-life conditions, in short, cannot satisfy Nadezhda's sexual and emotional thirst, for the source of love and life for her is located elsewhere—in the transcendental dimension (heaven) that is equated by Petrukhina with the realm of death (war).

Soviet Femininity and Thanatos

As already noted, for Petrukhina, love is inseparable from war. She seems capable of happiness only at the front, and not as a wife but as a "battle companion" equal to her beloved, killing and risking death by his side. The absence of these conditions and of equality in heterosexual relations makes "peacetime" love, let alone marriage, impossible for her, and the failure of her attempts at "seduction" corroborate this impossibility.

The dead end is particularly evident in the scene at the museum, where Petrukhina sees herself as a dead exhibit amongst the living visitors to the museum. Petrukhina heightens the paradox of the situation when she exclaims to Pasha, the museum's curator, who is in love with her, "Pasha! Marry me...." Despite his feelings for her, the request unnerves him: as a sensitive person and truly in love with Petrukhina, Pavel realizes that her suggestion reflects her utter despair. After the awkward pause that follows, Petrukhina sarcastically adds, "Imagine, a director of the museum marries his exhibit."

This dialogue is framed by two ironic images clearly analogized with the female protagonist: before Petrukhina's proposal, Pasha speaks excitedly of steak made of mammoth meat preserved in permafrost; it is still edible, but a little tough. After her proposal, Petrukhina looks around and, noticing a stuffed hen, sardonically exclaims, "A stuffed hen. The only one of its kind in the whole world." The prospect of marriage and family happiness for Petrukhina parallels eating a permafrosted mammoth steak. Both the mammoth (extinct) and the hen (dead and stuffed) reflect Petrukhina's "identities"—her wartime self and the self she might acquire if she becomes a "normal woman." Her genuine femininity, associated with the war, is dead, for the war and her beloved are long gone. Characteristically, she concludes this conversation with the rhetorical question: "Today one girl [at the museum] asked about me: 'Did she die [in the war]?' By the way, what do you think: did she die?" Emotionally, she did, becoming an extinct species.

The alternate prospect, that of "domestication," which would entail giving up the ability to fly (wings!) for the possibility of laying eggs and protecting the nest, is equally dead and meaningless for Petrukhina, and she has no illusions about this option: a stuffed hen looks like a "normal" hen, yet is just an empty shell. The episode, in fact, evokes the colloquial patriarchal equation of a woman with a hen: "A hen's not a bird, a woman's not a human" ("Kuritsa ne ptitsa, baba ne chelovek"). The heroine's desire to fly, to have wings, in this context reads as her resistance to the dehumanizing patriarchal reduction of a woman into a "domestic fowl."

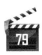

It is also quite symptomatic that Petrukhina's first recollection of her wartime love is situated in an ancient, abandoned city of stone. Her beloved, Mitia Grachev, explains that the town's inhabitants left it for "a better life" and as a result forgot their art of masonry. In other words, having abandoned the stones, they lost themselves. In the same episode, Grachev answers Petrukhina's question "Where should we go?" ("Kak nam teper' idti?") with an ironic quote from the fairy-tale formula: "Go left, you'll find your horse's death, go right, you'll find your death" ("Nalevo poidesh', konia poteriaesh'. Napravo poidesh', sam propadesh'"). Grachev's narrative and response symbolically foreshadow Petrukhina's fate after his demise. The loss of self experienced by the stone-town's inhabitants tropes Petrukhina's "military" self, which crumbles and dries up outside of war and wartime conditions. And Grachev's reference to death in his folkloric response predicts his own physical and Petrukhina's spiritual-emotional death. Not only this scene, but also the next episode of Petrukhina's recollections—depicting Grachev's death—testify to the fact that Petrukhina's love and femininity are rooted in *the land of the dead*: the abandoned city of stone provides a powerful visual metaphor for this concept. These scenes, as well as the film's finale, reveal the paradox at the root of the nostalgia Petrukhina (and Soviet society at large) felt for the war: the relative freedom of wartime is based on the presence of *death* as a major fact of existence.[6]

Another, alternative scenario of "normal" femininity is represented in the sequence following the scandal with Vostriakov, in which Petrukhina converses with the female bartender at a beer café, Shura (Rimma Markova), who functions as Petrukhina's double. Of the same generation, she likewise is a figure of authority among men (at least those men whose concept of manhood is inseparable from beer). Shura's family life is also far from happy: she has two children and "somebody else's husband." During their

[6] Svetlana Aleksievich in *Enchanted by Death* [*Zacharovannye smert'iu*, 1993] posits a tradition of fascination with death as inhering in Soviet and post-Soviet culture.

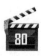

revealing conversation, Petrukhina admits that when she tries to write a letter to her wartime girlfriends, she has nothing to write about. Nothing she does brings joy to her or anyone else ("It turns out—I have no joy for myself, nor for others"). Shura's response, that she finds her life interesting despite all the odds, inspires Petrukhina's recollection of her reputation in school as an actress, which in turn prompts Shura to remember how she used to love waltzing. In a rare moment that represents woman-to-woman bonding, the two begin to waltz, humming the melody of Strauss's *Blue Danube* as they twirl, only to stop when they notice the amazed faces of men staring at them through the window. Shepit'ko orchestrates this unusual sequence to present via Shura a gendered version of the "simple life" (a popular conclusion in many films of the sixties and especially the seventies)[7], one that flows outside the uniformity of the symbolic order, yet can engage a subject. However, it is quite obvious that the scenario of "simplification" is not one Petrukhina can and will adopt: she is too well known and too independent to live a "simple life." Moreover, her present life derives its sole meaning from the past, which she cannot jettison.

The collapse of Soviet gender identity leaves an insatiable void that manifests itself in Petrukhina's striving for the sky—a spatial metaphor for her desire to return, if only symbolically, to the war, when she was free, loved, and in love. [...]

When interpreting the finale of *Wings*, it is important to remember that Petrukhina's nostalgia for war is also inseparable from her lost power to kill—her war record proudly lists twelve destroyed enemy aircraft, her trophies. An achievement from the standpoint of official ideology, this record is a sign of monstrosity from the perspective of 1960s gender mythologies, which equated womanhood with birthing and nurturing. From the latter viewpoint, Petrukhina's nostalgia for the war may be read as a variation on the Freudian death drive. In this context, the film's conclusion, in

7 See, for instance, the characteristic finales of such films as *Afonia* by Georgii Daneliia (1975) and *Moscow Does Not Believe in Tears* [*Moskva slezam ne verit* 1979] by Vladimir Men'shov, as well as the entire plotline of *Snowball Berry Red* [*Kalina Krasnaia* 1975] by Vasilii Shukshin.

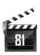

which the heroine soars skyward in a plane similar to the one she flew during the war, acquires an unambiguous meaning. Shepit'ko clearly implies the suicide of the former "warrior" woman unable to find her place in "normal" Soviet culture, for her identity has been formed by the discourses and practices of extraordinary mobilization. Unwilling to break herself to fulfill the constrictive gender demands of peacetime, Petrukhina simply leaves for the only freedom she knows—one secured by her wartime connection to death.

While exposing the contradictions in the gender discourses and mythologies of Soviet culture, Shepit'ko's film proffers no alternatives to this logic. *Wings* is important for its systematic rejection of illusions (both official and popular), for overcoming gender contradictions incarnated in the figure of the woman-soldier. Petrukhina's death certainly does not offer a resolution to these contradictions; it presents a desperate escape from them. Soberly and pessimistically, the film reveals the soldier-woman's death as a mandatory requirement for her symbolic acceptance into the "modernized patriarchality" of the sixties. Indeed, death seems to be the only honorable exit for Petrukhina, and Shepit'ko infuses her lack of options with a bitter, tragic irony that is maximally removed from both paternalist sentimentality and official pathos. […]

It is quite plausible that a reading of the film as a gender tragedy escaped the interpretational filters of the sixties and even of the eighties, when the film was perceived mainly as a statement against the crippling effects of Stalinism, mediated by the heroic mythology of the war. Any attacks on *Wings* concerned its perceived assault on the sacred cow of Soviet (Stalinist) culture—the Great Patriotic War and its veterans. As we have argued, a reading of Shepit'ko's film as a story of the gendered collapse of Soviet subjectivity has a more far-reaching effect. It suggests, among other things, that Soviet culture, with its emphasis on extreme situations of total mobilization such as the war, permitted a much greater degree of freedom and personal self-realization than during relatively "peaceful" historical periods. In relation to gender models, this means that the most radical, novel, and revolutionary paradigms of femininity emerged during these liminal and critical periods, but became irrelevant and even

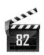

dangerous once the crisis ended. This explains why relatively liberal periods of Soviet history, such as the Thaw, or the late eighties and early nineties, witness not only the weakening of authoritarian/ patriarchal patterns of power, but also the paradoxical increase of patriarchal influence on the lives of women.[8] This paradox had been noticed before—for instance, in Aleksei Tolstoi's *The Viper* (*Gadiuka*, 1928), which depicts the dramatic transition of a heroine shaped by the Civil War into the more "normalized" NEP (New Economic Policy) culture; it is little wonder that this novella was frequently mentioned in discussions about *Wings*. Shepit'ko, however, was the first to present this gender tragedy as the psychological motivation behind personal nostalgia for the war (and Stalinism) and as the dark flip side of political liberation. This perspective deconstructs a simplistic binary opposition between "times of terror" and "times of freedom," acknowledging the presence of freedom during "dark times" and exposing the repression of women during relatively "liberal" periods. This nuanced vision emerges as the summation of all the components of the film narrative, enables *Wings* to transcend the cultural borders of the sixties, and accounts for the resonance of Shepit'ko's film with today's, rather than yesterday's, concerns and anxieties.

Further Reading

Kaganovsky, Lilya. "Ways of Seeing: On Kira Muratova's *Brief Encounters* and Larisa Shepit'ko's *Wings*." *Russian Review* 71, no. 3 (July 2012): 482-99.

8 For an analysis of this situation during the period of perestroika, see Helena Goscilo, *Dehexing Sex: Russian Womanhood During and After Glasnost* (Ann Arbor: University of Michigan Press, 1996), 5–18.

COMMISSAR

Komissar

1967 (released 1987)
110 minutes
Director: **Aleksandr Askol'dov**
Screenplay: **Aleksandr Askol'dov**
Cinematography: **Valerii Ginzburg**
Art Design: **Sergei Serebrennikov**
Composer: **Al'fred Schnitke**
Sound: **Nikolai Sharyi, Liia Benevol'skaia, E. Bazanov**
Production Company: **Mosfilm**
Cast: **Nonna Mordiukova (Klavdiia Vavilova), Rolan Bykov (Efim Magazannik), Raisa Nedashkovskaia (Mariia), Liudmila Volynskaia (Efim's mother), Vasilii Shukshin (Kozyrev, Vavilova's commander), Otar Koberidze (Kirill, Vavilova's lover)**

After graduating from the Gorky Institute of Literature in 1958, Aleksandr Askol'dov (1932-) published on Bulgakov and worked as an inspector for the theatre section of the Ministry of Culture, then as chief editor for film production, and later as a member of Goskino's committee for approval of screenplays. He left to study directing with Leonid Trauberg at the Higher Courses for Screenwriters and Directors (VKSR), graduating in 1966. Askol'dov's diploma project, *Commissar*, based on Vasilii Grossman's "In the Town of Berdichev" (1934), told the story of a female commissar who finds herself pregnant during the Civil War, must leave the army and is billeted with a poor Jewish family.

With the support of Sergei Gerasimov, the script by this supposed establishment insider, which coincided with the fiftieth anniversary

of the Bolshevik revolution, was approved for production, but in its last stages the project ran into official criticism for its "unheroic" and "non-humanistic" depiction of the Bolshevik cause. The film's positive depiction of Jews and its half-Jewish composer, Al'fred Schnitke, became further obstacles as the Arab-Israeli Six-Day War, in which the USSR took the Arab side, broke out in 1967. After Askol'dov refused to make substantive changes to the film, *Commissar* was banned in December 1967 and the director was fired from Mosfilm for professional incompetence and expelled from the Communist Party. Gosfilmofond, the state film archive, preserved the negative of the film. Askol'dov states that part of the negative was burned at one point and had to be reconstructed from the one surviving copy.[1] During perestroika, the recommendation of the Conflicts Commission of the Cinematographers' Union to release *Commissar* met with resistance from conservatives at Goskino. The romantic heroism of the Civil War, questioned by Askol'dov's film, remained a sacred cow for many Soviet officials, including Mikhail Gorbachev, who had initially opposed release, according to Elem Klimov, then head of the Union of Cinematographers.[2] It was only when Askol'dov demanded a screening of the film at a press conference during the fifteenth Moscow Film Festival (1987) that Gorbachev, upon the request of Gabriel García Márquez, ordered the release of *Commissar*, which subsequently enjoyed international success at film festivals. Askol'dov never made another feature film and, since the 1990s, has lived mostly in Germany, lecturing at film schools.

Commissar is a late Thaw film that questions the early Thaw romanticizing of the revolutionary project. Its quotations of classic Soviet films consistently work to deconstruct heroic Soviet myths. As Vavilova's commissar-lover is hit, his glasses fall to the ground and shatter, referencing the famous pince-nez of *Potemkin*. He bares

[1] Interview with Aleksandr Askol'dov, disc 2 of *Komissar*, Ruscico, 2004.

[2] "The Uncompromised Commissar," Interview with Alexander Askoldov, *Cineaste* 17, no. 1 (1989): 9-11; Ella Mitina, "Proezdom s kinorezhisserom Askol'dovym, kotoryi byl odnim protiv vsekh," http://www.peoples.ru/art/cinema/producer/askolidov/ (accessed 28 June 2012).

his chest, screaming in agony, for he is mortal, unlike the "immortal" worker Timosh at the end of Dovzhenko's *Arsenal*. The commissar's dead body hangs over the bridge like the dead horse and the murdered woman in *October*. At the end of *Commissar*, Vavilova and her student-soldiers, bearing their unit flag, march into nothingness, thus inverting the triumphant finale of Pudovkin's *Mother*.[3]

The metanarrative of *Commissar* is concerned with the public-private binary, aspects of which include all religions vs. the Civil War (the Madonna statue surrounded by Red Army troops; the jump shots of the synagogue, Catholic and Orthodox churches reacting to the scout's shot) and private life vs. public, humanitarian societal goals (Vavilova's personal fulfillment as a mother vs. her revolutionary duty; the Magazanniks vs. the Bolsheviks). Ultimately the Jewish family is more humane than the Bolsheviks because they accept a potential enemy who is foisted upon them and care for her, while the Bolsheviks kill their enemies.

After both Askol'dov's parents were arrested in the 1937 purges, he was taken in by family friends, whose experience was that of Jews from the Pale of Settlement. The director's memories of the family became part of the impulse to make the film.[4] American students, most of whom are familiar with Tevye the milkman from the musical *Fiddler on the Roof* (1971), sometimes question what seems to be Rolan Bykov's similarly stereotypical performance of a singing-dancing shtetl Jew. In both cases, seemingly excessive performance can be explained by the characters' Hasidic beliefs. Hasidism, which spread in Eastern Europe at the end of the eighteenth century, was originally a radical religious movement that emphasized joyful praise of God rather than asceticism and study of the Torah. In obedience to the Hasidic ideal of religious joy, Hasidim frequently engaged in energetic singing and dancing,

3 See Andrew Barratt, "In the Name of the Father. The Eisenstein Connection in Films by Tarkovsky and Askoldov," in *Eisenstein at 100: A Reconsideration*, ed. A. LaValley and B. Scherr (New Brunswick, NJ: Rutgers University Press, 2001), 148-60.

4 Interview with Aleksandr Askol'dov, disc 2 of *Komissar*, Ruscico DVD, 2004.

which were considered an avenue of worship. Efim's exuberance is thus a traditional expression of his religious background.

Consistent with Thaw era style, Askol'dov employs formal artifice both in the cinematography (jump cuts, sudden flashbacks, a flashforward) and the prominent, non-diegetic music of *Commissar*. The subjective camera, often hand-held, forces the viewer to identify with differing points of view, whether Emelin's, as he imagines his execution, or Vavilova's hallucinatory visions during childbirth, or soldiers running downhill toward water within her visions. The presence of the filmmaker is foregrounded during the night of Vavilova's arrival through a long tracking shot, resembling the curious progress of a visitor through the Magazannik house, that pulls us out of the diegesis. Schnitke's vocal music supports the unifying message of the film as Vavilova's folk song/lullaby, which tells her story in a way she cannot verbalize, merges with Schnitke's Jewish lullaby. The soundtrack of Vavilova's hallucinatory visions during childbirth is an arresting mix of diegetic sound (the screeching wheels of a gun carriage, human voices, the wind blowing over sands, the hoofbeats of galloping horses) and the non-diegetic (violin strokes replace the sound of a whip applied to horses).

SOVIET STRUCTURING MYTHS IN *THE COMMISSAR*

Elena Monastireva-Ansdell

The Commissar revisits the basic myths structuring Soviet national identity as it tackles the philosophical, societal, and ethnic tensions that tear at the Soviet social fabric in the mid-1960s. Askoldov diagnoses the fatal split in Soviet identity as an enduring fissure between the state conditioned model of society as a semimilitarized "big family" responsive to the administrative-command rule on the one hand, and the Thaw-era community modeled on a small family, an egalitarian institution that collapses social, political, and ethnic hierarchies on the other. In order to explore the conflict which the Thaw failed to resolve, the film adopts an analytical strategy whereby it amplifies the existential polarities of the Thaw-era value system before colliding them in a final debate.

The Commissar embodies the societal tensions in the multivoiced nature of its discourse, as well as in the fractured and disconnected structure of its imagined universe. In addition to responding to a wide variety of cinematic texts that were strongly imprinted on the film's audiences, Askoldov uses less familiar heterodox treatments of the revolutionary theme and its reverberations in early Soviet literature.[1] Two works republished during that period, Vasilii Grossman's 1934 short story "In the Town of Berdichev" and Isaak Babel's 1920s short prose cycle *Red Cavalry*, both set in the Red Army's 1920 Polish campaign, inspired Askoldov's cinematic revision of the revolutionary myth.[2]

[1] Trained as a literary and theatrical critic prior to becoming a film director, Askoldov was quite attuned to the Thaw's rediscovery and rehabilitation of authors banned or silenced under Stalinism.

[2] Vasilii Grossman (1905-64) first published "In the Town of Berdichev" in *Literaturnaia gazeta*, April 2, 1934. The story was not republished until 1958 in *Povesti, rasskazy, ocherki* (Moscow: Voennoe izd-vo Ministerstva Oborony SSSR).

The plot of Grossman's short story provided the core structure for *The Commissar*, while the inquiries of Babel's philosophers into the nature of revolutionary justice and his potent visual imagery helped flesh out Grossman's somewhat schematic psychological and spatial landscapes. The ethical dialogue with Babel as a participant of the Revolution and Grossman as a contemporary of Stalinist reforms strengthens the film's "intellectual," questioning stance.

The Commissar shifts its focus away from the military campaign to a highly personal moment: Red Army commissar Klavdia Vavilova faces a pregnancy, which she sees as a grave obstacle in her revolutionary struggle and therefore makes every effort to terminate. When various attempts prove unsuccessful, the pregnant commissar moves into the lively Jewish household of Maria and Efim Magazannik for her imminent delivery. After she gives birth to a son, Klavdia must choose between staying with her adopted small family or rejoining the big family of the revolutionary fighters. Even though she has grown attached to her newborn and her loving hosts, she eventually follows her urge to fight for the better future, leaving the infant with the Jewish family.

Klavdia's flash-forward to the Holocaust notwithstanding, the story seemingly concludes where it began. In the final scene, the commissar again leads the Red soldiers in battle but the film places its major focus upon the profound change that takes place within the protagonist in the course of her home stay. The commissar enters the narrative as an authoritarian leader in command of a powerful and ruthless military force complete with cannons and armored vehicles. When she suddenly finds herself outside the familiar militaristic setting, she simply does not know how to function. The commissar's situation in the film resembles the position of Soviet society, which entered the liberal atmosphere of a cultural and political Thaw after decades of semimilitaristic existence under authoritarian rule. Faced with a new political freeze, Askoldov tries to comprehend the reasons for the Thaw's failure to resolve the tension between the individual and the state and thus regenerate Soviet society on humane premises. Expanding the spatio-temporal boundaries of Grossman's short story, Askoldov symbolically depicts the Thaw's

search in his heroine's journey of physical and psychological liberation facilitated by her new, small-family environment. The stages of Klavdia's emotional and spiritual maturation in the film reverse the symbolic "progress toward consciousness" and the ritual initiation into the "big family" that shaped Stalin-era Civil War discourse, reappearing in the late Thaw quasi-Stalinist narratives. Askoldov's inverted enactment of a conventional Stalinist rite of passage shows Klavdia undergo its three main phases: separation from previous environment, transition to a new system of values and incorporation into the new community.[3]

The Previous Environment

The Commissar evokes and simultaneously recasts the image of a manly woman used to denote the unnaturally exaggerated masculinity of Stalinist authoritarian culture, juxtaposing it with the Thaw culture's feminine system of values. At the beginning of the film, Klavdia comes forth as an agent and a product of the militarized world governed by martial law and militant ideology. Dressed in a heavy military uniform and speaking in rough military jargon mixed with ideological clichés, the heroine strikes the viewer as more masculine than the men in her all-male army. When the commissar tells the regiment commander about her pregnancy in the scene directly following her cold-blooded order to shoot a deserter, the news comes as a joke both to him and to the audience. [...] In view of the film's heightened ideological polarities, the commissar's pregnancy becomes an ultimate test for the Revolution's ability to bring forth new life.

The film places little trust in the reason-driven verbal discourse discredited earlier in the Thaw, shaping its argument via almost exclusively visual and nonverbal auditory imagery. Within the movie's extensive metaphoric network, Klavdia's changing body becomes a symbolic battleground in the ensuing encounter between

3 For Katerina Clark's discussion of the Socialist Realist plot as a rite of passage see *The Soviet Novel: History as Ritual* (Chicago, 1981), 167-76.

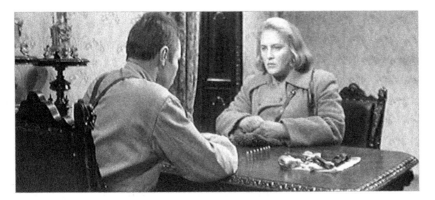

Fig. 85. Vavilova and the Commander

the two opposing sets of ideals and worldviews. In the war-consumed world of the big family, Klavdia's pregnancy is interpreted as a desertion from the communal cause. When she discloses her state to the regiment commander, she needs to justify her "ideological treason" by describing her assiduous, albeit fruitless, attempts at aborting the fetus. In order to stay loyal to the Revolution, Klavdia has to purge her body and her mind of any individualistic impulses. Prior to learning of her pregnancy, the viewer sees Klavdia wash in the town's deserted *"Family* Baths." Building up the steam to enhance the bath's cleansing effect (and most likely in hopes of inducing a miscarriage), the heroine violently beats her naked body with birch switches. The camera reinforces the punitive intent of a bathing ritual traditionally associated with healing when it cuts to the flogging that takes place outside, where a mounted orderly whips a helpless deserter, Emelin. Events that follow uncover a deeper correspondence between the expecting commissar and the deserter. Emelin absconded from the regiment to care for his sick wife and children, and a jug of milk that this parent-nurturer clutches to his chest confirms his infidelity to the communal ideal. [...]

Klavdia's relationships within the regiment lack the close familial nature traditionally attributed to the symbolic community that safeguards its members' social and personal welfare. The ties connecting "fathers" and "sons" are presented as sterile and impersonal; the big family cannot accommodate the richness of

life that it aspires to transform. Equating Klavdia's pregnancy with desertion, the commander threatens her with court-martial, thus expressing his regret over the loss of a valuable "combatant unit" (*boevaia edinitsa*), instead of rejoicing over the emergence of a new life. In the course of this conversation the camera slowly moves down from the commander's face to the table where he is lining up a row of bullets. It then follows the row across the table and slowly rises to connect in an uninterrupted movement the commander and the commissar, now a man and a woman, through potentially deadly ammunition (Fig. 85). Equally disturbing weaponry resurfaces in a retrospective episode which depicts Klavdia's romantic interlude with her lover next to a cannon hopelessly stuck in a barren desert. In Civil War films, military weaponry traditionally served as a prop that empowered characters or brought romantic lovers together; here it turns into an ominous phallic symbol of the official patriarchy. [...]

Klavdia's regiment makes no effort to protect her or her newborn and surely has no inclination to bond with the child. When the regiment commander and his orderly pay a visit to inform her about their retreat from the town and discuss her situation, they far too willingly accept Klavdia's decision to stay, especially given that a White occupation would most surely be fatal for a Red Army commissar, not to mention those harboring her. Although the sequence has humor, the camera portrays the two men as menacing intruders into the peaceful family abode. They track in dirt with their boots, the commander's cigarette smoke is harmful for the child, and the orderly's gold watch not only clashes with the poor simplicity of the household but also suggests plundering and possibly a pogrom. Ginzburg's camerawork emphasizes the lack of any deeper connection between the regiment's traditionally close-knit leadership: avoiding group shots, the camera films most of the conversation in a shot/reversed shot sequence, isolating the commander and the orderly from Klavdia and her child. The orderly's ironic farewell comment, "Let's hear from you, Vavilova" (*Pishi, Vavilova*), accentuates an essential disconnection between the worlds inhabited by the big and the small families.

The film, in fact, presents the protagonist's big family as her and the civilian characters' "chief victimizer"[4]; its brutality—epitomized in a massive cannon that threatens to crush Maria and her vulnerable naked children upon the army's arrival in town—becomes associated with the forces of the Revolution and war itself. Klavdia finds herself in Emelin's shoes when on a walk around town her former soldiers start shooting at her, with complete disregard for the child she is holding. The internecine nature of this conflict is most vividly conveyed through the Magazannik children's war games in which siblings attack and torture each other.

Transition to a New System of Values

The process of Klavdia's inner renewal starts on the day she leaves the oppressive environment of her military regiment and moves in with her Jewish host-family. The Magazanniks' inner courtyard presents a stark contrast to the deserted stone-paved streets of the war-ravaged town: it is filled with freshly washed linen, the sounds of cooking dinner, children's voices, and noises coming from Efim's workshop. Here strong family bonds and respect for elders attempt to keep at bay the martial law of the outside military world. If Klavdia employed a firing squad to protect her regiment's ideological unity in the deserter-execution scene, Efim summons his mother, wife, and six children, *his* "weapon" with which he intends to defend his household from an intrusion when the uniformed stranger appears at their door. Askoldov's choice of actors for the roles of Klavdia, Maria, and Efim is in line with the film's overall analytical strategy to amplify the existential polarities of the Thaw-era value scale before colliding them. If Nonna Mordiukova's tall, thick-set, resolute, sexually repressed, and uniformed Klavdia epitomizes big family paternity, Rolan Bykov's small, poorly dressed, slightly comical, sentimental, and ironic Efim, whose name appropriately

4 Aleksandr Prokhorov, "Soviet Family Melodrama of the 1940s and 1950s: From *Wait for Me* to *The Cranes Are Flying*," in *Imitations of Life: Two Centuries of Melodrama in Russia*, ed. Louise McReynolds and Joan Neuberger (Durham and London: Duke University Press, 2002), 215.

means "fruitful," incarnates the Thaw-era ideal of parenthood. Raisa Nedashkovskaia's delicately built, compassionate, and family-oriented Maria embodies the ideal of holy motherhood. [...]

Initially resisting the invasion, the family soon warms up to Klavdia, starting the process of her initiation into the small family and biological parenthood, the strongholds of Thaw-era values. The process begins on a purely surface level, when Efim sews her a loose light dress to replace her constrictive uniform and heavy overcoat. In place of Klavdia's military boots, Maria offers her Efim's house slippers. The old cradle which Klavdia inherits from Maria and Efim's six children performs the function, while it subverts the meaning, of the "baton," a symbolic object, gesture, or speech, the passing of which traditionally acted as an ideological blessing that assured the continuity of revolutionary teaching.[5] The explicit familial nature of Maria and Efim's baton reaffirms the need for the continuity of humane values disregarded in revolutionary lore.

The prolonged sequence of Klavdia's labor constitutes the next, mostly physical, stage of her transformation, in the course of which the heroine's feverish visions of her regiment's futile campaign in a barren desert eventually subside, giving way to a heavy rain that welcomes the appearance of new life. When Klavdia sets out on a walk around town with her newborn, she finally looks comfortable with her new identity. The heroine's visual resemblance to the Madonna with Child signals her *inner* change, while at the same time symbolizing the Thaw's hopeful vision of the Revolution as a cradle of a humane teaching launching a new era of internationalism and social equality. The image of the child's father, a bespectacled commissar-*intelligent* who momentarily appears in Klavdia's desert visions before perishing in battle, reinforces the hopes associated with the child: Askoldov names the father Kirill, thus comparing St. Cyrill's deed of bringing the humanistic ideals of Christianity to the Slavs to that of enlightening humanity with revolutionary ideals.[6]

5 Clark, *Soviet Novel*, 173.

6 Prior to Askoldov, Babel utilized the name's symbolic connotation in his own pseudonym, and that of his narrator in *Red Cavalry*: the name Kirill Liutov

Klavdia's walk around Berdichev—a town situated at the Russian Empire's ethnically, socially, and culturally mixed periphery—allows the protagonist to experience life's infinite variety. In his comprehensive exploration of Soviet national identity, Askoldov subverts both political and ethnic hierarchies. His ideal—and largely Utopian—community takes shape in opposition to both the big family of the state and the big family of Soviet peoples.[7] Along with exposing the ingrained authoritarian nature of the Soviet political system, the film reveals the hypocrisy of the official concept of internationalism as the central structuring principle of the nationalistic and anti-Semitic Soviet Empire. In contrast to the official view of internationalism as a homogenizing notion, Askoldov proposes his ideal of ethnic and cultural diversity. The emotional uplift and spiritual enlightenment the heroine experiences as a result of her initiation into this multiethnic community is conveyed through the formal structure of the "mother's walk" sequence in which Klavdia's ascending motion to the top of the hill symbolizes her search for a unifying moral vision.

The sequence starts with a rapid upward movement of the camera and a dynamic low angle shot of the Orthodox Church cupolas accompanied by tolling bells on the soundtrack. As the ringing gains volume, it is joined by an off-screen polyphony of human voices in the market square. The previously desolate market now bustles with music and dance and its stands abound with farmers' produce and artisans' wares. People interact peacefully in a community comprised of Gypsies, Jews, Poles, Ukrainians, and Russians, peasants, intelligentsia, craftsmen, and artists. Klavdia continues her walk up to the Catholic Church, eventually proceeding

(*liutyi* means "ferocious") combined the symbolism of spiritual enlightenment and humanism with the recognition of violence as an inseparable part of revolutionary reality. Askoldov's allusion, through the name of his doomed character, to Babel's hero and Babel himself questions the possibility of reconciling humane ideals with the violence performed in their name.

7 The utopian nature of this vision becomes evident when juxtaposed to the gradual waning of ethnic culture and traditions from the grandmother to Efim and Maria and then to the youngest generation.

to the very top of the hill, the location of the town's destroyed but not abandoned synagogue. An old rabbi looks out one of the synagogue's east-facing windows. When he turns around to greet Klavdia their eyes meet in symbolic communion.[8] Shnitke's non-diegetic music accompanying the heroine on her walk introduces special leitmotifs for each of the religions, and they all intertwine harmoniously with the central musical theme of motherhood. Amidst the overall fragmentation of the film's warring universe, the unity facilitated by the lyrical motherhood theme highlights the ecumenical nature of the scene on the top of the hill.

As she descends, Klavdia leaves the peaceful domain of tolerance and spirituality, to reenter the realm of warring ideologies: at the bottom of the hill several of her former soldiers taunt her about her new civilian status and, treating her as a deserter, shoot at her and her child. Running away from the attack, Klavdia, in a disturbing point-of-view shot, crosses a bridge and crashes into the cliff on the other side of it. The camera then slowly and ominously pans down the rocky wall to reveal the sobbing mother crouching at the bottom of the cliff. Her consequent return home is filmed in a long shot, with the small and vulnerable figures of the mother and child viewed against a background of overpowering cliffs. The road is a flat path at the very bottom of the screen. The sequence that started with the camera's inspiring flight to the cupolas in the clear sky finishes with the heroine falling against the stones and walking a depressing flat path against the rocky backdrop. Askoldov here and elsewhere cinematically renders both the Thaw's attempt to achieve a nonauthoritarian community and subsequently visualizes its failure in his heroine's journey through a warring world.

8 The symbolism connected with the synagogue adds another dimension to this scene. The rabbi stands across from the synagogue's entrance, thus looking out through an opening in the eastern wall. The rabbi's orientation toward the east signifies his openness to a dialogue with God, since the east wall of the synagogue traditionally contained the *aron-kodesh* niche, crowned with the inscription: "The almighty Father opened the gate for prayer." When Klavdia enters the synagogue from the "gate of the people" and the rabbi greets her from the "gate of God," he acts as an intermediary between the heroine and the source of the higher wisdom.

Incorporation into a New Community

Klavdia's metaphorical baptism during her visit to the town's three temples prepares her complete integration into her adopted small family. When the regiment retreats from the town, Maria and Efim come to Klavdia's room to offer her the protection of their humble home. All three protagonists are grouped around the cradle, conveying a sense of mutual support and close-knit community (Fig. 86). The composition of the shot and the postures of the characters

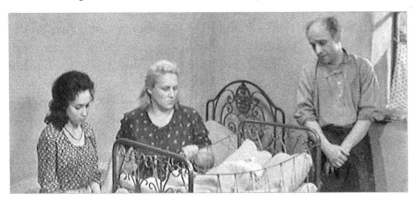

Fig. 86. Maria, Vavilova and Efim around the Cradle

evoke those of Andrei Rublev's venerated *Trinity*, the fourteenth-century icon that appeared on screen in Andrei Tarkovsky's *Andrei Rublev* (1966). In Tarkovsky's own words, his film intended "to show how the national yearning for brotherhood at a time of vicious internecine fighting and the Tatar yoke gave birth to Rublev's inspired *Trinity*—epitomizing the ideal of brotherhood, love and quiet sanctity."[9] Both in the original masterpiece and its cinematic reminiscence, the compositional center holds an object that draws the three participants together and emerges as a symbol of hopes for a better future and reconciliation. In Rublev's *Trinity*, it is the chalice that is peacefully shared by the three angels; in Askoldov's *tableau*,

9 *Sculpting in Time: Reflections on the Cinema*, trans. Kitty Hunter-Blair (London, 1986), 34.

it is the newborn child that brings out commonality in people with different ethnic and ideological backgrounds.

As Klavdia sings to her son, a fluid panning shot of the house celebrates the deeply personal ties connecting Klavdia and her new family. Without a single visible cut, the camera moves through the dark house to the accompaniment of a song, hovering over the family's three living generations and incorporating the ancestors' portraits hanging on the walls. Klavdia's song is not a conventional lullaby, but a series of short rhymed couplets of urban folklore, known as *chastushki*. It tells the protagonist's deeply personal story which she could not share with her commander when he asked her crudely about the father of her child: the loss of the loved one and a deeply felt compassion for him, a mother's sacrifice of her favorite dress for swaddling cloths for her children, and a couple's night walks under blooming locust trees. The secular words of Klavdia's song merge with the grandmother's Yiddish prayer, her appeal for God to spare the innocent children from murder. Fascinated by the emotion reflected in the commissar's song, Maria joins in with a Jewish tune and the two melodies complement each other. Despite the difference in languages, form, and content, the artistic means of three different genres (prayer, *chastushka*, and lullaby) merge to express the same feeling of compassion for the three women's loved ones.

The Final Debate

Klavdia's incorporation into her adopted family does not erase their respective identities and beliefs; it helps instead to reappraise their philosophies in view of alternative discourses. Ginzburg's lighting choices in the lullaby scene suggest that Klavdia's emerging self-identification as a mother exists next to her changing identity as a commissar: as the singing protagonist paces about the candlelit room, her silhouette doubles as her body, casting a prominent shadow on the back wall and reflecting the new complexity that has replaced her previously orthodox worldview. The protagonist's ideological convictions, suspended throughout her home stay, eventually become tested in light of her recent experiences and in a direct debate with the small-family ideologue Efim.

Efim's subversive irony works to challenge rigid ideological orthodoxies throughout the movie. As opposed to Klavdia's unwavering endorsement of official discourse as a sort of a divine revelation at the beginning of the film, Efim questions even the most sacred texts and authorities if they fail to take individual people into account. He doubts the wisdom of God's creation when he semi-jokingly complains about his family's meager rations consisting of nothing but potatoes: if God spent the first five days creating potatoes, then why on the sixth day did He create man? Efim uses the newspaper *Speech*, a mouthpiece of official propaganda, to make cutouts for Klavdia's maternity dress. When Efim sadly states that there will be no trams in his town because there will be no people to ride them, he questions the sacrosanct promise of the "bright future" and denies legitimacy to a state power, which asserts itself at the expense of enormous human sacrifice. Efim's words evoke a famous pronouncement by Mikhail Kalinin, who in 1923 stated that if a city has a functioning tram service, then Soviet power functions in that city. Efim defies the homogenizing effect of restrictions that any one ideology imposes upon human diversity and individuality when he comments that "a woman who puts on a military uniform does not become a man." His yearning for peace and freedom from authoritarian powers of all shapes comes true only during brief periods between military occupations, "when one power has left the town and another has not yet arrived."

The film's key philosophical debate takes place closer to the end of the film, when the family, including Klavdia and her infant, hide in the basement during enemy artillery bombardment. The doom hanging over this underground sequence contrasts with the hopeful spirituality of the scene on the top of the hill: oppressive reality once again reasserts its power over the characters' idealistic aspirations. While traditionally the commissar acted as an ideological elder to less politically conscious characters, affording them a glimpse of the glorious future, in this conversation Efim challenges Klavdia to consider the ethical dimension of her sweeping ideological assumptions. His philosophy echoes that of Babel's wise shopkeeper Gedali, who supports an "International of kind people" that ascribes equally high value to each individual, regardless of ethnicity or

philosophical conviction. Efim's evocation of the Jewish nation as a symbol of suffering humanity oppressed by ideological systems, and the film's subsequent flash-forward to the Holocaust, make a powerful argument in favor of his philosophy. The film draws parallels between three major autocratic/totalitarian empires—tsarist, Nazi, and Soviet—that used anti-Semitism and nationalism as a means of impressing ideological conformity and unifying the communal "us" against the deviating/deviant "them."

Sympathizing with Efim's kind International, Klavdia nonetheless insists on the use of active—and violent—means in the struggle for a better future for humanity. Her pronouncement about "a free brotherhood of workers," while invoking the Utopian idealism of the early Thaw years, strikes the post-Thaw Soviet viewer as ironically naïve and clichéd. Klavdia's subsequent admission to Efim of her emotional fatigue reveals her deep-seated frustration with her inability to reconcile the Revolution's proclaimed ideals with the need for their violent enforcement. In the aftermath of the debate, Klavdia begins to question her views on revolutionary ends and means and experiences a clairvoyant flash-forward to humanity's real future. The heroine's verbal defense of a militant official ideology clothed in abstract terms and unsubstantiated Utopian promises collapses before the vividly concrete depiction of the Holocaust, which provides a dramatic climax to Klavdia's moral rite of passage. Deeply moved by the tragic revelation about the destinies of her small family, Klavdia feels compelled to prevent the future from happening by changing the troubled present. In a gesture that is doomed to failure from the outset, the transformed commissar emerges from the basement to confront the forces of aggression that consume the outside world.[10]

10 The issue of revolutionary violence was widely debated in the mid-1960s. While disapproving the Civil War's bloodshed, many Thaw artists believed in its unavoidability. Such Leniniana films as *Lenin in Poland* (1965), *On One Planet* (1965), and *The Sixth of July* (1968) show the revolutionary leader as first and foremost striving for a peaceful resolution with minimum casualties, an insurmountable task in a hopelessly divided and warring world. These films represent Lenin as a "tragic thinker," who "unlike those around him knows full well what will happen in the future. He also knows, that it is not

If at the film's outset Klavdia embodied official discourse, at the end she opposes the forces of war associated with the authoritarian state in order to shield her small family, a cradle of interethnic and social communality. Preparing for combat, the heroine puts on her commissar's overcoat and heavy boots, but military garb is now no more than an outer shell for her maternal core, as she runs off to battle in her simple dark dress and headscarf. Her overcoat, blown back in the wind in the manner of the Mother of God's mantle (*pokrov*), becomes symbolic of the motherly protection Klavdia aspires to extend over her loved ones.[11] If at the film's opening the heroine headed a powerful military force, in the end she leads a small group of young idealistic graduates of the revolutionary Petrograd Courses for Red Commanders who oppose heavy bombardment with nothing but side-arms and rifles. Klavdia and a few other survivors of the barrage start their final advance toward the Thaw audience to the plaintive, off-key tune of a lonely trumpet playing the *Internationale*, but the screen freezes in a static view of the snow-covered town, thus precluding the longed-for meeting between the two epochs. [...]

within his power to prevent these future events from happening [including] ... Stalin's reign and World War II" (Evgenii Margolit, "Landscape, With Hero," in *Springtime for Soviet Cinema: Re/Viewing the 1960s,* ed. Alexander Prokhorov, trans. Dawn Seckler [Pittsburgh, 2001], 111).

11 Here Askoldov references the Mother of God's role as a divine intercessor (*zastupnitsa*) in Russian Orthodoxy.

FURTHER READING

Andrew, Joe. "Birth Equals Rebirth? Space, Narrative, and Gender in *The Commissar*." *Studies in Russian and Soviet Cinema* 1, no.1 (2007): 27-44.

Orkina, Inna. "'Malen'kii chelovek' v bol'shoi istorii." *Kinovedcheskie zapiski* 85 (2007): 152-93.

Roberts, Graham. "The Sound of Silence. From Grossman's Berdichev to Askol'dov's *Commissar*." In *Russian and Soviet Film Adaptations of Literature, 1900-2001. Screening the Word*, edited by Stephen Hutchings and Anat Vernitski, 89-99. London: Routledge Curzon, 2005.

Stishova, Elena. "Passions over *Commissar*." *Wide Angle: A Film Quarterly of Theory, Criticism, and Practice* 12, no. 4 (October 1990): 62-75.

FURTHER VIEWING

Askol'dov, Aleksandr and actors, interviews and supplementary materials. *Komissar*, Disc 2. DVD. Ruscico, 2004.

PART
FIVE

CINEMA OF STAGNATION LATE 1960s-1985

Elena Prokhorova

In 1964 Leonid Brezhnev replaced Nikita Khrushchev as General Secretary of the Communist Party. Scholars retrospectively dubbed Brezhnev's eighteen year-long rule "Stagnation," in contrast to the preceding, more dynamic era of the Thaw and the following perestroika. During this period, the USSR experienced escalating problems with its outdated, inefficient economy, a stagnating political system, an oversized and corrupt bureaucracy and cultural conservatism. The gerontocratic Soviet government was averse to change and determined to preserve the political and social status quo. Moreover, by the mid-1970s a cult of Brezhnev had developed: he received multiple, often undeserved, awards, was featured in epic films and had several books of memoirs ghost-written for him, which described him in laudatory, heroic terms. The official designation of the period—"developed" or "mature" socialism— advertised the achievements of the Soviet Union, while also hinting at its failures: socialist construction was at a dead end and communism was nowhere in sight.

In spite of Stagnation, late socialism is justly remembered as the time when Soviet citizens enjoyed the fruits of the welfare state after decades of war, repression and material deprivation. Stable salaries provided modest comfort, and with free education and medical care, people had money to spend on household appliances, clothes, vacations and cultural pursuits. Yet those very improvements also exposed the problems that plagued Soviet society: chronic shortages of food and basic consumer goods, a flourishing black market, and the widening gap between people's everyday concerns (private life, consumption, leisure) and the state's adherence to the outdated socialist rhetoric which masked the collapse of its oil-dependent, centralized economy.

The change in political and cultural life from the Thaw to Stagnation did not occur overnight. Several events in the late 1960s–early 1970s signaled the curbing of liberal policies: the trial in 1966 of writers Andrei Siniavsky and Iulii Daniel for publishing their works abroad, the quashing of the reformist government in Czechoslovakia by the Warsaw Pact armies in 1968, and the persecution of Andrei Sakharov and Aleksandr Solzhenitsyn and the latter's forced emigration to the US in 1974.

The late 1960s–early 1970s was consequently a transitional period for Soviet cinema. Gradually the relatively permissive cultural policies of the Thaw came under stricter ideological control. Scripts dealing with topics deemed important by conservative film administrators—in particular the Revolution, the Civil War and the Great Patriotic War—were closely supervised. Two politically significant dates—the fiftieth anniversary of the Revolution in 1967 and the hundredth anniversary of Lenin's birth in 1970—precipitated a demand for ideologically orthodox films and put increased pressure on filmmakers to comply with the canonical narrative of Soviet history.

Soviet cinema of the time was an industry controlled by administrators. On average, a film went through ten or more stages of censorship, including close supervision from the army, the police and the KGB. As a result, many finished films were shelved (not released), delayed for over a decade, or released in limited numbers of copies outside of major metropolitan areas. Among shelved films were Aleksandr Askol'dov's *Commissar* (*Komissar*, 1967), Kira Muratova's *Long Farewells* (*Dolgie provody*, 1971), Aleksei German's *Trial on the Road* (*Proverka na dorogakh*, 1971) and Elem Klimov's *Agony* (*Agoniia*, 1975). All were released only during perestroika. At the same time, some films banned domestically were sold to international distributors by Sovexportfilm. Soviet film administrators were well aware of the high quality of these productions and were not averse to applying a double standard: to "protect" Soviet audiences from unorthodox films, while earning profits from international sales, receiving international awards, and even projecting a more civilized and liberal image of the Soviet Union to the West. For example, *Agony*, a film about Grigorii Rasputin and

the fall of the Romanov dynasty, was released in the USSR only in 1985, but sold to the US, France and a few other countries in 1981. *Agony* was awarded the film critics' prize at the Venice Film Festival and, like films by Andrei Tarkovsky, contributed to the prestige of Soviet cinema abroad.

While many films were censored because of ideological "errors" (such as unorthodox treatment of the Revolution or WWII), it would be a mistake to think of 1970s cinema as pure socialist propaganda. Some film genres, such as war epics and police films, indeed bore a heavy load of party and state-glorifying messages. Yet in many other respects, the 1970s were extremely successful years for the Soviet film industry. Filipp Ermash, the head of Goskino (the State Committee on Cinematography) from 1972 until 1986, shared with his Stalin-era predecessor Boris Shumiatskii a preference for politically correct films for the masses. In practice, this meant supporting entertainment genre films rather than "difficult" (art) pictures, and thinking more of the bottom line and box office revenues than of ideology. Film attendance figures suggest that, like audiences in other countries, most Soviet viewers shared this preference for narrative films with a clear storyline, attractive characters, contemporary themes and spectacle/action.

Although, due to the spread of television, film attendance decreased compared to its peak in the 1960s, it was still one of the highest in the world, bringing steady revenues even with low ticket prices: on average, 25 kopeks per ticket, 10 kopeks for children. Moreover, many changes in the film industry spearheaded by the Thaw-era de-Stalinization continued in the 1970s. Socialist Realism continued to be the only officially approved method of filmmaking, but the culture of the period moved beyond Stalin-era propaganda of the bright future or even Thaw revolutionary romanticism. One of the major challenges facing the film industry and film critics was how to represent the new hero. The important film journals, *Art of Cinema* (*Iskusstvo kino*) and *Soviet Screen* (*Sovetskii ekran*) published discussions about "our Soviet contemporary." Interestingly, attempts to define the new hero or derive his features from existing films almost never invoked the positive hero of Socialist Realism or the building blocks of the master plot—class-mindedness, party-

mindedness, etc. Rather, the articles discussed this hero from an ethical perspective, emphasizing "spiritual qualities" at least as much as war and labor heroism.

The fragmentation of Soviet society along generational, educational and cultural lines, which began in the 1950s, continued during Stagnation. Soviet authorities were slow to acknowledge that a unified community of "Soviet people," with common goals and common tastes, was nothing but fiction. Yet it was becoming clear that the generation, which grew up after World War II, and did not personally experience Stalinist terror and the Great Patriotic War, was becoming alienated from socialist rhetoric. Addressing these audiences and their expectations was an important task of Soviet culture. Television, which developed rapidly in the 1960s-70s, was one way of providing a unifying channel of communication. Another was the further differentiation of cinema along genre and stylistic lines.

World War II occupied a special place both in filmmakers' imaginations and in the film administration's thematic planning. The victory in the war and the tremendous losses and suffering of the Soviet people made the war mythology central to Soviet identity in the 1970s. It was perhaps the only moment in the national past when state discourse and people's emotions coincided. Under Brezhnev, war commemorations acquired epic scale, and cinema was expected to respond with its own epic pictures. A number of state-commissioned films came out in the 1970s: a 5-episode *Liberation* (*Osvobozhdenie*, dir. Iurii Ozerov, 1969-72), a 4-episode *Blockade* (*Blokada*, dir. Mikhail Ershov, 1973-77), *Victory* (*Pobeda*, dir. Evgenii Matveev, 1984-85), etc. These films were spectacular propaganda vehicles, designed to convey the canonical version of World War II, in response to western cinematic accounts of the war, and to succeed at the box office.

In addition to these monumental pictures, many films continued the Thaw "trench warfare" line, focusing on individual fates. However, in contrast to the forward-looking cinema of the previous several decades, Stagnation films typically looked nostalgically at the "bright past," whether the Civil War or the Great Patriotic War, as the time of true heroes and moral clarity. The past became

a touchstone against which to measure the bleak and morally compromised present. For example, Andrei Smirnov's *Belorussia Station* (*Belorusskii vokzal*, 1970) tells of four men who, while trying to find a way to remember their deceased wartime friend, realize how shallow and materialistic their lives have become.

Literary adaptations of Russian and western classics continued to enjoy popularity. Some of the best examples are Nikita Mikhalkov's *An Unfinished Piece for a Mechanical Piano* (*Neokonchennaia p'esa dlia mekhanicheskogo pianino*, 1977) based on Anton Chekhov's *Platonov* and *Several Days from the Life of Oblomov* (*Neskol'ko dnei iz zhizni I.I.Oblomova*, 1980) based on Ivan Goncharov's novel, Andrei Konchalovsky's adaptations of *A Nest of Gentlefolk* (*Dvorianskoe gnezdo*, 1969) by Ivan Turgenev and *Uncle Vanya* (*Diadia Vania*, 1980) by Chekhov, El'dar Riazanov's *The Cruel Romance* (*Zhestokii romans*,1984) based on Aleksandr Ostrovskii's play, as well as Stanislav Govorukhin's adaptations of *Robinson Crusoe* (*Robinzon Kruzo*, 1973) and *Tom Sawyer* (*Tom Soier*, 1981). Film adaptations of approved works (those that were previously published in the USSR) meant looser script supervision and carried special prestige in a logocentric Russo-Soviet culture. At the same time, directors had more freedom to produce genre films under the label of "adaptation" (e.g., Riazanov's film is a bona fide melodrama) and to infuse the plot with contemporary allusions. Mikhalkov's adaptation of Goncharov, for example, can be read both as a commentary on Stagnation (its hero chooses the peace and quiet of his bed rather than his dreams and even love), as well as a loving tribute to nineteenth-century Russian culture, both meanings masterfully conveyed by the star actor, Oleg Tabakov. Mikhalkov's adaptations, as well as his other retro films of the 1970s, such as *Slave of Love* (*Raba liubvi*, 1975) precipitated the return of pre-revolutionary Russian culture to Soviet screens. Immaculately stylized as genre vehicles, these films claimed continuity between the Russian and the Soviet cultures and empires.

The complex heroes of late Soviet culture inspired the further development of such genres as melodrama and comedy, both of which represented the individual in the context of the new, more materialistic social environment and made private life the focal

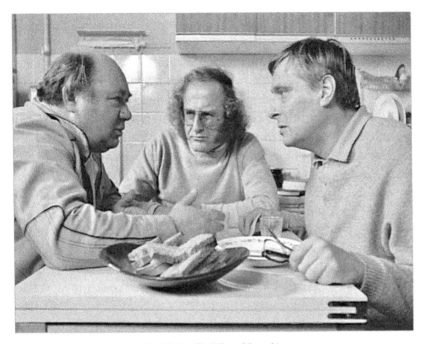

Fig. 87. Vasilii, Bill and Buzykin

point of the filmic world. The latter topic is especially important because private life, not as subordinated appendage to public service but as a major part of individual identity, returned to the screen for the first time since the 1920s. Romance and family relations, consumerism and everyday life (*byt*) are at the center of El'dar Riazanov's comedies, *Irony of Fate, or Enjoy Your Bath!* (*Ironiia sud'by, ili s legkim parom!*, 1976) and *Office Romance* (*Sluzhebnyi roman*, 1977) and the lyrical ("sad") comedies of Georgii Daneliia, *Afonia* (*Afonia*, 1975) and *Autumn Marathon* (*Osennii marafon*, 1979, Fig. 87). Riazanov's films are set in ordinary Soviet apartments and offices and tell stories of finding love. The comforting representation of Soviet reality and the mix of recognizable everyday situations and twists of fate made these films favorites of several generations of Soviet and Russian audiences. The protagonist of the *Irony of Fate*, for example, drinks himself senseless, ends up in another city, and finds true love—all in one night. The film became the Soviet equivalent of *It's a Wonderful Life*, and was screened on television on New Year's Eve every year.

Melodrama, which provided an opportunity for Thaw-era filmmakers to reclaim individual identity caught in the whirlwind of historical forces, occupies a central place in Stagnation cinema. As in Thaw cinema, 1970s melodrama's focus was on the nuclear family: failed relationships, divorce, extramarital affairs, etc. Stagnation melodrama, however, is qualitatively different from its predecessor. In Thaw cinema, social problems are typically rooted in the devastation of the war; incomplete families are reconstituted, often through an adoption of an orphan; and the new family, with the positive hero (more individualized and sensitive than his Stalin-era counterpart) at the helm, symbolized the rebuilding of the Soviet community. During Stagnation many of these utopian themes are abandoned. On the one hand, male heroes of Stagnation melodrama, for example in Daneliia's films, are weak and flawed, incapable of being reliable husbands, fathers, or colleagues. If these heroes symbolize anything, it is the fact that they are products of a flawed community. On the other hand, more and more women— stronger and more capable than their male partners—become protagonists of film melodrama. This trend culminates in Vladimir Men'shov's *Moscow Does Not Believe in Tears* (*Moskva slezam ne verit*, 1980). Using an archetypal plot—three provincial girls making it in a big city, coupled with the Cinderella motif—the film raises questions of woman's fate, male responsibility, and the relationship between public success and private happiness.

Contemporary problems were also in the center of other genres, such as adventure films and children's films. Adventure films, a broad category during Stagnation, included police and detective films, spy thrillers and sci-fi films. Some films, especially police and spy films, were intended as propaganda of the Soviet way of life and the dangers of Cold War-mongering capitalists. Other films used detective plots to raise questions of moral responsibility, individual choice, or to provide pure entertainment. One of the most prolific writers of scripts for late Soviet adventure films was Iulian Semenov, who wrote both detective stories and a series of works about a Soviet secret agent ("the Soviet James Bond") posted to various hot spots of the planet for several decades. The most popular of these was a TV mini-series *Seventeen Moments of Spring*

(*Semnadtsat' mgnovenii vesny*, 1973). By the late Stagnation, many adventure films began using politically correct narrative premises to legitimate purely commercial genre pictures. For example, *The Crew* (*Ekipazh*, Aleksandr Mitta, 1979) is a disaster film with elements of melodrama. *Pirates of the Twentieth Century* (*Piraty dvadtsatogo veka*, 1979), a bona fide action thriller with elements of martial arts film, became the highest-grossing Soviet film of all time, with 90 million tickets sold in 1980 alone.

The genre of children's films is also at the center of Soviet cinema during Stagnation. While some pictures were intended exclusively for children, others targeted adults and used school settings both to probe relations between the adult and children's worlds and to comment on social and moral problems. In films by Dinara Asanova (*The Key Should Not be Handed On*, *Kliuch bez prava peredachi*, 1976) and Rolan Bykov (*Scarecrow*, *Chuchelo*, 1983), school functions as a mini-model of the larger society and the children's collective reflects the condition of the Soviet society in systemic crisis.

Art cinema, in particular the films of Andrei Tarkovsky, occupied a peculiar position during Stagnation. On the one hand, all of his films before his emigration to Italy—*Andrei Rublev* (1966), *Solaris* (1972), *Mirror* (*Zerkalo*, 1974), and *Stalker* (1979)—had difficult production histories and limited distribution in the Soviet Union. On the other hand, the success of his films at international film festivals, including several prestigious awards at Cannes, ensured state funding of his projects even as they were officially criticized. While Tarkovsky's films confirmed the international standing of Soviet cinema, recapturing the 1950s success of *Cranes Are Flying* (*Letiat zhuravli*) and *Ballad of a Soldier* (*Ballada o soldate*), his success with Soviet audiences beyond the intelligentsia and film buffs was much more limited. This was due both to the film administration's efforts to limit the distribution of his films (e.g., *Mirror* was assigned to the third category, with only a few prints screened in some provincial cities), and to the complex, allusive nature of the director's style. In Tarkovsky's films, authorial subjective vision and memories trump conventional narrative continuity. Tarkovsky also redefined genres of works he chose for his scripts. For example, *Solaris* and *Stalker* are based on science fiction novels by Stanisław Lem and the Strugatskii

Brothers. Yet the films use the sci-fi premise to stage philosophical and allegorical parables about the individual's—and humanity's—road to self-awareness and coming to terms with the past.

Soviet animation flourished in the late 1960s-70s and three developments of the genre are of particular importance. First, many cartoons transcended juvenile audiences and either appealed to multiple age groups or targeted adults specifically, often through ironic discourse, contemporary references and philosophical themes. Second, the late 1960s saw the appearance of serialized cartoons: *Cheburashka*, *Winnie-the Pooh* (*Vinni Pukh*) and the longest-running *Just You Wait* (*Nu, pogodi!*), in which the antics of a wolf and rabbit, modeled on *Tom and Jerry*, are set in contemporary Russia to popular melodies. Third, many animation artists experimented with style and storytelling techniques, creating whimsical and poetic masterpieces. Yurii Norshtein's *Hedgehog in the Fog* (*Ezhik v tumane*, 1975) and *Tale of Tales* (*Skazka skazok*, 1979) received multiple international awards and are considered among the greatest animated films ever made.

In the 1970s, Soviet viewers also enjoyed a fair number of foreign films: French and Italian comedies, Indian "Bollywood" musicals and American spectacular epics. Many of them, like *Spartacus* and *Cleopatra*, were purchased at a considerable discount years after their release. These films, along with top-grossing Soviet films, provided steady revenues to the film industry, which was one of very few profitable sectors of the Soviet economy.

As Stagnation was drawing to a close, so was Soviet cinema as it had existed for seventy years. Even before perestroika exorcised many thematic and visual taboos, several very different films painted a devastating picture of Soviet society. Riazanov's *Garage* (*Garazh*, 1980) is a satirical story of a meeting at a research institute, where people, eager to get garages, are ready to eat each other alive. In his *Scarecrow* (*Chuchelo*, 1983, released in 1985), Bykov portrays a children's collective where good Soviet school kids humiliate and harass a girl simply because she does not fit into their egotistical, materialistic world. Tengiz Abuladze's *Repentance* (*Pokaianie*, 1984, released in 1987) is an allegorical denunciation of Stalinism and an exploration of conformity and guilt. While providing a coda to the

official optimism of Soviet culture, late Stagnation films also testified to the creative energy that characterized these years. In spite of the negative designation given to the era by economists and historians, for cinema, Stagnation was a time of many successful productions which ranged from genre to art films. The 1970s saw the last mass success of cinema at the box office before television, video and socio-political unrest put Soviet cinema in a state of crisis.

Further Reading

First, Joshua. "From Spectatorship to 'Differentiated' Consumer: Film Audience Research in the Era of Developed Socialism (1965-1980)." *Kritika: Explorations in Russian and Eurasian History* 9, no. 2 (Spring 2008): 317-44.

Golovskoi, Valerii. *Mezhdu ottepel'iu i glasnost'iu: Kinematograf 70-kh.* Moscow: Materik, 2004.

Kaganovsky, Lilya. "The Cultural Logic of Late Socialism." *Studies in Russian and Soviet Cinema* 3, no. 2 (2009): 185-99.

Youngblood, Denise. *Russian War Films: On the Cinema Front, 1914-2005.* Lawrence: University Press of Kansas, 2007.

THE DIAMOND ARM

Brilliantovaia ruka

1969

100 minutes

Director: **Leonid Gaidai**

Screenplay: **Moris Slobodskoi, Iakov Kostiukovskii,
 Leonid Gaidai**

Cinematography: **Igor' Chernykh**

Art Design: **Feliks Iasiukevich**

Composer: **Aleksandr Zatsepin, lyrics: Leonid Derbenev**

Sound: **Evgeniia Indlina**

Production Company: **Mosfilm**

Cast: **Iurii Nikulin (Semen Gorbunkov), Nina Grebeshkova
 (Gorbunkov's wife), Andrei Mironov (The Count), Anatolii
 Papanov (The Mechanic), Stanislav Chekan (Mikhail
 Ivanovich), Nonna Mordiukova (House Manager Varvara
 Pliushch), Svetlana Svetlichnaia (Anna Sergeevna)**

When Leonid Gaidai's *Brilliantovaia ruka* (*The Diamond Arm*) was
released in 1969, it became a box office leader and drew almost 77
million viewers. Since then the film has acquired cult status and
is screened several times a year on Russian television. The film's
enduring success among Soviet and post-Soviet spectators alike
has puzzled many critics. The reasons for the film's success are,
on the one hand, the themes of paranoia and ubiquitous fear of
persecution, and, on the other, its emphasis on physical humor. In
the Soviet Union, viewers could easily identify with a protagonist
obsessed with fear, while physical humor and slapstick provided
a breath of fresh air in the ideologically repressive culture.

Gaidai (1923-1993) is one of the few Soviet directors whose films outlived his time and remained popular after the end of the Soviet Union. In the 1960s he made slapstick comedies that Russian viewers had not seen since the 1920s experiments of Lev Kuleshov. The short film *Pes Barbos i neobychnyi kross (Dog Barbos and the Unusual Race,* 1960), had launched the director's popularity overnight: it introduced the Soviet version of the Three Stooges — Georgii Vitsin, Iurii Nikulin and Evgenii Morgunov (in short, ViNiMor) — who captured Soviet mass audiences for decades. They were known by their telling nicknames: Vitsin as *Trus* ("Coward"), Nikulin as *Balbes* ("Dumb Ass") and Morgunov as *Byvalyi* ("the Experienced One"). Gaidai's subsequent comedies with ViNiMor, *Operatsiia Y i drugie prikliucheniia Shurika (Operation Y and Other Adventures of Shurik)* and *Kavkazskaia plennitsa, ili novye prikliucheniia Shurika (Kidnapping Caucasian Style, or New Adventures of Shurik),* were the biggest box office successes of 1965 and 1966 respectively. After the dizzying triumph of *The Diamond Arm*, Gaidai shot three screen adaptations based on the satirical works of Il'ia Il'f and Evgenii Petrov, Mikhail Bulgakov, and Mikhail Zoshchenko: *Dvenadtsat' stul'ev (Twelve Chairs,* 1971), *Ivan Vasil'evich meniaet professiiu (Ivan Vasil'evich Changes Profession,* 1973), and *Ne mozhet byt'! (It Can't Be!,* 1975) at Mosfilm's Experimental Film Unit. Although the films were well received, they were less popular than Gaidai's comedies of the 1960s. Like Gaidai's idol, Charlie Chaplin, who could never adjust to the advent of sound, Gaidai never adjusted to the narrative constraints of the genre of screen adaptation.

In the late 1980s and early 1990s Gaidai attempted to reinvent himself and return to the genre of slapstick comedy. In 1992 he released his last film, a US-Russian co-production, *Na Deribasovskoi khoroshaia pogoda, na Braiton-Bich opiat' idut dozhdi (The Weather is Good on Deribasovskaia, It's Raining Again on Brighton Beach,* 1992). While the film looks cheap (a testimony to the death of the Soviet film industry), it is a visionary picture, the testament of a great filmmaker to post-Soviet Russian directors. *Weather is Good* parodies the conventions of Hollywood cinema and anticipates Aleksandr Rogozhkin's anarchic comedies about the peculiarities of Russian

identity and Aleksei Balabanov's provocative exploitations of global genre models.

The Diamond Arm starts with the modest Soviet clerk Semen Semenovich Gorbunkov going on vacation abroad. In a country like the USSR of the 1960s—behind the Iron Curtain—a story about a trip abroad sufficed to make the film a blockbuster. Nevertheless, Gaidai complicated the travel story with the elements of a comedy of errors: when Semen arrives in Istanbul, he is mistaken for a diamond smuggler. The local accomplices of the smugglers take Semen for their Russian connection and put a fake cast on his arm, in which they hide diamonds to be brought into the Soviet Union. Intimidated by the foreign environment, Semen does not resist the medical procedure but reports the incident to the proper Soviet authorities. For the rest of the film, the Russian smugglers try to remove surreptitiously the cast from Semen's arm. In order to do this, they try to knock him out by hitting him on the head, by making him drunk, and by seducing him with a prostitute, but each time they fail to accomplish their goal. The attempt to remove the valuable cast turns, again and again, into a cascade of slapstick scenes.

By choosing physical comedy, Gaidai inadvertently made body politics central to his films. In Stalinist culture, the body controlled by the individual had virtually disappeared from the screen: the human body was important either as a synecdoche for the ideological message, or as a fragment of the communal, machine-like body. Human bodies participated in ritualistic reenactments of the Utopian project, such as parades and organized rallies accompanied by mass songs. Gaidai's comedy reinvented the individual human body in his slapstick routines. In his films he created a zone for the physical joke, where the body stopped being a representation of Soviet ideology and became a comic body *par excellence.* This comic body was anarchic and profane, thus defying the collective discipline of Soviet ideology.

While Semen's body contributes to many slapstick scenes, Gaidai also allows Semen's plaster cast arm to act independently as a comic hero. In a dream sequence, the plaster cast fights with the smuggler "Count" (Andrei Mironov, 1941-1987), as he attempts to

remove it from Semen's arm. Throughout the film, the arm-in-a-cast acts as Semen's sidekick, often beating Semen on the head when he says or does something outrageously stupid. Gaidai also introduces the entire gang of smugglers through close-ups of their hands at the beginning of the film in a scene that unfolds as a rhythmic sequence of shots depicting a comic skirmish among the smugglers' greedy hands passing, counting, hiding and stealing gold coins from each other. One of Gaidai's favorite comic devices is the close-up of a body part in an unusual function (a cast arm fighting on its own with a smuggler) or in an unusual garb (an arm in a cast decorated with jewels). While most directors favor the close-up of a performer's face, Gaidai—following his favorite filmmaker, Chaplin—deploys the close-up to fetishize a body part in order to produce maximal comic effect. But if in the first part of the film visual gags involve characters' arms, in the second part of the film, the gags engage the characters' lower bodies, above all, their legs, feet and—occasionally—rear ends. In the finale the protagonist appears with his leg in a cast, immobile, moving only with the assistance of a construction crane and surrounded by his family. The film's title, *The Diamond Arm*, epitomizes the body part as the film's fully-fledged character competing with human characters for the role of the film's protagonist.

The gender politics of body representation in Gaidai's films deserves special attention. Because of numerous images of semi-dressed females, it is tempting to assume that Gaidai's films embrace the scopic regime of classical Hollywood cinema, with the woman serving as "the signifier for the male other," to use Laura Mulvey's term. But as a Soviet filmmaker Gaidai remained beyond the gender politics of American cinema. In his films the female body exists not as a visualized commodity circulated within the visual market; instead, nudity is a female garb that serves to carnivalize the uniformed body characteristic of Stalinist culture. The individual body, male or female, is turned into a grotesque body when set against the militarized norm of the Soviet collective body.

While the female body turns comic when it becomes mobile and aggressive, the male body becomes comic when it loses mobility. The main cause for the paralysis of the male body is fear: when

Semen is abroad, he is afraid of walking around a foreign city alone without his group of Soviet tourists; when he returns to the Soviet border, he is worried about crossing without being guided by the Soviet police, and goes through the customs twice, awaiting special instructions for his life after his trip abroad. Moreover, Semen's will and body are completely paralyzed by his fear that either the smugglers will attack him or he will inadvertently do something adverse to the Soviet police's instructions.

In fact, Semen is unable to act upon his own free will. His trip abroad comes about only because his wife has decided to send him on a holiday rather than buy a fur coat. The film evokes a grotesque Gogolian relationship between man losing his animate nature and inanimate objects acquiring a (human) life of their own. The relationship between the inert, almost inanimate Semen and his wife's fur coat recalls the relationship between the human copying machine, Akakii Akakievich, and his animated overcoat in Gogol's eponymous Petersburg tale. Moreover, Semen moves only when instructed either by the smugglers or by the police. When both cops and robbers order him to do something at the same time, Semen gets confused and hears a strange, paranoid humming in his head that puts him in a state of mental and physical paralysis. Semen turns into a broken social machine, whose elasticity is impeded by contradictory social constraints imposed on him by others. His arm in a plaster cast provides a humorous synecdoche of Semen's social and psychological condition. The laughter evoked by this character originates from the viewers' sense of superiority over the protagonist's comatose body and mind, and is therefore liberating.

Semen's body is so grotesquely dehumanized that his part could only be performed by an actor with a talent for overtly physical comedy. Gaidai and his co-authors Iakov Kostiukovskii and Moris Slobodskoi wrote the screenplay with one actor in mind: the clown Iurii Nikulin (1921-1997). In his rendition of Semen Gorbunkov, Nikulin combined histrionic acting with a stone-face expression that turned out to be the most precise comic image of the "Soviet man." Nikulin's performance solidified the success of the character conceived by Gaidai, and Semen Semenovich has been imprinted in Russian popular consciousness as the comic icon of repressed

humanity, a carnivalistic inversion of the ideal Soviet man visualized by filmmakers in the Stalin era.

The focus on physical humor also determined the remaining cast list for *The Diamond Arm*. Apart from Nikulin, Gaidai invited Andrei Mironov and Anatolii Papanov (1922-1987), both actors at the Moscow Satire Theatre led by Vsevolod Meyerhold's disciple, Valentin Pluchek. For the part of the blonde he chose an actress capable of playing a seduction scene in a comically exaggerated style, whilst rejecting in the process actresses with excessive sex appeal. The Artistic Council of Mosfilm Studio eventually confirmed Svetlana Svetlichnaia (b. 1940) for the part, over the Estonian actress Eeve Kivi, who was deemed to be too "Western" and erotic.

Fear and danger, followed by an escape through a comic turn, are common components of slapstick comedies. While fear paralyzes the protagonist of *The Diamond Arm*, vodka liberates him. Hence, vodka as freedom agent becomes the key ingredient of the film's mise-en-scène. As an exemplary citizen, Semen does not drink at all before his trip abroad. When he tells the Soviet authorities how he inadvertently became involved in the smuggling scheme and offers his cooperation, they suggest that he might consider loosening up and drink at least a little bit to fight his paranoia. This therapeutic advice brings most unexpected results: every time he gets drunk Semen discovers a totally different self. Vodka liberates Semen from all his fears: he becomes agile, free and even aggressive, but only for the time of intoxication; as soon as he sobers up, Semen lapses back into his Soviet coma.

In preparing his films, Gaidai emulated the work of Charlie Chaplin. Before each new film project Gaidai would watch two Chaplin films: *City Lights* (1931) and *Modern Times* (1936). Surprisingly, Gaidai eschewed the most obvious route of social satire, which was common for Chaplin's features as well as for Soviet cinema of the time, *Daite zhalobnuiu knigu* (*Give Me a Complaints Book*, 1964), *Dobro pozhalovat', ili postoronnim vkhod vospreshchen* (*Welcome, or No Trespassing*, 1964), *Tridtsat' tri* (*33*, 1965), and preferred slapstick comedy instead. In the long run such a choice proved more destructive for the ideological foundation of Soviet film, because Gaidai's films of the 1960s deconstructed the fundamental

discursive mechanisms underlying Soviet cinema as an ideological institution. For example, in *The Diamond Arm* Gaidai parodied the role of sound in Soviet comedy, which—as ideological anchor for the visual image—had remained unchanged since the advent of talkies under Stalin. The film's opening credits are accompanied by the sound of mysterious steps of invisible characters, their hard breathing, and a terrifying scream. This blood-curdling soundtrack provides a backdrop for humorous intertitles, such as, "The film has been shot by a half-hidden camera." Gaidai parodies the guiding role of sound in Soviet film, where the word with its ideological weight always controlled the possible ambiguity of the cinematic image. In *The Diamond Arm,* the horrific scream misleads and confuses the viewer, who is not sure what to expect next: a mystery, a comedy or a horror film. The scream also becomes a red herring, a parody of Stalinist mass song that had conveyed the meaning of the narrative to the viewer.

Audiences were even confused about some of the film's narrative turns because of the sound. For example, one of the joking intertitles thanked private citizens and state organizations for providing genuine diamonds and gold for the film's shooting. Whenever viewers met with the film crew, one of the most common requests was to say who had provided the diamonds and gold. Soviet viewers were accustomed to transparent narratives with sound providing continuity of the narrative. The written word, such as credits or intertitles, was supposed to convey the absolute, *pravda*-like, truth. Gaidai's interplay between the soundtrack and the frame, therefore, led to the viewer's utter confusion. Thus, Gaidai not only parodies the function of sound as established in Stalinist cinema, but also returns to sound as "the element of montage" proposed by Eisenstein, Pudovkin and Aleksandrov in their famous "Statement on Sound."

Furthermore, Gaidai's films redefine the role of songs in Soviet film. Song had played a special role in Soviet cinema, because of its potential to convey a clear ideological message. Grigorii Aleksandrov's *Veselye rebiata (The Happy Guys,* 1934) established the canon of musical comedy, in which mass song provided the foundation of the ideological narrative. The musical comedies' positive heroes

were in charge of such songs that were later broadcast around the country and recommended for communal singing as an indispensable aural manifestation of Soviet identity. While Gaidai also made song a key part of his comedies, he had the villains, not the positive heroes, perform these songs. Villains could sing about prohibited topics and were free to express unconventional opinions. Their songs neither controlled the images nor did they convey an ideological message, but rather served as ironic parables of Soviet life. Gaidai thus replaced the mass song with the carnivalesque song, the musical and verbal structure of which was in tune with the clownish bodies of his characters.

In *The Diamond Arm* songs underscore the key aspects of modern individual agency, which the Soviet state denied its citizens: freedom of movement, freedom from fear, and last but not least bodily and sexual freedom. Mikhail Brashinskii notes that *The Diamond Arm* set the tone for permissible dissidence against the Soviet regime in the late 1960s with its Aesopian language, its parables with political underpinnings and its absurdist humor. The film's songs played a crucial role in articulating the perception of Soviet life as "normalized absurdity" that had replaced the Stalin-era atmosphere of total terror. The composer Aleksandr Zatsepin (b. 1926) and poet Leonid Derbenev (1931-1995) wrote three songs for *The Diamond Arm* dealing with the major taboos of Soviet paradise: mobility, individual freedom and the right to live without fear.

First is the song of the smuggler, "The Island of Bad Luck." It is a parody of "The Song of the Motherland," the unofficial Soviet anthem that glorified Stalin's new Constitution of 1936 and praised the USSR as a land of free and happy people. "The Song of the Motherland" had been composed by Isaak Dunaevskii for Aleksandrov's *Tsirk (The Circus,* 1936), hailing the vastness of Soviet Russia at the height of Stalin's purges, when Soviet citizens had lost all opportunity to travel abroad; "The Island of Bad Luck" talks of a land of savages, who work hard but cannot be happy on their island where there is no calendar, so that the savages lost track of time. The place of the song in the film's diegesis reinforces the allusion to Soviet Utopia: when the heroes leave the Soviet port *en route* to foreign lands, the Count offers to sing a "topical" song. The

Soviet Union, isolated behind the Iron Curtain, is portrayed in the lyrics as a dystopian island of bad luck separated from the rest of the world.

The second song, "The Song About Hares," is performed by Semen himself. It is the centrepiece of the film and deals with hares, the most cowardly creatures of Russian folklore, who learn nevertheless to overcome their fear. The episode that culminates in this song parodies the battle-council scene from the well-known Stalin-era film about the Civil War, *Chapaev* (1934); instead of Red Army commanders, gangsters surround a ludicrously detailed map of the restaurant and its restroom, where they hope to ambush Semen and remove his precious cast. Only one thing goes according to the smugglers' plan: Semen gets drunk. As his state of inebriation increases, so does his courage and, instead of a planned visit to the restroom, Semen gets on stage and starts singing about the cowardly hares who live in a dark and dangerous forest, but who get out of their hiding places every night and sing the same refrain: "We couldn't care less/We couldn't care less/Bolder we'll be/Than the lion, king of beasts." While this innocent song has no direct political agenda, the rejection of fear—even by a hare in a fairytale song performed by a drunkard—could be interpreted as an act of dissidence in a country built on terror. Indeed, when the cultural authorities previewed the film's final cut, they demanded a reworking of the song, firstly because it was too macabre for a comedy, and secondly because the personages, even though they were animals, should not proclaim complete indifference to authority. Ironically, the paranoid censors themselves voiced the anti-Soviet interpretation of the song. The song was nearly omitted from the film, but as often happened in Soviet cultural politics, it was vodka that resolved the conflict and cleared the clouds hanging over the controversial comedy. When the then Minister of Culture, Ekaterina Furtseva, heard the song, she became incensed at the filmmaker and yelled at her minions: "Who 'couldn't care less'? The working class couldn't care less?" Only after she was assured that the song was harmless because it was performed by a drunken clown, that is to say the drunken character played by the professional clown Iurii Nikulin, the song received Furtseva's imprimatur.

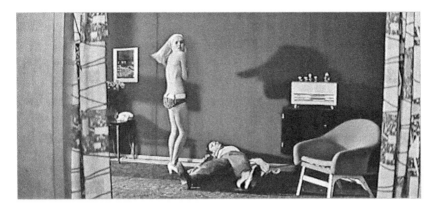

Fig. 88. Failure to Perform

The third song, "Help Me!," is a parodic tango about love in a tropical city performed by a passionate female voice. The aggressive blonde, Anna (Svetlana Svetlichnaia), plays the song on her tape recorder before getting undressed and launching her sexual offensive on Semen. On the one hand, the woman attacks and attempts to seduce Semen; on the other hand, Semen is a good Soviet citizen who knows that under no circumstances must he get entangled in extramarital sex. Instead of playing along with Anna, Semen crawls into a corner of the hotel room, hides his face behind his cast, and crouches before the topless temptress, petrified like a rabbit in front of a snake. Similar to the screams at the film's beginning, the tango serves as a red herring: a potentially erotic scene turns into a comic episode about Semen's fears and sexual repression (Fig. 88). The only erotic joke possible on the Soviet screen was the protagonist's failure to perform.

When the censorship committee, led by the chairman of the State Committee for Cinematography (Goskino), Aleksei Romanov, watched the final cut of the film, they suggested numerous changes: among them, to enhance the positive image of Soviet police, to improve Semen's role as an exemplary Soviet citizen and, obviously, to cut all nudity. Above all, the Committee was petrified and puzzled by the film's ending, comprised of documentary footage of a nuclear explosion. When the Committee gave Gaidai their comments, he said that he would not make any changes and would understand if the film were banned.

By the late 1960s Soviet cinema was no longer a purely ideological institution; instead it had become the most profitable branch of the Soviet culture industry. A ban would have hurt, above all, the Committee's annual report and the finance department at Mosfilm, required to account for expenditure. The censors gave Gaidai three days to consider what changes he would agree to make in order for the film to get released. Gaidai answered that he would remove the documentary footage of the nuclear explosion. The Committee, relieved to achieve at least one concession, immediately released the film after the "radioactive" ending had been cut.

The circumstances of the film's approval by Goskino reflect important shifts in cultural politics during this period. Firstly, financial concerns had become as important as ideological ones. Secondly, compromise was a more acceptable cultural strategy than an inflexible ideological stance for both cultural authorities and the artist. Finally, the inclusion of multiple endings was increasingly deployed in order to negotiate with the censors: the ending that satisfied the authorities usually differed from the ending that satisfied the artist. With the "unclear" ending, Gaidai had thrown out a red herring for the censors in order to save the rest of his film from massive changes.

Perhaps Mikhail Brashinskii found the key to Gaidai's art of comedy when he wrote that Gaidai did not create slapstick but sought its manifestations in Soviet life and transposed them onto the screen. By means of lighthearted physical comedy, Gaidai explored the changing role of the individual and the collective in Soviet culture after Stalin's death, and commented indirectly on the repressive nature of the Soviet regime. Serving as one of the few safety valves in a culture based primarily on terror, Gaidai's comedies have remained popular with post-Soviet viewers who rated his 1960s films still among as their favorites—forty years after they were released.

Alexander Prokhorov

References

Aleksandrov, G., S. Eisenstein and L. Pudovkin (1988 [1928]). "Statement on Sound," in R. Taylor and I. Christie, eds. *The Film Factory: Russian and Soviet Cinema in Documents 1896-1939, 234-5.* London and New York: Routledge.

Brashinskii, M. (2001). "Leonid Gaidai," in L. Arkus (ed.), *Noveishaia istoriia otechestvennogo kino 1986-2000, vol. 1.* St. Petersburg: Seans, 233-4.

Mulvey, L. (1975). "Visual Pleasure and Narrative Cinema," *Screen* 16, no. 3, 6-18.

Further Reading

Tsymbal, Evgenii. "Ot smeshnogo do velikogo. Vospominaniia o Leonide Gaidae." *Iskusstvo kino* 10 (2003): 109-27.

WHITE SUN OF THE DESERT

Beloe solntse pustyni

1969

85 minutes

Director: **Vladimir Motyl'**

Screenplay: **Valentin Ezhov, Rustam Ibragimbekov, Mark Zakharov**

Cinematography: **Eduard Rozovskii**

Art Design: **Valerii Kostrin, Berta Manevich**

Music: **Isaak Shvarts, Bulat Okudzhava**

Production Company: **Experimental Creative Unit, Mosfilm**

Cast: **Anatolii Kuznetsov (Sukhov), Pavel Luspekaev (Vereshchagin), Nikolai Godovikov (Petrukha), Spartak Mishulin (Said), Kakhi Kavsadze (Abdullah), Tat'iana Fedotova (Giul'chatai), Raisa Kurkina (Vereshchagin's wife), Galina Luchai (Katerina Matveevna, Sukhov's wife)**

The son of a Jewish-Polish father who perished in the Gulag and a mother who raised her son in exile, Vladimir Motyl' (1927-2010) studied acting at the Urals Theatre Institute and later received a degree in history from the Urals State University. He worked as a director in various theatres, as an assistant director at the Sverdlovsk Film Studio, and as artistic director of the *Ekran* film studio of Gosteleradio during the Soviet era. From 1993 he directed the independent studio *Arion* while also teaching at the Higher Courses for Scriptwriters and Directors in Moscow and several other film and television schools.

Motyl' directed relatively few films, and his relationship with Soviet film authorities was rocky. His most famous pictures, all

made before perestroika, deal with themes that were central to Soviet ideology but problematize them through mixed genres and ambiguous uses of cultural icons. For example, *Zhenia, Zhenechka and "Katiusha"* (1967), a film set during World War II, represented the war through a genre mix of comedy and drama. *The Star of Captivating Happiness* (*Zvezda plenitel'nogo schast'ia*, 1975) tells of the uprising of aristocrats and imperial officers (the Decembrists) in 1825 against the Russian monarchy. But instead of the usual Soviet glorification of the uprising as a precursor of the Bolshevik revolution, Motyl' focuses on the officers' wives, their suffering and heroism.

White Sun of the Desert was produced at the Experimental Creative Unit (ETO), a semi-independent company within the Mosfilm studio. Many late socialist Soviet blockbusters, including several of Leonid Gaidai's most popular comedies, appeared during the ten years of the ETO's existence. In the case of *White Sun of the Desert*, the comparatively modest intial attendance—34.5 million tickets sold upon release—understates the film's tremendous popularity with Soviet and post-Soviet audiences.

White Sun had a difficult production history. The original director, Andrei Konchalovsky (who later worked in Hollywood), left early in the process; several others were rejected because of disagreements over the film's genre: scriptwriters had in mind neither pure comedy nor pure action. Likewise, casting went through scores of actors for virtually all male roles, and searched for non-professionals to appear in the roles of Abdullah's wives and Sukhov's wife. The film's title went from "Basmachi" (rebels against Soviet rule) to "There and Back" to "Save the Harem!" to "The Desert" to the final version, reflecting shifts in the film's design. The Soviet cinema administration wanted the film to be an historical-revolutionary drama, with the requisite glorification of the Red Army and Soviet power and the vilification of Abdullah's fighters. For Motyl' and the studio, *White Sun* was first and foremost an adventure film, in which universally recognizable "good guys" defeat "bad guys," and where good and evil are not limited to ideological class definitions. After watching the finished print, censors demanded 27 revisions, which amounted to ruining the

film. The refusal to change the film would have resulted in its "shelving." What saved the picture, according to the filmmakers, was a bit of luck and Leonid Brezhnev's positive opinion. A western action film he was to watch at his summer house was misplaced and, in order not to anger the leader, his assistants screened *White Sun of the Desert*. Brezhnev liked the film, and this version was released.

White Sun is set during the Russian Civil War, with the Red Army fighting counter-revolutionary and nationalist forces in Turkestan (Central Asia). The establishment of Soviet power in the southern territories had been the subject of many Soviet films since the 1920s. Many of them, including Dziga Vertov's *Three Songs of Lenin* (*Tri pesni o Lenine*, 1934), focus on the liberation of local women from the dual oppression of rich feudal masters and patriarchal power. Freeing "women of the East" from harems and re-educating them to be Soviet citizens was one of the most tangible—and advertised—achievements of Soviet Russia. This subject, as well as the Civil War itself, thus demanded a serious and politically correct treatment, which meant adhering to the conventions of Socialist Realism.

On the surface, all elements of Soviet Civil War mythology are present in Motyl's film: the heroic Red Army soldier Sukhov fights the evil warlord Abdullah and his ruthless army; "women of the East" are liberated from their husband-master and from societal prejudice; Russians and Turkmens fight side by side to modernize desert territories; and revolutionary violence and sacrifice result in the victory of the new order. Yet the Civil War setting serves simply as a historical backdrop for the genre elements that are central to the film's meaning and reception. *White Sun* is an adventure film, more specifically the Soviet version of a western, which has become known as an "eastern." Just like their American counterparts, Soviet "easterns" portrayed life on the frontier between "wilderness" and "civilization" and the establishment of a new order via violence and a clash of values. Most of them were set during the Civil War, fought by the Reds—the supporters of the Soviet power—against the Whites, who defended imperial Russia. The tradition of Soviet "easterns" dates back to the 1920s (Ivan Perestiani's *Red Imps, Krasnye*

d'iavoliata, 1923) and 1930s (Georgii and Sergei Vasil'ev's *Chapaev*, 1934). In 1967 *The Elusive Avengers* (*Neulovimye mstiteli*), featuring the adventures of a group of teenagers fighting for Soviet power during the Civil War, captured the imagination of Soviet audiences via chases, violence, humor and plenty of good music. In *White Sun of the Desert* the Civil War setting similarly provides a legitimate, ideologically impeccable frame for entertainment: violent clashes between the Reds and the Whites (in the eastern version), oriental beauties, humorous dialogue, spectacular vistas and a song "Your Majesty, Lady Luck" by one of the famous guitar poets, Bulat Okudzhava, which became a hit in its own right.

White Sun appropriated many conventions of the American western and its European version, the spaghetti western. Like John Wayne and Clint Eastwood's characters, Sukhov is a loner and a man of few words. He is entirely self-reliant and is always the last man standing; and he has a local sidekick, Said, who, like the Lone Ranger's Tonto, conforms to the heroic yet "orientalist" (exotic) vision of Asia. Being a Soviet character—and a Red Army soldier— Sukhov is not exactly a gunslinger, but he masterfully handles a gun, a machine gun and dynamite. Although *White Sun* appeared at the time when the cinematic western abandoned the idealized portrayal of frontier life, Sukhov is a straight shooter and not an anti-hero. Because the Civil war mythology was a fundamental part of Soviet ideology, *White Sun* retains the moral contrast and ideological clarity typical of the classical western which, like many other film genres, made use of melodramatic elements: the villainous Abdullah terrorizes his wives and ruthlessly kills the innocent young couple. As the Soviet revolutionary utopia was waning, *White Sun* infused the Civil War narrative with western mythology and conventions. The result is the ultimate masculine fantasy in an ideologically impeccable package.

The character of Sukhov also has many features of the Russian folk hero, another reason for the film's enduring popularity. He is strong, invincible and quick-witted; he appears from nowhere and disappears into the distance; he speaks little and in one-liners. His friends and foes are also creatures of folk imagination: Said is his magic helper, always by Sukhov's side when he is most needed;

Vereshchagin, the grey-haired customs official, is an epic warrior who comes out of retirement with an arsenal of weapons; Adbullah and his army are the dark forces, worthy foes for Sukhov's prowess. Sukhov's revolutionary ideals are mixed in equal proportion with the protagonist's ingenuity and sheer luck. As befits a folk tale, the plot premise—accompanying a harem through the desert—is simple and characters are somewhat flat, with little psychological development but plenty of opportunities for action.

This combination of Soviet ideology, commercial genre conventions and folk tale motifs accounts for the film's eclectic style and serio-comic tone. The film opens with Sukhov's dream about his wife and the Russian countryside. The wife's open, round face and the bright colors of the sequence—the green of Russian nature and the red of the woman's dress and head scarf—contrast with the white desert, Asian women in black burkas and the washed-out uniforms of Red Army soldiers. The dream sequences recur several times in the film, incorporating Sukhov's stranger-than-dream reality of being an unwilling polygamist. Sukhov's first encounter is with Said, who is buried alive in the sand (we never learn why or by whom) and who is obsessed with avenging his father's death by killing Dzhavdet (who never appears in the film). Russia is then represented by a peasant woman, birch trees and fields, pails of water and a samovar; the harem with Oriental beauties, the desert, the old fortress and brutal but courageous horsemen epitomize Central Asia.

If both the "Russian" and the "Asian" worlds are represented through their most stereotypical cultural signs, what about the "Soviet" world? In its most concentrated form, Soviet ideology appears in Sukhov's attempts to re-educate Abdullah's wives. Yet by the late 1960s both the idea of re-education and the revolutionary socialist utopia have lost their urgency and turned into familiar tropes that could be used dramatically or comically. In *White Sun of the Desert* it is the latter, and this plotline provided plenty of visual and verbal jokes that have been circulating in Russia independently from the film. Some of them appear in the film as slogans: "First Dormitory of Free Women of the East" (*Pervoe obshchezhitie svobodnykh zhenshchin Vostoka*) and "Down with Prejudice. Woman is

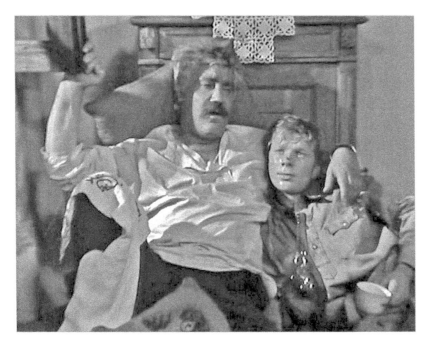

Fig. 89. Vereshchagin and Petrukha

Human Too!" (*Doloi predrassudki. Zhenshchina—ona tozhe chelovek!*).[1]
Others come from Sukhov's attempts to explain ideological subtleties
to the women who stubbornly consider him their "new husband":
"Comrade women! You will work freely, and each will have a sep-
arate husband." The dormitory is located in "The Museum of the
Red (Socialist) East." One might argue that it is precisely this ironic
reading of the film as a museum of utopian revolutionary ideas,
slogans and tropes—which in late Soviet culture were viewed with

[1] The latter slogan is an ironic reference to an episode in Fedor Dostoevsky's
 Crime and Punishment, in which Razumikhin offers Raskol'nikov an
 opportunity to earn some money by translating a German brochure, "Are
 Women Human?" While Razumikhin ("the reasonable one") is not averse
 to making money, he mocks the treatise, which methodically and positively
 "proves that women are indeed human." *White Sun's* use of this reference
 is both serious (at the center of the film is the liberation of the "Woman of
 the East") and profoundly ironic: the women challenge Sukhov's "liberation
 speeches," while the film's style pokes fun at the rationality of the socialist
 project.

skepticism if not considered dead altogether—that turned a rather simple film into a cult picture whose dialogue several generations of Russians can reproduce verbatim.

Another way to approach the film is through the prism of heroic masculinity in its socialist version. One of the most important ideas of socialist ideology was the passing of the baton from fathers ("mentors") to sons ("disciples") who abandon their spontaneous impulses and mature into conscious fighters for socialism. This ritual is problematized in the film because both Petrukha and Giul'chatai, the two youngest and most spontaneous characters in the film, are killed without learning much of anything. This is especially remarkable because the film brims with potential father/mentor figures: Sukhov, Abdullah, Vereshchagin, village elders and the old museum curator. Petrukha passes from Sukhov to Vereshchagin to Abdullah, learning to fight, to drink (Fig. 89) and to die. While these "skills" are ironic representations of a "real man," the paradigm hardly corresponds to the Soviet "road to consciousness."

The character of Vereshchagin is a remarkable departure from a socialist realist narrative set in the early years of Soviet power. As an old customs officer protecting the borders on the Caspian Sea, he represents the Russian empire, precisely the enemy that Sukhov and the Red Army are fighting. Yet, in the film, he is not only a positive character whose death at the end is truly tragic, but also the most rounded and complex character.[2] As he performs the hit song "Your Majesty, Lady Luck," the camera pans across pictures of his youth and marriage and his heroic service to Russia. We learn that the chaos of the Revolution forced him into retirement and that he drowns his sense of uselessness in "decadence"—exchanging his uniform for peacocks and eating spoonfuls of black caviar.[3] He loves

[2] The character bears the name of a nineteenth-century Russian artist, Vasilii Vereshchagin, who became famous for his epic battlefield paintings. He participated in several campaigns of the Russian army, including colonial wars in Central Asia and the Far East. In a way, the heroic and tragic fate of Motyl's character mirrors the artist's complex art which captured both imperial military glory and the horrors of war.

[3] While Vereshchagin follows this diet unwillingly (his wife forces it on him

and pities his wife, yet joins Sukhov to fight Abdullah. The reasons for this sacrifice are many, each satisfying various film agendas. For the film censors, his heroic death serves as a proof of the truth behind revolutionary ideas. On the surface level of the plot, he comes to avenge the death of Petrukha, his adopted son. But even more importantly, his character signals the desire to re-establish continuity between imperial and Soviet Russia via the idea of state service. Vereshchagin's line "My heart bleeds for the Great Power" (*Za derzhavu obidno*) blurs the boundaries between the Soviet and Russian state; it is, not surprisingly, one of the most quoted lines in today's Russia which attempts to restore its image as the Great Power via nationalist rhetoric.

The film acquired its second life on Soviet television in the 1970s, and continues to be broadcast annually on various channels in post-Soviet Russia. Soviet and Russian astronauts consider it a "good luck" film, required viewing before every space flight. Many lines from the film now exist independently from the film as a shared layer of cultural allusions, many of them with not quite politically correct associations: for example, "The Orient is a delicate matter" (*Vostok—delo tonkoe*) or "Giul'chatai, open your sweet face" (*Giul'chatai, otkroi lichiko*).

Elena Prokhorova

because she cannot find flour to bake bread in the war-torn region), his frustrated "Caviar again?!" sounded ironic to late Soviet audiences.

WE HAVE BEEN SITTING HERE FOR A LONG TIME

By the late 1960s, the Romantic mythology of the Civil War in Central Asia was essentially bankrupt. As part of this discourse, *White Sun of the Desert* interrogates the Soviet colonial project of economic hegemony and civilizing/reeducating the native population, and constitutes it as *failed*.[1] The Islamic Other is presented via comic stereotypes (congruent with the genre of the film), but also with a certain sympathetic understanding of the culture and history of the region. The three muslim elders in *White Sun* (Fig. 90) provide comic relief both by their motionless presence as well as by its opposite—the turbans that fly off when Sukhov explodes a stick of dynamite—but the image of the silent, inscrutable old men, which recurs five times at various points in the film, also defines this world as repetition both devoid of change and impervious to external influences. One elder speaks their only words: "We have been sitting here for a long time."[2]

Distinguished by his quiet humming, even when buried up to his neck in sand, Said is the imperturbable and wise helper to Sukhov: "Don't go to Pedzhent," he counsels, "Abdullah will come there." Instead of gratitude to Sukhov for rescuing him from slow death in the desert, he complains, "There will be no peace for me while Dzhavdet is alive. Why did you dig me up?" Sukhov understands the code by which Said lives and leaves him a dagger. Said returns good for good, repeatedly returning to help Sukhov out of tight spots, but in the end rides away to carry out the revenge ethic of the

[1] See Emily Hillhouse, "White Sun of the Desert," 222-23, in Further Reading.

[2] The trio of elders is complemented at one point by a fourth lying on a box of dynamite—both necessary for the comedic plot and possibly a reference to the incendiary potential of the region.

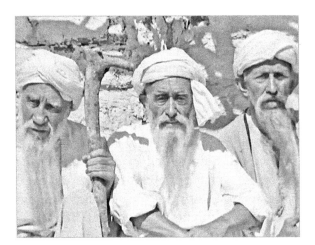

Fig. 90.
The Three Elders

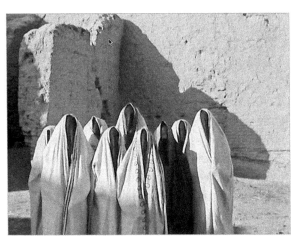

Fig. 91.
Abdullah's Wives

culture. He has not become enlightened by his contact with Sukhov, the representative of Soviet power, and remains unchanged.

The character of Black Abdullah is not simply adapted from the cigar-chomping villains of spaghetti westerns. Early on, Said asserts that "Dzhavdet is a coward; Abdullah is a warrior (*voin*)." Later Abdullah explains the trajectory of his life, both as rebel and as bandit: "Before his death my father said, 'Abdullah, I've lived my life as a poor man and I want God to send you an expensive robe and a beautiful harness for your horse. I waited a long time. Then God said, 'Get on your horse and take what you want yourself, if you're brave and strong'." Abdullah, who wears military garb, is

Sukhov's opposite and erstwhile equal. He tells Vereshchagin, "I've gotten old and lazy, but do you remember what I used to be like?" Abdullah is a Basmach fighter for an independent Turkestani state, driven to banditry after the defeat of the movement by the Red Army, and now forced to escape the country by sea. Villain that he is, Abdullah is also a victim of Soviet imperialism.

Abdullah's nine wives are framed as "no one"—their elided subjectivity represented by black holes within the robes covering their bodies (Fig. 91). Sukhov attempts to enlighten them by means of a safe dormitory, uplifting slogans and the singing of Chaliapin— a scene of ultimate culture clash, but to no avail. When he gives Giul'chatai responsibility for keeping order among the wives, she immediately declares herself his "favorite wife" and later attempts a comic seduction. In the end, Giul'chatai dies because, according to her cultural code, she cannot disobey the call of Abdullah, her husband and master.[3] The Soviet utopian project has failed, for the women remain unchanged.

White Sun plays with the comic love triangle of Sukhov, his wife Katerina Matveevna and Abdullah's wives. Sukhov is devoted to his wife, but is also tempted by the wives, his "accommodating and kindly new comrades," as he calls them in the mental letters to Katerina Matveevna. After Giul'chatai's comment on the division of labor in polygamy, Sukhov imagines himself back in Russia, surrounded by the wives, engaged in domestic tasks and wearing kitschy Russian folk costume. In the film's metanarrative, which interrogates Soviet colonial power in Central Asia, Sukhov's dream is a metaphor for how colonies enrich the mother country. The prominence of oil storage tanks in the mise-en-scène is not accidental (one even encloses the characters), for Russia had coveted Central Asian natural resources from the time of the tsarist empire.

During the Civil War the Soviets successfully occupied Turkestan and undertook a westernizing initiative. By the sixties

[3] Petrukha dies because he breaks the Islamic code by asking Giul'chatai to show her " little face." He is punished instead by a view of Abdullah's craggy countenance and by death.

Russians had been in Central Asia for many years; *White Sun* asks whether they should be there and even *want* to be there. At the beginning of the film Sukhov, who has been prevented from going home, explodes in anger: "Am I supposed to wander around this desert for my whole life?" Said quietly looks down and says nothing, for the desert is his home. In the end Sukhov does not betray Russia/Katerina Matveevna and heads home because he does not belong in the East. Although he has saved the lives of eight wives, like Said, they remain unchanged and true to the old ways, and a high price has been paid for the failed Soviet colonial project: Petrukha, Giul'chatai and Lebedev, the museum curator, are dead, Vereshchagin is dead, and his distraught wife is left alone to face an uncertain and difficult future.

Rimgaila Salys

FURTHER READING

Ezhov, Valentin. *Beloe solntse pustyni*, 69-112. Ekaterinburg: Lad, 1994.

Gillespie, David C. "The Sounds of Music: Soundtrack and Song in Soviet Film." *Slavic Review* 62, no. 3 (Fall 2003): 473-90.

Hillhouse, Emily. "White Sun of the Desert." In *Directory of World Cinema: Russia,* edited by Birgit Beumers, 221-23. Bristol, UK: Intellect, 2010.

Ivanov, Mikhail. "30 Years Under the *White Sun.*" *Russian Life* (April/May 1999): 17-23, 64.

Kuznetsova, Marina. "Beloe solntse pustyni." In *Rossiiskii illiuzion*, edited by Lev Parfenov, 459-64. Moscow: Materik, 2003.

Prokhorova, Elena. "Mending the Rupture: The War Trope and the Return of the Imperial Father in 1970s Cinema." In *Cinepaternity: Fathers and Sons in Soviet and Post-Soviet Film*, edited by Helena Goscilo and Yana Hashamova, 51-69. Bloomington: Indiana University Press, 2010.

Youngblood, Denise. *On the Cinema Front: Russian War Films, 1914-2005.* Lawrence: University Press of Kansas, 2007.

Zorkaia, Neia. "*Beloe solntse pustyni*—reiting zritelei." In *Krutitsia, vertitsia shar goluboi: Desiat' shedevrov sovetskogo kino*, 173-84. Moskva: Znanie, 1998.

SOLARIS

Soliaris

1972

169 minutes

Director: **Andrei Tarkovsky**

Screenplay: **Fridrikh Gorenshtein, Andrei Tarkovsky, based on the novel** Solaris **by Stanisław Lem**

Cinematography: **Vadim Iusov**

Art Design: **Mikhail Romadin**

Sound: **Semen Litvinov**

Production Company: **Mosfilm, Moscow**

Cast: **Donatas Banionas (Kris Kelvin), Natal'ia Bondarchuk (Hari), Vladislav Dvorzhetskii (Berton), Nikolai Grin'ko (father), Jüri Järvet (Snaut), Anatolii Solonitsyn (Sartorius)**

Andrei Tarkovsky was born on 4 April 1932 in the town of Iur'evets on the Volga River. His father, Arsenii Tarkovsky, was a respected poet who left his family soon after Andrei's birth; the director grew up in a household consisting of his mother Mariia Vishniakova and sister Marina. He began his university studies pursuing oriental languages, but soon left. After a term spent on a geological expedition, he enrolled in 1955 at VGIK, the main Soviet cinema institute, in Moscow, with the intention of becoming a film director. After assisting Marlen Khutsiev on the film *The Two Fedors* (*Dva Fedora*) in 1956, Tarkovsky and Aleksandr Gordon co-directed the short film *The Killers* (*Ubiitsy*) in 1956, based on Ernest Hemingway's short story and featuring Vasilii Shukshin. Tarkovsky's made-for-television movie *There Will Be No Leave Today* (*Segodnia uvol'neniia ne budet*, 1958) became a staple of TV celebrations of World War II.

Tarkovsky's first independent film, *Steamroller and Violin* (*Katok i skripka*, 1961), was a quaint cinematic poem about the friendship between young musician Sasha and steamroller driver Sergei, who saves the boy and his violin from the bullies of post-war Moscow. After joining Mosfilm, Tarkovsky's first assignment was *Ivan's Childhood* (*Ivanovo detstvo*, 1962), based on a story by Vladimir Bogomolov about a young child scout during World War II. *Ivan's Childhood* attracted broad praise, winning the Golden Lion at the Venice Film Festival, and instigated international discussion.

Tarkovsky ran into trouble with *Andrei Rublëv*, a biopic of medieval Russia's most famous icon painter. Tarkovsky's first two cuts (the first entitled *The Passion according to Andrei*) were rejected by Goskino. The stalemate persisted until 1969, when it was sold to a European distributor and shown at the Cannes Film Festival, out of official competition, to great acclaim. The Soviet authorities finally allowed its domestic release in 1971 after Tarkovsky faced down calls for further cuts. Thereafter Tarkovsky and the State Cinema Council resigned themselves to an uneasy accommodation which persisted right up to 1982.

Tarkovsky's next film, *Solaris* (1972), was based on the sci-fi novel by Stanisław Lem concerning a team of scientists studying a distant planet which mysteriously projects humans' thoughts as material forms. The success of *Solaris* at Cannes and at the box office confirmed Tarkovsky as a major Soviet director and thorn in the side of the authorities. *Mirror* (*Zerkalo*, 1975), an autobiographical film originally entitled *Confession*, was tolerated by the authorities as a vanity project. Despite some friction over its complex narrative structure, *Mirror* was approved, its harmfulness having been curbed by limited distribution. The quest film *Stalker* (1979), based on a screenplay by Arkadii and Boris Strugatskii, showed Tarkovsky continuing to rethink the sci-fi genre as a framework for investigating human beings' encounters (intellectual, sensorial, metaphysical) with their world.

With a commission from the Italian TV network RAI, Tarkovsky traveled to Italy in 1980 and 1982 to shoot *Tempo di Viaggio* (*Voyage in Time*) and *Nostalgia* as joint Italian-Soviet productions with

screenwriter Tonino Guerra. *Tempo di Viaggio* documents Tarkovsky and Guerra's search for locations for *Nostalgia* (1983), in which a Russian poet in Italy resolves his existential crisis with the ideas of madman Domenico, with whom he seems to merge. Unhappy with the attitude of the Soviet film authorities, in part over *Nostalgia's* presentation at Cannes, in July 1984 Tarkovsky announced he would not return to the USSR.

In the extended fallow periods between films, Tarkovsky contributed to numerous film projects by other directors and pursued projects outside of film. In 1965 Tarkovsky produced William Faulkner's "Turnabout" for Soviet radio, and in 1974-1975 he staged *Hamlet* in Moscow. Tarkovsky staged Mussorgsky's *Boris Godunov* at Covent Garden in 1984, before shooting *Sacrifice* (*Offret*, 1986) in Sweden. A Bergmanesque film, *Sacrifice* presents the crisis of Alexander, an aging professor of aesthetics, who makes a series of wagers with God in order to avert nuclear war. The film ends with Alexander burning down his cherished house, in one of Tarkovsky's longest and most elaborate long takes.

By the time Tarkovsky completed the shoot of *Sacrifice* he had been diagnosed with lung cancer. He died in a Paris clinic on 29 December 1986.

Solaris, Tarkovsky's third feature film, was partly conceived and has often been perceived as the director's attempt to tailor his idiosyncratic and uncompromising style of art cinema to the ideological and commercial demands of the Soviet film industry after the end of Nikita Khrushchev's Thaw. *Solaris* was proposed in 1968, at a low point in Tarkovsky's career. His previous film, *Andrei Rublëv*, had been planned and approved during the Thaw, but by its completion in 1966 this period of cultural liberalization had ended and the film was placed "on the shelf." After substantial re-editing, *Andrei Rublëv* received its debut at the Cannes Film Festival in 1969, where it won the FIPRESCI prize; it was shown on limited release in the USSR only in 1971. Tarkovsky was so exhausted by the wrangling over *Andrei Rublëv* that for his next film he chose the relatively safe route of adapting the popular science-fiction novel *Solaris* by Soviet-bloc author Stanisław Lem, which had already been adapted

for Soviet television by Boris Nirenburg in 1968 and projected a futuristic image of socialist society. Critics have frequently viewed the film as a compromise, and Tarkovsky later claimed it was his least favorite film because "the science fiction element [...] was too prominent and became a distraction."[1] Nonetheless, it has proven to be popular and influential. Alone among Tarkovsky's films, it was remade for American audiences by Steven Soderbergh in 2003, with George Clooney in the role of Kris Kelvin.

Tarkovsky's original proposal to Mosfilm from 8 October 1968 began with an acknowledgement of the popularity of science fiction and the "entertaining plot" of Lem's novel, which Tarkovsky found "tense, surprising, full of unexpected peripeteia and suspenseful collisions." Tarkovsky concluded with assurances of the film's commercial success.[2] He also stressed the potential usefulness of the film for a space-age society: the film prepares "us" for the encounter with "unusual forms of the existence of matter" and presents "an ideal of moral purity that our descendents will keep in order to achieve victory on the path of perfecting reason, honor and morality."[3] The finished film was subjected to detailed critique by the authorities at the studio and the government cinema agency Goskino, resulting in the addition of an introductory explanatory text (subsequently omitted) and the deletion of some scenes; however, this treatment was light compared to *Andrei Rublëv* and *Mirror*. Unlike those films, *Solaris* clearly fit an existing cultural discourse, namely the Thaw-era polemics regarding the moral limits of technological progress. This dispute had been at the heart of *Nine Days of a Single Year* (*Deviat' dnei odnogo goda*, 1962) by Tarkovsky's mentor Mikhail Romm, in which a nuclear physicist is exposed to radiation in the course of an experiment. The official description of *Solaris* concludes: "In this film a suspenseful and entertaining plot is organically connected to an acute formulation of serious moral questions that may arise—and are already arising—in connection

[1] Andrey Tarkovsky, *Sculpting in Time*,199, in Further Reading.

[2] D. A. Salynskii, 301; cf. 317, in Further Reading.

[3] Ibid., 301.

Fig. 92. Chris Kelvin

to the rapid development of science and technology in our century, and in connection to man's entrance into the cosmic expanses."[4] The film was an international success, garnering the FIPRESCI and Grand Jury prizes at Cannes and remaining perhaps Tarkovsky's most accessible film after his debut *Ivan's Childhood* (1962), though until the late 1980s it circulated in the West mostly in shortened cuts that made the narrative even more difficult to understand.[5]

The story follows the psychologist Kris Kelvin as he prepares to fly to a space station in orbit around the planet Solaris. For years scientists and cosmonauts have tried to penetrate the secret of this nebulous planet; an older cosmonaut Berton shows Kelvin a film of his testimony on Solaris to a skeptical board of inquiry many years earlier. He had shot a film of the fantastic shapes he observed, including the giant simulacrum of a young child, but when developed the film showed only clouds. Arriving at the space station, Kelvin finds all three of its residents in crisis: Snaut and Sartorius have mysterious visitors, while Gibarian has just committed suicide, leaving Kelvin an enigmatic videotaped letter. Soon Kelvin encounters his own late wife, Hari, who years before

[4] Ibid., 261.

[5] Jonathan Rosenbaum, 276-77, in Further Reading.

committed suicide in despair. He tries to get rid of this ghost from his past by sending her (it?) into space, but she quickly reappears. The rest of the film chronicles Kelvin's struggle to choose between Hari's semblance and his professional responsibilities, perhaps even his sanity. In the end Hari chooses self-destruction, thereby showing the impossibility of changing the past; however the finale leaves us unsure whether Kelvin has returned to earth as a loyal subject or has remained on Solaris to continue to slake his conscience (Fig. 92). Nariman Skakov argues that the finale reverses the film's initial proposition, going from "the external impossibility of contact to the internal actuality of contact."[6] Vida Johnson and Graham Petrie contend that it confirms the two sides of Tarkovsky, "the realist and the visionary": "scrupulous respect for even the humblest aspects of the natural world [and] taking that world as its basis but transforming it into something no longer 'real' yet containing its own inner, spiritual truth."[7]

As such responses indicate, Tarkovsky's engagement with Lem's novel was far from purely opportunistic. (In fact, his interest probably predated the controversies over *Andrei Rublëv*.) Tarkovsky was clear in his public statements that he had no intention of satisfying viewer expectations with a genre film:

> For me there is no difference between a science-fiction, an historical and a contemporary film. As long as it is directed by an artist, then the problems that concern the director are the legacy of the current day, whatever time the plot might occur in. The most realistic plot is always invented, is always fantasy, while the ideas and thoughts of a true artist are always topical and current, they are always reality, whatever unlikely or supernatural form these ideas might take. After all, true realism is not the copying of any particular circumstances of life, but the unfolding of phenomena, of their psychological or philosophical nature. [...] This is why I dream of adapting Stanislaw Lem's novel *Solaris*; I am attracted not by its

[6] Nariman Skakov, 97, in Further Reading.

[7] Vida T. Johnson and Graham Petrie, 110, in Further Reading.

entertaining and provocative plot, but by the profound philosophical idea of the knowability of the world, which is conveyed in a precise psychological conception. [...] I do not yet see the future film in its entirety, but I would not choose to make it an entertaining science-fiction or adventure film. It appears that I should have to reject the science-fiction trappings and call the spectator's attention to the psychology of a protagonist who has encountered his past. I am afraid that this is impossible, but ideally I imagine the action taking place in a single room with each character seeing his past— even if it's unappealing—as reality, and not as some dusty junk in a hold-all of memory. The task of such a film is to show people that even in everyday life it is necessary to think in a new way and not to settle with customary categories that have frozen into prejudices.[8]

Solaris, then, is a study in authenticity. It asks directly: who is this person with whom I share space? Kelvin has at some point in the past evaded this question, causing his lover Hari to commit suicide. However Kelvin remains trapped by his responsibility before her. Thus a film about venturing into the future of the cosmos finds itself lashed to the earth and to the memory of earthly life. In his early comments Tarkovsky professed himself satisfied that the completed film fulfilled his expectations, writing in his diary on 16 February 1972: "I have finished my *Solaris*. It's more harmonious than *Rublyov*, more purposeful, less cryptic. More graceful, more harmonious."[9] Thus, despite the evidence of aesthetic and ideological compromise, *Solaris* is wholly consistent with the aesthetics Tarkovsky had developed in *Ivan's Childhood* and *Andrei Rublëv* and leads quite logically to *Mirror* and *Stalker*. This aesthetics was marked by long takes, often with a mobile camera, and a loose narrative structure punctuated with meditative conversations. In a review of *Solaris*

8 Andrei Tarkovskii, "Dostoianie segodniashnego dnia," *Sovetskii ekran*, no. 8, 1967.

9 Andrey Tarkovsky, *Time within Time: The Diaries 1970-1986*, 53, in Further Reading.

Jonathan Rosenbaum wrote that "as a passionate, critical thinker about the world we live in, and as a poetic filmmaker whose images and sounds have the ring of truth, I find it impossible to dismiss [Tarkovsky]" despite the latter's "pretentious, egocentric and downright offensive" ideas and "Neanderthal" views on gender.[10] *Solaris* confirmed Tarkovsky's reputation as an *auteur* whose films comprise a stylistically and thematically coherent body of work.

It is not surprising, then, that the differences between Tarkovsky's adaptation and Stanisław Lem's novel immediately became the central topic in critical responses to the film (even of subsequent responses to the novel as well). In many respects Gorenshtein and Tarkovsky's screenplay hews surprisingly close to Lem's text. Many seemingly Tarkovskian features and details are taken directly from Lem's novel, including the odd illumination caused by the blue and red suns' rising and setting, the way this light illumines the velvety fuzz on Hari's face, and even the paper strips on the ventilators, which replicate the familiar rustle of leaves on earth. In this sense the novel was a good match for Tarkovsky's aesthetic sensibility.[11] However when Lem traveled to Moscow in 1969, he expressed his strenuous disapproval of the screenplay. He disagreed with the invention of a second female character, Maria, for whose sake Kelvin had abandoned his wife Hari and to whom he would return, chastened and renewed, at the end of the film; after some argument Tarkovsky relinquished the character. More serious was Lem's consternation concerning the addition of an extended prologue on earth. Along with other changes to Kelvin's character, the prologue seemed to Lem to betray the "point" of his novel, which was that, since in our cosmic wanderings we may be confronted with a fundamentally different kind of intelligence, we must pursue exploration of the unknown with an open mind. He later claimed that, by stressing Kelvin's responsibility to his life on

10 Jonathan Rosenbaum, 282.

11 Tarkovsky, *Sculpting in Time*, 74.

earth, Tarkovsky "did not make *Solaris*; what he made was *Crime and Punishment*."[12]

If for Lem the unknown is elsewhere and in the future, for Tarkovsky the unknown is in the here and now, perhaps at the very heart of the human psyche. As Slavoj Žižek comments, "Communication with the Solaris-Thing [...] fails not because Solaris is too alien, the harbinger of an intellect infinitely surpassing our limited abilities, playing some perverse games with us whose rationale remains forever outside our grasp, but because it brings us too close to what in ourselves must remain at a distance."[13] For Žižek, a psychoanalytical theorist in the tradition of Jacques Lacan, what Tarkovsky's protagonists discover is their own obscure desire. For his part, Tarkovsky resisted attempts to reduce the film to any "point" whatsoever, emphasizing instead the way the film renewed viewers' sensorial experience of the world. If there is "philosophy" in the film, he said, it is "the impossibility of re-playing what you once experienced in life. You would play it all again the same way."[14]

A similar pattern emerges in Tarkovsky's comments regarding Stanley Kubrick's *2001: A Space Odyssey*, which was released during the build-up to Tarkovsky's shoot and was an obvious comparison for many viewers and critics. Tarkovsky's stated response to Kubrick's film was negative; he called it "a spectral sterile atmosphere, like a museum of technological achievements."[15] The contrast helped Tarkovsky to formulate anew his distinct understanding of cinematic representation: "Of course, the action of *Solaris* occurs in a unique and unfamiliar atmosphere," he explained. "Our task is to concretize this uniqueness in its sensuous external features, so that it be material and tangible, without anything ephemeral, uncertain, special or intentionally fantastic; so that the screen manifests the

12 Stanisław Bereś, *Rozmowy za Stanisławem Lemem* (Krakow: Wydawnictwo literackie, 1987), 134.

13 Slavoj Žižek, 236, in Further Reading.

14 D. A. Salynskii, 332.

15 Tarkovskii, "Zachem proshloe vstrechaetsia s budushchim?," 101.

'flesh' and the texture of the atmosphere [*sreda*]."[16] Kubrick's film, by contrast, was merely "fake."[17]

The lack of distinction between genuine and virtual orders of reality is central to the film. The planet Solaris is an alien flow that congeals into shapes (very often human ones, like Hari) without achieving material presence. Can humanity free itself from the relentless flow of nature and its simulacra? Is there no chance of suspending this flow of images into firm experience, into a memory, an image or a dwelling? Tarkovsky saw the narrative of *Solaris* not merely as an occasion for flowing liquids, wide-eyed gazes and virtuosic camera tricks, but also as a means of framing and dramatizing the nature of cinematic representation. Like the film Berton shot on Solaris, Tarkovsky's film may seem to show merely the surface continuity of nature (flowing water, rushing wind, ploughed earth) in long, continuous takes; when observed by human subjects, however, these flows form themselves into discontinuous folds and shapes which interact with the spectator's own memories and fantasies. This cinematic image achieves presence not on screen, but in the spectator's inner eye.

This explains the ample quotations of painting in *Solaris*, most famously Rembrandt's *Return of the Prodigal Son* in the final shot of the film: does it belong to Tarkovsky or Kelvin? The many literary, artistic and cultural references thicken the supra-personal traffic of images, what might be called the imaginary. The investigation of this imaginary, Tarkovsky suggests, is the particular province of the cinema. At the end of *Solaris* Kelvin's memories, films, photographs and visions all merge into a continuous fantasy that tempts him with its fluidity. These representations promise to settle into symbols, i.e. conceptual representations that will yield some determinate meaning. The problem is revealed to be not how to access (and redeem) one's past, but how to escape from the imaginary realm of

[16] Ibid., 100.

[17] Naum Abramov, "Dialogue with Andrei Tarkovsky about Science Fiction on the Screen," 36, in Further Reading; N. Abramov, "Dialog s A. Tarkovskim o nauchnoi fantastike na ekrane," *Ekran. 1970-1971. Obozrenie kinogoda* (Moscow, 1971), 165.

memory and hope into presence. As Mark Le Fanu has written, "we live in significance to the extent that we are prepared to embrace the shadows of our loss."[18]

In this light, the philosophical problems of the film can be paired with the aesthetic problems Tarkovsky set himself in its production. By going to outer space, Tarkovsky explained, "We wanted to see Earth with a monotonous, as if numb gaze."[19] Steven Dillon has argued that *Solaris* is "a model for cinematic hallucination" and "the essence of self-conscious film."[20] *Solaris* was Tarkovsky's first film in color since his student film *Steamroller and Violin*; moreover, color was particularly difficult given Tarkovsky's preference for the widescreen format. After shooting its first color sequences, Tarkovsky reportedly said, "you can see it's fake! I need to shoot black-and-white pictures! My next picture will be black-and-white and on a small screen."[21] Tarkovsky's solution to the artificiality of cinematic color was constantly to shift in a meticulously planned manner between black-and-white, sepia, and color film.

> Color on screen is, as a rule, obnoxious and even provocative. Why? After all no one notices color in life. [...] And then we shoot what we see on color film: everything becomes colorful! And we can no longer perceive this image as reality without the color. Color exists everywhere in this image; it everywhere insinuates itself on our eye. Here there arises conventionality, which may be either artistic or anti-artistic...[22]

Tarkovsky noted that the only phenomena that are always perceived as colorful are sunsets and other "transitional states of

18 Mark Le Fanu, *The Cinema of Andrei Tarkovsky* (London: British Film Institute, 1987), 59.

19 D. A. Salynskii, 332.

20 Steven Dillon, 10, in Further Reading.

21 Ol'ga Surkova, *S Tarkovskim i o Tarkovskom*, 2nd ed. (Moscow: Raduga, 2005), 57.

22 Andrei Tarkovskii, "Beseda o tsvete," in Leonid Kozlov, *Proizvedenie vo vremeni* (Moscow: Eizenshtein-tsentr, 2005), 431.

nature."[23] To make the spectator *see* color is thus to convey a transition within the represented object, manifested as a change in texture. The textural difference between color schemes registers the passage of time and the change in the order of the image as it passes from hope to perception to fantasy to memory. As in an autumn leaf, "color directly expresses processes concealed in the texture"[24]; "only together with texture, manifesting it," Tarkovsky added, "can color convey the state of what is depicted, its 'history' and its 'actuality,' so that the viewer feels he is sensing it with his own skin."[25]

An analogous pattern can be traced in the film's music and sound design. Beginning with *Solaris*, Tarkovsky engaged Eduard Artem'ev, who worked mainly in electronic music, which he added to recordings of classical (mainly baroque) music. Together with Artem'ev, Tarkovsky began to conceive of his soundtracks as an integration of music and diegetic sound, including (post-synchronized) dialogue and (de-synchronized) sound effects, resulting in complex synchronizations between sound and image. The play of familiarity and distortion, as well as of venerable age and jarring novelty, augments the indeterminacies of the narrative and visual representation.

As his first feature film in color and without an orchestral score, *Solaris* marked a clear shift in Tarkovsky's sensorial poetics. The first key sequence is the "city of the future" in *Solaris*, which was shot in Tokyo in 1971 with both black-and-white and color film and which was accompanied by a particularly dissonant piece of Artem'ev's music. The growing visual intensity is matched by Artem'ev's electronic composition, which rises out of grating noise to cacophonic beauty. When Iusov first saw the edited sequence he felt that its point was to show how the increasing quantity becomes a change in "quality"; the viewer emerges from the interminably monotonous cinematic tunnel with transformed powers of vision.

23 Ibid.

24 Ibid., 433.

25 Ibid., 434.

The "city of the future" breaks off to a black-and-white sequence, beginning with a shot of Kelvin's home. Kelvin burns his archive in a bonfire, as his father and aunt look on; he asks permission to take with him the "film with the bonfire," as if he wishes his family memories to include only those tinged by this act of renunciation. Color is restored in a shot of the starry sky, with the yellow lights of a spaceship approaching the spectator. Kris asks, "When is lift-off?" and is told, "You are already flying." Improbable as it is that one would fail to notice being launched into space, it illustrates the fact that, in Tarkovsky's work, subtle changes to the quality of the image often convey more information than dialogue or narrative.

The second reversion to black-and-white occurs when Kelvin views Gibarian's suicide video for the second time, now in his own cabin. First we see the black-and-white video framed by its screen within a color room, but an axial cut reveals a black-and-white shot of Kris watching, and further shots of the video take up the entire frame, so that Kris and Gibarian are now united in the same black-and-white space. When (in the video) Sartorius knocks at Gibarian's door Kris turns his head, confusing the tape with reality. (This confusion is consistent with Lem's novel, where Gibarian appears to Kris in a dream or as a solarian spectre.) Kris then lies on the bed and views himself in the mirror; the image reverts to color to show first Hari's face in deep shadow, and then Kris's outstretched hand. While the initial change to black-and-white appears to mark Kris's transition from the real space of the spacecraft to the imaginary space of Gibarian's video, the change back to color marks, if anything, a deepening of the imaginary and the loss of any decisive criterion of reality. The third black-and-white sequence follows Kris's delirium, when he dreams (?) of his home and his deceased mother, who rinses off his arm with a pristine white porcelain jug and basin.

The remainder of the film is the multiplication and ordering of these layers of images. Brueghel's paintings on board the spacecraft are echoed in Kris's color film of family memories, which itself is reproduced as a full-screen image that blurs the boundaries between *Solaris* and its film-within-a-film. As Tatiana Egorova has pointed out, Bach's *Chorale Prelude in F* "not only awakes nostalgic images in Kelvin's consciousness, it also miraculously influences

the state of the inanimate phantom Hari," who "suddenly begins to 'recollect' her human past," as the soundtrack expands to include noises of the forest, a folk chorus, and the chimes of bells.[26] After seeing her prototype on film and hearing its soundtrack, Hari-2 walks to a mirror, exclaims, "I don't know myself at all," and then begins to talk to Kris through the mirror, as the camera shifts right to show a stream of water. Here the soundtrack changes to an excerpt from Viacheslav Ovchinnikov's soundtrack to *Andrei Rublëv*, and Kris is shown alongside a reproduction of Rublëv's *Holy Trinity*, which weave the characters' imaginaries and narratives together with that of their extra-diegetic creator. Is Kris (and by extension Tarkovsky) forever condemned to re-play the past, locked within his representations of it (whether in memory, dream, or technical media)? Is Kris's love for Hari (and Tarkovsky's love for film) the desire for a fluid state where memory is indistinguishable from perception, the original from its virtual repetition? It is fitting that *Solaris* is the only one of Tarkovsky's films to have been paid the tribute of a Hollywood remake; in fact, Steven Dillon has argued that *Solaris* has had "particular relevance to American film of the 1990s, where amidst a cultural landscape of virtual reality, fantasy takes on an unprecedented significance."[27]

In the end the film equivocates on its central issues; in his most important single line Kris wonders:

> Do I have the right to refuse even the imaginary possibility of contact with this Ocean, to which my race has for decades tried to extend a thread of understanding, and remain here among the things and objects which we both [Kris and Hari] touched, which still remember our breath. In the name of what? For the sake of my hope for her return? But I have no such hope. All that remains for me is to wait. For what? I don't know. New miracles?[28]

[26] Tatiana K. Egorova, 235, in Further Reading.

[27] Steven Dillon, 2.

[28] Cf. the corresponding place in the screenplay: Andrei Tarkovsky, *Collected Screenplays*, trans. William Powell and Natasha Synessios (London: Faber and Faber, 1999), 184.

As the film ends, Kelvin's equivocation is communicated to the viewer. Tarkovsky hoped that the spectator, "having been immersed in the previously unknown and fantastic atmosphere of Solaris and having returned to earth, would obtain the ability to breathe freely and in the familiar way, that he become refreshingly light in this familiarity. In short, that he feel the salvific bitterness of nostalgia."[29] But is this nostalgia enough to sustain, or is it a mere phantom of obscure desire? What is crucial is that the viewer's consciousness has been disrupted by the sensory plenitude of the film, cultivating attention to the unrepeatable and unrepresentable tissues of life within each present moment, which is always trapped between regret and desire.

Robert Bird

[29] A. Tarkovskii, "Zachem proshloe vstrechaetsia s budushchim?," 101.

Further Reading

Abramov, Naum. "Dialogue with Andrei Tarkovsky about Science Fiction on the Screen." In *Andrei Tarkovsky: Interviews*, edited by John Gianvito, 32-37. Jackson: University of Mississippi, 2006.

Beer, David. "Solaris and the ANS synthesizer: On the relations between Tarkovsky, Artemiev, and music technology." In *Through the Mirror: Reflections on the Films of Andrei Tarkovsky*, edited by Gunnlaugur A. Jónsson and Thorkell Á. Óttarsson, 100-117. Newcastle: Cambridge Scholars Press, 2006.

Bird, Robert. *Andrei Tarkovsky: Elements of Cinema*. London: Reaktion Books, 2008.

Dillon, Steven. *The Solaris Effect: Art and Politics in Contemporary American Film*. Austin: University of Texas Press, 2006.

Egorova, Tatiana K. *Soviet Film Music: An Historical Survey*. Translated by Tatiana A. Ganf and Natalia A. Egunova. Australia: Harwood Academic; Amsterdam: OPA, 1997.

Johnson, Vida T., and Graham Petrie. *The Films of Andrei Tarkovsky: A Visual Fugue*. Bloomington: Indiana University Press, 1994.

Kozlov, Leonid. "Beseda o tsvete." In *Proizvedenie vo vremeni*, 430-436. Moscow: Eizenshtein-tsentr, 2005.

Rosenbaum, Jonathan. "Inner Space (Tarkovsky's *Solaris*)." In *Movies as Politics*, 276-283. Berkeley: University of California Press, 1997.

Salynskii, D. A., ed. *Fil'm Andreia Tarkovskogo* Soliaris: *Materialy i dokumenty*. Moscow: Astreia, 2012.

Skakov, Nariman. *The Cinema of Tarkovsky: Labyrinths of Space and Time*. London: I.B. Tauris, 2012.

Tarkovskii, Andrei. "Zachem proshloe vstrechaetsia s budushchim?" *Iskusstvo kino* 11 (1971): 96-101.

Tarkovsky, Andrey. *Sculpting in Time*. Translated by Kitty Hunter-Blair. Austin: University of Texas Press, 1984.

Tarkovsky, Andrey. *Time within Time: The Diaries 1970-1986*. Translated by Kitty Hunter-Blair. London: Faber and Faber, 1994.

Turovskaya, Maya. *Tarkovsky: Cinema as Poetry*. Translated by Natasha Ward. Edited and with an Introduction by Ian Christie. London and Boston: Faber and Faber, 1989.

Žižek, Slavoj. "The Thing from Inner Space." In *Sexuation*, edited by Renata Saleci, 216-59. Durham and London: Duke University Press, 2000.

STALKER

1979

161 minutes

Director: **Andrei Tarkovsky**

Screenplay: **Arkadii and Boris Strugatskii, Andrei Tarkovsky**

Cinematography: **Aleksandr Kniazhinskii**

Composer: **Eduard Artem'ev**

Sound: **V. Sharun**

Art Design: **Andrei Tarkovsky**

Production Company: **Mosfilm**

Cast: **Aleksandr Kaidanovskii (Stalker), Alisa Freindlikh (Stalker's wife), Anatolii Solonitsyn (Writer), Nikolai Grin'ko (Professor), Natasha Abramova (Stalker's daughter)**

Stalker took four years to complete and was the last film Tarkovsky made in the Soviet Union. Although the script was approved without difficulty, the film was plagued with production and personality problems due to ostensibly defective imported Kodak film stock, a location change from a desert landscape in Tadzhikistan to a ruined power plant near Tallin, Estonia, disagreements with the original cinematographer, Georgii Rerberg, the voluntary departure of his replacement, the firing of the film's artist, and the divisive presence of Larisa, Tarkovsky's second wife. Most importantly, Tarkovsky, who had prepared meticulously for his previous films, had been occupied with other projects and was not ready creatively to shoot *Stalker*. The production delays gave Tarkovsky the opportunity to completely revise the script, originally an adaptation of the Strugatskii Brothers' *Roadside Picnic* (*Piknik na obochine*), which,

through thirteen rewrites, gradually moved away from science fiction conventions and developed a straightforward, chronological narrative structure.

In a post-industrial world of the future, the stalker-hero takes a writer and a scientist into the Zone, a forbidden area that contains the room of desires, in which a visitor's deepest wish is granted. Tarkovsky resisted symbolic readings of his films because a set, finalized interpretation would obscure the dynamic functioning of a polysemous image for the viewer: "I don't believe in symbols. This concept contradicts a concept such as the artistic image. An image presupposes a plurality of interpretations. A reflection in a drop of water—that's what an image is. But a symbol …. As soon as it becomes comprehensible, it ceases to live. It's an empty capsule, the cocoon from a butterfly."[1] Perhaps the best way to understand the Zone then is to accept its multiple meanings in Russian. (See the essay in this section by Robert Bird.) Whether the Zone is the site of the supernatural or simply the vehicle for the Stalker's power trip may also be left open.[2]

Tarkovsky frequently emphasized that cinema was, for him, a moral occupation and not simply a professional one. *Stalker*, *Nostalgia* and *The Sacrifice* comprise his final triad of films in which he sends a message to humanity, continuing the nineteenth-century tradition of the artist as conscience of the people. Like all of Tarkovsky's films, *Stalker* lends itself to mythological interpretation: the hero departs for "another world"; the aim of the journey is the search for a means to save the world; in the "other world"

1 Viktor Loisha, "Takoe kino. Chetyre dnia s Andreem Tarkovskim," *Druzhba narodov*, vol. 1 (1989): 225. Tarkovsky made this statement soon after the premiere of *Stalker* in Moscow, during a question and answer session following the screening of the film in Tomsk.

2 At the Tomsk screening, Tarkovsky commented: "The idea of *Stalker* is not at all the disavowal of miracles. But miracles—all of them!—must come either from ourselves or from nature, and not at all from somewhere outside. If different kinds of visitors, flying saucers and similar phenomena exist—and I'm inclined to think that this is completely possible—then they are absolutely useless to us, just as we are to them. It's doubtful that we'll be able to understand each other anyway. And it's really unnecessary!" Loisha, 218.

the hero comes into (friendly or inimical) contact with (positive or negative) higher forces; the path to salvation through sacrifice is revealed to the hero.[3] During the time when *Stalker* was in production, Tarkovsky was deeply interested in the spiritual and artistic integration of eastern and western religion and culture, which influenced both the content and style of the film: *Stalker* quotes both from the New Testament and the *Tao-te-ching*, chapter 76; electronic music blends with eastern instruments. On the other hand, fragments of classical works such as the *Marseillaise*, Ravel's *Bolero* and Beethoven's *Ninth Symphony*, overlaid with mechanical noises and all sharing a generalized marching tempo, denote the aggressiveness of industrialized western civilization.[4] Although *Stalker* is an aesthetically complex film in its use of spatial displacement, color, sound and Tarkovsky's trademark long takes, its ideas are conveyed explicitly through the characters' exchanges. Tarkovsky's representation of women as dependent and sometimes hysterical is a vexed issue. Although the Stalker's wife is among the most positive of his female characters, this is because she embodies self-sacrifice, which Tarkovsky considered the preeminent womanly trait. An indicator of the continuing popularity of the film is Geoff Dyer's recent *Zona: A Book about a Film about a Journey to a Room* (2012).

[3] Dmitrii Salynskii, *Kinogermenevtika Tarkovskogo* (Moscow: Prodiuserskii tsentr "Kvadriga," 2009), 394.

[4] Nataliia Kononenko, *Andrei Tarkovskii. Zvuchashchii mir fil'ma* (Moscow: Progress-Traditsiia, 2011), 74-5. Kononenko also points out that, early in the film, Writer haphazardly whistles a melody from Bach's *St. Matthew's Passion*, No. 47—the profanation of a sacred classical text (73-4).

STALKER

Vida T. Johnson and Graham Petrie

The links between *Solaris* and *Stalker* go rather deeper than their common origin in works of science fiction, in which Tarkovsky professed to find little interest for their own sake. In both films the characters are given the opportunity to have their wishes granted—only to find that this involves a painful and searching self-examination, leading to the discovery that what they think they want is not quite what they really do want: "You dream of one thing and get something quite different," as Writer observes in the scene in the "telephone room." Both films explore the conflict between science, rationalism, and technology on the one hand and love, humanism, and faith on the other: Sartorius of *Solaris* is close to Professor in *Stalker* in his belief that rational analysis can resolve all human dilemmas, and both are forced to acknowledge a mystery (hope, faith, or love) that their world view cannot encompass.

From another perspective *Stalker* can be seen as forming a trilogy with *Nostalghia* and *The Sacrifice* in presenting a society apparently bent on self-destruction because it has lost all links with nature, its own past, and any sense of a spiritual or moral dimension to its behavior. Stalker leads on to Domenico in *Nostalghia* and Alexander in *The Sacrifice* as a "holy fool" whose words are greeted with scorn or incomprehension by those they are intended to save, while Writer's aimlessness, self-contempt, and sense of entrapment are echoed, to at least some extent, by Andrei and Victor in the later films. [...]

Although attempts [...] to force "late" Tarkovsky into an explicitly Christian straitjacket must surely be rejected, it remains true that *Stalker*, like all his later films in particular, does operate within an overall system of Christian iconography and Biblical reference. This is most evident in the scene often referred to as "Stalker's dream," as the men rest after the "waterfall" scene and

before they enter the "Meatgrinder." They are seen in a series of individual shots, with Writer lying prone on a mossy patch of earth projecting into a stream; Professor half sitting, half lying on a slope; and Stalker lying full-face, facing in the opposite screen direction to Writer, almost entirely surrounded by water, with a waterfall visible behind him.[1] After a brief cut—to what looks like quicksand and a background of trees, with windspouts and the unmotivated fluff that usually signals "strangeness"—an off-screen woman's voice (probably Stalker's wife) begins to whisper the passage from Revelation 6:12-17 about the opening of the sixth seal, the destruction of Heaven and Earth, and the vain attempts by the survivors to hide themselves from "the wrath of the Lamb." A brief shot of Stalker in close-up is followed by a cut to black and white and another extreme close-up of his sleeve and then his face before the camera tracks away, as in the "waterfall" scene, over a collection of debris lying in shallow water: a syringe, a bowl, a glass dish with a goldfish swimming inside,[2] rocks, a mirror, a metal box containing coins and a plunger, a fragment of Jan Van Eyck's Ghent altarpiece with coins lying on it, a rusting pistol, a coiled spring, paper, a torn calendar, a clockwork mechanism, and other detritus. The voice-over, which is occasionally spoken in a tone of uneasy laughter, gives way toward the end of the shot to the softly pulsating Indian-like electronic melody that had accompanied the opening credits.

Clearly enough this sequence, like some to follow in *Nostalghia*, makes its own comment on a world dominated by transitory

[1] De Baecque (25) suggests that their positions here imply their spiritual state (at least at this stage of their journey): the materialistic Professor fully on earth; the imaginative but skeptical Writer on waterlogged ground; and the spiritual Stalker almost enclosed by water. [...] This interpretation derives some validity from the importance of water as a redemptive force throughout Tarkovsky's work (Antoine de Baecque, *Andrei Tarkovski* [Paris: Cahiers du Cinéma (Collection "Auteurs")], 1989).

[2] The fish, of course, was an important early symbol of Christ, accepted as such by both the Catholic and Orthodox traditions. Here it is imprisoned; the fish in the shot that ends the scene of the men outside the "Room" is bleeding and also perhaps being suffocated by pollution.

material concerns, in which faith and spirituality have been forgotten or discarded. At this point in the film only Stalker has shown any real inclination toward faith (in his comments on the nature of the Zone and his prayer for his companions to be granted a childlike capacity for belief); Professor remains an enigma, characterized so far mainly by his pragmatism; and Writer, though expressing scorn for himself and his profession, has just been musing unexpectedly on the redemptive power of art. Stalker now goes on to offer a Biblical quotation of his own, that describing the meeting on the road to Emmaus between the resurrected Christ and two of his apostles who fail to recognize him (Luke 24:13-18), stopping with the words of Cleopas. [...] As he speaks there is a cut to Professor lying down, with his eyes closed, and the camera then tracks slowly along his body to show Writer resting his head against Professor, also with his eyes closed. The camera stops on Writer's face with the words "But their eyes were holden that they should not know him"—at which point Writer opens his eyes. The camera then tracks back to Professor's face and stops there on the words of Cleopas, as he speaks to, but does not recognize, Jesus. Although Professor's eyes are now open, the very specific matching of camera movement and words here suggests clearly that Writer has the capacity for redemption (opening his eyes), while the more pragmatic Professor has the capacity to see but does not yet use it.

Yet, though there is much explicit Christian reference here, the overall pattern of the film tends more toward a general framework in which faith, spirituality, and art (none of them seen as exclusively Christian attributes) are set against materialism, cynicism, and disbelief, with the oppositions clearly demarcated in the relationship between Stalker and his two companions. In the interviews that he gave around the time of making this film, Tarkovsky seemed more concerned with attacking the spiritual emptiness of contemporary society in general than with proposing specifically Christian remedies, and he even told Marcel Martin, "For me the sky [heaven] is empty," and that he did not have the "organ" that would enable him to experience "God." Meanwhile, in his diary entries at the time, he was beginning to record the interest in Rudolf Steiner and Eastern philosophy that was to coexist

with traditional Christian doctrines throughout the remainder of his work.[3]

For Tarkovsky himself, in *Sculpting in Time,* the main theme of the film was "human dignity; and . . . how a man suffers if he has no self-respect."[4] He also saw it as being about the redemptive power of love, embodied specifically in the figure of Stalker's wife, and how "her love and her devotion are that final miracle which can be set against the unbelief, cynicism, moral vacuum poisoning the modern world, of which both the Writer and the Scientist are victims."[5] These ideas are clearly enough expressed in the film and are elaborated on by most critics—one problem with *Stalker,* in fact, which is in most other respects one of Tarkovsky's finest works, is that it is so explicit about what it is saying and articulates so many of its basic thematic conflicts in its dialogue.

Critics as varied as Maya Turovskaya, Peter Green, and Gilbert Adair all suggest that Writer and Professor learn little from their experience. For Adair, Writer "contemptuously declines even to formulate a wish," while for Turovskaya the two men recognize only their own "poverty of spirit," and for Green they realize little more than their inability to "subject themselves to a possible revelation."[6] Although Tarkovsky himself seems to support this negative assessment of Writer and Professor ("They had summoned the strength to look into themselves—and had been horrified; but in the end they lack the spiritual courage to believe in themselves,"

3 Andrei Tarkovsky, *Time Within Time: The Diaries 1970-1986,* trans. Kitty Hunter-Blair (Calcutta: Seagull Books, 1991), 156.

4 Andrei Tarkovsky, *Sculpting in Time: Reflections on the Cinema,* trans. Kitty Hunter-Blair. Rev. ed. (London: Faber and Faber, 1989), 194.

5 Ibid., 198. Although the moral significance of the film remained constant for him, he occasionally toyed in interviews with the idea that neither the Zone nor the Room really existed, and that Stalker "invented" them and their magical powers in an attempt to reintroduce a sense of faith and hope into the world that has lost these.

6 Gilbert Adair, "Notes from the Underground: *Stalker,*" *Sight & Sound* (Winter 1980/81): 63; Maya Turovskaya, *Tarkovsky: Cinema as Poetry* (London: Faber and Faber, 1989), 113; Peter Green, "The Nostalgia of the Stalker," *Sight & Sound* (Winter 1984/85): 53.

he somewhat contradictorily asserts that "even though outwardly their journey seems to end in fiasco, in fact each of the protagonists acquires something of inestimable value: faith.")[7] Kovács and Szilágyi seem to agree with this somewhat more positive view when they suggest that the silence of the two intellectuals (in contrast to their previous bickering and verbal assertiveness) as they look into the Room suggests a degree of respect and acceptance that is perhaps a form of prayer.[8]

Tarkovsky told Aldo Tassone that he felt closest to Stalker, who represented "the best part of me, that which is also the least real"; that he also felt very close to Writer, who had gone astray but was capable of finding a spiritual outlet; but that Professor was too limited to be sympathetic—though he immediately went on to concede that Professor was capable of going beyond these limits and was in reality quite open-minded.[9] It does in fact seem to be the case that both Writer and Professor learn a good deal about themselves during their journey and that both change as a result. Professor listens to Stalker's pleas not to use his bomb and finally throws it away and, though Writer accuses him of being a time-serving careerist, Professor tells his boss on the phone that he is no longer afraid of him, and acts accordingly. His refusal to enter the Room (which he had, of course, originally come to destroy) perhaps suggests a degree of humility and an acceptance that it is not up to him to save humanity from itself.

Writer is a rather more complex figure who appears to despise not art itself (he appears to speak directly for Tarkovsky in this respect) but himself as an unworthy practitioner of it. Though he knows what art *should* be, he is also aware that his own motives for writing are suspect and egotistical. It is the nonintellectual Stalker who becomes the spokesman for the "unselfish" nature of art in his comments on music and his heartfelt recital of the poem supposedly

7 Tarkovsky, *Sculpting in Time*, 198, 199.

8 B.A. Kovács and A. Szilágyi. *Les Mondes d'Andrei Tarkovski*. Trans. from Hungarian, V. Charaire (Lausanne: L'Age d'Homme, 1987), 137-38.

9 *Dossier Positif*, ed. Gilles Ciment (Paris: Editions Rivages, 1988), 129.

by Porcupine's brother. (The walls of his home are also lined from floor to ceiling with books.) Writer's self-disgust is projected outward in his cynicism and sarcasm toward his companions, his readers, and the world in general (his caustic humor is inadequately rendered in the subtitles). His ostensible reason for going to the Zone is to ask for inspiration, yet his attitude even toward that aim seems both half-hearted and flippant; his motives for the journey seem to derive from boredom and curiosity rather than from any real desire to change. It is perhaps his awareness of this that prevents him from entering the Room. [...] His theatrical bravado gives way to the simple gesture of putting his arm protectively around Stalker — whom he had unmercifully ridiculed and even beaten — while the thoughtful expression on his face on their return to the bar suggests that a genuine transformation has at least begun within him.[10]

Stalker himself ("one of the last idealists," as Tarkovsky called him in the Tassone interview) is clearly both the most sympathetic and the most tormented of the three. [...] He asks nothing for himself: recognizing his own wretchedness, cowardice, and inadequacy, he wants genuinely to help those in a worse state than he is because they have lost the last vestiges of hope and faith. The fact that he is weak and despised, even a bit mad, yet spiritually and morally strong, relates him both to the Russian tradition of the *yurodivy* and to the characters of Dostoyevsky, who often possess the same seemingly incompatible character traits. "Weakness" and "flexibility" are explicitly favored over "hardness" and "strength" in the lines he speaks in voice-over[11] as he edges his way toward his companions, whose intellectual and spiritual hardness has to be broken and who have to "become helpless like children" (Tarkovsky said this to his

[10] Writer's progress through the Zone involves the progressive discarding of all the protective coverings with which he shields himself from true self-knowledge: he has to leave behind a woman and his cigarettes, and during the journey he loses his liquor and his gun (J. Gerstenkorn and S. Strudel, "La quête et la foi," in *Etudes cinématographiques*, ed. Michel Estève [Paris: Lettres Modernes, 1983], 75-104).

[11] The thought is borrowed from Lao Dze. (See the diary entry for December 28, 1977, *Time Within Time*, 147.)

actors!) if they are to embrace "life" rather than "death." Though this "breaking" does seem to happen, at least to some extent, by the end of their journey, he appears—surprisingly—not to accept or recognize this. His expressions of despair to his wife on his return home, and his sense of failure as he condemns his companions for their lack of belief and their materialism and complains that no one needs him or the Room, have the effect of undercutting this sense of possible change for the viewer and help to give the film a bleaker and more despairing tone than Tarkovsky seems to have intended. When asked by Aldo Tassone if *Stalker* was a despairing film, he replied that if it was, it would not be a work of art, for art should create a sense of hope and faith.[12] […]

The later *Stalker* script (1978) ended with the family walking off and Monkey chattering away about goodies she would like to eat or buy. Both Stalker's lament and the girl's "miracle" are later additions. The film's editor told us that three different endings were shot and tried out, all of them finally being incorporated in one way or another into the film. By including Stalker's lament and then following it with the wife's monologue (originally intended to be delivered in the bar), Tarkovsky may have chosen to throw another important theme into relief: the consoling and healing power of love as embodied in Stalker's wife, who clearsightedly sees her own situation for exactly what it is and yet chooses to accept it. The addition of the miracle shows that some good may result from Stalker's tortuous trips into the Zone.

Kovács and Szilágyi suggest that the wife represents the ethical principle in the film, Stalker the spiritual, and their daughter the mystical. As most critics point out, the three men likewise embody different philosophical principles: Stalker—faith; Professor—rationalistic, scientific materialism; and Writer—an artistic principle that has degenerated into skepticism, cynicism, and egotism. After the apparent but false "miracle" of the child appearing to walk at the end of the film, Tarkovsky gives us a typically double-edged sense of transcendence and hope through the daughter's telekinetic

12 *Dossier Positif*, 128.

powers. Though the "miracle" in *Stalker* is trivial enough in itself, it is presented with such beautiful gravity and intensity that it offers a convincing alternative to the squalor, misery, and ugliness of the world outside the Zone and the ambivalent and remote promise of the Room itself.

The endings of Tarkovsky's films have two things in common: while offering reconciliation, they are essentially open-ended with a number of possible meanings and interpretations that cannot be fully rationally or "objectively" explained and require "a leap of faith" on the viewer's part. [...]

Stalker creates its own ambivalences at the end: the child's moving of the glasses deliberately parallels the earlier scene in Stalker's bedroom in which we see the objects on the bedside table quivering and shifting position in response to the vibrations of a passing train. In the final scene, the train is heard and its effects are seen only *after* the child has exerted her own powers on the objects, and it can hardly therefore be said to have "caused" the movements;[13] yet it might still be possible for a pure rationalist (like the Professor of the first half of the film or the Writer who lamented the lack of "mystery" in modern life) to claim that the vibrations of the oncoming train made their effects felt before the engine itself was heard. The rendering of the "Ode to Joy" that struggles to make itself heard—briefly and discordantly—before being overwhelmed by the rattle of the train is likewise deliberately ambiguous: the final triumph of the ideals expressed by the music still seems a long way off.

The scenes in the bar also parallel one another, with the men standing in almost identical postures round the table, but, in contrast to the lengthy portrayal of their outward journey to the Zone, the return journey appears almost instantaneous. Most critics agree that the significance of the film lies in the fact that the men's quest is essentially an internal rather than an external one, and several [...] have pointed to the similarities between Stalker's home

13 A point that is obscured by Peter Green (52) who says, wrongly, that we hear the train "at the beginning" of the scene.

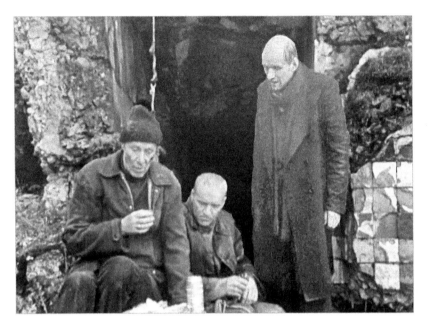

Fig. 93. By the Tiled Wall

and what they refer to as "the Room" — meaning presumably what we have called "the telephone room" — where the similarities in the floorboards, the defective lighting, and the presence of the sleeping pills have been noted in our synopsis. (The floorboards of the bar also resemble those in the other two settings, and a potentially defective light flickers overhead.)

Once the men reach the Zone it becomes impossible to measure the length of their journey, for the clues that would allow us to judge time are simply lacking;[14] and it would be equally impossible to draw a map of their travels, for the relationship between the various locations is purposefully obscured throughout, and few indications are given as to how they move from one setting to another. The real problems begin after the "*Stalker.* 2nd part" title, with Stalker mysteriously separated from his companions, the metal pipe from which they, equally mysteriously, emerge, and the threefold visit

14 In *Sculpting in Time* (193), Tarkovsky says that he "wanted it to be as if the whole film had been made in a single shot."

to the area with the tiled wall (Fig. 93). Even within the various settings, the spatial clues are often contradictory and misleading, most notably in the complex and crucial sequence as the men rest at the swampy area near the tiled wall. The conversation here—first between Writer and Stalker on the motives of those who wish to visit the Room, followed by some musings by Writer on himself and his art and then an inventive exchange of insults between Writer and Professor—is virtually continuous, yet the physical positioning of the characters, in relationship to each other, their surroundings, and even within the film frame, changes, apparently arbitrarily, from one shot to the next. Stalker, for example, is sometimes shown totally surrounded by water, sometimes only partially so; he is lying on his back, on his side, and face down; sometimes he has his head to the left of the screen, sometimes to the right—all over what the dialogue indicates is a continuous period of time. Color alternates randomly with black and white or sepia, and a dog appears from nowhere and settles down beside Stalker. The sequence also includes the quotations from Revelation and Luke discussed earlier. Although the first of these, with its mysterious nondiegetic source, may be what Tarkovsky refers to as "the *dream*" in his diary,[15] everything in this sequence is so totally dreamlike that it is invidious to single out any part of it as being especially so: we are clearly now following an interior, spiritual journey in which time and space operate in an oneiric rather than a naturalistic fashion. In this respect, the Zone obeys laws of its own that differ from those of everyday reality, which is, after all, one of the premises of both the original story and the film itself.

Another curious and paradoxical feature of the Zone is that, for all Stalker's dire warnings of what will happen if his companions disobey his instructions, they ignore him with apparent impunity and no harmful consequences result: Professor safely retrieves his knapsack, and although Writer is turned back from the house, he is not punished for his transgression. Even the dreaded "Meatgrinder" appears frightening only because of Stalker's evident terror of

[15] Tarkovsky, *Time Within Time*, 156.

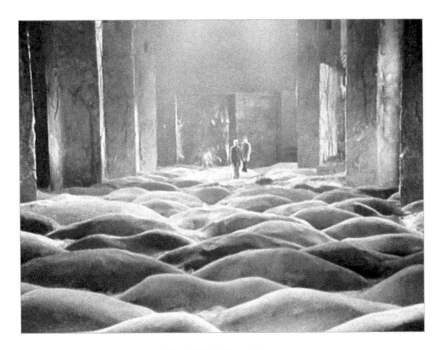

Fig. 94. The Dune Room

it and the unease that he transmits to Writer. Certainly strange and inexplicable things happen within the Zone (Fig. 94), but the sense of real danger, once they have broken through the barrier, is curiously absent. Perhaps what matters here is not the physical peril (which is much more evident in the original story) but the fact that Stalker understands and respects the special powers of the Zone, in contrast to the matter-of-fact Professor and the frivolous Writer.

With an average shot length of almost one minute (142 shots in 161 minutes, with many 4 minutes or longer),[16] *Stalker* also marks a decisive shift toward Tarkovsky's later style. The director's own desire to give the impression that the film had been made in a single shot is reflected in miniature in the scene which many viewers consider to be one of the most hypnotic and compelling

[16] The first shot after the men's arrival in the Zone lasts 4 minutes 15 seconds; Writer's self-condemnation in the "dune room" is filmed in one continuous take of 4 minutes 30 seconds.

in all Tarkovsky's work—the ride to the Zone on the flatcar—and which, significantly, is often misremembered as consisting of a single shot rather than the actual five. More even than in *Mirror* (where the leaps backwards and forwards in time are more evident), Tarkovsky succeeds in this film in creating a world governed by its own dream logic: on the one hand is the slow, inexorable pacing of individual shots (often with the camera virtually motionless or tracking forward so imperceptibly that it is only toward the end of the shot that we realize how much our spatial perspective has changed); on the other, the fusion of these shots into a whole whose seeming inevitability counteracts the spatial and temporal discontinuities of the individual segments. Within this framework, the everyday world in all its commonplace and often sordid reality is authentically transformed and made strange, so that for two hours and forty-one minutes we live inside it and accept its laws.

In a good print, the arrival at the Zone becomes genuinely magical, the grass a pulsating green that contrasts with the shabbiness and dinginess (yet, in a good print, intensely tactile detail) of the preceding sepia images and allows us to share with the characters the belief that here things are really going to be different. The green is an obvious presence for most of the first half of their journey, before giving way (as the men's energies also ebb away into quarrels, doubts, and fears) to interiors and man-made constructions with their darker tones. As usual Tarkovsky works with a very restricted color scheme, centered around brown, black, and grey, until we reach the telephone room and the Room itself, where subtle shades of gold and red, rising and falling in intensity, suggest the magic and the wonder that the men can glimpse but cannot fully seize—colors that are echoed in the rich golden texture of the daughter's headscarf. Here, as later in *Nostalghia* and *The Sacrifice*, lighting takes on a quality of its own that helps to define and shape the spiritual state of the characters. The electronic music, with its haunting, pulsating rhythms that reappear in various permutations throughout the film, also creates its own sense of strangeness while providing almost subliminal links between the Zone and the everyday world of Stalker and his family: its main theme accompanies the opening credit sequence, parts of the scene

in the swamp, and the scene in which Monkey is carried on her father's shoulders.

[…] The film's virtues are perhaps best epitomized in the flatcar sequence, where Tarkovsky comes closest to creating the "pure cinema" — working solely in terms of time, sound, and images — that he dreamed of in *Sculpting in Time*. This three-and-a-half-minute sequence is made up of five shots focusing on close-ups of the three men seen from the back or in profile as they look cautiously and curiously around against a blurred and out-of-focus background that occasionally sharpens to reveal a landscape scarred by industrial debris or dotted with piles of lumber. The monotonous clicking of the flatcar along the rails is slowly joined by whirring electronic music that gradually takes on a whipping, twanging, rhythmical intensity of its own that merges with and then drowns out the sound of the wheels. Although the sound and music are an essential factor in creating the mesmerizing effect of this scene, Tarkovsky, like Bergman, also creates a whole landscape out of the human face and body and is not afraid to let his camera linger and explore it. The slowdown in the film's pace from the relatively action-filled (for Tarkovsky) sequences that precede this one helps to prepare us for the more reflective scenes that follow with their alien time/space continuum.

But there is much else, too: the faces, especially that of Stalker himself, lined, haunted, stark, and tormented; the scenes set around the tiled wall and the roaring waterfall and those in the swamp that follow; the lighting and the movement of the characters in the telephone room; the men sitting, staring into the Room as rain falls and trickles to a halt; the wife speaking of her hopeless devotion to her husband; Stalker carrying his daughter across a poisonous wasteland, with nuclear power stations in the background; and the final sequence — all these rank among the finest images in the whole of contemporary cinema.

ANDREI TARKOVSKY: THE ELEMENTS OF CINEMA

Robert Bird

As Tarkovsky's style became more elementary, the three dominant spaces of his world achieved ever purer expression: the rickety apartment alongside the railway tracks that serves as home; the nature of the Zone, which appears in league with an alien will; and the cathedral space of the "Room of Desires" to which the three men trudge, where their own wishes will reorganize their world. The antechamber to the Room—where the protagonists decide to forego this test of their will—was especially designed as a columned "temple" standing right on the lapping waters.[1]

Many attempts have been made to define what is meant by the "Zone" in *Stalker*. For Raymond Bellour it is an image in which dream is indistinguishable from memory.[2] For Žižek it is "the *material presence*, the Real of an absolute Otherness incompatible with the rules and laws of our universe."[3] More specifically, Žižek lists several connotations of the word "Zone" in the Soviet imaginary: a prison camp; the site of an ecological disaster; the area where elites live; foreign territory; or a site of cosmic incursions such as meteorites. Žižek concludes that "the very indeterminacy of what lies beyond the limit is primary." In fact, the limit itself—or rather the act of delimitation—is the primary condition for the "presence of the Other," the source of "the void that sustains desire." In many respects the Zone is simply the demarcated area within which

1 Ol'ga Surkova, *S Tarkovskim i o Tarkovskom,* 2nd ed. (Moscow: Raduga, 2005), 274.

2 Raymond Bellour, *L'Entre-Images* 2: *Mots, Images* (Paris: P.O.L., impr., 1999), 190.

3 Slavoj Žižek, "The Thing from Inner Space," in *Sexuation,* ed. Renata Saleci (Durham and London: Duke University Press, 2000), 237-39.

an event can occur, akin to the screen in the cinema. Tarkovsky defined the Zone as "not a territory, but a test that results in a man either withstanding or breaking. Whether a man survives or not depends on his sense of individual worth, his ability to distinguish what is important from what is transient."[4] The Zone, then, is the quintessence of Tarkovsky's spaces: a locus of experience formed of inquisitive human gazes and an uncanny impersonal gaze that cannot simply be identified with the camera. The Zone is where one goes to see one's innermost desires. It is, in short, the cinema. [...]

"I like making long films, films which utterly 'destroy' the spectator in a physical manner," Tarkovsky once said.[5] In order to exert such effect, however, temporal form requires at least a skeleton of narrative, which in *Stalker* is not only reduced to the barest minimum, but at key moments threatens to come completely apart. The physical evidence for the Zone and of the Room of Desires is almost entirely circumstantial: the closed perimeter, the rumors of miracles and the flags by which the Stalker marks out a path. In comments on the film Tarkovsky stressed that the story of Porcupine, the Stalker's mentor, could be a mere legend[6]; perhaps the Porcupine is really the Stalker himself. In sum, Tarkovsky professed: "It would be good if at the end the spectator came to doubt whether he had even seen a story."[7] It is almost as if the Stalker is conducting an apocalyptic variation of a children's game, like hide-and-seek or "capture the flag." The only evidence of supernatural forces, that is of otherwise unsolvable diegetic puzzles, are the voice which calls the Writer back from his solo foray and the bird which

4 Andrei Tarkovsky, "Pered novymi zadachami," *Iskusstvo kino* 7 (1977): 118; cf. Andrei Tarkovsky, *Sculpting in Time*, trans. Kitty Hunter-Blair (Austin: University of Texas Press, 1986), 200.

5 A.A. Tarkovskii, "Poiasneniia k fil'mu 'Soliaris.' Otvety na vstreche so zriteliami (Vostochnyi Berlin, mart 1973 g). Publikatsiia Rut Kherlingkhauz i L.K. Kozlova," *Kinovedcheskie zapiski* 14 (1992): 49.

6 Andrei Tarkovsky, *Sculpting in Time*, 198; Andrei Tarkovskii, *Zapechatlennoe vremia*, in *Andrei Tarkovskii: Arkhivy. Dokumenty. Vospominaniia*, ed. P.D. Volkova (Moscow: Podkova-Eksmo-press, 2002), 317.

7 Surkova, 247.

disappears over the sand dunes. Both are cinematic tricks that, if anything, detract from the sense of mystery; the three characters accuse each other of ventriloquism, but the viewer is acutely aware of the director's manipulation. The general state of discomfiture and unease is maintained mostly by the smoothly floating camera, the alternations in color, the conspicuous sound effects and their synthesized elaboration. The ringing telephone and working fuse-box in the antechamber to the Room strike the characters and spectators as uncanny precisely because they so evidently contradict the pretence of the Zone. The Professor discards his device, not because he loses faith in the Zone, but because he comes to believe in it more than in his own judgement.

The fragility of the border between realism and fantasy is perhaps most puzzling in the episode of the "Dry Tunnel"—a joke, as the Stalker remarks, because it is in fact a violent current of water. The beginning of the second part finds the Stalker raising his two clients from their rest; the Professor leaves his rucksack, not realizing that it is impossible to return, but upon remembering it he goes back all the same. The Stalker and the Writer press on, wading through the water and despairing of ever finding the Professor again; after all, as the Stalker keeps repeating, no one ever returns the same way they came. However, the Stalker and the Writer emerge from the Dry Tunnel only to meet the Professor enjoying a quiet snack near the very place they left him. The Stalker treats this fold in space as a "trap" and their survival as proof of the Professor's benevolence, but it is difficult to rid oneself of the suspicion that he was actually leading the Writer, so to speak, up the garden path. The Stalker's strictures are improvised, not to protect his visitors from unknown dangers, but solely to stamp his authority on their quest.

FURTHER READING

Bird, Robert. *Andrei Tarkovsky: Elements of Cinema*. London: Reaktion Books, 2008.

Foster, D. "Where Flowers Bloom but Have no Scent: The Cinematic Space of the Zone in Andrei Tarkovsky's *Stalker*." *Studies in Russian and Soviet Cinema* 4, no. 3 (2010): 307-20.

Gianvito, John, ed. *Andrei Tarkovsky: Interviews*. Jackson, MS: University Press of Mississippi, 2006.

Johnson, Vida T., and Graham Petrie. *Andrei Tarkovsky: A Visual Fugue*. Bloomington and Indianapolis: Indiana University Press, 1994.

Kononenko, Nataliia. *Andrei Tarkovskii. Zvuchashchii mir fil'ma*. Moscow: Progress-Traditsiia, 2011.

Martin, Sean. *Andrei Tarkovsky*. Harpenden, UK: Oldcastle Books, 2011.

Redwood, Thomas. *Andrei Tarkovsky's Poetics of Cinema*. Newcastle upon Tyne: Cambridge Scholars Publishing, 2010.

Salynskii, Dmitrii. *Kinogermenevtika Tarkovskogo*. Moscow: Prodiuserskii Tsentr "Kvadriga," 2009.

Skakov, Nariman. *The Cinema of Tarkovsky: Labyrinths of Space and Time*. London and New York: I.B. Tauris, 2012.

Tarkovskii, Andrei. *Uroki rezhissury*. Moscow: Vserossiiskii institut perepodgotovki i povysheniia kvalifikatsii rabotnikov kinematografii, 1993.

Tarkovsky, Andrei. *Sculpting in Time: Reflections on the Cinema*. Translated by Kitty Hunter-Blair. Austin, TX: University of Texas Press, 1986.

Tsymbal, Evgeny. "Sculpting the *Stalker*: Towards a New Language of Cinema." In *Tarkovsky*, edited by Nathan Dunne, 338-51. London: Black Dog Publishing, 2008.

MOSCOW DOES NOT BELIEVE IN TEARS

Moskva slezam ne verit

1979

150 minutes

Director: **Vladimir Men'shov**

Screenplay: **Valentin Chernykh**

Cinematography: **Igor' Slabnevich**

Art Design: **Said Menial'shchikov**

Composer: **Sergei Nikitin**; Lyrics: **D. Sukharev, Iurii Vizbor, Iurii Levitanskii**

Sound: **Mark Bronshtein**

Production Company: **Mosfilm**

Cast: **Vera Alentova (Katerina/Katia Tikhomirova), Aleksei Batalov (Gosha), Irina Murav'eva (Liudmila/Liuda Sviridova), Aleksandr Fatiushin (Gurin), Raisa Riazanova (Antonina/Tonia), Boris Smorchkov (Kolia), Iurii Vasil'ev (Rudol'f/Rodion Rachkov), Natal'ia Vavilova (Aleksandra), Ol'ga Pavlovna, Liia Akhedzhakova (Ol'ga Pavlovna, the singles club director), Oleg Tabakov (Volodia, Katerina's lover). Cameo appearances: Tat'iana Koniukhova, Georgii Iumatov, Leonid Kharitonov, Innokentii Smoktunovskii as themselves**

Like his heroine, Katia Tikhomirova, in *Moscow Does Not Believe in Tears*, Vladimir Men'shov (1939-) came from the provinces and made good through perseverance and hard work. He was not accepted to the State Film Institute on his first try and returned home to Astrakhan' to work as a lathe operator, miner and sailor. In 1961 he was accepted into the acting program of the Moscow Art

Theatre Studio, graduating in 1965. Over the years he has continued to act in films; for American audiences, his most famous role is that of Geser, the leader of the forces of light, in *Night* and *Day Watch*. On his second try, Men'shov was accepted as a special graduate student into the State Film Institute by Mikhail Romm and graduated in 1970. He became a mainstream filmmaker, a practitioner of "people's cinema" (*narodnoe kino*), which both engaged topics from ordinary life and sought to provide hope and consolation to millions of lonely women in *Moscow Does Not Believe in Tears* and *Liubov' i golubi* (*Love and Pigeons*, 1984) or comic relief during the crises of the mid-nineties with *Shirli-Myrli* (*What a Mess!*, 1995).

By 1970 Soviet cinema had moved away from the monologism of Socialist Realism and had officially recognized different cinematic genres. Melodramas were encouraged as potential moneymakers. *Moscow Does Not Believe in Tears*, Men'shov's second and most famous film, was received unenthusiastically by critics, but attracted 84.4 million viewers during 1980 and won an American academy award for best foreign film, one suspects because of its resemblance to an American film. The director was not permitted to travel to the US for the award ceremony and did not receive his Oscar until 1989.

Moscow Does Not Believe in Tears follows the lives of three girls from the provinces as they search for a better life in the big city. Katia begins as a factory worker, Tonia is a house painter and Liuda works in a bakery. All three are *limitchiki*, workers with temporary residence permits, who must have either steady employment or marry to remain in Moscow. The film is influenced by both American romantic comedy, films of upward mobility and the paradoxes of desire, such as Negulesco's *How to Marry a Millionaire* (1953) and the American melodrama, which often turns on a mistake that changes a woman's life, as in the films of Douglas Sirk. Other themes and tropes relating to the American tradition include: the urban-individual nexus (a night scene with hundreds of brightly lit windows in large apartment buildings at the end of the film); nostalgia for "the way we were"; parody of the western detective genre (Kolia's dress and words to the women before leaving to search for Gosha); mild voyeurism (girls showering after work and Aleksandra getting dressed in the morning); cameo star appearances

at the French film festival; the mimicking of Technicolor chromatic values (Katia's red shoes and handbag or Liuda's bright orange suit); anticipatory camera movement during Katia and Volodia's tryst.

Although *Moscow* openly refers to social problems in Soviet society (alcoholism, juvenile delinquency, the trivialization of culture through television, the lack of marriageable men, a materialistic, spineless professional class) and privileges sisterly friendship over socialist collectivity, it is nevertheless a conformist film in its ideological treatment of class, albeit attenuated by a Stagnation era discourse of desire operating beyond class paradigms. The fate of the three girls is predetermined by Marxist theory. Whatever their actual social origins, the girls perform different classes in the film: Katia is the proletarian, Tonia the peasant, and Liuda the bourgeois parasite.[1]

In terms of bodily discourse Katia represents the head, Tonia the heart, and Liuda the belly. Liuda is connected to conspicuous consumption from the very beginning, when Kolia enters the girls' dormitory room and is frightened by her strawberry mask. She is uninterested in work and career for their own sake and seduces Gurin for the same reason Rudol'f does Katia—social advancement. Liuda has no understanding of or interest in the cultural revival of the Thaw era; she is puzzled by a street event—Voznesensky reciting poetry to a crowd by the Mayakovsky monument—and complains: "I don't understand *anything*." At the end of the film, she is still looking for a husband, this time at the cemetery. She relies on good luck, but gets bad luck: her hockey star husband is ruined by a fatal flaw—not Liuda's fault, but, given her undesirable social origins, there can be no other outcome.

Kindhearted Tonia marries early and becomes a model wife and mother with a dacha and garden. In ideological terms the peasantry was always second-best as a class, lacking in socialist consciousness and attached to private ownership of the land. Consequently, Tonia's life and that of her family is circular and without progress: when

[1] Anna Lawton, *Kinoglasnost'. Soviet Cinema in Our Time* (NY: Cambridge University Press, 1992), 18.

her son brings his girlfriend to the dacha, the same conversations repeat as those of twenty years ago, when Kolia brought Tonia to meet his parents.

Katia is an updated version of the socialist realist heroine of labor — naturally talented, able to face and overcome obstacles to become a chemist and factory director, after which she gets her Prince Charming. Katia's prince is a proletarian, even if he quotes Diocletian, as the old socialist realist model remakes itself to combine worker and intellectual. Nevertheless, by the late seventies, these rigid class paradigms are greatly diminished: Tonia is not criticized for her limited horizons and Liuda is not really condemned for her desires. In fact, it is Liuda who speaks the title of the film. And the girls' lives, with their joys and sorrows, unfold in private — and not public — space. While the atmosphere of Thaw culture is vividly present in the film, the state is largely absent. At a 1980 round table, the actress Vera Alentova (Katia) stressed that "reality is much more complicated than set models ... any one of us is formed first of all by surrounding life, acquiring *one's own* — sweet or bitter — experience." She stressed that the members of the film crew all wanted to make a "kind film" in which good people, friends, are always ready to help each other.[2]

The message of *Moscow Does Not Believe in Tears* is contradictory and regressive in two areas — gender relations and the treatment of alcohol. Katia's view of her past is colored by female self-punishment. Because she lied to Rudolph about her background and then withheld the truth from Gosha about her professional status, she views her abandonments as deserved. Male abuse is justified in the same way: twenty years after the event, she tells Rudolph-Rodion it was good that she had been hurt so badly; otherwise she would never have achieved what she had in life. For his part, Gosha speaks the language of gender essentialism: "I will decide everything for myself because I'm a man"; after the fight with the teenage toughs: "I acted like a normal man. Would you be proud of a woman who cooked a meal?" Gosha pleases Katia by preparing dinner during

[2] "Pochemu tak vzvolnovany zriteli?" *Iskusstvo kino* 9 (1980): 21, 25.

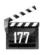

the early days of their acquaintance, but considers "professional" cooking the only appropriate male occupation: shashlyk grilled over a fire "won't tolerate female hands" ("*shashlyk zhenskikh ruk ne terpit*"). The film reaches happy resolution only through the differentiation of gender roles in public and private space. In the end, Gosha implicitly acknowledges that the husband may earn less than the wife, but insists that the man must be head of the (private) family, to which Katia gratefully accedes. This has been the de facto Soviet model since the revolution: a woman may be more successful than her mate in the public sphere, but she is always second in the family hierarchy.

As a hockey player, Gurin initially refuses drinks, but then succumbs to impossible social pressure—because from his closest friends—at the party for Katia's baby, and subsequently his habit is supported by former fans. Yet in another context, drinking to excess is framed positively: Kolia and Gosha bond over vodka and snacks, and neither is sober at different times.[3] In the end, Gurin alone is blamed for his alcoholism, while the other men have merely performed a traditional ritual in which Kolia's intoxication is presented as simply humorous.

[3] Aleksei Batalov (Gosha) has commented that in his drinking scene he is naked under his raincoat and that the censor removed the comic, but risqué scenes in which he paraded back and forth in this state ("Moskva slezam ne verit," Radio Svoboda, http://archive.svoboda.org/programs/cicles/cinema/russian/MoscowDistrustsTears.asp [accessed 1 September 2012]).

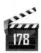

THE CULTURAL LOGIC OF LATE SOCIALISM

Lilya Kaganovsky

In his history of Russian popular culture, Richard Stites qualifies the apparent stability of the Brezhnev period (1964-82), the second longest in Soviet history, as "the peace of a graveyard" (Stites 1992: 148). The period of "stagnation" (*zastoi*) as it was retrospectively called, was marked by a sense of status quo so profound that it felt like the life of the nation had come to a halt. By the time Mikhail Gorbachev was elected in March 1985 as General Secretary of the Communist Party of the Soviet Union (CPSU), "the Soviet economy had been in a period of steady decline for thirty years; by the late Brezhnev era overall growth rates were zero or negative" (Bandelin 2002: 70). This sense of stagnation was not merely economic, it was also rhetorical and ideological: the Soviet Constitution of October 1977 asserted that the attainment of "socialism" had been completed — "Socialism was now said to be 'developed.'" (Bandelin 2002: 70). That is to say, the Soviet Union had reached the end point of the road towards the "bright future." Like Andrei Platonov's "Communism," developed socialism was named in memory of a future that was never going to arrive.

The economic and political stagnation translated as well into the cultural domain. There was, to borrow a formulation from Fredric Jameson, a "cultural logic of late socialism" that had ramifications in the sphere of popular culture. Literature and cinema responded to the economics of "stagnation" with a metaphorization of desire, by repeatedly staging its absence. Emblematic of this absence was Georgii Daneliia's *Autumn Marathon* (*Osennii marafon*, 1979), in which a man caught between his wife, his mistress and his job only feels truly happy when he has seemingly been abandoned by all three. Similarly, El'dar Riazanov's romantic comedy *The Irony of Fate* (*Ironiia sud'by ili s legkim parom!*, 1975), opens with a cartoon about an endless repetition of the same: rows and rows of identical

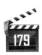

buildings taking over the vast space of the USSR. Though seemingly concerned with love and possibly even sex, these "sad comedies" entirely eliminated sexual desire (as well as its representation on screen): in *Autumn Marathon*, Andrei takes no pleasure in either his wife or his mistress, while in *Irony of Fate*, Zhenia and Nadia seem to fall in love based strictly on the perceived identity of their two apartments, a kind of real estate *méconnaissance*. [...]

Neither Cold War politics (which were perhaps partially responsible for giving an Academy Award to Vladimir Men'shov rather than to Akira Kurosawa or François Truffaut), nor Soviet viewers' love of melodrama are enough to account for the immense popularity of *Moscow Does Not Believe in Tears*, a film that became a Soviet "blockbuster," despite having been under-publicized and initially dismissed by Soviet cinema cadres.[1] As Andrew Horton and Michael Brashinsky suggest, the film was able to capture something about the era in which it was made, while transcending the genre to which it belonged:

> Why did Hollywood, for the first time in thirty years, honor the Soviet picture? Why, if not because it recognized itself on the screen, even though it was dressed in exotic Russian fabrics and set in scenic Russian landscapes? The late 1970s, when *Moscow* was made, were the climactic years of Brezhnev's stagnation period. The whole country paused at the edge of the abyss, in calm and obedient inertia. What could have been a better time for genres to spread, clouding reality with temptingly sweet dreams? Yet *Moscow*, well packaged and performed, was not a typical stagnation movie. Except for rare cases [...] the favorites of the time were war films, essential for Russian culture ever since World War II, and the

[1] As John B. Dunlop has pointed out, the film opened quietly, with almost no publicity, playing in only two theatres in Moscow. Yet, "in the two theaters that showed the film, 1,860,000 viewers queued up to see it in the first two months, breaking all previous records" (Lawton 1992: 239). In 1980, the leading film journal *Iskusstvo kino* published a round-table discussion titled "*Pochemu tak vzvolnovany zriteli?*" to discuss the unprecedented popularity of Men'shov's film. In 1981 *Moscow Does Not Believe in Tears* received an Academy Award for the Best Foreign Film, beating out Akira Kurosawa's *Kagemushu* and François Truffaut's *The Last Metro*. See Beumers (2003).

ugly Communist creation, "industrial films," in which the only conflict was "will the party plan for the plant be fulfilled or not?" (Horton and Brashinsky 1992: 158)

A grand melodrama focused on the lives of three women, *Moscow Does Not Believe in Tears* was also, despite Horton and Brashinsky's formulation above, responding to the prevalent sense of "calm and obedient inertia" with "temptingly sweet dreams." In many ways, *Moscow Does Not Believe in Tears* was the "last Soviet film" of the "last Soviet generation." Its time frame spanned twenty years and attempted to show precisely the movement from socialism's "attainment" (or re-attainment) under Khrushchev to its "developed" state. A decade later, its immense popularity was surpassed by Vasilii Pichul's *Little Vera* (*Malen'kaia Vera*, 1988), by which point Soviet Socialist Realism and Soviet cinema were officially over.[2]

Set in Moscow first in 1958 and then in 1978, Men'shov's *Moscow Does Not Believe in Tears* tells the story of three friends, or perhaps of true love, or better still, a story of late-Soviet desire. Katia, Liuda and Tonia share a room in the workers' dormitory, where they dream of a better life: of education, jobs, marriage and assimilation (not necessarily in that order). The film opens with Katia's slow walk past the dormitory windows after getting the results of her university entrance exam—she has failed by two points and will now have to wait another year before she can begin to study chemistry. "Chemistry," as Liuda explains, is "the future," but it is not "real life." Real life, in her definition, involves dreaming the impossible dream: "to fall in love with a queen [...] to lose a million!," she tells the depressed Katia, after getting rid of two unsuitable suitors, whom she recognizes as fellow *limitchiki*. I would suggest that the "limit" here is not only their distance from Moscow, but also their limited imagination: Liuda's dreams, on the other hand, are without

[2] Richard Taylor brackets his history of Soviet cinema between the dates of the "paper nationalization" of the Soviet film industry in 1919 and the "tumultuous" V Congress of the Union of Soviet Film-makers in May 1986 (in Beumers 1999: 35).

limits, not circumscribed by rules or regulations or accepted codes (Fig. 95). Liuda epitomizes the economy of desire, its "circulation around an always missed piece," its continuous search for an object that promises a future. Her sacred belief is that "Moscow is one big lottery," and you can hit the jackpot ("which is why I always play," she says), suggesting that there is always more to be had than what one has been given. Because she wants to "win everything all at once," Liuda lies, cheats, pretends, and in the end is punished: of the three women, she ends up alone without children, with an alcoholic ex-husband who always wants to borrow money from her, doing her best to attract the attentions of married men. This punishment, like the money her ex-husband demands from her, is payment for her uncontrolled and uncontrollable desire, but more importantly, for her refusal to answer the demands of the state. A telling moment early in the film sets up the economic mechanisms at work in this narrative: we see the manager of the bread factory asking that Liuda pay her union dues—a demand she refuses to acknowledge. Because Liuda will not "pay," because she believes in "winning everything at once," she ends up with nothing—or worse still, forever in debt.

Liuda's failures are clear (and marked as such against Katia's successes, including, finally, Katia's luck in finding an unmarried man in a city in which, as the singles' club director tells her, there are five single women for every single man), but I want to suggest that the film contrasts Liuda not so much with Katia, as with Tonia. But what is Tonia—is she good or bad? Is she the fantasy of proper womanhood, of which Katia, without a man and with an illegitimate daughter, is but a mere shadow? Or is she a *"kulak"* living off private property in the most non-Soviet way? Tonia starts out the film engaged to an electrician—a man, as Liuda points out, she could have as easily found back home in her own village. Liuda makes fun of his qualifications as a suitor: while he seems to have "the right stuff" ("I see you are a worthy suitor: a car, a *dacha...*" she tells him), he dreams small, or possibly, not at all: "Here we'll have strawberries, here we'll have apples," he tells Tonia. "And here we can plant parsley!" she chimes in. Indeed, as Liuda is right to point out, Tonia's married life is pre-scripted, her future perfectly mapped

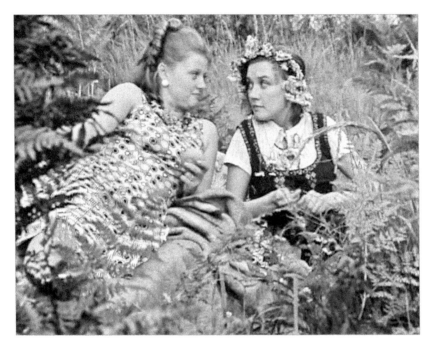

Fig. 95. Liuda and Katia

out for her: first they will save enough for a television set, then for a washing machine, then for a refrigerator. Not only are their desires well known in advance, but they are also the "proper" desires, made available to the Soviet citizenry in pre-packaged forms—as Liuda says, everything is "state planned" ("*vse kak v gosplane raspisano*"). Tonia and her husband are rewarded for their lack of desire: they have two boys, an orchard and a garden that seem to overflow with abundance. "I can see I'm going to have to report you for violating labor laws" ("*Vas pora razkulachivat' za pol'zovanie rab-sily so storony*"), says Liuda, helping to pickle cabbage.

This image of rural happiness that runs counter to the standard socialist realist fantasy of urban success is one of the ways in which *Moscow Does Not Believe in Tears* speaks to the economic, political and discursive conditions of "late socialism." What should be the socialist realist fantasy—Katia, who is meant to remind us of Tania Morozova in *The Radiant Path* (*Svetlyi put'*, Aleksandrov, 1940)— may no longer in fact be the "ideal Soviet woman." On the surface, Katia is everything the film (and Soviet society) should want: she

gets an education, she works hard, overcomes difficulties without help or complaint, rises through the ranks of both skilled labor and bureaucracy, raises a child and has her own car and two-room apartment, with a television set. In the end, she is rewarded for answering the demands of the state: after a number of unsuccessful love affairs, she finally meets her man. "How long I have searched for you!" she says wistfully at the closing of the film, watching Gosha eat soup. But Katia has too much desire, and so the material conditions of late socialism, of calm and obedient inertia, are partially responsible for the creation of Tonia, a character that would have been inconceivable, for instance, in Stalinist film. As Katia says to Tonia, looking out at the orchard heavy with fruit: "I'm generally not envious, but I envy you!"

In *Moscow Does Not Believe in Tears*, Tonia represents a "rural nostalgia" that acts as a countermeasure to the urban desires of Katia and Liuda.[3] Never breaking free of her class origins, Tonia is the happy peasant with two children, a low-skilled job (she is a house painter), and her own overly abundant and overly productive orchard and vegetable garden. One of her earliest lines in the film is to say she is going "*v kontsert*," a mistake Liuda immediately jumps on as symbolic of Tonia's backwardness. Tonia's peasant roots signal her distance from urban "culture" and, with it, desire for things that are "foreign," "imported" and non-Soviet. Liuda, on the other hand, uses foreign words (though her vocabulary is mostly limited to "ciao" and "hello"), reads foreign books (famously, Erich Maria

3 Stites writes that Brezhnev-era culture was split between "the pomposity of power (public gloss, monumentalism, dessicated oratory, and the relentless ritualism of the state)" and the search for personal "authenticity": debates about sex and politics and the inflow of western styles and fashion. The battle was complicated by the fact that large segments of the population continued to prefer traditional Soviet forms of culture. Indeed, many retreated into religion, nationalism, cultural preservation, questing for a lost yesterday, and exaltation of the rural way of life in a continuous and growing divergence between urban dynamic and rural nostalgic mentalities" (Stites 1992: 149). For Russian nationalist themes in Soviet films of the 1970s, including a discussion of *Moscow Does Not Believe in Tears*, see Dunlop (in Lawton 1992).

Remarque's *Three Comrades*, on the Moscow metro), and dreams of a world without limits (or at least, without *limitchiki*). Similarly, Katia's love affairs with wrong men are accompanied by a recording of "Bésame Mucho," the soundtrack underscoring the "foreign" and "imported" nature of this desire. The film marks these imports not only as self-destructive for both Liuda and Katia, but also as symbolic of the period: the Thaw's fascination with the West, and the search for an alternative to what is offered by the Soviet state. […]

In this sense, the role of Gosha is perhaps the most representative of the cultural logic of late socialism and the economics of stagnation. Gosha appears on the commuter train in muddy boots and carrying a samovar. His name, Georgii Ivanovich—also Gosha, also Goga, also Zhora—speaks to a true Russian essence (in contrast to Rudolph/Rodion's affected foreignness and later affected Russianness). But he is also the final version of the "New Soviet Man" in its late Soviet incarnation: as a metal worker, he performs statistically the most common job in the Soviet Union. And though he has the skill and education for advancement, he has no desire to do so.

The birthday picnic staged as a ploy to introduce Gosha's "almost perfect" character is filmed like a dream sequence: the "magic" light of the 1970s […] is perfectly represented here by the autumn sun, the golden trees and the smoke from the *shashlyki*. Indeed, contrasted to the rest of the film, this sequence is composed with a completely different colour palette and soundtrack, that mark it explicitly as "fantasy": Katia is told to close her eyes and go to sleep, dreaming the dream of perfect Soviet happiness. This fantasy turns on finding (or being found by) the perfect Soviet man. Gosha is famously a character that lacks nothing. "I have almost no flaws," he says, and then, perhaps realizing that this might sound a bit too arrogant, adds an element of *samokritika* (self-criticism) in its late Soviet version: "I feel a bit uneasy about it, it sounds like I am somehow ideal; somehow a bit too talented, or something" ("*kakoi-to ideal'nyi, slishkom talantlivyi*"). Asked later by Aleksandra if there is anything he wants, Gosha replies that with a glass of mineral water, he would be the happiest person on earth. We are not far here, in other words, from a film "clouding reality with temptingly

sweet dreams" while the whole country remains paused at the edge of the abyss, "in calm and obedient inertia."

And yet, it is precisely here that Men'shov's *Moscow Does Not Believe in Tears* might be offering us something other than the "straight" reading of the dangers of desire and the rewards of wanting absolutely nothing. In this "dream" sequence, the conversation between Katia and Gosha is counterpointed, one could even say undermined, by a parallel soundtrack: the song "*Dialog u novogodnei elki*" ("Dialogue by the New Year's Tree"), written by Iurii Levitanskii and Sergei Nikitin. In the song, somewhat mimicking the dialogue between Gosha and Katia, a woman and a man conduct a conversation:

* What's going on in this world?
* I believe it is a winter?
* Just a winter, you think?
* Certainly so. [...]
* What would come next?
* April will come... [...]
* What should we do now, then?
* We should just live; make summer dresses from cotton;
* And, you believe, they would be worn one day?
* I believe they should be made regardless...

This contrast between a self-satisfied Gosha in the midst of late Soviet tranquility, on the one hand, and the song, with its repeated message—never give up your desire (that is to say: keep making your summer dresses in the middle of winter)—points to a dissatisfaction; and with it, to the possibility of movement towards some uncertain and unspecified goal. The song historicizes the present by announcing its finality, by promising a future that will be different. Keep wanting, the song appeals, the waltz is about to start ("*i karnaval'nye maski po krugu, po krugu*," "the carnival masks go round and round"). The desire here is structured negatively—it is about acknowledging a state of bewilderment rather than about stating the goals one wants to achieve ("first they save up for a TV..."). It is the "desire to desire" rather than a desire for some thing. In other words, this is desire in its purest form, desire that reproduces

itself, that seeks not satisfaction but its own continuance. It is a dangerous desire because it cannot be halted or fulfilled—it requires movement, a continuous search, a future. At the very moment when Katia seemingly gets everything she wants (a payment from the state for a job well done), the song suggests that she should not accept this as final but continue to dream, to make summer dresses in the middle of winter; the waltz, it says, "is about to start." And this discrepancy between the signifier and the signified, between the dialogue and the song, between the different levels of the film's enunciation, allows Men'shov's film to simultaneously uphold and transgress the late Soviet symbolic order with its demand for maintaining the status quo, pondering perhaps some solutions or "exit strategies" from the society within which it finds itself.[4]

The last line of the film—Katia's wistful observation "*Kak dolgo ia tebia iskala!*" ("How long I've been searching for you!")—undoes this moment of transgression. Gosha's answer to this is mundane: eight days, he says. But Katia, framed in close-up, repeats the line for the second time, equating the importance of the search with the found object, the arbitrary "thing" that comes to fill the void, the gap in the order of being. Soviet subjects are not supposed to lack, and this is made clear by the film's "happy end," Katia finally rewarded for her hard work and sacrifice to the state with the ideal Soviet man. And yet, a lack of desire means death—the "peace of the graveyard"—a condition that speaks to the cultural logic of late socialism that Men'shov's film, at least, makes some attempt to resist.

[4] I am indebted to Sergei Oushakine for his insightful response to this piece and for making his analysis of this scene available to me. I have incorporated his comments and the comments of the anonymous *SRSC* reader here.

WORKS CITED

Bandelin, Oscar J. (2002). *Return to the NEP: The False Promise of Leninism and the Failure of Perestroika*. London: Praeger.

Beumers, Birgit (ed.) (1999). *Russia on Reels: The Russian Idea in Post-Soviet Cinema*. London: I.B. Tauris.

Beumers, Birgit (ed.) (2003). "Soviet and Russian Blockbusters: A Question of Genre?" *Slavic Review*, 62:3, pp. 441-54.

Horton, Andrew and Brashinsky, Michael (eds.) (1994). *Russian Critics on the Cinema of Glasnost*. Cambridge: Cambridge University Press.

Jameson, Fredric (1991). *Postmodernism, or, The Cultural Logic of Late Capitalism*. Durham, NC: Duke University Press.

Lawton, Anna (ed.) (1992). *The Red Screen: Politics, Society, Art in Soviet Cinema*. New York: Routledge.

"Pochemu tak vzvolnovany zriteli?" (1980). *Iskusstvo kino* 9, 28.

Stites, Richard (1992). *Russian Popular Culture: Entertainment and Society since 1900*. Cambridge: Cambridge University Press.

FURTHER READING

First, Joshua. "Making Soviet Melodrama Contemporary: Conveying 'Emotional Information' in the Era of Stagnation." *Studies in Russian and Soviet Cinema* 2, no. 1 (2008): 21-42.

Gillespie, David. "Moscow Doesn't Believe in Tears." In *The Cinema of Russia and the Former Soviet Union*, edited by Birgit Beumers, 193-201. London: Wallflower Press, 2007.

MacFadyen, David. "*Moscow Does Not Believe in Tears*: From Oscar to Consolation Prize." *Studies in Russian and Soviet Cinema* 1, no. 1 (2007): 45-67.

Tiazhel'nikova, Viktoriia. "'Moskva slezam ne verit': zhiznennye strategii sovetskikh zhenshchin v 1950-1970-e gody." In *Istoriia strany. Istoriia kino*, edited by S. S. Sekirinskii, 363-74. Moscow: Znak, 2004.

PART

SIX

PERESTROIKA AND POST-SOVIET CINEMA 1985-2000s

Vida Johnson and Elena Stishova

Before Perestroika: The Film Industry Crisis (1975-1985)

The systemic crisis in contemporary Russian cinema, which some say has not yet been resolved in the 20 years of the turbulent post-Soviet era, began during the Stagnation period. In the late 1970s the Soviet Union, at least outwardly, seemed indestructible. Soviet leaders were especially proud of their national cinema, which remained "the most important of all the arts" (as Lenin was reputed to have said), at a time when the rapid growth of television in Europe and America had overshadowed that of the movies, forcing film industry moguls to compete by producing ever more visually stunning, action-packed, big-screen productions.

In the Soviet government-controlled film industry, where ideology had always trumped market considerations, the television threat came later and had a different dynamic. Annual movie attendance peaked in 1968 at 19 per capita, continuing at this high level until 1975, when the TV boom finally reached the Soviet Union. In the following decade, movie attendance plummeted about 25 percent, partly because much of the traditional socialist realist fare no longer met audience expectations. This significantly reduced film industry revenue, which throughout the Soviet period had held steady in third place, after oil revenues and vodka sales. In the ensuing crisis, the head of Goskino USSR, Filipp Ermash, a Brezhnev-era party-line bureaucrat with a producer's instinct, actively supported commercializing Soviet film on the American model. A tentative genre revolution took place, which offered the Soviet public some high quality films but also many mediocre knock-offs, lowering, according to some Russian film critics, the level of professionalism on which the Soviet industry had prided itself.

The culmination of this process was the awarding of the best foreign film Oscar in 1980 to Vladimir Men'shov's mainstream film, *Moscow Does Not Believe in Tears*, still a beloved Russian audience favorite, with 84.4 million ticket sales in the year of its release. Despite the film's international success, a growing ideological crisis—some might even say collapse—threatened the industry. Its leadership, ignoring the changing reality, insisted on the long-dead triad of Communist priorities—ideology, party-mindedness and popular spirit—at a time when such film epics no longer even recouped production costs. In 1984, despite a few huge hits, the no longer profitable Soviet film industry became fully subsidized. This crisis was not caused by but coincided with the process of political and economic liberalization begun in 1985 by the Soviet Union's new leader, Mikhail Gorbachev.

Glasnost' and Perestroika (1985-1991)

In March of 1985, after a number of aging leaders had died in quick succession (a cause for much black humor among the cynical population), a relatively young and charismatic "Gorby" was elected General Secretary of the Central Committee of the Communist Party of the USSR. Much of the country responded to his call to rebuild the Soviet state through a process of "glasnost'" (openness) and "perestroika" (restructuring). The Filmmakers Union, as the most liberal-leaning creative organization (from the perspective of the times) was the first to support Gorbachev. Its Fifth Congress, which convened in mid-May of 1986, became an historic event in the country's cultural restructuring. In the Grand Kremlin Palace, where Communist Party Congresses usually took place, and where the Supreme Soviet of the USSR held its meetings, the wave of perestroika swept out of office the "untouchables," the Union's official, party-line leaders, the film bureaucrats and "artists," who still supported the teetering, grand structure of Soviet cinema. After a three-day-long debate, the Union's leadership changed radically with the election of Elem Klimov, the highly respected director of *Agony* (*Agoniia*, 1974/1981), *Farewell* (*Proshchanie*, 1982) and *Come and See* (*Idi i smotri*, 1985), films that challenged the Soviet party line.

Although other creative unions followed in the filmmakers' steps, the Union of Filmmakers, which earned Gorbachev's personal favor, remained the leader in this process of liberalization.

One of the new leadership's first resolutions was to create the so-called Conflicts Commission, charged with releasing films banned for ideological reasons (the most famous being Aleksandr Askol'dov's 1967 *Commissar*) and with reestablishing the director's cut of the many films wrecked by the censors' scissors. The most significant of these re-releases was Andrei Tarkovsky's *Andrei Rublev*, the nonconformist, naturalistic and violent wide-screen epic of medieval Russia, retitled as *The Passion According to Andrei (Strasti po Andreiu)*. But while the Commission was working in 1987-88 to release some one hundred banned films from Soviet times, as well as approximately 250 that were never released, recent films continued to be censored by the conservative bureaucrats of Goskino, the Ministry of Cinema.

Confrontations between a stagnating Goskino and the innovating Filmmakers' Union were inevitable, but the leaders of the Union, mostly from the idealistic Thaw or Sixties generation, were more preoccupied with the romantic notion of annihilating Soviet structures like Goskino than with pragmatic ways to create a functioning structure for the film industry. The new 1987 governmental economic directive of "*khozrashchet*," by which industries were required to be profitable without government subsidy, only exacerbated the film industry crisis.

What effect did Gorbachev's glasnost' and perestroika have on the films themselves? What kind of films were being made and how were they received?

Despite structural problems within the industry, Soviet films of the late 1980s were well received both domestically and internationally. 1986 saw the release of *Repentance* by the outstanding Georgian director Tengiz Abuladze. Although the film had been completed in 1984, it could not break through government censorship until after Gorbachev came to power, despite the personal support of Eduard Shevardnadze, the first Secretary of the Communist Party of Georgia. The film's appearance was a shock: it was an openly anti-totalitarian and anti-Stalinist state-

ment. *Repentance's* expressionist and surreal filmic style dealt a death blow to the realistic-positivistic tenets of Socialist Realism, the only approved method in the arts since 1934, to which filmmakers were paying decreasing lip service by the 1980s. *Repentance* received both the Grand Jury Prize and the prestigious FIPRESCI international press award at Cannes.

From that moment on, international festivals tried to obtain perestroika films. The Berlin International Film Festival invited Marina Goldovskaya's concentration camp documentary *Solovky Power* (*Vlast' solovetskaia*, 1987), and two years later Kira Muratova's *Aesthenic Syndrome* (*Astenicheskii sindrom*, 1989), a diagnosis and revelation about an ailing Soviet society and its *homo sovieticus*, won the Silver Bear, the highest prize in Berlin. In short, an up-to-date perestroika repertoire of hard-hitting films that explored and critiqued Soviet history and society coalesced rather quickly. There was a sense among filmmakers and the intelligentsia that the crisis might have passed; here was the renewed art form that both artists and viewers desperately craved.

The glasnost' period was, first and foremost, marked by the rediscovery of cinematic treasures, the banned films which attested to the richness of Soviet filmmaking and often officially unacknowledged Stagnation-era artistic talent. These works complicated and rewrote the history of Soviet cinema. Secondly, this was also a time of the wholesale rewriting of Soviet history, of exposing, especially in documentaries or docudramas, the horrors of the Stalinist period. Finally, glasnost' and perestroika films explored contemporary social and economic decay and the loss of ideals and beliefs, often portrayed as a generational conflict between believing Soviet-era parents and their rebellious, cynical children.

As noted in the introductory essay to the Stagnation period, a number of films from the early 1980s had already dealt with social problems and the growing disillusionment with Communist ideology and the decaying Soviet system. The films of the late 1980s, however, offered a no-holds-barred, full-scale demolition of that system. In the noted documentary *Is It Easy to be Young?* (*Legko li byt' molodym?*, 1987), as well as feature films like *The Burglar* (*Vzlomshckik*, 1987), *The Courier* (*Kur'er*, 1987) and Sergei Solov'ev's

campy cult film *Assa* (1988),[1] alienated youth with their protest rock, drugs, punk dress and hair styles offered a critique of the now apparently meaningless sacrifices of the older generation: these conformist parents could not let go of the Soviet myths instilled in them, despite the fact that their difficult lives clearly belied those myths. The positive Communist heroes and heroines of the past gave way to alienated antiheroes, and the modern industrial and urban environments were replaced by settings of decay: rusting machinery, aging industrial plants, polluted landscapes, claustrophobic communal apartments, run-down buildings and trash heaps. The formerly highly-touted progress of Soviet society was nowhere to be seen. A whole new movement appeared — what the British call "kitchen sink" films, hard-hitting social dramas with naturalistic, "in your face" cinematography featuring extreme close-ups and rapid hand-held camerawork.

The most representative and arguably the best of these films was Vasilii Pichul's début, *Little Vera* (*Malen'kaia Vera*, 1988), notorious for breaking the last taboo of Soviet cinema — on-screen sex. Officially criticized for its candid bedroom scenes, the film was also one of the last to be temporarily censored. Its main revelation, however, was the desacralization of the working class hero: the heroine's father, a hard-drinking truck driver, is depicted as aggressive, poorly educated and narrow-minded, and who, despite loving his daughter, is far removed from the progressive ideas of the working class heroes who populated Soviet screens of the past. In fact, the film, step-by-step, exposes and then annihilates the communist mythology so carefully nurtured in Soviet cinema: class equality created by education for all, the happy working class family, the industrial progress that leads to a better life, the belief in a communist future, society as a big, happy family, the absence of serious crime and social ills, the essential goodness and morality of the country's youth, who represented its future. *Little Vera* became the glasnost' response to the utopian idyll of *Moscow Does not Believe in Tears*.

[1] It was Solov'ev who taught the next generation of filmmakers.

In the late 1980s the distribution network was still functioning, movie theaters were full, audiences were eager for the next revelation and one even had to stand in line for tickets. *Little Vera,* one of the last two Soviet-era hits, was seen by some 55 million viewers. The other significant film was the 1989 *Intergirl* (*Interdevochka*) by Petr Todorovskii, a highly respected director of the older generation, who demolished another taboo theme in Soviet culture—prostitution. The film was a contemporary social drama of a nurse moonlighting as a hard-currency prostitute catering to foreign clients, whose potentially happy future, after marriage to her Swedish "john," is cut short when she rejects the cold West to return home to the Soviet Union. Sociologists have noted that, in the socially and economically turbulent final years of the Soviet Union, being a high-class call girl was rated in polls (especially among young women) as one of the most prestigious women's professions. With some 40 million viewers at home, the film also made the festival rounds and earned the top prize at the Tokyo International Film Festival. This last Soviet hit was also the first film to represent a new, western-style producer's project, here in the capable hands of the director's wife, Mira Todorovskaia, who brought in Swedish partners as well as the Mosfilm studio. The final years of the 1980s signaled the end of the Soviet cinema with its mass viewership.

The Post-Soviet Period: The 1990s Crisis

At the beginning of the 1990s, economic decline and the government's inability even to feed the population exacerbated an existing political crisis that resulted finally in the breakup of the Soviet Union. In August of 1991 reactionary forces within the government took advantage of Gorbachev's vacation in the Crimea to stage an armed coup, which failed when the military refused to fire on the massive crowds that protested the takeover and supported democratic reforms. Boris Yeltsin, who in June of that year had been elected President of the Russian Federation, one of the constituent Soviet republics, became the ideal vision of the country's next leader. His athletic figure poised atop a tank and his fiery address to the crowd became symbols of heroism, fearlessness and devotion to the peo-

ple's cause. When Gorbachev returned from vacation, it was clear that his time had ended. Just a few months later, the leaders of the Soviet republics met and voted to disband the Soviet Union, which was then one year shy of its 70th anniversary. With Gorbachev's resignation on December 25, 1991, the Soviet Union officially ceased to exist. Yeltsin then became President of Russia, the largest Soviet successor state, but clearly no longer a global superpower. The 1990s were marked not only by a serious economic crisis (rampant inflation, the default of the ruble in 1998) which impoverished the population, but also by the collective psychological trauma of lost national identity and world status, and the difficulties of a new life in an upended political and social system. All this was reflected in the fate of the cinema industry and in the films themselves.

The turbulent nineties proved to be almost fatal for Soviet cinema, with the breakdown of film distribution and the structure of the film industry, rampant privatization of state property, a disastrous reduction by mid-decade in film production and the disappearance of both movie theaters and their audiences. Viewers grew tired of the films pejoratively referred to as *"chernukha"* (blackness) and *"pornukha"* (porno). By the early 1990s, cinema had become a barometer of the country's problems, offering a steady and shocking diet of societal dysfunction: violence, rape, drugs, prostitution and all manner of other crimes. But Russian viewers no longer wanted to see on the screen the hardships they experienced in daily life. Until late in the decade, one of the unanswered questions was how to make films that audiences could relate to at a time when there seemed to be no rules, laws, or beliefs, and no reliable economic structures in the film industry itself.

Six months before the Soviet Union's collapse, a governmental ruling had eliminated the old Soviet structure of Goskino as a separate ministry, as well as all its organizational structures, including the film distribution department. Privatization of state property under Yeltsin brought a massive buying up of state movie theaters and film distribution licenses. Huge movie theaters with outdated technologies were often turned into automobile showrooms or furniture stores, or were closed, thus limiting venues for film screenings. It was not until 1996 that Kodak Kinomir, a new type

of modern movie theater with Dolby surround-sound appeared in Moscow, followed in later years by western-style multiplexes. With high ticket prices aimed at the well-to-do class of New Russians, especially young adults, audiences remained small until the Russian blockbuster revival in the mid-2000s.

Poor distribution plagued Russian films throughout the 1990s, as film distributors successfully hooked viewers on cheap, mostly pirated, Hollywood action films. Opening nights for first-run, highly rated American films took place in the U.S. and Russia at the same time. Throughout the 1990s, the American film industry fought hard against the film and video piracy rampant in Russia, which finally came under control by 1998. The only venues where Russian films could be seen on the big screen were the Russian Open Film Festival in Sochi and the Russian sidebar at the Moscow International Film Festival. As a result, a number of films that were important for understanding the changes taking place in the Russian mentality, society and culture never reached viewers.

Just as in other aspects of the turbulent post-Soviet economy of the 1990s, a lawless, wild-west capitalism prevailed in the film industry. Gray-market and black-market money found its way to film production, and in the beginning of the 1990s some 300 or more feature films were made annually (compared to 100-150 in Soviet times), most never released, and clearly never profitable for their investors. The easy money then dried up and there was very little remaining government subsidy. The film industry nearly collapsed, while the television industry showed steady growth; nowadays feature films are also produced by TV companies. The lowest point in Russian film production occurred in the mid-1990s, with approximately 28 features in 1995 and only a few more the following year. Film attendance dropped drastically throughout the 1990s and did not begin to revive until the new millennium. Only a few major Russian hits emerged towards the end of the decade, and they were aimed primarily at younger, mostly male, viewers.

Meanwhile, production relations in the cinema industry were changing. The hierarchy was evolving as well: the role of the producer as the main figure in the filming process was being defined more clearly. One of the most successful has been the director-turned-

producer Sergei Sel'ianov, whose company STV has produced, since the 1990s, some of the best Russian films. A reformed, albeit much truncated, structure of Goskino continued to exist and still exists today. Its main function is the partial subsidizing of film projects approved by its committee of experts, but this is far less than the total funding provided by Goskino during the Soviet period, when there was no private film industry. Thanks to privatization, filmmakers had to learn to raise funds themselves for their projects and many private production companies were formed, one of the earliest and most profitable being Nikita Mikhalkov's TriTe. Parallel to the continuing partial government subsidy, new sources of funding emerged: large corporations, like Gazprom (the gas monopoly) could afford to participate in prestigious film projects. The amounts of such funding were never openly accounted for, nor were taxes paid, especially in the early 1990s, as much illegal money was laundered through film.

No one other than the filmmaker himself knows the budgetary details of Nikita Mikhalkov's legendary *Burnt by the Sun*, awarded the best foreign film Oscar in 1994. This anti-Stalinist, anti-totalitarian family melodrama failed to impress serious Russian critics, although no one denied Mikhalkov's talent and professionalism. Abroad, the film fared better in festivals and even in modest distribution in the U.S, as it was recognized for its compelling story line, outstanding acting and luminous cinematography. At home, Mikhalkov distributed the film himself, attending screenings in the far reaches of Russia under armed guard, making sure that the film was not pirated (literally copied off the screen), because he did not trust Russian distributors.

In this period of extreme instability, the Russian Law on Cinema was passed in 1996, clarifying Goskino's responsibilities: to control film licensing and registration, support development of industry infrastructure, help distribute and promote Russian films, and determine authors' rights to films. As new laws began to take effect and as the major studios, especially Mosfilm and Lenfilm, restructured and were placed on firmer footing, the industry situation towards the beginning of the new millennium allowed for improved film production.

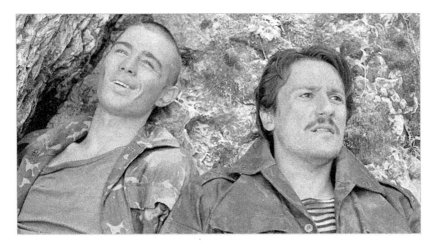

Fig. 96. Vania and Sasha

What kinds of films were made in the unstable 1990s? Russian filmmakers began to copy American action films, seriously diminishing the production of traditional Russian (formerly Soviet) film genres: comedies, psychological dramas, literary adaptations, and children's and youth films simply ceased to exist. Some Russian critics argue that the thematic impoverishment of post-perestroika cinema could only be compared to the *malokartin'e* (era of few films) of the post-war Stalinist period (late 1940s to early 1950s), when only epic, patriotic projects were approved and financed by the government. Or that filmmakers seemed unable to come up with socially relevant themes, despite that fact that in the 1990s there was a war with Chechen separatists, society was being criminalized, corruption was expanding, industry was collapsing, thousands of people were losing their jobs, and a large population migration was taking place throughout the territory of the collapsed empire. In short, real life offered plenty of up-to-date material for major socially analytical and critical film projects, but filmmakers were hampered by the collapse of the accustomed Soviet ideological framework and the absence of a new meta-language for film.

Not even critics were ready to accept the attempt at a new film style and language in Alexander Mindadze and Vadim Abdrashitov's 1997 *Time of the Dancer* (*Vremia tantsora*). This story of the dramatic consequences of a seemingly minor colonial war, fateful for both the

victors and the defeated, was not recognized for its deep exploration of the collapse of the Soviet empire. Other films of the 1990s openly engaged the post-colonial war in the former Soviet borderlands, set in what is obviously Chechnia. Sergei Bodrov's internationally recognized *Prisoner of the Mountains* (*Kavkazskii plennik*, 1996, Fig. 96), starring his son in the role of the innocent, pacifist recruit who was to morph into the honorable hitman in *Brother*, brought universal human values and understanding of both sides to a wartime conflict. One of the best films of the 1990s, Aleksandr Rogozhkin's *Checkpoint* (*Blokpost*, 1998), was an ironic commentary on borderland wars, really standoffs, with no clear-cut heroes or objectives, also a theme of Bodrov's film.

A number of important films in the mid-1990s began a search for a new, post-empire Russian identity and a new definition of Russian space: *The Muslim* (*Musul'manin*, 1995), *The Time of Sorrow Has Not Come* (*Vremia pechali eshche ne prishlo*, 1995) and the wildly popular *National Hunt* comedy series (1995-99), replete of course with the Russian national product—vodka. At the Fourth Congress of Filmmakers in 1998, Mikhalkov, the new chairman of the Filmmakers' Union, called for a new Russian national identity and a new national hero. He attempted to do just that in his much maligned and far-fetched historical melodrama, *The Barber of Siberia* (*Sibirskii tsiriul'nik*, 1998), where he himself tellingly played Tsar Alexander III. Along with Mikhalkov, other directors began to search for a new Russian identity in its pre-revolutionary, pre-Soviet past, thus reviving the genre of historical epic, with much heroic action, albeit often without much success. One exception among the historical films is *The Russian Ark* (*Russkii kovcheg*, 2002), Aleksandr Sokurov's tour de force, 97 minute single-shot romp through the Winter Palace and Russian imperial history.

Towards the beginning of what Russians call the "zero years" (the 2000s), films began to screen the actual social turmoil of the 1990s in a very realistic manner. Aleksei Balabanov's films *Brother* (1997) and *Brother 2* (2000) merge the basic structure of an action film with both traditional and evolving Russian values in a lawless society. Balabanov brought to the screen a new hero, whom the children of perestroika recognized as one of their own. Sergei

Bodrov Jr. turned out to be the ideal actor for the role of Danila, the baby-faced killer shaped by brutal wartime experience in Chechnia, which does not deprive him of his childlike charm and naïveté, while also giving him a powerful impetus to defend the weak. Danila honors justice and family relations, loves his country and is proud to be Russian. His anti-American rhetoric, his tough fighting with the black pimps who exploit Russian prostitutes in Chicago in *Brother 2* evoked crushing criticism of the film and its hero from the liberal intelligentsia. Both works, with their musical soundtracks, their pride in "being Russian" and even their xenophobia, became cult films among the young, perhaps because they were released at a time when the post-Soviet crisis of identity and the awareness of Russia's loss of superpower status were at their peak. These films laid the groundwork for a cinematic revival of Russian nationalism in the new millennium, wholeheartedly supported by the new President, Vladimir Putin, who was elected in 2000.

Post-Soviet Cinema: Putin's Russia and the Zero Years

The "fat" (*tuchnye*) zero years, so called because of the rising price of oil that lifted Russia out of its financial crisis, represent a qualitatively new stage in Russian cinema. One cannot quite call it a revival, but important internal changes did occur; filmmakers regained the confidence that the formerly great Soviet cinema might have a Russian and an international future after all. Towards the end of the 1990s, the film world of international festivals again began to talk about Russian cinema: it was shocked by the opening at Cannes of *Khrustalev, My Car!* (*Khrustalev, mashinu!*, 1998), the highly scandalous and long-awaited anti-Stalinist film by Aleksei German, featuring graphic violence, sexual abuse and the decomposing body of the dying Stalin. This unusually long, narratively and visually complex film failed miserably at Cannes, although that did not prevent respected critics, just one year later, from calling it a work of art. The film concluded the anti-Stalinist, anti-totalitarian theme so prevalent in Russian cinema of the 1990s. To *Khrustalev, My Car!* one can add *Taurus* (*Telets*, 2001) by Aleksandr Sokurov, the internationally acclaimed heir-apparent to Andrei Tarkovsky

and the most famous auteur of late Soviet cinema. *Taurus* is an uncompromising film about the last days of the terminally ill Lenin, a prisoner in his suburban Moscow residence, isolated on Stalin's orders from all outside contact. Despite the differences in style and content between these films, they share the presence of a new historical discourse, although neither positions itself as an historical film. The dying Lenin and Stalin in films at the end of the millennium are themselves metaphors for the death of the Soviet empire.

The year 2000 saw another controversial film, Aleksandr Zel'dovich's *Moscow* (*Moskva*), with an original screenplay by the well-known writer Vladimir Sorokin. This ambitious postmodern deconstruction of Soviet myths and even symbolic geography was not immediately accepted at home because Russian critics did not understand postmodern analysis. *Moscow* became the first film in which, through eccentric characters, the filmmaker and writer explored the spiritual state of the segment of society dubbed the "New Russians." The film's hopelessly pessimistic message casts a shadow on the near future, unable to fulfill the promise that life could be better. Yet this film also offers a visual message for the future in presenting the landscape of twenty-first-century Moscow with its glistening glass, western-style architecture that would become a standard setting in many films to follow.

Does the failure to attract audiences of auteur projects like *Moscow* or *Magnetic Storms* (*Magnitnye buri*, 2003)[2] mean that Russian cinema has ceased to be "the most important of the arts," that Russian audiences have become indifferent to films making serious statements about their own society? Or is it that the limited domestic distribution of auteur films, as well as their complex narrative structures and metaphoric language, will always relegate them to a small festival viewership, as is true of films worldwide in the twenty-first century? Or is the international market and producer-

2 *Magnetic Storms*, the last joint film by the well-known director-scriptwriter pair of Abrashitov and Mindadze is a highly metaphoric film that explores the experience of the working class hero, a factory worker caught in the criminal privatization struggles of the 1990s.

based business model for cinema crowding out art cinema in Russia, as elsewhere? Or is it a combination of factors resulting both from the breakdown of the Soviet system and the resulting new social, economic and political realities, as well as from the development of an international Hollywood-driven cinema industry model? A number of different forces appear to be at work.

What is clear is that the market-based western economic model, adopted for the whole Russian economy in the 1990s, was a huge shock to filmmakers, especially those of the older generation, accustomed to film production with only one funding source and one producer—the state. Now filmmakers had to raise their own funds and become producers. The Russian government did partially retain its role of producer with the Ministry of Culture's film department (still popularly called Goskino), providing some subsidies for film projects, although in 2009 subsidies for feature films were moved to the independent Fund for Social and Economic Support of Domestic Cinema, proposed by the most powerful man in Russian cinema, Nikita Mikhalkov. While the small Goskino subsidies did not require a return, the Fund has a market model, so that resources go to the most successful major studios that have developed in the last decade, making art films even more difficult to finance. The Film Fund has become the main distributor of the budget for Russian cinema, with some 3.8 billion roubles, while the Ministry of Culture has barely a billion, mostly for small films.

In addition to these changes in funding, the whole infrastructure for film production, which had functioned smoothly in Soviet times, disintegrated over the 1990s and is slowly being rebuilt. From the numerous small studios which have come and gone in the 1990s, the zero years saw the rise of "majors" producing mainstream commercial pictures. As a result, a genre boom took place in the middle of the decade, which some argue destroyed the cinema of ideas through blockbusters, thrillers, action films and gangster sagas of the Russian ilk, catering to lowbrow audience appetites for entertainment. However, other industry observers see as positive the development of blockbuster cinema which is bringing viewers back into theaters, pointing to Timur Bekmambetov's popular action-packed mystical thriller, *Night Watch* (*Nochnoi dozor*, 2004), which

even Hollywood distributors bought for worldwide release. In addition, *The Ninth Company* (*9 rota*, 2005), Fedor Bondarchuk's epic about the Soviet war in Afghanistan, with its resurgent patriotism, became the box office winner of the post-Soviet era with 6 million viewers, still orders of magnitude less than late 1980s glasnost' films were able to muster. But after the disastrous box office of the 1990s, such films offered hope that an industry revival was underway.

Although the authorities who loosely supervise the film industry do not regulate a film's message, as in Soviet times, the rise of ambitious patriotic films (historical and World War II epics) has been supported from "above" in the Putin years, implicitly exposing the government's renewed superpower ambitions.[3] Mid-decade, near the sixtieth anniversary of the end of World War II, known in Russia as the Great Patriotic War, a number of action war films appeared with the clear intent of raising the national spirit by reminding Russians of their past victories.

Nikita Mikhalkov's latest blockbuster and probably the most expensive post-Soviet Russian film ever made, *Burnt by the Sun 2*, literally resurrects the hero of the first film, arrested and supposedly killed during the Stalinist purges, by having him become a war hero tested in front-line military service in a penal battalion. Despite Mikhalkov's reprise of his role as the charismatic Kotov, the public did not respond to the film, nor did war veterans, because its many improbable coincidences and over-the-top fairy tale plot undermined the reality of that terrible war.

The desire to revive large-scale Soviet-era epics can be seen in the continuing production of war films: Fedor Bondarchuk, now one of the most successful industry figures, is completing *Stalingrad* (to be released in late 2013), an account of the biggest World War II battle on Russian soil and the first Russian film shot in IMAX 3D. There have also been a few revisionist war films, such as Aleksei German Jr.'s *The Last Train* (*Poslednii poezd*, 2003), which, in the

[3] Although Putin was President from 2000 to 2008, acting as Prime Minister under Dmitri Medvedev from 2008-2012, when he was re-elected President, he had firm control of the government and its policies throughout these years.

continuing tradition of art cinema, questions the cost of World War II for both sides.

There are at present worrisome signs of increasing state regulation of the cinema industry, primarily through a plan to finance only ministry-approved film proposals on desirable topics, as an antidote to unpatriotic and morally questionable, privately produced commercial films and the influence of mainstream American cinema. At Putin's May 2013 meeting with politically sympathetic filmmakers, minister of culture Vladimir Medinskii announced that films would henceforth receive state funding according to the specific project rather than by studio. (This facilitates closer supervision of content by the government.) In a reversion to Soviet practice, Medinskii also announced an annual "thematic plan" for feature and documentary films. Proposals relating to twelve set topics, such as the anniversary of the World War II victory, the war against drug addiction, heroes of labor and the hundredth anniversary of World War I, would receive funding priority. The ministry would also begin to commission film scripts, an old—and unsuccessful—Soviet-era strategy.[4]

Blockbusters may be bringing viewers back into theaters, but they are for the most part aimed at domestic audiences, and simply lack the continuing international appeal of Russian art films. International festival organizers prefer to choose the Russian mystical or spiritual product, serious films that explore the "Russian soul." It is the Venice International Film Festival that brought a new talent to the Russian audience, the filmmaker Andrei Zviagintsev, who earned two of Venice's highest awards, the Golden Lions, for his then little known début film, *The Return* (*Vozvrashchenie*, 2003). In that same year, he was awarded the prestigious European film prize, the Felix, in the "discovery of the year" category.

4 "Putin i kino," *Takie Novosti* , http://takie.org/news/putin_i_kino/2013-05-25-4175 (accessed 27 May 2013); an earlier, more extensive list of topics for the "thematic plan" can be found in Valerii Kichin, "Kino zakazali. Ministerstvo kul'tury vozvrashchaet v kino 'tematicheskii plan'," *Rossiiskaia Gazeta* (19 Feb. 2013), http://www.rg.ru/printable/2013/02/19/kino-site.html (accessed 2 June 2013).

Zviagintsev, who has now become the representative of international Russian film discourse, may also be considered the leader of a new post-Soviet film generation. This potential leader has no such ambitions himself, nor do the rising filmmakers of his generation. Someone has wittily named them the "new quiet ones" (*novye tikhie*). This young cohort (mostly in their thirties) does not position itself as manifesto-bearing rebels or protesters. Aleksei Popogrebskii, Boris Khlebnikov, Andrei Proshkin, Larisa Sadilova, Svetlana Proskurina, and the even younger and more strident Valeriia Gai-Germanika are gradually telling viewers about contemporary Russian life, about the new realities of the post-Soviet era, to which people have become accustomed without noticing the changes. Popogrebskii's *Simple Things* (*Prostye veshchi*, 2007) offers a modest slice of this reality: a conscientious anesthesiologist is constantly forced to make compromises and even take bribes because salaries in the traditional professions, unlike those in the business world, are not sufficient even to feed his family in today's Russia. In Soviet times, such behavior would have been possible only in a criminal story. Popogrebskii's internationally successful *How I Ended This Summer* (*Kak ia provel etim letom*, 2010) tells the story of two meteorologists working at a remote station in the Arctic. In an intense study of human relationships that explode under the pressure of isolation in a hostile environment, the film takes up a number of contemporary issues, conveyed in an austerely minimalist cinematic language: the generational conflict of fathers and sons, the tension between Soviet and post-Soviet values, the effects of Soviet-era environmental pollution on the Far North, and modern psychology's — and cinema's — radical oversimplification of human motivation.

Many of these films explore the hard life in the provinces, where supposedly authentic Russia, whether good or bad, is to be found, and implicitly or explicitly contrast it to the new, artificial construct, based on the superficial western model, now flourishing in the major cities. Films of the "new quiet ones," such as Boris Khlebnikov and Aleksei Popogrebskii's *Koktebel'* (2003) and Svetlana Proskurina's *Truce* (*Peremirie*, 2010), and those of other directors, such as Anna Melikian's *The Mermaid* (*Rusalka*, 2007), Aleksei Fedorchenko's *Silent*

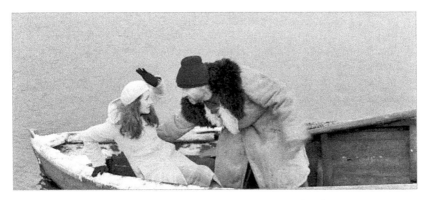

Fig. 97. Father Anatolii and the Possessed Girl

Souls (*Ovsianki*, 2010), and Sergei Loznitsa's *My Joy* (*Schast'e moe*, 2010), present physical and metaphorical journeys (often including elements of the road movie), which attempt a discovery of self or a new definition of identity. The growing rejection of western values and the search for traditional Russian ideals leads, in a number of films, including historical epics, to a rediscovery of Orthodox Christianity, whose worship was suppressed throughout the Soviet period. Thus, it is not surprising that Pavel Lungin's *The Island* (*Ostrov*, 2006) (Fig. 97), the story of a man expiating his sins by becoming a monk in a distant monastery, became an audience hit.

Although contemporary Russian cinema offers popular genres such as comedy, fantasy, action, melodrama, historical epics and war films, based on homegrown as well as western models, but with definitely Russian content—something that audiences have been clamoring for—serious viewers and critics can appreciate the low-budget art films that critically explore life in today's Russia. Such films will continue to earn festival acclaim if not large theater distribution in Russia and, fortunately, are widely available on DVD. In the meantime, the search for new, at times more realistic, heroes and for a mass audience continues and intensifies with well-made 2013 blockbuster hits *Metro* by Anton Megerdichev and *Legend No. 17* by Nikolai Lebedev.

Further Reading

Condee, Nancy. *The Imperial Trace: Recent Russian Cinema.* New York: Oxford University Press, 2009.

Goscilo, Helena, and Yana Hashamova. *Cinepaternity: Fathers and Sons in Soviet and Post-Soviet Film.* Bloomington, IN: Indiana University Press, 2010.

Hashamova, Yana. *Pride and Panic: Russian Imagination of the West in Post-Soviet Film.* Bristol: Intellect, 2007.

Horton, Andrew, and Michael Brashinsky. *The Zero Hour: Glasnost and Soviet Cinema.* Princeton: Princeton University Press, 1992.

Lawton, Anna. *Before the Fall: Soviet Cinema in the Gorbachev Years.* Washington, DC: New Academia Publishing, 2007.

Merrill, Jason. "Brothers and Others: Brotherhood, the Caucasus, and National Identity in Post-Soviet Film." *Studies in Russian and Soviet Cinema* 6, no. 1 (2012): 93-111.

Norris, Stephen M., and Zara M. Torlone. *Insiders and Outsiders in Russian Cinema.* Bloomington, IN: Indiana University Press, 2008.

Norris, Stephen M. *Blockbuster History in the New Russia: Movies, Memory, and Patriotism.* Bloomington, IN: Indiana University Press, 2012.

Stishova, Elena. *Rossiiskoe kino v poiskakh real'nosti.* Moscow: Agraf, 2013.

REPENTANCE

Monanieba (georgian); Pokaianie (russian)

1984 (1986 premiere at Dom Kino; 1987 release)

153 minutes

Director: **Tengiz Abuladze**

Screenplay: **Nana Dzhanelidze, Tengiz Abuladze, Rezo Kveselava**

Cinematography: **Mikhail Agranovich**

Art Design: **Georgii Mikeladze**

Music Coordinator: **Nana Dzhanelidze**

Sound: **Dmitrii Gedevanishvili**

Production Company: **Gruziafilm**

Cast: **Avtandil Makharadze (Varlam and Abel' Aravidze), Zeinab Botsvadze (Keti Barateli), Iia Ninidze (Guliko Aravidze), Merab Ninidze (Tornike Aravidze), Ketevan Abuladze (Nino Barateli), Edisher Giorgiobani (Sandro Barateli), Kakhi Kavsadze (Mikhail Korisheli), Nino Zakariadze (Elena Korisheli), Amiran Amiranashvili (Doksopulo), Veriko Andzhaparidze (old woman pilgrim)**

Georgian director Tengiz Abuladze (1924-1994) graduated from the State Film Institute in 1953, where he studied with Sergei Iutkevich. His early film *Magdana's Donkey* (*Lurdzha Magdany*, 1955), co-directed with Revaz Chkheidze, received special mention in the short films category at Cannes. His comedy *Grandmother, Iliko, Ilarion and I* (*Ia, babushka, Iliko i Ilarion*, 1963) gained him wide popularity in the Soviet Union. With *The Prayer* (*Mol'ba*, 1968) and *The Tree of Desire* (*Drevo zhelaniia*, 1977) Abuladze turned to themes from Georgian history; *Repentance* is the last film in his self-described trilogy. When

asked why he made *Repentance*, Abuladze explained: "Artists, if they are worthy of the name, have a tried and tested theme. ... Mine is tyranny, violence and the mistreatment of human being by human being. It's the theme running through all my films.... It's the theme connecting the three films of my trilogy ... In all of them 'the innocent are found guilty'."[1]

Abuladze worked on *Repentance* between 1981 and 1984, before the beginning of perestroika. Eduard Shevardnadze, the Party boss of Georgia, supported the project, suggesting that the film be made for Georgian television, which had a three-hour daily time slot free of Moscow's supervision. Production was interrupted after the actor who had originally played Tornike was arrested and executed for hijacking a plane. The film was shelved in 1984 and not shown until 1986, becoming the cinematic harbinger of glasnost'. The effect of the film on audiences is hard to picture today. *Repentance* premiered at the Moscow Dom Kino: "The film ended, and there was a pause of about three minutes, I'm not exaggerating. Then people began crying out loud because there were those there who had experienced all that themselves, who had passed through all that, who had despaired, thinking that no one would ever learn the truth about that terrible era. And when Tengiz went downstairs, he had to be protected, because people fell at his feet, kissed his hands. I had never seen anything like it in my life."[2]

As a political event, *Repentance* has a permanent place in Russian history; as a film it is long and difficult, both brilliant and sometimes heavy-handed in its symbolism. Stated simply, *Repentance* chronicles the deeds of Varlam Aravidze, the mayor of a Georgian town during the 1930s, including the destruction of the Barateli family, and the effects of his villainies on his own descendents. Varlam's actions generally follow the stages of early Stalinism and the purges: the

1 Elizabeth Waters, "The Politics of *Repentance*: History, Nationalism and Tengiz Abuladze," *Australian Slavonic and East European Studies* 2, no. 1 (1988): 134-35.

2 Kora Tsereteli, "Pokaianie" radio broadcast Radio Svoboda, vedushchii Sergei Iurenen, http://archive.svoboda.org/programs/cicles/cinema/russian/Repentance.asp (accessed 29 August 2012).

destruction of religion and substitution of the Soviet utopian project of paradise on earth (the use of the historic church for scientific experiments and its destruction); courting, then destroying the intelligentsia (Varlam's meeting with Sandro, Miriam and Moses, followed by their arrests); destroying the old guard who made the revolution (arrest of Mikhail Korisheli and his wife); the escalating absurdity of purge rhetoric (Varlam on enemies of the people as black cats); arrests for gain, according to quotas. (Doksopoulo arrests all members of the Darbaiseli family to gain a reward.)

The mix of realism and fantasy in *Repentance*, so striking to the foreign viewer, is more familiar to Georgian audiences steeped in the national tradition of fable and allegory, and the more symbolic language of Georgian filmmakers. Abuladze explained the immediate motive:

> Our main source was the people who had been repressed and were then rehabilitated, who in 1937 were arrested and then 10, 12, 15 years later returned, at least some of them that is, not many. We talked to these people and that's how the film became possible. ... When we listened to their stories our first impression, our first reaction, and I can't stress this enough, was: "Can this really be true? Surely this couldn't have happened in real life?" The stories they had to tell were so absurd, so fantastic. I listened and I couldn't believe my ears. It was too inhuman; too terrible. That was when the idea for the style and form of the film first came to me. I realized that because the stories were so absurd and phantasmagoric, the whole breadth and depth of this human experience could only be expressed through the surrealistic and the grotesque.[3]

The film's surrealism is supported by a number of visually realized sayings and metaphors. The farcical water main break during Varlam's inauguration represents—and here replaces—the fountain of senseless Bolshevik rhetoric. At the funeral the new mayor, Tseretso, hopes that Varlam will rest easy in the earth of his homeland (*"Da budet pukhom tebe rodnaia zemlia"*), and the saying,

[3] Waters, 136.

Fig. 98. The "Wedding"

of course, plays out ironically in the film as Varlam's corpse is repeatedly exhumed. Sandro's metaphorical "If they want to, they'll get us from under the earth" is realized in Nino's dream as a peasant tells Varlam where Sandro and Nino are hiding, buried in a field. Stalin's supposed liking for the proverb, "When they chop down a forest, splinters fly" (*"Les rubiat—shchepki letiat"*), is visually realized as the logs with prisoners' names are ground into chips. Finally, the corrupt Stalinist justice system is realized in the "wedding" of the interrogator and blind Justice, complete with traditional Georgian headpieces, formal dress, the Mendelsohn march and a white piano (Fig. 98), as well as the attempted "wedding" of prisoners Sandro and Mikhail Korisheli through an admission of mutual guilt.

The structure of *Repentance* is circular, but also complex: the first framing tale is set in the present, as Keti Barateli sees the obituary for Varlam Aravidze. In the second framing tale she imagines his funeral, her digging up the corpse and her trial. Varlam's deeds during the 1930s are revealed in a flashback that extends over half of the film. The second framing tale then resumes, as Keti is

declared insane and the action culminates in Tornike's suicide and Abel's throwing his father's corpse off a cliff. As the first framing tale resumes and we are returned to the obituary, the bitter motive for this convoluted structure becomes clear: Keti's revenge is only imagined. Justice has not been performed and there has been no repentance. The ending of the film possibly implies that judgment will be left in the hands of God.

Counterbalancing its fragmented narrative, *Repentance* is unified by a number of tropes extending across the different tales and linking the 1930s to the 1970s diegesis. For example, the same objects exist in the old and new worlds: medieval guards,[4] metal paddywagons, churches (even if cake-simulacra), Barateli family possessions (a chiming clock, a crucifix, Sandro's paintings), portraits of Varlam, crows, a high field outside the city. The color dominants in the mise-en-scène are red, black and white, borrowed from the flag of independent Georgia (1918-21),[5] and thus balancing the universalism of the film with localized national references e.g., red carnations, black suits and white shirts at Varlam's funeral; Nino's red robe, Varlam's white sheepskin mantle, his gift of red flowers, his two henchmen in black and white evening dress during the visit to the Baratelis; the interrogator's black and white evening dress with a red flower in the lapel; the old woman pilgrim's black and white hat with a red flower at the end of the film. Finally, kitschy American tunes ("What Made Little Boy Blue" and "Sunny") connect the superficial optimism of the old and new Soviet worlds.

Music in *Repentance* typically tells the truth: circus music during Varlam's farcical inauguration; at the Baratelis' Varlam performs an aria from Verdi's *Il Trovatore*, a tale of revenge in which brothers kill each other. (Varlam has already pointed out their common ancestry to Sandro.) Khachaturian's violent "Sabre Dance" at the end of Varlam's audience with Sandro, Miriam and Moses contradicts his graceful accedence to their petition regarding the ancient church.

4 Abuladze: "… I took from Bosch his heroes in armour; for Bosch, you know, armour was a symbol of oppression" (Waters, 131).

5 The red, black and white flag was also used 1990-2004.

Elena Korisheli's ecstatic rendition of the "Ode to Joy" points up the links between Fascism and Communism, and the diegesis (Sandro going to his death) belies the future brotherhood celebrated by the ode. Abel's performance of "The Moonlight Sonata," Lenin's favorite piece, reinforces his conformism. The heavenly chorus from Gounod's *Mors et Vita* (*Life and Death*, 1885) sounds at the end of the film; the work is an oratorio on death, judgment, resurrection and eternal life—a summation that opens the film to the universal.

Finally, a Shakespearean subtext across the different tales also contributes to the universal valence of *Repentance*. Varlam recites sonnet 66, which in the film alludes to the impending purges. He ends his life like the guilt-ridden, tragic figures in *Othello* and *Macbeth*, fearing the sun, imagined blood dripping from his fingers. His son, Abel', quotes *Hamlet* for his own self-serving purposes in response to Tornike's question about Varlam's deeds: "It was a question of to be or not to be. We were surrounded by foes."[6] In accord with the inexorable workings of fate, Tornike kills himself with the rifle that was a gift from his grandfather, the same weapon with which he wounded Keti.

[6] Josephine Woll and Denise J. Youngblood, *Repentance* (London and New York: I.B. Tauris, 2001), 60, 62. See detailed analysis of color, music and literary references in the following reading.

SIGNS AND SYMBOLS
REPENTANCE'S STYLISTIC DEVICES

Josephine Woll and Denise J. Youngblood

Abuladze's repertory of stylistic devices is varied and impressive. As Tatiana Khlopyankina noted, *Repentance* "speaks to us in the language of metaphors and symbols."[1] These stylistic devices include numerous visual anachronisms, fantasy and reverie, music, literary and historical allusion, in addition to the imaginative use of color, cutting, camera movement and the extreme close-up. The most consistent, most obvious, and perhaps most important device contributing to the picture's overriding surrealism appears early in the film—anachronism.

Anachronism

Movie anachronisms typically situate items from the present in the past, as the famous example from the Twenties, of Rudolph Valentino's wristwatch-sporting Sheikh, demonstrates. Abuladze, however, prefers what we might dub a "counteranachronism": the placement of details from the past into the present. These details undercut the viewer's efforts to establish the timeframe from the mise-en-scène and therefore serve as universalizing signs in the cinematic text. In the opening scene, the baker (Keti) and her guest are dressed in more or less modern (if not obviously contemporary) clothing, yet Keti's customer comes by the window in the evening clothes of a more formal era, riding in a horse-drawn carriage, perhaps a re-enactment of traditional wedding rites. Likewise, when Varlam is unearthed for a second time, the police haul him away in an

[1] Tatiana Khlopyankina, "On the Road That Leads to the Truth," in Michael Brashinsky and Andrew Horton, *Russian Critics on the Cinema of Glasnost'* (Cambridge: Cambridge University Press, 1994), 51.

obviously outdated vehicle that looks suspiciously reminiscent of the "paddy wagon" or Black Maria that carried victims of the Terror away during the Stalin era.

More important examples of this self-conscious placement of details from the past into the present can be found in the continued use of costumes recalling the late Middle Ages or Renaissance, especially various types of armor. This device, though it has been disparaged as "more than simple," in fact provides one visual link between the officialdom in the second framing story's courtroom scenes and those surrounding Varlam in the flashback. (Another is color, to be discussed below.) Although no particular time period is overtly established for the second framing story, the way the Aravidzes and their friends are dressed for the funeral indicates a more or less contemporary timeframe. Likewise, the white suit Keti wears for her courtroom appearance, although absurdly glamorous for the occasion, is of a reasonably modern cut. But the guards who escort her into the courtroom are arrayed in full armor, and the panel of comic-opera judges, lawyers and court officials are dressed in faux-Elizabethan garb. (In an especially ironic visual pun, the bewigged head judge plays unsuccessfully with a Rubik's cube throughout the proceedings. In this particular instance, which is the anachronism?) The overall effect is nonetheless obvious: this "trial" is an Inquisition.

The flashback appears to be set in the Thirties, an assessment again based primarily on costuming, particularly on Varlam's frameless eyeglasses (recalling those worn by Lavrenti Beria) and his Hitler/ Mussolini-style uniform. But here as well, the cohort of guards and Varlam's enforcers wear full armor. We first see this when Varlam meets with Sandro, Moise and Miriam in the greenhouse garden; while they talk, the camera cuts away to the glass roof of the greenhouse. Armored knights are walking overhead, occasionally peering through the glass. These "knights-in-shining-armor" eventually come to arrest Sandro, and, decades later, Keti. The agents of the Inquisition also utter anachronistic incantations—"Peace unto this house"—at the very moment when peace will be no more.

There are fewer examples of the more typical kind of anachronism in *Repentance*. One of these is, however, both eerie and memorable. In the garden sequence just mentioned, as Varlam listens, with an expression of sympathy and understanding, to the trio's arguments in favor of saving the church as a symbol of history and civilization, the fruit-laden trees begin to look more and more sinister. The pendulous fruits are in fact listening devices, recording every word these aristocratic and superfluous Judeo-Christian humanists utter against science and progress.

Fantasy and Reverie

Also critically important in shaping *Repentance* as an exercise in surrealism is Abuladze's frequent employment of fantasy sequences throughout the course of the movie. These appear in both framing stories as well as in the flashback. Most obviously, the final scene of the film suggests that the *entire* film was, more than likely, nothing more than Keti's reverie as she decorated her cakes. But there are other important fantasies to consider, especially in the second half of the film.

The first of these occurs in the flashback, just after the unwelcome night visitors have left the Barateli apartment. As Sandro plays a mournful tune on the piano, Nino dozes. She dreams a fateful dream, about what in fact will soon befall them. In her dream, she and Sandro are vainly attempting to flee pursuers first unseen, then revealed as a demonic Varlam (in an open roadster) accompanied by his knights on horseback. Nino and Sandro run through sewers, through city streets, then out of town, until finally they are in the foothills high above Tbilisi. In a nod to another great surrealist film, Dali's *Un Chien Andalou*, Abuladze next shows us Nino and Sandro buried up to their necks in a newly plowed field. (There is a similar scene in Eisenstein's *Que viva Mexico!* as well.) Varlam, standing in his car, cheerfully belts out an aria from *Il Trovatore* (another Italian allusion) to his captive audience. Upon awaking, Nino tries to persuade her husband to run away, but Sandro ruefully responds that they will be "tracked to the ends of the earth." His arrest immediately follows; this is dream is prophesy.

Nino's second dream is also visionary. After Sandro's arrest, as Nino becomes more and more desperate, struggling to save herself and her daughter, she dreams that Sandro is walking along a prison corridor on his way to his crucifixion. Nino is awakened from this nightmare by the sound of explosions: the historic church, symbol of the town's long and proud history and culture, has been destroyed (a pointed historical reference to the demolition by Stalin of the Cathedral Church of Christ the Savior in Moscow in 1931). Sandro, she knows instinctively, is dead.

The third important sequence in the flashback to consider as an exercise in surrealism is not a dream *per se*, but a fantasy representing the interrogation and torture of Sandro and Mikhail Korisheli. This fantasy is all the more vivid because it follows a long, intensely realistic and painful series of scenes showing Nino and Keti after Sandro's arrest. Abuladze juxtaposed the two quite consciously. As he explained in an interview with Lidya Pol'skaya that appeared in *Literaturnaia gazeta:*

> The entire image-system of the film permits multiple readings. But there are individual episodes that cannot sustain multiple interpretations. All viewers must understand them the same way ... We deliberately created these shifts from polysemantic to monosemantic, from ambiguity to simplicity.[2]

The episode begins with a scene that recalls Anna Akhmatova's famous poem *Requiem*. Nino waits in a long line outside the prison, with other hopeless women, trying to learn where Sandro is and whether she can send him a package. She is curtly informed, by a faceless official behind an impenetrable window, that Sandro has been "exiled without the right to correspond." Next, Nino attempts to make a personal appeal to Varlam, degrading herself with a touching and futile appeal to her helplessness, her beauty and indeed her sexuality (to which Varlam has obviously previously been attracted). Finally, and most brutally, Nino and Keti learn

[2] "About the Past for the Sake of the Future" (O proshlom dlia budushchego), *Literaturnaia gazeta*, 25 Febr. 1987, in Viktor Bozhovich, 16, in Further Reading.

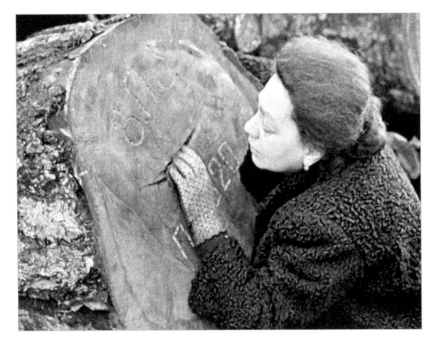

Fig. 99. Inscribed Logs

that logs cut by prisoner labor have arrived at a local lumber yard. They have been told that sometimes prisoners carve their names on them (Fig. 99). Mother and daughter move from log to log, ankle deep in mud, but their desperate search yields no result. And when the lumber goes to the saw mill, all traces of their loved ones will vanish, reduced to dust.

After these three dreadful scenes, the return to surrealism is a jolt, but not unwelcome. A realistic depiction of Sandro's interrogation would be unendurable. So we find ourselves in a sunny and pleasant, if somewhat overgrown, garden. A couple in evening dress are seated together at a white grand piano playing Mendelssohn's *Wedding March*. Sandro, looking worn and dishevelled, his shirt bloodied and torn, suddenly appears to disturb this pretty scene. The jolly youngish gentleman at the piano turns out to be Sandro's inquisitor; his female partner stands to reveal herself as Blind Justice. The inquisitor blithely informs Sandro that his friend Mikhail Korisheli has implicated him in a vast political conspiracy. (It was not uncommon for the charges to be discovered *after* arrest

in these extraordinary times.) Sandro is incredulous; he naïvely informs his persecutor that "if men like [Korisheli] are being arrested, you might as well arrest the whole country."

Korisheli is then brought in to corroborate the cheerful inquisitor's allegations. Korisheli is in very bad shape, both physically and mentally. His confession staggers Sandro: Korisheli admits to leading a conspiracy of 2700 men to "dig a tunnel from Bombay to London" and to "poison corn to annihilate the entire population." Lips trembling, Korisheli explains to the stunned Sandro that he did, indeed, implicate Sandro and others: "We must accuse as many people as possible and call them enemies of the people . . . We'll sign everything and reduce it all to complete absurdity . . . We'll sign a thousand stupid statements." Korisheli breaks down, howling in anguish. Sandro's eyes glisten with tears.

As the film returns to the "present," that is, the courtroom where Keti's trial is being held, the use of fantastical reveries as surrealist counterpoint to what passes for "reality" continues. Tornike has two important daydreams. The first, which we have already discussed briefly, occurs just as Keti finishes her testimony about Varlam. Tornike, in his mind's eye, now sees his grandfather's soul laid bare. Imprisoned in a decaying bunker, Varlam is a crazed and unkempt old man who fears the light of day as much as he fears the truth.

Tornike's second daydream, mentioned earlier, occurs when the Aravidzes return home after the trial's adjournment. As the scheming Guliko takes charge of the family's plot to put Keti away forever, Tornike is forced to realize that his mother is no more the person he wants her to be than was Varlam. In Tornike's fantasy, Guliko rejoices at Varlam's death, perhaps because it allowed *her* to assume the position of authority in the family and within their clique. By dancing around Varlam's corpse in the dream, Guliko might as well be dancing on his grave.

Music

The film's imaginative use of existing musical scores, selected by the film's screenwriter Nana Djanelidze, reinforces the surrealism of *Repentance* as well as underscoring intertextual motifs. The first

instance of this device occurs at Varlam's funeral, when the mourners break into song. The tune is *Samshoblo,* which is not a funeral song, but rather a Georgian political anthem from the days of the short-lived Georgian Menshevik republic (1918-21).[3] *Samshoblo* therefore embodies Georgian independence, nationalism and opposition not to communism, but to Bolshevik (Soviet) power.

The next incidence of music employed as ironic counterpoint in the film is heard when Sandro visits the church *cum* laboratory to see for himself the damage the vibration testing has wrought. A radio is playing, and the music is definitely secular. We hear a doomsday speech by Einstein, immediately followed by *What Made Little Boy Blue?,* one of those jolly ditties that people in the thirties found so uplifting, whether they were suffering from the ravages of the Great Depression, fascism or Stalinism.

Other musical interludes also provide pointed intertextual references. Shortly before his arrest, Sandro plays Debussy's haunting and impressionistic *Les Pas sur la neige,* which was also an important musical motif in the 1976 Soviet film *The Ascent [Voskhozhdenie],* Larisa Shepit'ko's harrowing cinematic tale of Soviet collaboration and betrayal during World War II.

Yet another musical reference alluding to the fascist era can be found after Mikhail Korisheli's arrest. Nino tries to get her friend Elena Korisheli, a true believer like Mikhail, to understand the implications of the terror that surrounds them. Elena believes that, regardless of the fates of their husbands, the "great cause" they serve makes their sacrifices worthwhile. Face alight, she triumphantly begins to sing the Schiller *Ode to Joy* from Beethoven's Ninth ("Choral") Symphony, joined by a swelling chorus. (This music, which—like Wagner's—enjoyed special popularity during the Nazi era, serves as the segue to Nino's dream about Sandro's crucifixion.)

Finally, Varlam's fondness for Italian music, as exhibited in his visit to the Baratelis and in Nino's dream of their flight and live burial, is worth noting. Varlam, garbed like Mussolini, belting

out an aria while Nino and Sandro are up to their necks in dirt, certainly makes one of the movie's more obvious points about the links between Stalinism and fascism.

There are also two noteworthy musical interludes in the final scenes of *Repentance*. When Tornike confronts his father for the last time, Abel is seated at the piano playing Beethoven's *Moonlight Sonata*. This piece, which links Abel to the founder of the Soviet state, was well-known to Soviet audiences as Lenin's favorite piece of music and has been used in other important Soviet films, like the 1934 classic *Chapayev*. And Tornike dies to the brash strains of the seventies' American pop music hit *Sunny*, as his parents' crass friends, as insensitive to Georgian culture as their predecessors, bob up and down in a parody of western dance.

Literary and Linguistic Quotation

Abuladze's literary and linguistic allusions are effectively marshalled to provide intertextual linkages. We have already mentioned that the scene of Nino and the other wives of the vanished standing in line recalls Akhmatova's *Requiem*, written in 1935-40, but unpublished until 1957 when it appeared abroad. The entire poem evokes the anguish Abuladze has rendered in images in *Repentance*, but *Requiem's* epilogue, memorializing those who were left behind, seems a particular source of inspiration:

> There [in the queue] I learned how faces fall apart,
> How fear looks out from under the eyelids,
> How deep are the hieroglyphics
> Cut by suffering on people's cheeks.

A few lines later:

> And I pray not only for myself,
> But for all who stood there
> In bitter cold, or in the July heat,
> Under that red blind prison-wall.

And very near the poem's conclusion, Akhmatova specifies the site of any monument erected to her in the future: not in her

birthplace by the sea, nor in Tsarskoe Selo where she triumphed as a poet:

> But here, where I stood for three hundred hours
> And where they never, never opened the doors for me.[4]

We see Nino and Keti, waiting "three hundred hours," before the doors that would "never, never" open.

Another important literary allusion is to the Georgian national poem, *The Knight in the Panther's Skin*, which Sandro mentions as a pointed rebuke to Varlam when they are discussing whether or not "the people" need re-education. This poem is absolutely central to Georgian cultural identity. It was written by Shota Rustaveli (ca. 1166-?) in the Golden Age of Georgian history, sometime during the marriage of Queen Tamara to Davit Soslan (1189-1207).[5] *The Knight in the Panther's Skin* is first and foremost a romance, but it is also political, celebrating the virtues of enlightened rule. Rustaveli ends the epic this way:

> They [the three sovereigns] poured upon all alike their mercy, like snowflakes from heaven.
> The orphans and the widows; the helpless and the poor were enriched, made happy.
> Evil-doers dared not appear but recoiled and vanished.
> Harmony reigned, like sheep, goat, and wolf fed together.[6]

Sandro is obviously implying that Georgia's national bard would have disapproved of Varlam Aravidze's methods of rule and ideas about art. [...]

4 Anna Akhmatova, *"Requiem" and "Poem without a Hero,"* trans. D.M. Thomas (Athens: Ohio University Press, 1976), 31-2.

5 Donald Rayfield, *The Literature of Georgia: A History* (Oxford: Clarendon Press, 1994), 73-4.

6 Shota Rustaveli, *The Knight in the Panther's Skin*, trans. Venera Urashadze (Tbilisi: Sabchota Sakartvelo, 1971), 221. There is also a prose translation of this poem into English: Rustaveli, *The Lord of the Panther Skin*, trans. R.M. Stevenson (Albany, NY: State University of New York Press, 1977).

Varlam frequently demonstrates his command of the rhetorical flourishes of Stalin-speak. "Intimate boudoir art," he tells Sandro, is an "escape from reality." Varlam, like Stalin, is adept at verbal juggling acts, as when he informs Korisheli that he had (sadly) acceded to the will of the people by arresting "his relative" Sandro: "He's our foe, and we're his victims." The few times in the film that Varlam speaks Russian (with a heavy Georgian accent, like Stalin's) are especially noteworthy examples of Stalin-speak. For example, Varlam tells Sandro, without a trace of irony, that "modesty is a fine quality in a man." Stalin thought so too in his 1933 speech to the First Congress of Collective Farm Workers: "Skromnost' ukrashaet bol'shevika" ("Modesty adorns a Bolshevik").

[...] There can be no doubt that the most important literary reference in *Repentance* is Shakespeare's Sonnet 66. Varlam recites the sonnet from memory when he visits the Baratelis, and in its entirety — save for the last two lines. This sonnet, which is not particularly well-known, is absolutely critical to an informed understanding of the film. Varlam has already revealed the cultured side of his complicated persona to the Baratelis in his musical performance, but the recitation of Shakespeare is quite the most unexpected event of that fateful evening *chez* Barateli. (And for English speakers, hearing Shakespeare in the rhythms of the mellifluous Georgian language is quite a treat.)

> Tired with all these for restful death I cry,
> As to behold desert a beggar born,
> And needy nothing trimm'd in jollity,
> And purest faith unhappily forsworn,
> And gilded honor shamefully misplaced,
> And maiden virtue rudely strumpeted,
> And right perfection wrongfully disgraced,
> And strength by limping sway disabled,
> And art made tongue-tied by authority,
> And folly, doctor-like, controlling skill,
> And simple truth miscall'd simplicity,
> And captive good attending captain ill,

(Varlam omits the final two lines):

> Tired with all these, from these I would be gone,
> Save that, to die, I leave my love alone.[7]

Within the cycle of Shakespeare's sonnets, number 66, with its "schematic list of grievances" and its preoccupation with the world's basic injustice, has links to others with similar themes, as well as to Hamlet's "To be or not to be" speech. On its own, however, and particularly without the last two lines that humanize and soften its tone of dull resentment, the sonnet stands as a catalogue of antitheses of virtues and their inversions.[8] Each abstract noun— faith, honor, virtue, perfection, strength, art, truth—is defeated by a subjectless past participle and adverb—unhappily forsworn, shamefully misplaced, rudely strumpeted, etc. That Varlam should recite this particular sonnet seems ironic indeed, given that he wields the authority that tongue-ties art, and his "captain ill" demands the attendance of "captive good."

In sum, Shakespeare appears to have prophesied Stalinism and its attack on "gilded honor," "purest faith," and "simple truth" more than three centuries before the fact. The expression on Sandro's face at the end of the recitation makes it clear that he at last understands that he is powerless before the evil that Varlam represents.

Filmic Techniques

Purely cinematic devices [...] also play an important role in reinforcing the surrealism that is central to Abuladze's style. The color in the film is dense and vibrant. (Since the movie was originally

7 William Shakespeare, "Sonnet 66," in *The Complete Works of Shakespeare*, Cambridge edition text, ed. William Aldis Wright (New York: Doubleday, 1936), Vol. 1, 412.

8 David K. Weiser, *Mind in Character: Shakespeare's Speaker in the Sonnets* (Columbia, MO: University of Missouri Press, 1987), 72. Weiser persuasively argues, on p. 73, that the last lines of the sonnet suggest that love "sustains the speaker and suggest[s] that personal relations can compensate for all the world's dishonesty. Love survives the destruction of all other ideals, because it is a personal rather than a conventional value."

made for television, watching it on video actually provides an excellent sense of the intensity of the color saturation.) The color is in marked contrast to the pallid, washed-out palette of most Soviet films of the late Brezhnev era—and certainly in contrast to the grayness of Soviet life. For most Soviet audiences watching the film at the time of first release, the jolts of color would have been particularly noticeable and "foreign" in their stylishness. (Residents of Tbilisi, on the other hand, were by Soviet standards almost Italian in their sense of style.)

Moreover, the visually striking red-black-white color scheme (that of the Georgian national flag) that rears throughout the film suggests thematic connotations as well. In contrast to the black-robed judges and business-suited men, Keti and Guliko, the two moral opponents within the film's "present," both appear in the courtroom in outfits dominated by white. The luxuriant red carnations that blanket Varlam's coffin reappear in the bouquet Riktafelov hands to Nino and in those that droop in a vase on Varlam's secretary's desk. Nino's richly red robe, a mantle worthy of a queen, or indeed a Madonna, acts as a visual symbol of her warmth and maternal love; it disappears after Sandro's arrest. The same colors, woven into a characteristic Caucasus pattern, are visible in the rug hanging behind Varlam in the Barateli apartment.

In terms of editing, the takes are several minutes long (making a long film feel even longer, especially for western viewers accustomed to the rapid montage of television advertising or MTV). Quick cutting and noticeable camera movement are rare, except in the first three scenes. There the jump cuts reinforce the viewer's uncertain sense of what is going on. One good example from the beginning of the film is the cut from a close-up of the newspaper obituary notice to the flowers on Varlam's casket. Another is the cut from the mourners singing *Samshoblo* to a close-up of Guliko's face, to flowers on the path, etc. (During the opening shots of the funeral procession, camera placement is low, so that we are at eye level with the coffin being carried down the stairs, a rather unsettling perspective.)

The use of the close-up, especially the extreme close-up, *before* rather than *after* the perspective has been established, is an effective

way to make the audience realize from the opening moments that this is not a Hollywood film. The first shot in the film is one such example of Abuladze's aesthetic of the extreme close-up: a woman's hands making something—which turns out to be a marzipan flower—*on* something— which turns out to be an elaborate cake.

Further Reading

Aleinikov, Igor. "Between the Circus and the Zoo." In *Russian Critics on the Cinema of Glasnost*, edited by Michael Brashinsky and Andrew Horton, 54-57. Cambridge and New York: Cambridge University Press, 1994.

Bozhovich, Viktor, ed. *Pokaianie*. Seriia "Ot zamysla k fil'mu." Moscow: Kinotsentr, 1998.

Christensen, Julie. "Tengiz Abuladze's *Repentance* and the Georgian Nationalist Cause." *Slavic Review* 50, no. 1 (Spring 1991): 163-75.

Woll, Josephine, and Denise J. Youngblood. *Repentance*. London and New York: I.B. Tauris, 2001. [This is the most detailed analysis of the film.]

Zorkaia, N. "Dorogoi, kotoraia vedet k khramu." *Iskusstvo kino* 5 (1987): 33-53.

LITTLE VERA

Malen'kaia Vera

1988

129 minutes (Russia); 119 minutes (US)

Director: **Vasilii Pichul**

Screenplay: **Mariia Khmelik**

Cinematography: **Efim Reznikov**

Art Design: **Vladimir Pasternak**

Music: **Vladimir Matetskii; lyrics: Igor' Shaferan**

Sound: **Pavel Drozdov**

Production Company: **Gorky Film Studio**

Cast: **Natal'ia Negoda (Vera), Andrei Sokolov (Sergei), Iurii Nazarov (Father/Kolia), Liudmila Zaitseva (Mother/Rita), Aleksandr Alekseev-Negreba (Viktor, Vera's brother), Aleksandra Tabakova (Lena Chistiakova), Andrei Fomin (Andrei), Aleksandr Mironov (Tolik), Aleksandr Lenkov (Mikhail Petrovich)**

Vasilii Pichul (1961—) was trained by the prominent Thaw era director Marlen Khutsiev at the State Film Institute. His first full-length film, *Little Vera*, scripted by his wife, Mariia Khmelik, became the iconic perestroika cinema work, attracting almost fifty-five million viewers in the first year of release. Pichul's next two films, *V gorode Sochi temnye nochi* (*Dark Nights in Sochi*, 1989) and *Mechty idiota* (*An Idiot's Dreams*, 1993) were more experimental and less successful. Pichul has worked in television since the nineties, directing the highly successful satiric program, *Kukly* (*Puppets*, 1994-98), and more recently, the much tamer satiric *Mul't lichnosti* (*Cartoon Characters*). He has made a number of documentaries and

several other feature films, the most successful of which was *Nebo v almazakh* (*The Diamond-Studded Sky*, 1999).

Little Vera, the first Soviet-era film with explicit sex scenes, presented working class life in an honest yet sympathetic way, free of ideological prostheses.[1] The immediacy of raw life conveyed in the film still shocks today. Vera, the rebellious daughter of a proletarian family, falls in love with Sergei, the cynical son of well-to-do parents. Sergei does not hit it off with Vera's parents and, in a drunken rage, her father, Kolia, stabs Sergei. Vera is then forced to choose between her dysfunctional family and her lover. After lying to the police to save her father from prison, rejected by Sergei and almost raped by a former classmate, Vera attempts suicide, but is saved by her doctor-brother. As the film ends, Sergei returns to Vera's family, Kolia apparently dies of a heart attack, and the young couple is left facing an uncertain future.

Little Vera is remarkable for its artistic wholeness—a unity of message, image and camera work—and its almost encyclopedic but completely unforced depiction of working class life in late Stagnation era Russia. A closed and confining society emerges from such scenes as the chaotic outdoor dance arena surrounded by police with guard dogs, reminiscent of the labor camps. In Vera's claustrophobic apartment the camera cannot show any room in its entirety. The repeating motif of a clanking goods train represents the dead-end repetition of characters' lives, driving Sergei to smash his hospital window and then escape from the ward. Vera's parents are played by two stars of the Soviet era, whose socialist realist type is inverted: "The casting of Liudmila Zaitseva and Yuri Nazarov as Vera's parents is far from random. Zaitseva used to be a patent 'simple, heartfelt woman' of the Soviet screen; Nazarov was a well-known 'brawny, reliable guy'... It is hard to forget the father growing

[1] In a recent article, Volha Isakava argues that sexuality in the film represents trauma, not the individual liberation brought by glasnost'. (See Further Reading.) Natal'ia Negoda's fame as the last Soviet film star continues: Boris Berman and Il'dar Zhandarev made a documentary, *Zvuchnaia familiia—Negoda, ili "Malen'kaia Vera" 15 let spustia*, about the actress and the film in 2003.

flabby in drunken complacency or becoming bestially violent: He is at once disgusting and pitiful. And long after the film ends, you remember the mother with her vacant, almost automatic thriftiness and the panicky terror on her face when someone refuses to eat."[2]

Among the markers defining late 1980s working class life in the film are: the irrelevance of the State—and loyalty or duty—to the lives of working class youth; generational and class enmity; an absence of spiritual values, whether moral or intellectual (there are no books in the apartment); familial communication through shouting (verbal violence), which leads to physical violence, as well as non-communication (Vera's mother doesn't realize her daughter has attempted suicide); alcoholism; a double standard for the genders (Viktor's view of his sister's affair vs. his own behavior in the dorm); environmental degradation; racism (Chistiakova's black half-brother and the Africa cartoon); a low standard of living despite hard work; bourgeois values (what will the neighbors say?); and fear of independence in a regimented society (Sergei unexpectedly returns to Vera's family, saying that he was afraid). Nevertheless, the film is sympathetic and tolerant toward its flawed characters: Kolia loves his daughter and she returns his affection; Rita, the mother, is clearly worn down by the everyday struggle to maintain a minimal standard of living and longs to see her grandson; Vera loves and cares for Sergei; and best friends Vera and Lena Chistiakova exemplify supportive female bonding.

[2] Tatyana Moskvina, "Forward, Singing!," in *Russian Critics on the Cinema of Glasnost,* ed. Michael Brashinsky and Andrew Horton (Cambridge and NY: Cambridge University Press, 1994), 106.

BETWEEN JOY AND SUICIDE
FATHERS, DAUGHTERS, AND *LITTLE VERA*

Andrew Horton and Mikhail Brashinsky

On the most immediate level, the film can be seen as a clear example of glasnost. But it is much more: one of the most popular films of the first five years of perestroika is about a young provincial Soviet *woman.*

While not a feminist film per se, this work, set in a drab Ukrainian industrial town, was written by a woman, Pichul's wife, Maria Khmelik, and centers on Vera (Natalia Negoda), an eighteen-year-old Russian woman whose disjointed emotional life suggests significant questions of gender as well as of glasnost. The raw edges of *Little Vera's* narrative are those of an Oedipal and patriarchal system (political, economic, cultural) of signification and representation that are showing serious signs of disruption and change.

Three early shots set the tone and direction for the rest of the film. The establishing shot is of a bleak industrial town on the banks of a large body of water before dawn. The second is a morning scene on the balcony of a cheaply built apartment house, as Vera is told in a brusque and unsympathetic manner by her mother, "Make something of your life . . . as your brother has done." Shortly thereafter, again on the balcony, Vera's working-class father quietly tells her, in a comforting voice, "Cherish your youth" (a paraphrase of a famous line by Pushkin).[1]

Little Vera is striking, in part, for its many firsts. As a low-budget Soviet feature, it is a debut film by a young husband-and-wife team, the first Soviet film with a sense of sexual candor (the actress Natalia

[1] Kolia's paraphrase from the epigraph to Pushkin's *The Captain's Daughter* is actually: "You must look after your honor from your youth" ("Chest' nado berech' smolodu"), but it is a kindly warning (RS).

Negoda gained instant celebrity status in the United States for her May 1989 cover appearance in *Playboy*), the first mention of AIDS in a Soviet feature film (a passing joke about government warning pamphlets), and a direct suggestion of nonwhite children as the offspring of white mothers.

Our focus here, however, is on the strength of the film as a refreshingly straightforward portrait of a contemporary provincial young woman and her relationships. In particular, it is her close ties to her father that hold a special interest. But it is also important to view the film in relation to the changes being wrought under glasnost since filmmakers began to replace bureaucrats in the hierarchy of the Soviet film industry in 1985. From this perspective, Pichul's film is notable on at least four counts: it is made by a director who came from the working-class provincial background he treats on the screen (he is of Russian origin from Zhdanov, a Ukrainian industrial town on the Sea of Azov); it dares to show rough edges in terms of cinematic style—a direct alternative to the long tradition of "well-made" Soviet films, including even the auteuristic and lyrical works of Tarkovsky, the folk-mythic surrealism of Paradjanov, the sense of robust humor of Georgian comedies and satire (Otar Ioseliani's *Falling Leaves* [*Listopad*, 1967] and Irakli Kvirikadze's *Swimmer* [*Plovets*, 1982]), or the imaginative mixed-media films (drama and documentary) of someone like the president of the Filmmakers' Union from 1986 to 1988, Elem Klimov; and it is an important contribution to a growing number of films that honestly capture the "no-win" mood of many Soviet youth today, as opposed to the forced optimism of so many socialist-realist films of the past.[2]

Maria Khmelik's script found no sympathetic producer for four years, or in other words until glasnost had come into being. She wrote it in 1983 after visiting her husband's native town and family, and it captures Vera's marginal, "on-edge" existence. [...]

Khmelik depicts a life without spiritual or even passionate materialistic values, a life in a vacuum, affected by the vestiges of stagnation and decay. Vera is at the same time empty and cramped.

2 This text was published in 1992 (RS).

She is cramped by the drabness of her town and her job prospects (she plans to become a switchboard operator), by the lack of physical and psychological space in her family's apartment, and by her general absence of alternatives to the roles that appear laid out for her. And she appears to have no clue as to how to break out of her environment. Her name, of course, is emblematic. "Vera" means "faith"; thus "little Vera" reflects her age and position and her lack of hope or, conversely, the glimmer of hope that may exist. Both readings make sense given Pichul and Khmelik's diegesis.

Vera is on the edge of perceiving how her life is predominantly defined by the men who surround her. There is her successful doctor brother, Victor, who has managed to move to Moscow. Andrei is the ineffectual young man, "calm and polite," who pursues her like a puppy dog and who thus offers her a traditional romance, marriage, and social status, which she rejects. More important, however, Vera exists between the sympathetic acceptance of her quietly desperate alcoholic father and the antisocial freedom represented by Sergei and their tempestuous affair. Neither wholly modern (despite her streaked hair and mod clothes) nor traditional (despite time spent helping her mother cook and clean), Vera is caught squarely in the middle with little hope of escape, an accurate portrait, according to many Soviets, of a young woman from a blue-collar family today.

Little Vera does, however, chart this young Soviet woman's movement away from her father and toward her fiancé. While much of feminist theory details the importance of the mother-daughter relationship in its reevaluation of Freudian psychology (the Demeter-Persephone pattern, as Carol Gilligan and others note), little work has updated Freud's brief exploration of the Electra complex (a daughter's adoration of her father). While there is much in literature and film about daughters under the spell and shadow of domineering or impressive "successful" fathers, there has been relatively scant attention given to the possibility of nurturing relationships between an "unsuccessful" and basically non-domineering father figure and daughter. *Little Vera* explores this terrain. (While there are a few scenes in which mother and daughter share their troubles, the mother is portrayed as more distant and

hostile than the father and thus as less of an influence on Vera.) From the beginning, Vera's life is overdetermined: there is literally and psychologically no space or time she can call her own. Because of the distance between her mother and her father, Vera chooses to play wife and mother to her father. [...] Vera is, in fact, the one who takes his complaints about his heart trouble seriously and who then undresses him and tucks him in bed in a clearly mixed mother/wife/daughter role early in the film.

The developing conflict of values within Vera comes to a crisis once Sergei is officially her fiancé. At a birthday party for her father, confusion reaches a climax. Pichul and Khmelik effectively structure Vera's dilemma. Almost every scene starts on a seemingly congenial note and then proceeds to break down; the birthday party is no exception. Vera is caught in the middle once more as the two main people in her life suddenly quarrel and come to blows. Sergei, who operates on spontaneous passion with no apparent respect for anyone, beats up Vera's father and tosses him into the bathroom, locking him in. The scene ends as the father frees himself and stabs Sergei, sending him to the hospital in critical condition.

Afterward, as Vera attempts to cope with her divided feelings, the family plans a picnic by the sea. That moment dissolves into bitter antagonism as her mother shouts at Vera, "I never wanted to have you anyway." She goes on to say that she only kept Vera in order to get a larger apartment.[3] Denied maternal friendship and support, Vera retreats to the edge of the sea in a rainstorm, only to be followed by her father. He holds her gently and quietly says, "My little daughter." Pichul holds the moment long enough for us to feel their mutual understanding and shared loneliness. He manages to do so without pushing the scene into traditional melodramatic forms (the absence of underscoring music alone is one example).

Vera is unable to negotiate her emotional and psychological life between her father and Sergei. If her father had been a traditional

[3] It is Vitia, Vera's brother, who contradicts his mother's sentimentalizing about Vera by reminding her, "You had Vera to get an apartment!" (RS)

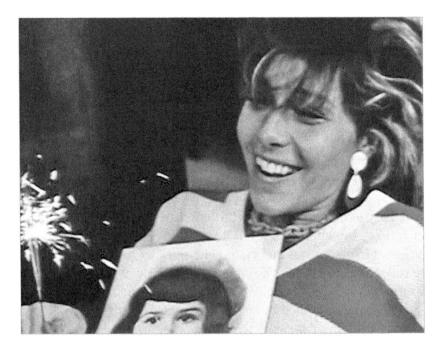

Fig. 100. Vera Attempts Suicide

Russian patriarch, the separation would have been easier. But though Vera herself never verbalizes her anxieties, we sense she glimpses the limiting realities of life with either man and, as presented in the film, has not yet reached a level of consciousness in which she would consider life alone. Consider how such a dilemma contrasts with the strong ending of Abram Room's *Bed and Sofa* [*Tret'ya Meshchanskaya*, 1927, coscripted by theoretician Viktor Shklovsky], in which the young heroine, caught between life with her husband and with her lover, walks out on both, claiming "Neither of you is worthy to be the father of my child."

Unlike Room's heroine, Vera finally cannot face the tough decisions she must make and so tries to kill herself. In a terrifying depression involving booze and pills, she clasps a childhood photograph of herself to her chest (Fig. 100). Her brother and Sergei (who has escaped from the hospital) reach Vera before she loses consciousness, and soon thereafter she and Sergei are shown together again in Vera's bed, exhausted, frightened, quiet. "Do you love me?" she asks Sergei, as she has throughout their relationship.

"I was afraid," he replies.[4] They are not yet married, and they have no apartment to go to, no careers unrolling before them. Vera still has little faith in her own identity. However, they are together . . . alone.

A little hope.

But the film closes with two final images: the father keeling over in the kitchen, followed by another long shot of the small city similar to the opening image. The mother has no role in this resolution. Whether her father is dead or having another heart attack, it is clear that Vera has already begun the difficult task of growing up and leaving her childhood behind. As comforting as her father's affection has been, it was not enough, could never be enough. Pichul ends as he began, with another dawn shot. Hope or life repeating itself? We, the spectators who have lived vicariously through her experiences, and Vera are free to decide.

In the spaces created by such "unfinalizedness" (to use Bakhtin's term), the Sphinx has a chance to set an alternative agenda in the Oedipus tale without the need for suicide and self-sacrifice.

The British phase of neorealism in cinema in the late fifties and early sixties was characterized as "kitchen-sink" realism. *Little Vera* would have to be dubbed "kitchen-table" cinema, a "novy realizm." Pichul's unflinching camera grounds Vera in a literally cramped familial environment (the apartment), centered further on the kitchen table and the different functions it serves for the family—work, meals, and conversation. Even the finely etched scene between Vera and her girlfriend at her apartment is set around the kitchen table as Lena, her friend and the mother of the half-black child,[5] announces she is content to settle for a relationship with a boring but well-meaning middle-aged man because he is "calm and polite." In the same scene, shortly before what is to be Vera's wedding, Vera, who

4 The full exchange is:
 Vera: Why did you come back?
 Sergei: I got scared.
 Vera: Do you love me?
 No answer. (RS)

5 The little boy is actually Lena's half-brother (RS).

has been on edge throughout the film, suddenly breaks into tears: "It's the happiest time of my life, but I want to cry all the time." [...]

There is one positive note, however, in the extended scene with Vera's girlfriend. Maria Khmelik has written an honest scene about the importance of girlfriends, of women trusting and supporting each other. The scene exists as something of a female oasis in a male world. In what becomes one of the genuinely comic and touching moments of the film, Vera learns from Lena one way to express her frustration: a kind of Zen primal scream that involves rising on one's toes, shouting, and collapsing to the floor. We laugh when Lena demonstrates. We are moved when Vera, drunk on vodka (and thus indirectly communicating with her father by sharing his sickness), rises unsteadily to her toes, screams, and falls. Nothing has been solved, but, as written by Khmelik, much has been shared between women. The scene reaches a level of honesty beyond the new American subgenre, the "female buddy film," as practiced, for instance, by Bette Midler (*Outrageous Fortune, Big Business, Beaches*).

Such a scene—and the film is chock full of revealing "everyday" moments—suggests how far contemporary Soviet cinema has shifted from the false enthusiasms and wooden idealism of Socialist Realism in its most rigid forms. There is an engaging offhandedness about many of the sequences that suggests a blend of improvisation and keen writing paired at a conceptual level. Such a disjointed approach to narrative reflects Vera's youth and her perspective as a woman who is unhappy with her lot, but not yet articulate enough to determine her own destiny.

Some of the images, lines, and contexts may be striking but not completely intelligible to a non-Soviet audience. In a beach scene, for instance, restless youths tattoo large images of St. Basil's Cathedral on their backs. A sign of protest, or of religious belief, or of some kind of joke? Perhaps a blend of all three. On the beach, Sergei asks Vera, "What is our common goal?" and she replies "Communism" in a voice tinged with irony, with parody, but also, we sense, with the leftover response of years of conditioning that has lost all meaning. "The challenge today," Pichul explained during his first visit with his wife out of the Soviet Union, "is to find some spiritual values in this life."

[…] his answer to those who felt the overall impression of the film was one of a crushing hopelessness was revealing: "The film is an attempt to come close to the abyss of our life today. Actually our real life is even darker, and yet I remain an optimist. Making a film is an exercise in hope" — a fitting remark for a film about a woman named Little Faith.

Further Reading

Beardow, Frank. *Little Vera*. London and NY: I.B. Tauris, 2003.

Eagle, Herbert. "The Indexicality of *Little Vera* and the End of Socialist Realism." *Wide Angle* 12, no. 4 (October 1990): 26-37.

Isakava, Volha. "The Body in the Dark: Body, Sexuality and Trauma in Perestroika Cinema." *Studies in Russian and Soviet Cinema* 3, no. 2 (2009): 201-14.

Lagerberg, Robert, and Andrew McGregor. "Home, Sweet Home: The Significance of the Apartment in the Film *Malen'kaia Vera/Little Vera*." *Studies in European Cinema* 8, no. 1 (2011): 57-65.

BURNT BY THE SUN

Utomlennye solntsem

1994

142 minutes (Russian release), 135 minutes (American release)

Director: **Nikita Mikhalkov**

Screenplay: **Rustam Ibragimbekov and Nikita Mikhalkov**

Cinematography: **Vilen Kaliuta**

Art Design: **Vladimir Aronin and Aleksandr Samulekin**

Composer: **Eduard Artem'ev**

Sound: **Jean Umanskii and André Rigaut**

Production Company: **Studio TriTe, Camera One (France), Goskino, Russkii klub, Canal+ (France)**

Cast: **Nikita Mikhalkov (Sergei Kotov), Oleg Men'shikov (Mitia), Ingeborga Dapkunaitė (Marusia), Nadia Mikhalkova (Nadia), Viacheslav Tikhonov (Vsevolod Konstantinovich, Marusia's grandfather), Svetlana Kriuchkova (Mokhova, the maid), Vladimir Il'in (Kirik), Avangard Leont'ev (the truckdriver), Inna Ul'ianova (Ol'ga Nikolaevna, Marusia's mother), Evgenii Mironov (Lieutenant, tank forces)**

Director, actor and producer Nikita Mikhalkov (1945–) was born into a prominent Soviet intelligentsia family. His father, Sergei Vladimirovich, was co-author of the text to the Soviet national anthem, author of the revised anthem of the Russian Federation and a popular children's writer; his mother, the writer and poet Natal'ia Petrovna Konchalovskaia, was the daughter of the painter Petr Konchalovskii. Mikhalkov studied piano, then acting at the Shchukin School. After being expelled for acting in film (then forbidden to

theatre students), he transferred to the State Film Institute to study directing under Mikhail Romm, graduating in 1971. He began his career as an actor in the 1960s and has continued to appear in films. Mikhalkov has directed too many films to mention here, but among the most well-known are: *A Slave of Love* (*Raba liubvi*, 1975), *Five Evenings* (*Piat' vecherov*, 1978), *Oblomov* (1979), *Kinfolk* (*Rodnia*, 1981), *Dark Eyes* (*Ochi chernye*, 1987), *Urga* (1991, Golden Lion, Venice), *The Barber of Siberia* (*Sibirskii tsiriul'nik*, 1999), *Twelve* (*Dvenadtsat'*, 2007). Most recently, he has directed two unremarkable sequels to *Burnt by the Sun*: *Burnt by the Sun 2: Exodus* (*Predstoianie*, 2010) and *The Citadel* (*Tsitadel'*, 2011). Since 1987 Mikhalkov has run his own production company, Studio TriTe. He is also a controversial public figure who has sought power and influence in both the film industry and Russian politics, and is a strong Putin supporter.

Mikhalkov is an accomplished mainstream filmmaker, largely loved by the broader public and despised by professional critics. An actor himself, he has the reputation of inspiring his actors to produce their best work. For better or worse, he has always managed to adapt to the status quo. His films were never banned during the Soviet period and he has prospered in post-Soviet Russia with films that promote an agenda of national revival. His films have evolved "from a nostalgia for a past that is openly constructed as a myth to a nostalgia for a past that pretends to be authentic. ... this move is a result of the collapse of the Soviet value system—a system that encouraged myth making—and the director's inability to face up to the reality of the 1990s, when he turned both past and present into a myth that he himself mistook for real and authentic."[1] *Burnt by the Sun* is just such a nostalgic myth about the Stalin era.

The film narrates a twenty-four hour period in June 1936 during which secret police (NKVD) officer Mitia accepts the assignment to arrest Red Army commander and Civil War hero Sergei Kotov at the family dacha outside Moscow. Mitia, the first love of Kotov's wife, Marusia, spends the day with her family, whose pre-revolutionary lifestyle has survived, thanks to Kotov's protection. At the end of

[1] Birgit Beumers, *Nikita Mikhalkov* (London and NY: I.B. Tauris, 2005), 2.

the day Mitia takes Kotov back to Moscow and commits suicide the following morning.

Mitia's complicated life story requires some explanation: During the Civil War he fought in the White Army against the Bolsheviks. After the defeat of the Whites, he made his way to France in 1921, where several years later he was recruited by the Soviet secret police with the promise of permission to return to Russia. Around 1927 Mitia returned to Russia, where he fell in love with Marusia, but was forced to resume his secret police work in Paris by Kotov. In 1936 Mitia returns to Moscow for good and accepts the assignment to arrest Kotov. Historically, Mitia is modeled on the husband of poet Marina Tsvetaeva, Sergei Efron, who spied for the Soviet government while in Paris but, unlike Mitia, was arrested and executed several years after his return to the USSR. As a compelling historical melodrama, *Burnt by the Sun* won the Grand Prix at Cannes (1994) and the Oscar for Best Foreign Film (1995).

BURNT BY THE SUN

Birgit Beumers

Binary Oppositions
The title and names: double meanings

The working title for the film was *The Absolute Effect of the Fireball* [*Bezuslovnyi effekt sharovoi molnii*]. According to Mikhalkov the title was changed to *The Weary Sun of 1936* in the course of filming, since he did not like the consonant clusters in the first title. The final version of the title was inspired by an accidental mispronunciation by a caller enquiring when the film would be ready, and was immediately adopted.[1]

The film's title draws on the 1930s tango "Utomlennoe solntse" ("The Weary Sun"), changing the grammatical correlation to *Utomlennye solntsem*—"those who are made weary *by* the sun," those who are burnt *by* the sun of the Revolution. This is partly because of the rights held by the composer Jerzy Peterburgski, partly in order to create an assonance between "Burnt by the Sun" and "Gone with the Wind" (in Russian "Unesennye vetrom"—"those carried away by the wind").

There are only a few real events, figures and places that occur in the film, but a number of associative names, such as the placename "Zagorianka" (the village which the driver is seeking), derived from the verb *zagoret'*—to get sunburnt: if he comes too close to this place, he will get burnt; indeed, when he is about to be told how to get there, he is shot. Kotov has no direct model in history, but the name is disyllabic, like that of Kirov, a figure whose popularity reveals certain parallels to Kotov; furthermore, both bear the

1 Nikita Mikhalkov, "Rezhisser ne dolzhen dolgo nakhodit'sia pod obaianiem svoei kartiny. Eto opasno," *Iskusstvo kino* 3 (1995): 9-13, 12.

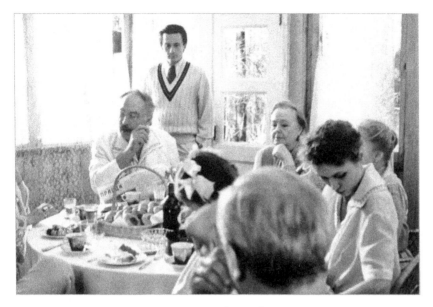

Fig. 101. At the Dacha

Christian name Sergei. The name of Marusia's family, the Golovins, echoes not only that of the theatre director Meyerhold's famous set designer Alexander Golovin; it is derived from the Russian word *golova*, meaning head, which alludes to the intellectual background of Marusia's family

Time and space

The film begins and ends with a view of the red stars on the Moscow Kremlin spires. The action of *Burnt by the Sun* departs from and returns to Moscow: NKVD officer Mitia arrives at his Moscow flat and accepts a special assignment. He travels to the country dacha to arrest Kotov, and brings him back to Moscow. Mitia's Moscow flat is located in the grey building that was the apartment house of the government, the "House on the Embankment" featured in Trifonov's eponymous novella,[2] with a close view of the center of

2 Yuri Trifonov, *Dom na naberezhnoi* (*The House on the Embankment*), in *Sobranie sochinenii*, vol. 2 (Moscow: Khudozhestvennaia literatura, 1986).

political power (of the Reds), while the "Whites" — the intellectual Golovin family — live on the periphery, on the outskirts, at least for the summer (Fig. 101).

Burnt by the Sun operates within a closed circular structure in terms of time: the story begins at 6 a.m. and ends at 7 a.m. the following morning. If we remove the intersection of time and place, only one hour has elapsed between Mitia's attempt to shoot himself and his suicide in the bath. It could almost be that none of the events between the two suicide attempts had ever happened. The day portrayed in the film is a long and happy day for a little girl whose ideals remain unshattered throughout. [...]

Contrasts and oppositions

In terms of structure *Burnt by the Sun* draws mainly on diametrical oppositions and contrasting principles. The film contrasts Moscow and the dacha, urban and rural life. It juxtaposes the idyllic setting at the dacha with its Chekhovian characters with the grey-and-red dominated picture of Moscow. The summer scenes of the main body of the film are contrasted with a brief glimpse of the winter season when Kotov and Marusia dance a tango at the pavilion as the film titles are shown. Classical music, arias from Italian operas, are opposed to Soviet march music. Western and eastern traditions conflict: Kotov prefers the wooden bathhouse to a civilized bathroom; Mitia's tap-dance performance is answered by a Russian step-dance performance from Kotov; the Francophone family excludes Kotov, who speaks no French. The individual games of tennis and croquet played before the Revolution are replaced by the collective (and more "proletarian") game of football [American soccer]. The inside of the dacha is formed by a wooden interior with many photographs on the walls and rattan furniture, very much in a turn-of-the-century tradition; it is juxtaposed to the Soviet reality of marches and pioneers outside. A second, parallel, political reality impinges upon the idyll with the arrival of the tanks in the fields; the pioneers who march in honor of Stalin and who congratulate Kotov; the gas attack evacuation practice; and the scenes at the construction site where a dirigible is being built to raise Stalin's banner into the sky.

Temporally, the past and present are juxtaposed: the recollections of the past and the action in the present, the pre-Revolutionary dacha setting, and the Revolutionary present. The world of children and pioneers, who look into the bright future, contrasts with the view into the past offered by the older generation.

These diametrical oppositions represent two worlds, each with a different pace of life, which conflict with each other: the frantic horseman interrupts Kotov's leisurely Sunday bath; the tanks shatter the peace in the fields and threaten the harvest; Mitia disturbs Marusia in her life from which he has been effaced; the truck interferes with the tranquillity of the village, of the peasant and of the construction site; the black limousine penetrates into the periphery like an envoy from the capital; and the evacuation exercise prevents relaxation at the beach.

These opposing principles serve to support the main contrast of the film: the theme of the marriage between the old Russian intelligentsia (Marusia) and the Revolutionary system (Kotov). The issue of whether this marriage works and whether the two systems are compatible is addressed: the marriage is based on lies (Kotov never confessed his involvement in sending Mitia away), and held together by Marusia's attempt to forget the past. The alliance survives, mainly because of the energy and (sexual) power of the Revolutionary, Kotov. It survives, however, only in a place that eclipses Soviet reality and continues with past traditions. The dacha is an artificial environment, out of space and out of time. Mitia is introduced to the viewer in terms of real time (for him time is indicated by the radio), and real space (Moscow). This reality destroys the illusion of a past life in a house protected from the outside world by gates and fences.

Duplicities: puns and *double-entendres*

The binary principle is also echoed in the duplicity and *double-entendres* which run throughout the film. The Soviet period was characterized not only by the renaming of places in honor of great revolutionaries, but also by a plethora of acronyms, ranging from NKVD and KGB to the name of the country itself, USSR. This

trend is mocked in the film by two acronyms: KhLAM, the name of the village of "painters, writers, artists and musicians" (*poselok KHudozhnikov, Literatorov, Artistov i Muzykantov*) translates, when read as a proper word, as "trash"; and the name for the Civil Defence unit (*GRazhdanskaia OBorona*) is shortened to GROB, meaning "coffin."

Characters are rather playful with language, too: returning from the swim and the conversation with Mitia about the happy past, Marusia pretends to be "injured" for the sake of the evacuation exercise, which has the benefit of her being carried away on a stretcher. Mitia emerges from the water behind her and claims to be "dead"; yet as such he will not be carried away. The adjectives they choose reflect their emotional states: Marusia is hurt, her old wounds are uncovered because of the meeting with Mitia whom she had tried to forget; Mitia is "effaced," annihilated, and emotionally dead.

Kotov's use of language differs from the family jargon used by the Golovins. His expression "to put up a melon" (*vstavit' arbuz*), meaning "to be caught up in a situation" is deliberately misunderstood by Vsevolod, who comments that this is the wrong season for melons. When Mitia repeats Boris Golovin's last words, "trains with geese," Kotov cannot understand the significance of the phrase and replies instead on the level of recipes for the cooking of geese. Mitia identifies himself as part of the family by using their jargon: when he arrives, he greets everybody with a key phrase he remembers. Only Kotov is not greeted with a phrase, but instead Mitia reminds him of his telephone extension from the days when Kotov worked for the secret service. Mitia belongs there, Kotov does not. The Golovins (including Mitia), do not speak the same language as Kotov. Whilst the Golovins talk about the past, Kotov is interested in the future. [...]

The Fireball

Twice in the film a special effect is used: the fireball. "What is the fireball? It is the Revolution. It is not by accident that at the beginning of the film the Frenchman Philippe reads a newspaper article about

a fireball that destroys everybody in motion, who thrust themselves forward. But for me this explanation does not mean anything—it is rather for critics and students…. For me the fireball is an emotion that requires no explanation."[3]

When Mitia tells the fairy tale about the past, the fireball emerges on the river, enters the house and makes the glass on a photograph burst before it leaves the house. The fireball ignites in collision with a falcon and eventually burns down one tree in the wood. This destruction of a bird and a single tree in the wood can be interpreted as the destruction of Mitia's life for the first time, when Marusia was taken away from him. The second fireball effect accompanies Mitia's physical destruction, his suicide. The fireball is red and can also be understood as a symbol for the Soviet system in an extension of the color symbolism discussed above. In this reading the system destroys one single tree in an indiscriminate manner. The effect is symbolic and not integrated in the overall realism of the film.[4] It obtrudes as artificial, although it is reported in the newspaper article that Philippe reads at the beginning of the film. It is unreal in that nobody notices the fireball, nor the effect that it has on the picture (showing a happy family scene). […]

Masks and Carnival

Mitia appears as an old, blind man emerging from the pioneers marching past the dacha: he is a blank page on to which any history and any identity can be written. In order to win Nadia's heart he poses as a magician; in order to gain entrance into the house he claims to be a doctor. He removes his carnival disguise, only to put on another mask; some time later he wears a gas mask. He is an entertainer, musician, dancer, story-teller, as well as a calculating NKVD officer who does his job. He pretends to be married with three children, yet he is a sad, lonely man. He can adopt any role, indeed needs to do so in order to give his life a meaning, at least

3 Nikita Mikhalkov, "Rezhisser ne dolzhen…," 12.

4 See Louis Menashe's review in *Cineaste*, XXI, 4 (1995): 43-4.

temporarily. He recites the tunes he taught Marusia, repeats the steps he learned in Paris, cites Hamlet, plays an invalid at the beach to be helped up by the fat lady asking him for the time, and "performs" a dive into the river. His every movement is a calculated action, a performance. There is no other way for him to return to the past than by creating a carnival atmosphere that allows him to behave like a child and play all sorts of—forbidden—games. He needs to create masks for himself, rather than a personality; he lacks psychological depth and, burdened with his role, he cannot change or reveal his emotions. [...]

Mirror-images of Fairy Tale and Reality

A fairy tale is reality beautified, the inversion of the reality on earth, seen in the light of cosmic transcendence.[5] Fairy tales almost always have a happy ending. When Mitia first appears, he is a "Santa Claus" (*ded moroz*)—in the middle of the summer. He emerges from a group of marching pioneers who are singing the "Aviators' March" (by Pavel German and Yuli Khait, 1920):

> We were born to make a fairy tale come true,
> To conquer the distances and space,
> Our minds made steel wings for our hands,
> And throbbing engines take the place of our hearts.
> Ever higher, higher and higher
> We aim the flight of our birds,
> The tranquility of our borders breathes in each propeller.[6]

The song anticipates the 1930s' call for a varnished and perfected reality, while it also echoes two themes relevant to the film: the birds that fly too high and get burnt by fireballs; and the theme of aeroplanes that conquer territory. "We are born to make a fairy

5 Compare Andrei Siniavsky's study of *svet* in the fairy tale in *Ivan-durachok* (*Ivan the Fool*).

6 Pavel German, Yuli Khait, "Aviators' March," 1920, translated in von Geldern and Stites, *Mass Culture in Soviet Russia* (Bloomington, IN: Indiana University Press, 1995), 257-58.

tale come true" is the premise upon which Mitia enters the house. Nadia's first question for the magician from the country of the Maghreb, the country of summer Santas, is whether the country is Soviet, and only her second question is whether there are winter Santas as well:

> Are you the summer Santa?
> Yes, Nadia, I'm the wizard from the Maghreb.
> What's the Maghreb?
> The Maghreb is the land where the summer Santas live.
> In the USSR?
> Of course. All the summer Santas live in the USSR.
> And the winter ones?
> They do, too.

Although Mitia has entered the world of fairy tales, he speaks the truth: he is from the country of the Maghreb, the Arab word for West. The happy past is remembered in the form of a fairy tale narrated by Mitia, about the boy Yatim who was taken on by the kind musician Sirob who then had a daughter, Yasum; Yatim then had to fight in the war, and when he returned Yasum had become a beautiful princess and Yatim fell in love with her. But then an important man—whose name he cannot remember—took Yasum away from him and sent Yatim abroad.

Mitia inverts the names of the protagonists (Mitia and Musia, a diminutive for Marusia, in itself a diminutive for Marina or Maria) to Yatim and Yasum. Mitia's fairy tale lacks, however, the happy ending that Nadia expects. The inversion of names also reflects the inversion of worlds, of the old order for the new, and as such continues the principle of oppositions and contrasts. Mitia's and Marusia's names, as well as Nadia's, are marked on the glass panel by the door. Mitia marks his height and age now, in the present, as Yatim, aged 37: he has changed his identity. Nadia understands the principle of fairy tales very well: she expects a happy ending, and when Yatim and Yasum do not marry she correctly assumes that the "important man" must be an ogre. She also understands the principle of inversion of names and applies it to herself: she figures out that she would be Yadan in the story. But she does not decipher

the inverted names of the fairy tale figures. Nadia transposes herself into fairy worlds, but does not transpose the fairytale world into reality. The principle advocated in the Soviet march does not work: we do not turn the fairy tale into reality, but make reality a fairy story, a myth, a lacquer box.

BURNT BY THE SUN

Susan Larsen

In Sergei Kotov, the "legendary" division commander who is the charismatic hero of *Burnt by the Sun*, Mikhalkov reclaims an image of triumphant masculinity and honorable national identity from the Stalin era in a form that defies the widespread tendency in 1990s Russian cinema to depict Stalin-era loyalists as flawed or false heroes.[1] *Burnt by the Sun* stages its contest for the historical moral high ground between its two protagonists—the civil war hero Kotov (Mikhalkov) and Mitia (Oleg Men'shikov), the NKVD agent assigned to arrest Kotov on a sunny June day in 1936—as a romantic rivalry for the affection and respect of Kotov's beautiful young wife, Marusia (Ingeborga Dapkunaitė). As several Russian critics observed, the film inverts contemporary stereotypes about the Stalinist past that would ordinarily have cast the piano-playing émigré Mitia as the victim and the Bolshevik hero Kotov as the villain in the love triangle in which all their conflicts—moral, political, and romantic—are played out.[2] As Mikhalkov noted in an interview, however, "I do not give the viewer the right to pity [Mitia]."[3] The principal strategy used to crystallize the opposition between Mitia and Kotov is based less in history than in the conventions of melodrama, however, as Kotov wins a moral and sexual victory over Mitia, the man who tries—unsuccessfully—to usurp Kotov's

1 On contemporary films set in the Stalin era, see Julian Graffy, "Unshelving Stalin:After the Period of Stagnation," and Anna Lawton, "The Ghost That Does Return: Exorcising Stalin," both in Richard Taylor and Derek Spring, eds., *Stalinism and Soviet Cinema* (London, 1993), 212-27; 186-200.

2 Andrei Plakhov, "Mikhalkov protiv Mikhalkova," *Seans*, 1994, no. 9:21.

3 Mikhalkov, "Rezhisser ne dolzhen nakhodit'sia pod obaianiem svoei kartiny. Eto opasno," *Iskusstvo kino*, 1995, no. 3: 11.

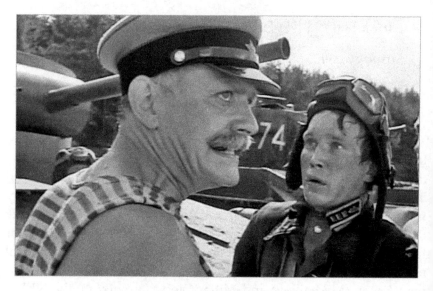

Fig. 102. Moment of Recognition

place in the affections of his wife and daughter, Nadia (Nadia Mikhalkova, the director's daughter).

The film structures its audience's response to its two protagonists by emphasizing visual rather than verbal narratives of heroism. Although the film provides far more details about Mitia's history than it does about Kotov's heroic past, Mitia's stories about himself are never buttressed by the visual evidence that affirms Kotov's position as the melodramatic hero. Mitia's character is revealed in long theatrical sequences in which he is always an *actor:* he arrives at Kotov's dacha disguised as an old man, later dons a gas mask and bathrobe while playing a frantic can-can on the piano, then improvises a puppet show in which he tells a fable intended to persuade Marusia that he abandoned her only because Kotov blackmailed him into becoming a Soviet spy among the Russian émigré community in France. This fable, like the many actual masks Mitia assumes, offers what the film argues is a *disguised,* and thus inauthentic, version of the truth. Mitia's story remains just that— a story.

Kotov's "story," however, never has to be told, because his heroism is universally acknowledged by everyone around him— from his five-year-old daughter, Nadia, to the NKVD thugs who

beat him into a bloody pulp at the film's conclusion. The film repeatedly stages scenes in which Kotov is the object of almost speechless adoration. Much of *Burnt by the Sun* is shot from Nadia's point of view, and her wide-eyed vision of her on-screen father, the "legendary" division commander Kotov as played by her offscreen father, the equally legendary filmmaker Mikhalkov, shapes the viewer's response to the film. Kotov radiates love for his youthful wife and innocent daughter, and it is their loving admiration of him as husband and father that makes the strongest case for Kotov's status as an authentically Russian national hero, whose principal allegiance is to his extended "family," the Soviet people (*narod*), and only secondarily to the Soviet government.

This distinction between popular and official heroism is established from the film's first shots of Kotov, lying prone in an old-fashioned wooden bathhouse and beaming as Nadia beats him with the traditional birch switches. His wife smiles at them both as she stands with her naked back to the camera, bathed in amber light from the window. This idyllic vision of family togetherness is markedly *not* sexual: it presents the film's hero as a man of simple, domestic pleasures, one who prefers traditional, rural Russian cleansing rituals to the modern conveniences of gas heat and running water. Kotov's moral purity is further accented by the opening shot of his bare-chested young daughter perched astride his own naked back. This family's nakedness—to each other and to the viewer—suggests that they have nothing to hide and nothing to fear; like Adam and Eve before the Fall, they are strangers to shame. This bathhouse idyll is interrupted, however, by an urgent demand for Kotov to protect the local villagers' fields from a division of tanks performing military maneuvers. Kotov, not unlike his cinematic predecessor, the equally legendary division commander Chapaev, immediately leaps astride a horse and gallops off to intervene. Unlike Chapaev, however, Kotov is riding to forestall a military charge, not to lead it. This scene establishes Kotov's primary loyalty, to the Russian land, rather than to the Soviet chain-of-command. Kotov has only to demand, "Don't you recognize me?" (Fig. 102) to plunge the young commander of the tank division into a fit of giddy veneration and unquestioning obedience. Similar incidents

recur throughout the film, among them a scene in which a troop of Young Pioneers wearing shirts with Kotov's portrait march by his dacha to salute him in honor of the holiday on which the film takes place—Stalinist Dirigible Construction Day.

The film's pivotal demonstration of Kotov's moral authority occurs at the moment when it is most profoundly called into question. In a moment of quintessentially melodramatic *misrecognition,* Marusia rebels against her husband after hearing Mitia's fable about the nameless evil wizard who separated the young lovers.[4] As Marusia flees the dinner table in tears, Kotov runs after her, but the ensuing pursuit is shot as if it were a silent film. Kotov and Marusia's lips move as they remonstrate with each other, but the soundtrack offers only the tune of the tango, "The Weary Sun," that is the film's theme song. The dialogue track gradually resurfaces as Kotov pounds up the stairs into the attic after Marusia. The attic setting recalls the bathhouse of the film's opening scenes: the warm light bouncing off rough-hewn wooden walls and rafters evokes the same pastoral mood, and the ceiling is hung with *veniki* (the bundles of twigs bathers beat themselves with as they steam). As Kotov comes in the door, he begins removing his clothes and tells Marusia to "wait, come here," while she threatens to jump out the window if he comes any closer. Kotov makes no attempt to defend himself against Mitia's accusations but simply displays what the film intends both Marusia and the viewer to respond to as his masculine authority—which the film equates with moral virtue. Kotov pulls his wife into his arms and begins to remove her dress; in the ensuing love scene Kotov and Marusia wordlessly reach orgasm together on a bed of straw in a haze of golden light. The choreography of the sex scene places Marusia on top, as if to emphasize that Kotov has not forced her into bed, but drawn her there with his magnetic charm.[5]

[4] On melodrama's characteristic "misprision and recognition of virtue," see Peter Brooks, *Melodramatic Imagination: Balzac, Henry James, Melodrama, and the Mode of Excess* (New York, 1985), 28-34.

[5] For one viewer's enthusiastic, if probably tongue-in-cheek, response to the novelty of this sexual position, see A. Akulov, "Seks po-mikhalkovski," *Argumenty i fakty,* 1996, no. 6 (no. 799): 1.

His appeal in this scene, as throughout the film, is powerful, but passive—he lies back and accepts the adoration of his wife and everyone else. The purely visual logic of this scene argues that Marusia returns to Kotov not because of any "stories" he tells her, nor because he forces her to submit, but because of his literally incredible sexual magnetism—a magnetism that the film casts as a moral force. The conflation of sexual and moral arguments is most apparent in the moment of post-coital bliss when Kotov explains to Marusia that he, like Mitia, would also have abandoned his loved ones if so ordered, but that he would have been motivated by duty and love for the Motherland, while Mitia was motivated only by fear. Kotov makes this argument, however, only after it is no longer necessary, because—as the film hammers home in these scenes—his wife is back on his side the minute he touches her.

All of these scenes mobilize the substantial expressive means at Mikhalkov's command to stage what Peter Brooks has compellingly identified as the "core of melodrama's premises and design . . . the admiration of virtue."[6] This admiration of virtue is precisely the function of the many scenes in which Kotov is the silent object of other characters' esteem and love. In their emphasis on Marusia's and Nadia's unquestioning love for Kotov, these scenes recast a model hero of the Stalin era as a model family man, restoring a sense of generational—and historical—continuity between the public heroes of the Stalin era and their descendants that almost all other post-Soviet films set in the 1930s have felt compelled to deny.

6 Brooks, *Melodramatic Imagination*, 25.

FURTHER READING

Beumers, Birgit. *Burnt by the Sun.* London: I.B. Tauris, 2000. [This is the most detailed analysis of the film.]

Beumers, Birgit. *Nikita Mikhalkov.* London: I.B. Tauris, 2005.

Condee, Nancy. "Nikita Mikhalkov: European but Not Western?" In *The Imperial Trace: Recent Russian Cinema*, 85-113. Oxford and NY: Oxford University Press, 2009.

Larsen, Susan. "National Identity, Cultural Authority, and the Post-Soviet 'Blockbuster': Nikita Mikhalkov and Aleksei Balabanov." *Slavic Review* 62, no. 3 (2003): 491-511.

BROTHER

Brat

1997

96 minutes

Director, Screenplay: **Aleksei Balabanov**

Cinematography: **Sergei Astakhov**

Art Design: **Vladimir Kartashov**

Composer: **Viacheslav Butusov**

Sound: **Maksim Belovolov**

Production Company: **STV, Goskino RF, Gorky Film Studio**

Cast: **Sergei Bodrov Jr. (Danila Bagrov), Viktor Sukhorukov (Viktor, Danila's brother), Svetlana Pis'michenko (Sveta), Mariia Zhukova (Kat), Iurii Kuznetsov (the German), Viacheslav Butusov (as himself), Irina Rakshina (Zinka), Sergei Murzin (Kruglyi, the proverb-loving gangster), Sergei Astakhov (truckdriver)**

Until his recent death, Aleksei Balabanov (1959-2013) was Russia's most talented and controversial contemporary filmmaker. He has been called a genius, a media provocateur, xenophobe, anti-semite, racist, nationalist and russophobe. Balabanov consciously sought to provoke audience reaction in his films and was the *enfant terrible* of the film establishment, which he mostly avoided.[1] Critic Iurii

[1] "In general I was always against something. I think that this pathos has remained with me from the Soviet era," "Balabanov o Balabanove," *Seans*, no. 17/18 (May 1999), http://seance.ru/n/17-18/portret/balabanov-o-balabanove/ (accessed 5 October 2012). See also Igor' Naidenov, 2008 Balabanov interview, *Russkii reporter*, http://alekseybalabanov.ru/ (accessed 30 September 2012).

Bogomolov has argued that Balabanov posed vexed questions about Russian society, diagnosed traumas, but provided no solutions. "His films, from *Brother* to *The Stoker*, are a kind of medical history of our societal organism, where all the heart attacks, strokes, partial amnesias, stresses, Napoleonic complexes and persecutions are recorded.... I can't name a single other Russian director who was so sensitive to what has been happening in the substratum of our society during the past two decades."[2]

Balabanov was trained as a translator and as a young man travelled abroad accompanying Soviet arms dealers. From 1983-87 he worked as a director's assistant at the Sverdlovsk film studio, then studied at the Higher Courses for Scriptwriters and Directors, graduating in 1990. After his first feature film, *Happy Days* (*Schastlivye dni*, 1991), he co-founded, with Sergei Sel'ianov, the production company STV, which has produced most of his films. After an unsatisfactory adaptation of Kafka's *The Castle* (*Zamok*,1994), Balabanov made his breakthrough gangster film *Brother*, which has become a cult work in Russia, followed by the less subtle but equally successful *Brother-2* (*Brat-2*, 2000). Between the two "brothers" Balabanov released his auteur film *Of Freaks and Men* (*Pro urodov i liudei*, 1998), which he views as his best work.[3] *Brother*, a low budget film shot in the interval between other projects, determined the second half of Balabanov's career as he consciously made the decision to shoot films for the broader Russian population, incorporating both the Hollywood idiom and a serious examination of national identity. Balabanov's later films in various genres include *War* (*Voina*, 2002), *Dead Man's Bluff* (*Zhmurki*, 2005), *It Doesn't Hurt* (*Mne ne bol'no*, 2006), *Cargo 200* (*Gruz 200*, 2007 — his most controversial work), *Morpheum* (*Morfii*, 2008), *The Stoker* (*Kochegar*, 2010) and *Me Too!* (*Ia tozhe khochu!*, 2012).

2 Iurii Bogomolov, "Portret. Aleksei Balabanov," *Seans*, no. 17/18 (May 1999). http://seance.ru/category/n/17-18/portret/2505/ (accessed 23 September 2012). Iurii Bogomolov, "Nam ne bol'no?..," *Rossiiskaia Gazeta* (20 May 2013), http://www.rg.ru/printable/2013/05/20/balabanov.html (accessed 4 June 2013).

3 Elizaveta Okulova, 2010 Balabanov interview, *Kinopoisk*, http://alekseybalabanov.ru/ (accessed 30 September 2012).

Balabanov contends that his morally questionable hero of *Brother*, Danila Bagrov, was turned into a positive cult figure by audiences:

It's not my fault. Sorry. Audiences made him into that. I wanted to show a person who was, on the one hand, ordinary, on the other—far from unambiguous. Danila does a lot of things that are forbidden in normal life.... In general this is another generation—the generation of those who were in the war, who killed. People who have been through war think differently in civilian life. Man gets used to everything, as is well known. Having killed the first time, he probably suffers. Having killed a second time, he suffers less. And having pressed the trigger a third time, he doesn't suffer at all. And besides, the guys who fought in the Caucasus saw a lot of foreign customs. Could you, for example, slaughter a sheep? You couldn't. I couldn't either. But in the Caucasus this is considered a virtue.... I wrote this story specially for Serezha Bodrov. By that time I had already seen *Prisoner of the Mountains* (*Kavkazskii plennik*), where he had one of the main roles. I had some idea of what Serezha was like in life. What's he like? Charming. Not at all an actor. For example, he couldn't play Hamlet; he doesn't know how to act at all. He simply exists naturally in space. And so in the end his Danila turned out to be very natural: in life he goes by his own truth, from his gut, as they say, not from his head. To him it seems that this is exactly how one should live. And the viewers themselves will decide whether or not to judge him.[4]

[4] Iuliia Shigareva, 2002 Balabanov interview, *Argumenty i fakty* (1115), 6 March 2002, http://alekseybalabanov.ru (accessed 30 September 2012). See also 2009 GZT.ru interview on same site. Balabanov has made no secret of his personal views: "In Nizhnii Novgorod, Ekaterinburg, Noril'sk, Irkutsk, Vladivostok—everywhere there's the spirit of the culture, and it's Russian. But in Petersburg and Moscow—the dark-skinned ones (*chernye*) are there, the diasporas are there, there people are already preparing and beginning to knock off Russians, to simply kill them. In Siberia and the Urals there's none of that yet." When the interviewer questioned his use of "chernye" for Chechens and other ethnic minorities, Balabanov responded, "That's what I think." (Mikhail Vereshchagin, "2012 Interv'iu gazete *Izvestiia*," http://alekseybalabanov.ru [accessed 28 May 2013]).

Brother displays stock features of the director's subsequent films: the isolated, alienated hero who tries to make sense of an unfamiliar, hostile world; the city as site of conflict; exploration of the criminal world; dysfunctional families; Balabanov's signature post-Tarantino graphic violence; the transgressive violation of moral taboos; open-ended plots; the prominence of music as polysemantic, complicating commentary to the narrative; strong attention to form (black screen, carefully composed panorama shots, atmospheric color; extended driving/walking sequences with coordinating musical accompaniment); reliance on a small cohort of favorite professional actors, along with a preference for non-professional or relatively unknown performers.

BROTHER

Birgit Beumers

Aleksei Balabanov's *Brat* (*Brother*, 1997) was, in a sense, the first genuine Russian blockbuster. Released at a time when audiences had not yet returned to cinemas that were awaiting refurbishment, Brother was a "blockbuster" on account of its video sales. Thus, it cannot be compared, in theatrical release figures, to later films such as Nikita Mikhalkov's *Sibirskii tsiriul'nik* (*The Barber of Siberia*, 1999), which grossed $2.6 million at the box office, but had cost $45 million to produce, or even to its sequel *Brat 2* (*Brother 2*), which was released on 11 May 2000 and, with a budget of $1.5 million, grossed $1.08 million in the CIS (Commonwealth of Independent States) territory alone.

At the time of *Brother*'s release, Russian critics were preoccupied with cinema's relationship between art and commerce, education and industry, and propaganda and business. In the eyes of many, cinema remained the most powerful means of expressing moral values and providing guidance, while some Russian directors and producers began to realize cinema's potential as a business that could, one day, make a profit. The dilemma of cinema appeared to lie in its place between the fetters of ideology and capital, and its dependence on an infrastructure in desperate need of repair or reconstruction. It was not until 2000 that multiplexes opened in Moscow, and the distribution network expanded rapidly in the period that followed, making Russia's cinemas among the most modern and largest multiplexes in the world and putting the Russian distribution market into a key position for world sales.

It is important to bear this in mind, as well as the fact that Russian film production had reached an all-time low in the year preceding the release of *Brother*. Those films that did appear were concerned with crime and the bleakness of Russian life in the Yeltsin era. Filmmakers who had provided moral guidance amidst

the corruption of the Soviet system found themselves in a difficult position: should filmmakers be expected to show a cleansed version of the surrounding world and create ideals for the people to believe in? Or should they openly portray the bleakness and despair of a generation whose (Soviet) ideals had been pulled away from under their feet? It may not have been pleasant or entertaining to watch Russian films of the late 1990s that refused to create a "positive hero" and instead showed a gruesome and blackened reality (*chernukha*), but the use of cinema for the projection of a national identity in the spirit of socialist realist principles (*lakirovka*, or the varnishing of reality) was then, and remains today, extremely problematic.

Balabanov's film has to be placed into this context in order to fully comprehend the significance *Brother* had for the development of the national film industry on the one hand, and for the concept of the "Russian hero" on the other.

Brother and *Brother 2* playfully engage with the action movie genre. The plot of Brother concerns a killer with a good heart who reinstates justice and fights evil. The cast features largely unknown or non-professional actors (with the sole exception of Viktor Sukhorukov, b. 1951). Danila Bagrov (Sergei Bodrov Jr.) returns to his provincial hometown from army service. When he gets into trouble with the police, his mother sends him to visit his elder brother, Viktor (Sukhorukov), in St. Petersburg. Viktor is a killer, who enlists Danila to shoot the "Chechen" mafia boss, whom he has been paid to kill. Carrying out the assignment Danila realizes that his brother has betrayed him, and that he is not killing a "terrorist" who is a threat to Viktor and other people. While his own brother lets Danila down, an unknown tram driver, Sveta (Svetlana Pis'michenko), helps him. They subsequently have an affair, but Sveta stays with her husband, despite the fact that he beats her. Danila carries out his assignment: he kills the "Chechen" and bails out his brother. Danila is a professional killer; more professional than his elder brother who had hitherto been a father figure to him (Fig. 103). It is this explanation that Danila uses when he tells Viktor why he is helping him and before he sends Viktor home "to look after mum." Whilst cold-bloodedly carrying out the killing of the Chechen and of some other mafia members who have set Viktor up, Danila is

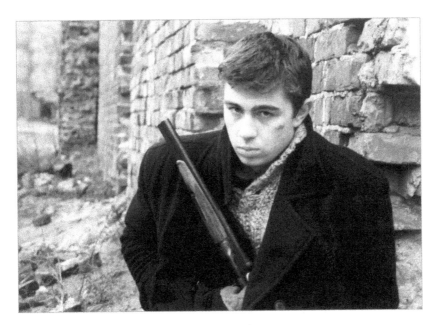

Fig. 103. Danila

also a knight who helps the poor, suppressed and underprivileged. Having conquered the criminal world of St. Petersburg, he leaves for Moscow at the end of the film; it is from his arrival in Moscow that the sequel picks up Danila's story.

Brother sets out a new type of hero, who upholds no moral standards. Unlike the soldier of the 1960s Soviet war movie, Danila is modelled on the Russian fairytale figure of Ivan-the-Fool, as Susan Larsen has convincingly argued. Danila is a dumb provincial boy where contemporary culture is concerned: he does not recognize famous people; he runs into a film location without realizing it; and he has no idea where to purchase the CDs he wants. He is generally good-hearted and streetwise. He helps the poor: he defends an old man—Hoffman, the German—against a racketeer; he helps the conductor collect a fine from two Caucasian "black arses" ("*gnida chernozhopaia*"—a xenophobic phrase that has outraged Russian critics Daniil Dondurei and Viktor Matizen) travelling on a tram without a ticket; he shoots at his girlfriend Sveta's violent husband in an attempt to defend her. He is ruthless to his enemies and is a man of action: Danila possesses skill, strength and courage; he

knows how to use guns, is physically fit to fight, and his actions display a sense of military logistics. A killer, he is also a romantic hero, a knight who keeps his word. Larsen has drawn attention to the parodic reference to the image of the knight in Vasnetsov's painting in Sveta's room, and the fact that Danila cannot quite live up to knighthood—because in the criminal world he is a killer. He combines within himself the contradictions at the heart of the Russian idea: the right to judge and the compassion to redeem. Danila has no role in society at large: a true killer, he is a loner, an individual acting without a reason. At the same time, Balabanov also rejects the *chernukha* model, which perceives man as a victim of circumstance. The new Russian hero is no victim; instead he lives on the spur of the moment and acts according to the situation.

The title of the film parodies the concept of a "brotherhood of people" (the collective spirit of the Soviet people). Real "brotherhood" is further mocked when Viktor, the elder brother replacing the absent father, is protected by his younger brother: Danila saves Viktor from the mafia bosses who hired him after Danila has successfully carried out the killing for which Viktor was paid. Yet "brotherhood" here also means the criminal brotherhood (*bratva*) which is more clearly referred to in the sequel to *Brother*, both in the thematic concern with brothers of war and real brothers, but also in the fact that the title is a homophone of *bratva*: it is pronounced brat-dva. The criminal brotherhood to which Viktor belongs has superseded the relation to his real brother; later Danila abandons Viktor in Chicago and instead devotes himself to the defence of his "brothers" of war, Il'ia and Kostia. The bond with those who share Danila's personal history is ultimately stronger than family ties. Moreover, the absence of fathers to protect any of the "children of modern Russia"—be they Il'ia, Kostia or Danila— also hints at the collapse of the family as a functional unit in modern society and at the lack of a lineage, or linearity, instead emphasizing the severed link to past and future (indeed, there are no children in the films, except for an oligarch son, who plays a purely functional part).

Danila has neither a perspective in life nor a past. If he does have a history, it is the fictional biography of Bodrov Jr.'s previous

hero, the soldier of the Chechen war, Vania Zhilin of Bodrov Sr.'s *The Prisoner of the Mountains*. At the beginning of *Brother* Danila claims that he spent his army service as a scribe in some office. It soon becomes clear that this is a lie: he has very good knowledge of firearms and his maneuvers are carefully planned. It is much more likely that Danila has served in Chechnya (as is confirmed in *Brother 2*). Danila is a young man hardened to the realities of life by his experience of war. Indeed, his personality and background are like a blank page onto which any story could be written. This is reflected in the technique of black-outs after each episode which fragment the film and allow it to be reassembled in any order. Danila is deprived of any psychological depth, and the choice of a non-professional actor reflects Balabanov's need for a facade rather than a character.

Brother begins when Danila accidentally walks into the location of a clip for the rock group Nautilus Pompilius's latest album "Kryl'ia" ("Wings"). This song describes the absence of wings, the lack of a means that would allow man not only to move, but to float above the world.

> Some time ago we used to have time,
> > now we have things to do:
> To prove that the strong gobble up the weak,
> > to prove that soot is white.
> We have all lost something in this senseless war,
> By the way: where are your wings which I liked so much?

The song deals with the lost dreams of a generation that lived through the Soviet era, dreaming of freedom. Now that they are free from ideological fetters, they are busy doing things that are no longer important (or as important as fighting for ideals of freedom). The romantic dreams of the underground dissident were so much more attractive than the real world, preoccupied with insignificant trivial banalities, that the wings which allowed them to fly (in their dreams) are no longer there; there is a hint at the absence of a future, of a dream to live for. The song is about disillusionment, a theme that Danila identifies with: he searches for an ideal, and all he finds are the traces of where such ideals may have been in the past. It is

for this reason that he searches for the musical icons that belong not to his generation and not to his time.

Later, Danila literally marches into lead singer Viacheslav Butusov's flat; he seeks to identify with this group of people, yet fails to realize that this is a different world from his own. In both the scene of the clip and the visit to Butusov's flat, Danila crashes back to reality—at the police station, bruised and beaten, and to the murder scene in the empty flat. Nautilus's music functions as a leitmotif for Danila's journey to St. Petersburg. The band is originally from Sverdlovsk (now Ekaterinburg), but moved to St. Petersburg in the early 1990s; Danila too comes from provincial Russia to St. Petersburg, where he finally acquires a compact disc of "Wings." Danila plays Nautilus most of the time on his CD player. He lives in the world of the music and only partly understands the reality that surrounds him. The songs endow the film with a dreamlike quality. Bagrov's movements are paced by the rhythm of the music, and thus appear as though they were performed under a spell or under the influence of drugs, but not by an individual who reflects upon the world that surrounds him. Nautilus's songs are about another world, about daydreams, and about the crippling effect of reality; the wings that enable man to fly have been lost and all that remains are scars. Most curious is another fact: the entire soundtrack of the film is from the albums "Atlantida" and "Yablokitai," which, in fact, are the two albums Danila fails to acquire in the music shops. In other words, the film's spectators hear the music that Danila wishes to hear, but has actually not yet managed to acquire. The hero lives in the sound system of another world, in which he is immortal: the CD player literally saves his life when it deflects a bullet.

Brother is set in contemporary St. Petersburg, a setting that features in most of Balabanov's films, and employing his favorite locations: streets, courtyards, trams, bridges and cemeteries. Danila's arrival on a train is reminiscent of Balabanov's short film *Trofim* for *Pribytie poezda* (*Arrival of a Train*, 1996). After leaving the station Danila strolls around the city, looking at the sights: the streets, the canals, the monument of the Bronze Horseman, the rostrums and St. Isaak's Cathedral. Again, Balabanov's (or rather Sergei Astakhov's) camera never rises above eye level, so the viewer

never sees the city's roofs or spires. Balabanov's St. Petersburg is a place that lacks perspective, for both the viewer and protagonist.

The "German," Hoffman, takes Danila to his home; the Lutheran cemetery is Hoffman's "rodina" (homeland), the place where his ancestors rest. The German work force that was drawn to St. Petersburg during the reign of Peter the Great and Catherine the Great is no longer needed in the modern city; these great-great-grandchildren of German origin are orphaned, isolated, lonely and deprived of social status. It is for these uprooted people that Bagrov feels compassion, while he would not think well of Jews and certainly not of Caucasian nationals. Viktor's claim that he wants to put the street trade under Russian control is fine with Danila: he is happy to get rid of the "Chechen," but he is quite protective of the "German." Danila listens attentively to Hoffman's deliberations about the city that is a "huge force" and takes energy away from the weak (like himself), but strengthens those who are strong (like Danila).

The center of St. Petersburg is depicted as a bustling shopping center with McDonalds, Littlewoods and other western shops, as well as clubs. The street markets are controlled by the mafia and form a sharp contrast to the western shopping centers. These central areas of the city are juxtaposed to the Primorskaia district with its 1970s blocks of flats on the Baltic shore. It is here that Danila rents an apartment; that the murder of a number of gangsters takes place; that Danila meets Butusov; and that he himself is shot at. Numerous monuments make St. Petersburg attractive for the tourist, but the city appears as an alien place to its inhabitants. The cemetery and the Primorskaia flat are the spaces that are paradoxically filled with life, but both are spaces on the outskirts of the center. Correspondingly, Viktor's flat in the center is a place where people die, Svetlana's center flat is a place of violence and racketeering, and the flat where Danila rents a room to hide and prepare for the killing is inhabited by a drunkard. Life is not in the center, but on the periphery; it is not in the apartments but on the cemetery, while it is in living spaces that people get shot.

The tram features as a means of transport when Danila collects a fine from the two Caucasians: the tram is occupied by "illegal"

users. Another tram, not an ordinary one, but an empty car which serves only to check the tracks, rescues Danila when he is on the run after having been shot in the stomach. The tram is driven by Sveta, who first rescues and later protects Danila. Before his departure from St. Petersburg Danila catches a final glimpse of the Neva bridges and watches a tram run across the bridge, offering a frame for the view on St. Petersburg and St. Isaak's Cathedral. This is his farewell to the city, and the end of his love affair with the tram driver. Trams run through the city with no apparent function or destination; they seem to run because the tracks are there. They provide an aperture, a window on to the city's skyline, making it an object for the viewer's gaze rather than a living organic conglomerate.

The figure of Hoffman serves as a moral testing ground for Danila. Hoffman refuses Danila's "dirty" money, relying on his own earnings which he makes, significantly, by selling old watches — a reference to a measuring device for time which is otherwise absent in the film. Balabanov neither condemns nor rejects the amoral conduct of his protagonist, but merely shows a new type of man: a hero who sets no standards. In this consisted the main opposition to the mainstream of Russian cinema, and this characteristic made Bagrov/Bodrov a cult figure. [...]

REFERENCES

D. Dondurei, "Ne brat ia tebe, gnida…." *Iskusstvo kino* 2 (1998): 64-7.

S. Larsen, "National Identity, Cultural Authority and the Post-Soviet Blockbuster: Nikita Mikhalkov and Aleksei Balabanov." *Slavic Review* 62.3: 491-511.

V. Matizen, "Skromnoe ocharovanie ubiitsy." Seans 16 (1997): 41.

FURTHER READING

Condee, Nancy. "Aleksei Balabanov: The Metropole's Death Drive." In *The Imperial Trace: Recent Russian Cinema*, 217-36. Oxford and NY: Oxford University Press, 2009.

Day, Jennifer J. "Strange Spaces: Balabanov and the Petersburg Text." *SEEJ* 49, no. 4 (2005): 612-24.

Gladil'shchikov, Iurii. "Znai nashego 'Brata'." In *90-e. Kino, kotorye my poteriali*, compiled by Larisa Maliukova, 136-40. Moscow: Novaia gazeta, Zebra E, 2007.

Hashamova, Yana. *Pride and Panic: Russian Imagination of the West in Post-Soviet Film*. Bristol and Chicago: Intellect Books, 2007.

Larsen, Susan. See above, in References.

RUSSIAN ARK

Russkii kovcheg

2002
96 minutes
Director: **Aleksandr Sokurov**
Screenplay: **Anatolii Nikiforov, Aleksandr Sokurov**
Cinematography: **Tilman Büttner**
Image Design: **Aleksandr Sokurov**
Editing: **Sergei Ivanov**
Sound: **Vladimir Persov**
Production Company: **Hermitage Bridge Studio, Egolli Tossell Film AktienGesellschaft**
Cast: **Sergei Dreiden (Marquis de Custine), Mariia Kuznetsova (Catherine the Great), Leonid Mozgovoi (the spy)**

Born 14 June 1951 in Podorvikha in the Irkutsk region of Russia, Aleksandr Nikolaevich Sokurov worked at the television studios in Gorky (now Nizhnii Novgorod) while studying history at Gorky University from 1968 to 1974. In 1975 Sokurov enrolled at the All-Union State Institute for Cinematography (VGIK), where he studied in the popular-scientific section of the department of film direction. Originally entitled "The Return of Platonov," Sokurov's diploma project was supposed to weave scenes from Andrei Platonov's story "The River Potudan" into the Soviet writer's biography. When the completed film *Solitary Voice of a Man* (*Odinokii golos cheloveka*) turned out to be an experimental adaptation of the story, it was rejected by VGIK and the administration ordered the destruction of all copies (The film survived nonetheless and was released in 1987 to critical acclaim.) Sokurov was able to receive his degree for a documentary he had made for television at Gorky, entitled *The Summer of Mariia*

Voinova (1978, later folded into *Mariia*, 1988) and was hired as a director at Lenfilm.

Over the next ten years Sokurov made numerous films for Lenfilm and for the Leningrad Studio of Documentary Film (LSDF) without any of them reaching the screen. By the beginning of perestroika, Sokurov began to exhibit his sizeable back-catalogue and, together with new films made in the spirit of the time, quickly established himself as one of the leading directors in alternative Soviet cinema. The feature films *Days of Eclipse* (*Dni zatmeniia*, 1988) and *Second Circle* (*Krug vtoroi*, 1990) brought him to the attention of the international festival audience. His adaptations of George Bernard Shaw's *Heartbreak House* (*Mournful Indifference*, *Skorbnoe beschuvstvie*, 1987) and Gustave Flaubert's *Madam Bovary* (*Save and Preserve*, *Spasi i sokhrani*, 1989) are oblique glimpses of motifs derived from the sources with little attempt to reproduce the narratives. *Whispering Pages* (*Tikhie stranitsy*, 1993) combines an elegiac homage to Dostoevsky with a rigorously experimental study of visual distortion to create a hallucinatory improvisation on "the motifs of nineteenth-century Russian literature" (primarily *Crime and Punishment*). His international status was reinforced by *Mother and Son* (*Mat' i syn*, 1996) and by the first three installments of his "tetralogy on power": *Moloch* (1999), *Taurus* (*Telets*, 2000) and *Sun* (*Solntse*, 2004). Sokurov reached unprecedentedly large audiences with *Russian Ark* (2002), after which he made *Father and Son* (*Otets i syn*, 2005) and *Alexandra* (2007), the latter starring Galina Vishnevskaia as the mother of a Russian soldier serving in Chechnia. His 2011 feature *Faust*, completing his "tetralogy on power," won the Golden Lion at the Venice Film Festival. In recent years Sokurov has also worked in the theatre, staging Aleksandr Pushkin's *Mozart and Salieri* and Modest Musorgsky's opera *Boris Godunov* in 2007.

In addition to his feature films the prolific Sokurov has continued to make documentaries and homages (which he calls "elegies"). Most of Sokurov's elegies commemorate individuals who figure broader histories, from Chaliapin to Yeltsin; here Sokurov seems intent on capturing and preserving (or prolonging) their physical presence in the world, with sentimental voiceovers by the director.

Many of his documentaries chronicle marginal modes of attending to the world, such as farm work (*Mariia*), naval service (*Confession, Povinnost'*, 1998), or the labor of an aging writer (*Conversations with Solzhenitsyn, Uzel. Besedy s Solzhenitsynym*, 1998); long in duration and low on story, they are almost utopian in their melancholy absorption. They frequently build complex landscapes inspired by painterly models.

Russian Ark opens with a group of men dressed in the fashion of the 1830s entering the Winter Palace in St. Petersburg. It closes with a view of the leaden waters of the Neva River and the Baltic Sea in wintertime, seen through a low palace window. In between these bookends the camera strolls, in one unbroken take, through the State Hermitage Museum, passing from room to room, encountering characters and scenes from Russian history, pausing to examine the architecture, décor and masterpieces of European painting. Throughout the film the unseen director conducts a conversation about Russian history with a visiting nobleman, who, though unnamed, represents the Marquis de Custine, a perceptive but sharply critical visitor to Nikolaevan Russia in 1839. The film casts itself as Russia's and Europe's dream about each other, countering the marquis's skepticism with the view that, despite (or because of?) its tumultuous history, Russia has preserved European cultural values throughout modernity just as Noah's ark preserved the species during the Biblical flood.

Tim Harte describes the film's use of paintings as a "protest against death through the preservation of Russia's immortal cultural spirit."[1] Isabelle de Keghel has echoed this interpretation of the film as "a second Noah's Ark, in which the cultural heritage of Europe and the romanticized history of pre-revolutionary Russia are preserved from the catastrophes of the nineteenth and twentieth centuries."[2] The Old Masters in the Hermitage provide a model for this kind of immortalizing representation. Moreover, the film

[1] Tim Harte, 45, in Further Reading.

[2] Isabelle de Keghel, 85, in Further Reading.

uses painting as a metaphor for its own framing of tableaux from Russian history: "Sokurov's constant accentuation of framed spaces highlights not only the passage of life into art's eternal realm, but also the passing of art into the living sphere."[3]

Russian Ark represented a markedly new direction for Sokurov, who hitherto had specialized in slow-plotted portraits of individuals in sparsely designed situations of fragile intimacy. Louis Menashe has called the film "an anti-Sokurov carnival."[4] The film stands in particularly vivid contrast to *Moloch* (1999), *Taurus* (2000) and *Sun* (2004), each of which critiqued a political tyrant (Hitler, Lenin and Hirohito, respectively) by examining their fragile psyches in intimate settings of home life. Against these narratives of emasculated power, *Russian Ark* projects a vivid tapestry, posing rulers alongside and amidst the masses. In *Russian Ark* Sokurov is less an *auteur* than a "traffic cop," marshaling a cast and crew numbering 4700 (including 867 costumed actors) through an unimaginably grand set, the Winter Palace, home to the State Hermitage Museum.[5] The film was shot by a specially imported German cameraman with a digital Steadicam weighing 77 pounds, accompanied by seven other crew (including Sokurov), whose every movement had to be precisely choreographed to avoid capturing any inadvertent trace of the off-screen preparations and manipulations. The day before the shoot forty electricians stormed the Hermitage to install lighting along the camera's intended route.[6] *Russian Ark*, José Alaniz writes, is "a monument to [the director's] megalomaniacal control [...] of the object."[7] Eschewing visual metaphors, in interviews Sokurov described the film as produced "in a single breath."

Ideologically, *Russian Ark* confirmed Sokurov's hardening reputation as a cultural conservative and Russian nationalist. The

[3] Harte, 58.

[4] Louis Menashe, 321, in Further Reading.

[5] José Alaniz, 156, in Further Reading.

[6] Menashe, 22.

[7] Alaniz, 162.

historical narrative largely elided the Soviet period, as if it were a mere aberration in an otherwise respectable past. The city is never once called Leningrad. The most trenchant critique of Sokurov's historiographical vision has been given by Pamela Kachurin and Ernest A. Zitser, who characterize Sokurov's stance as "a nostalgic and sentimentalized vision that exists only in the partisan interpretations of nationalist mythmakers," made only more pernicious by all the "technological razzle-dazzle" of cinema.[8] For the more nuanced Fredric Jameson, in the context of Sokurov's oeuvre "the nationalistic effervescence of *Russian Ark*, perhaps a little too shrill and unmotivated (save by the paintings it was commissioned to celebrate), marks a nostalgia and a falling off."[9]

The celebration of pre-revolutionary Russian culture culminates in the grand ball at the end of the film, which appears to be a re-enactment of the 1913 tercentennial of the Romanov dynasty (Fig. 104). Historically, this ball was the last hurrah of tsarism and its aristocratic elite, right on the eve of the First World War. In the film, it includes personages from throughout Russian history, most notably the national poet Aleksandr Pushkin, who desperately searches for his wife Natal'ia. Moreover, the music is produced on-site by the current orchestra of the Mariinskii theatre under the baton of Valerii Gergiev, its powerful conductor. Thus a notorious event that signaled Tsar Nicholas II's self-satisfied blindness is cast as a pan-historical pageant of Russianness, akin to one of Il'ia Glazunov's sentimental paintings of processions of Russian political and spiritual leaders.[10] On this reading, the film—co-produced by the State Hermitage Museum as a kind of advertisement for itself and the Russian state—ends on a self-congratulatory note.

As Yana Hashamova has commented, "the prolonged applause at the end of the ball registers the enjoyment and the satisfaction

[8] Pamela Kachurin and Ernest A. Zitser, 17, 22, in Further Reading.

[9] Fredric Jameson, "History and Elegy in Sokurov," *Critical Inquiry* 33, no. 1 (Autumn 2006), 3.

[10] Alaniz, 169.

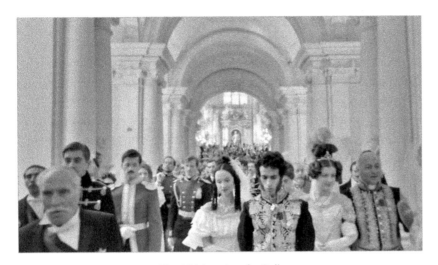

Fig. 104. Leaving the Ball

in the extraordinary celebration of harmony and perfection."[11] However Hashamova also argues that, in constructing Russian history in this way, Sokurov is consciously asserting a "double temporality" that supplements linear history with structures of repetition—such as Russia's periodic re-engagements with the West—which disrupt national identity as a stable category.[12] Dragan Kujundzic was the first to read the film as opening up nationalism for critique, whether consciously or not, by stopping the flow of history and framing it as an archive (or, as Kujundzic puns, an *arkive*).[13] Even the notion of Noah's ark is undermined; what Sokurov produces looks more like a taxidermist's gallery or the Kunstkamera that stands across the bridge from the Hermitage. The Marquis's references to the smell of formaldehyde only underscore the self-deconstruction of the triumphal narrative perceived by Kachurin and Zitser.

J. Hoberman identified Sokurov's film as an "anti-*October*" i. e., a response to Sergei Eisenstein's film of 1928, which reenacted the

[1] Yana Hashamova, 72, in Further Reading.

[2] Ibid., 74.

[3] Dragan Kujundzic in Further Reading.

storming of the Winter Palace in 1917.[14] If Eisenstein's subject was revolution, then Sokurov's is the continuity of history and national identity across historical rifts and ruptures. If Eisenstein's method was montage, i.e. the rapid juxtaposition of contrasting shots, then Sokurov chose to make his film in a single continuous take. Thus, returning to a primary scene of historical and cinematic rupture, Sokurov's camera performs the very idea of continuity that his screenplay (co-authored with Anatolii Nikiforov) describes. Nancy Condee has commented that for Sokurov "history is subject to montage, but the film is not."[15]

The danger is that Sokurov's film turns out to be a naive pastiche of pseudo-historical highlights and his decision to shoot his film in a single take on a digital camera is a mere gimmick (one which paid off royally, judging from its critical and commercial success). The desire for continuity at all costs forced the director to compromise on other technical parameters, especially lighting, which is frequently less than ideal, especially in the passages between rooms and when the camera dwells on paintings. Moreover, the film was hardly an unadulterated slice of life-caught-unawares or theatrical performance. The digital file required extensive post-production elaboration, including the recording and synchronization of most dialogue and sound and some 30,000 digital effects.[16] The final shot of the frozen Neva dissolves into one of the Baltic Sea.[17] Moreover,

[14] J. Hoberman, 54, in Further Reading.

[15] Nancy Condee, *The Imperial Trace: Recent Russian Cinema* (Oxford, New York: Oxford University Press, 2009), 177.

[16] Alaniz, 164. Indeed, according to David Rodowick, not only is *Russian Ark* "a 'montage' film as are all expressions of digital cinema," but Sokurov's digital compositing exemplifies a new form of montage: "here montage is no longer an expression of time and duration; it is rather a manipulation of the modularized image subject to a variety of algorithmic transformations [...] While marketed as a heroic feat of recording in a physical location, the movie is better characterized, like most digital cinema, as an aesthetic of postproduction, highly subject to computational processes and the imaginative intentions of its authors." D. N. Rodowick, *The Virtual Life of Film* (Cambridge, MA: Harvard University Press, 2007), 173-74.

[17] Menashe, 23.

though shot digitally, the film was projected mostly from 35mm prints divided into multiple reels.[18] The viewer's perception of continuity would hardly have been compromised had Sokurov shot the film in a series of long takes (à la Bela Tarr) that would have allowed for more precise calculations of lighting conditions. As it is, the physical transitions between rooms in the Hermitage often serve as cuts between scenes, especially when the camera is forced to linger in front of closed doors, apparently because of hurried preparations taking place off-camera.

The main practical justification for the single-shot technique was the impossibility of an extended shoot at the Hermitage, to which Sokurov and his team had unlimited access only for a single brief day, in fact one of the shortest days of the year — 23 December 2001. In this sense, Sokurov's technique pursues not only continuity, but also documentary authenticity. Moreover, with the film marketed as a feat of technical virtuosity, the viewer cannot help but feel suspense about the film's flawless performance of its conception. The cameraman Tilman Büttner has stated that "sometimes actors and extras had to improvise their movements and positions during the shooting because of mistakes we made."[19]

Viewing the film at odds with Sokurov's stated intent, José Alaniz identifies numerous technical flaws: shadows of the crew; actors registering the crew's presence; figures in anachronistic dress in plain sight. These "film flubs" manifest "the 'uncontainable' beyond the director's control, that sliver of the object that cannot be finalisably organised, re-made or smoothed over in representation."[20] Büttner describes his irritation when "one of the extras with her big costume walked into the room and knocked [a light] over."[21] Mikhail

18 On the contradictions in Sokurov's use of a digital camera see: Natascha Drubek-Meyer, "An Ark for a Pair of Media: Sokurov's *Russian Ark*," *Artmargins*, 5 May 2003, http://artmargins.com/index.php/6-film-a-video/273-an-ark-for-a-pair-of-media-sokurovs-russian-ark (accessed 1 January 2013).

19 Menashe, 23.

20 Alaniz, 163.

21 Menashe, 23.

Iampol'skii has made a related argument that the "film's form inevitably recognized and assimilated the effect of serendipity, the excess of matter over idea that generates meaning."[22] Instead of accepting these flaws as an ineluctable trace of contingency — the very contingency that forms historical process—Sokurov chose to blame the German Steadicam operator, publicly objecting to his nomination for the cinematography award at the European Film Academy in 2002. Kujundzic has seen a particular irony in the film's rejection of the western technological expertise on which it relied; this underscores the cultural anxiety that the film's narrative of Russian progress from Peter to Putin appears to celebrate: "That anxiety, needless to say, which in the movie is energized and turned into the creative impetus of the film, here appears as the blind spot."[23] Instead of producing a documentary investigation of the visual textures of Russian history, Sokurov ends up reproducing the age-old Russian inferiority complex, projecting fragile statehood into a myth of eternal empire.

The impression of naïvely defensive nationalism is belied by the film's aesthetic self-reflexivity. The director's opening monologue asks: "Is everyone acting for me or is it me who must play some role?" At the film's end, abandoning the Marquis, the entire historical pageant streams down a staircase around the camera, eyes downcast, forcing the viewer to ask whether the filmic representation has formed or disrupted the authentic flow of history. The revelers "retain the glow of pleasure on their faces" as they descend to face "the threat of the unknown and the unpredictable."[24] The sullen dismissal of the massed actors suggests a dispirited closure of Russian historical consciousness. It is an admission both that the Russian ark has been leaking history and that it sails along a sea of tears.[25] The film might preserve memory, but only as

22 Mikhail Iampol'skii, 281.

23 Kujundzic, "After 'After'."

24 Hashamova, 76.

25 Kujundzic.

a closed set of signifiers; the film begins with the off-screen narrator hinting at some disaster that has led to oblivion, and the only remaining horizon is that of the forbidding, frozen sea. Dwelling on such moments, the viewer is returned to Sokurov's more experimental beginnings. In particular, as Alaniz has pointed out, seen alongside *Evening Sacrifice* (1984/1987), *Russian Ark* could be described as documenting the dispersal of a crowd after a celebration.[26] Like such films as *Whispering Pages* (1993) or *Mother and Son* (1996), much of the film flickers on the border of the visible, audible and comprehensible.

Thus, J. Hoberman argues, though it has been taken "as an exercise in czarist nostalgia, the movie is far more concerned with evoking Russia's sense of national unreality."[27] For Birgit Beumers "Sokurov uses the camera to elevate cinematic art as capable not of creating and remaking the past, but of erasing it: between the painted and performed scenes lie the 'real stories,' the gaps that are blanked out" as a "void" that resists representation.[28] The film's anachronisms betray a more thoroughgoing anachronism, i.e. a belief in the power of film to capture time and its powerlessness to represent the traumas it engenders. "I open my eyes and see nothing," the narrator says at the film's opening, before the images appear to belie and confirm the elusiveness of the nightmare he has experienced. Yana Hashamova has read this paradox as relating to Jacques Lacan's notion of the *object of desire*: Russian national identity is a suppressed object "that remains operative in what is seen," hinting at the "presence of displaced elements that orchestrate the field of vision and appearance."[29] Even if Sokurov desires to symbolize Russian identity in monumental images, he "senses and cinematically suggests the impossibility of its symbolization in the presentation of double historical temporality and the constant dialogue between the visible

[26] Alaniz, 155-57.

[27] J. Hoberman, 54

[28] Beumers, 177.

[29] Hashamova, 71, 114.

and the invisible."[30] The character in the film with the greatest insight into the Hermitage's paintings is Tat'iana Kurenkova, a blind artist whom the Marquis misleads but who still sees more than he in Rubens's *Feast in the House of Simon the Pharisee*. For Beumers, Kurenkova stands for "the insight into European art of which Russians are capable"[31]; however she also stands for the ability of cinema to represent the invisible: "it is as if her actual blindness protects her from the post-revolutionary blindness of the museum and allows her an anachronistic insight."[32] Another privileged spectator is Alla Osipenko, a St. Petersburg ballet dancer "who communicates with Rembrandt's *Danaë* through speech and dance."[33] Thus Sokurov's luxuriant and virtuosic pageant is riddled with a mistrust of vision.

Sokurov's Russia is a funereal ark, which "had its glory in the past, but that past is dead and 'preserved' only in the museum, while the present is void, empty, non-existent."[34] It thus extends Sokurov's interest—exercised in such films as *Second Circle* (1990), *Mother and Son* (1996) and *Taurus* (2000)—in "the ruination of the visible" as a means of making death visible.[35] This ark-coffin is also "an empty frame that signals the helplessness of the film-maker at the secondariness of cinema," in particular its inferiority to painting.[36] The final paradox is that in its impotence to do more than simply record spectral performances of history Sokurov's cinema finds its greatest power.

Robert Bird

30 Ibid., 74.

31 Beumers, 184.

32 Kujundzic.

33 Isabelle de Keghel, 83.

34 Beumers, 186.

35 Kujundzic.

36 Beumers, 186.

FURTHER READING

Alaniz, José. "Crowd Control: Anxiety of Effluence in Sokurov's *Russian Ark*." In *The Cinema of Alexander Sokurov*, edited by Birgit Beumers and Nancy Condee, 155-75. London: I. B. Tauris, 2011.

Beumers, Birgit. "And the Ark Sails On..." In *The Cinema of Alexander Sokurov*, edited by Birgit Beumers and Nancy Condee, 176-87. London: I. B. Tauris, 2011.

de Keghel, Isabelle. "Sokurov's *Russian Ark*: Reflections on the Russia/Europe Theme." In *Russia and Its Other(s) on Film*, edited by Stephen Hutchings, 77-94. New York and Basingstoke: Palgrave Macmillan, 2008.

Harte, Tim. "A Visit to the Museum: Aleksandr Sokurov's *Russian Ark* and the Framing of the Eternal." *Slavic Review* 64, no. 1 (2005): 41-58.

Hashamova, Yana. *Pride and Panic: Russian Imagination of the West in Post-Soviet Film*. Bristol and Chicago: Intellect Books, 2007.

Hoberman, J. "And the Ship Sails On." *Film Comment Magazine* 38, no. 5 (September-October 2002): 54.

Iampol'skii, Mikhail. "Lovets istorii sredi ee eksponatov." In *Sokurov: Chasti rechi*, edited by Liubov' Arkus, 277-81. St. Petersburg: Seans, 2006.

Kachurin, Pamela, and Ernest A. Zitser. "After the Deluge: *Russian Ark* and the Abuses of History." *NewsNet* 43, no. 4 (2003): 17-22.

Klawans, Stuart. "Haunted Hermitage." *The Nation*, 14 October 2002.

Kujundzic, Dragan. "After 'After': The Arkive Fever of Alexander Sokurov." *Art Margins*, 5 May 2003. http://www.artmargins.com/index.php/archive/272-after-qafterq-the-qarkiveq-feverof-alexander-sokurov (accessed 1 January 2013).

Lawton, Anna. *Imaging Russia 2000*. Washington D.C.: New Academia Publishing, 2004.

Menashe, Louis. "Filming Sokurov's *Russian Ark*: An Interview with Tilman Büttner." *Cineaste* 28, no. 3 (Summer 2003): 21-23.

THE RETURN

Vozvrashchenie

2003

106 minutes

Director: **Andrei Zviagintsev**

Screenplay: **Vladimir Moiseenko, Aleksandr Novototskii**

Cinematography: **Mikhail Krichman**

Art Design: **Zhanna Pakhomova**

Composer: **Andrei Dergachev**

Sound: **Andrei Khudiakov**

Producers: **Dmitrii Lesnevskii, Andrew Colton, Elena Kovaleva**

Production Company: **REN-Film**

Cast: **Vladimir Garin (Andrei), Ivan Dobronravov (Ivan),
Konstantin Lavronenko (the Father), Natal'ia Vdovina (the
Mother), Galina Popova (the Grandmother)**

Andrei Zviagintsev (1964–) was educated as an actor, graduating
from the Novosibirsk Theatre School in 1984 and GITIS (The
Russian University of Theatre Arts, Moscow) in 1990. He acted in
independent theatrical productions and had several episodic roles
in TV serials and films. In 2000 he shot three short films for REN-
TV, which prompted its co-founder, Dmitrii Lesnevskii, to offer him
the opportunity to make a feature film. Shot on a minimal budget
of $400,000 without any government support, created by a director
and cinematographer without any formal education in the field and
a novice composer without experience in film, with an unknown
adult actor and two youthful beginners, *The Return* achieved
phenomenal international success after it was awarded two Golden
Lions (for best film and best director's debut) at the 2003 Venice
Film Festival.

Zviagintsev's next film, *Izgnanie* (*The Banishment*, 2007) won Konstantin Lavronenko a prize at Cannes for Best Actor, but the film itself was less successful. *Elena* (2011) is the director's most recent and fairly controversial work, which won the "Un Certain Regard" special jury prize at Cannes. He is currently working on a film set in contemporary provincial Russia with the working title *Leviathan*. Zviagintsev belongs to the *novye tikhie* ("new quiet ones") generation of Russian directors, who focus on restrained, minimalist, arthouse works that incorporate the traditions of international as well as national cinema. He has acknowledged the influence of Antonioni, Bresson, Tarkovsky, Bergman, Kurosawa and Kitano.[1]

In *The Return* the father comes back to his family after a twelve year absence. He takes his two sons, Andrei and Ivan, on a road trip that combines camping and fishing with the father's mysterious assignment. The authoritarian father tries to teach the boys adult skills during the trip, eliciting the rebellion of the younger son, Ivan, and leading to tragic consequences. At the most basic level, the film can be read as a psychological thriller which conveys a sense of mystery and effectively builds suspense: where has the father been for twelve years? Why did he eat too much fish at one time in his life? What is in the buried ammo box?

Zviagintsev has consciously constructed *The Return* as myth in both its narrative and formal aspects: the father and mother as nameless archetypes; lack of narrative specificity; non-specific time and place; minimal but significant dialogue; minimalist mise-en-scène (spare interiors, ascetic northern landscapes, deserted urban spaces and roads, strong vertical and horizontal shapes, such as broad stretches of water, the flat island and the two towers); cool color palette; long takes (the three-minute return of the father's body) and slow tracks; distant thunder and cleansing rain, and otherworldly, non-diegetic music that culminates in a quiet folksong

1 Zviagintsev interview, Valerii Kichin, " 'Chernye loshadki' Venetsii," *Rossiiskaia Gazeta*, 14 October 2003, http://az-film.com/ru/Publications/74-Chernie-loshadki-Venecii-.html (accessed 12 October 2012).

about two brothers performed by a very old man.[2] The mythical construction of *The Return* opens the film to different readings: rites of passage into adulthood, along with the Christian self-sacrifice of the father, read through the road movie, a foreign genre taken up by post-Soviet auteurs; Freudian, Lacanian and Jungian approaches; the symbolic rejection of the tyrannical Soviet father by post-Soviet society, accompanied by subsequent nostalgia for a strong father figure. Zviagintsev himself has provided yet another interpretation:

> … all the nuances, slang, language, mimicry, the entire substance of these characters had to be realistic. But underneath this whole layer a model was important to me—the model of man's mutual relations with God. One type of such relations suggested by the older brother is absolute faith. "What's wrong with you," he tells Ivan, "This is our Father. Mama said that he's our father, there can be no doubts. And he's like that on the photograph. He's like what he is. It's not important when he came or why he was absent. Here he is." And there is Ivan's relationship to God. His doubts, his daring acts, his question: "Where were you? Why were you not around? Why are you forcing me to be unhappy? Why are you not the incarnation of that God the Father who will fulfill all my desires, according to my prayer, according to my whim, and who will protect me?" This is a theomachist mise-en-scène. The rejection of God, because God is *like this*.

2 According to Zviagintsev, "The film is a close mythological look at human life," http://az-film.com/ru/books/ (accessed 12 October 2012). See also Zviagintsev interview, Kseniia Golubovich, "Doroga:vnutrennii vzor," 14 August 2007, http://az-film.com/ru/Publications/95-Doroga-vnutrennij-vzor.html (accessed 10 July 2012). DoP Krichman suggested a processing method that faded color and heightened contrast and monochromaticism as in Vermeer and Rembrandt's paintings (Zviagintsev interview, Eric Eason, "In a Silent Way," 1 October 2003, http://az-film.com/en/Publications/24-In-a-Silent-Way.html [accessed 12 October 2012]); for the director's comment on the long take of the return of the father's body, see Zviagintsev interview, Mariia Lebed', "Den'gi reshaiut mnogoe, no ne vse," 6 July 2004, http://az-film.com/ru/Publications/119-Dengi-reshajut-mnogoe-no-ne-vsjo.html (accessed 12 October 2012).

Like Dostoevsky's *Ivan* Karamazov asking, if God exists, how does He stand a child's tears? This was my point of departure. And that's why the first appearance of the Father is the manifestation in the mise-en-scène of the dead Christ from Andrea Mantegna's painting, repeated down to the last fold.[3]

[3] Zviagintsev interview, Kseniia Golubovich, "Doroga:vnutrennii vzor." See also Zviagintsev interview, Mariia Lebed', "Den'gi reshaiut mnogoe, no ne vse."

TARKOVSKY'S RETURN,
OR ZVIAGINTSEV'S *VOZVRASHCHENIE*

Birgit Beumers

After the screenings in Venice, critics and audiences constantly compared Zviagintsev's *The Return* to Tarkovsky's *Ivan's Childhood*, which had won a Golden Lion in Venice in 1962. This comparison with the master of Russian cinematography of the twentieth century is, on the one hand, indicative of the audience's and critics' inability to come to terms with the meaning of the film and instead resort to a cliché. On the other hand it is a curious bow to a past master, suggesting the film's potential for an award.

Tarkovsky is a key figure in Soviet and Russian film history, and—along with the name of Eisenstein—often the only Russian filmmaker known to the non-specialist. Yet while Tarkovsky's influence in cinema in general has been acknowledged in many studies, his impact on new Russian cinema remains limited. Since he was a solitary artist rather than a teacher, any "heritage" in cinema stems from imitation rather than initiation by the "master." Indeed, Zviagintsev's film makes you wonder to what extent the director deliberately set out to make a film that, at first viewing, looks like a film by the young Tarkovsky and could easily have been made in the 1960s. Did *The Return* impress because of originality or imitation—of poetic images, of allusions to classical art, of cinematic traditions? [...] Critics' and audience responses unanimously labelled Zviagintsev the "new Tarkovsky" and compared *The Return* to *Ivan's Childhood*, largely because of the film's religious symbolism and the construction of frames that imitates compositions of Renaissance paintings of Christ.

Returning and Returns

Zviagintsev's *The Return* opens with a shot of the murky, grey sea, reminiscent of the final shot of Sokurov's *Russian Ark*. It closes with

a shot of the quiet sea dipped in sunlight. Zviagintsev appears to refer to the temporal and spatial limbo earmarked by Sokurov. Indeed, spatial issues are crucial in the film. *The Return* is set in the northern regions of Russia (filmed near Lake Ladoga), in a flat, unpopulated and barren land that is dominated by shades of grey and cold hues of blue. Under these grey skies lies a small village, almost deserted by its inhabitants, with derelict houses, dilapidated stairwells and empty streets. The story takes the protagonists to a remote lake, an isolated beach and a desert island. In the vast spaces of Russia there seem to be only a few living souls. Time is deliberately unspecified: the cars appear to be Soviet makes, and people's clothes are modern but not indicative of any fashion. Russia's empty space is timeless and lends itself to universal metaphors. But neither does Russia's vastness offer any refuge. Nature is hostile, exposing man to wind, rain and cold; nature is man's enemy. Zviagintsev presents Russia's expanse not as a space of freedom, but of isolation and desolation.

Thematically, the film returns to a prominent theme for Soviet film history: the relationship between a father and his two sons, Ivan (aged 12) and Andrei (aged 15). The theme of father(s) and son(s) has dominated several new Russian films, such as Sokurov's *Father and Son* (*Otets i syn*, 2003), as well as the stunning debut by Aleksei Popogrebskii and Boris Khlebnikov, *Koktebel'* (2003). In Zviagintsev's film the father, returning home after twelve years, is unjust and cruel. He shows hardly any love for his children, disciplining them instead of offering praise or encouragement; he imposes his views without offering explanations; and he acts irresponsibly when abandoning the younger boy or physically exhausting both sons to their limits. Ivan's rejection of the father as a figure of authority and the ensuing disrespect are a most natural response, much more so than Andrei's unlimited admiration for the father and his instant consent to the father's suggestions.

The film is charged with Christian references and open to a number of interpretations of the meaning of the plot, the images and the title. Apart from the *return* of the father at the beginning of the film, there is the boys' *return* home at the end of the film. The *return* could refer to cinematic traditions of the 1960s, with all the

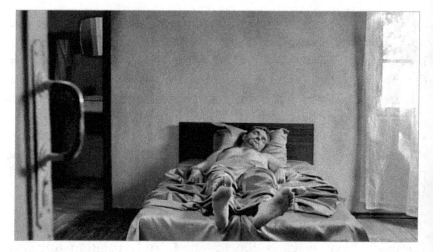

Fig. 105. The Father

corresponding religious symbolism. On a religious level, there is the *return* of Christ, or a Christ-like figure, onto the screen and into the world. *The Return* is divided into sections covering the seven days of the week: the seven days of the working week, echoing the days of God's creation of the world; and the seven days of Holy Week. This double meaning immediately establishes the two main levels on which the film can be read: the everyday and the religious.

While the everyday level operates largely through words and actions, the religious layer is developed through images. The Father makes his first appearance as a risen Christ figure straight from Andrea Mantegna's *Lamentation over the Dead Christ* (c. 1480). The first glimpse that the boys catch of their returned father shows him lying on the bed, asleep; his body is covered with a silky blue sheet (Fig. 105). The camera captures him from the same angle that Mantegna uses: from a position at the feet of the figure, slightly from below to allow for foreshortening (perspective). The camera then moves to an overall view of the body from above, before zooming in on the head. The sheet covers the body in exactly the same manner as in Mantegna's painting, almost replicating each fold. The boys stare at the image before rushing into the attic to search frantically for a picture of their father from the time before he left twelve years ago. They find this in an old edition of the bible richly illustrated with etchings, including (in a brief shot) *Abraham*

Sacrificing Isaac, another iteration of the father-son relationship. They then go to the dinner table, which is laid out in the composition of Leonardo da Vinci's *Last Supper* (1498): the light falls into the room from two windows at the back, behind the Christ/Father figure, while the boys are at the side of the table, taking the places of the apostles. Like Christ, the Father shares wine and bread (and rips apart a chicken) with his disciples—or his family. More allusions to classical paintings follow: the scenes on the boat and near the sea echo the color scheme of Tintoretto's *Christ at the Sea of Galilee* (1560), with the sea in turmoil, dipped in cold shades of blue-grey. The flat landscape shots of the rocky beach and the blue lake also remind us of Vasilii Polenov's painting of *Christ on Lake Tiberias* (1886), while the overall composition of the frames, the mist and fog, the rain and storm, reflect the nature paintings of Caspar David Friedrich.[1]

The children bear the names of two apostles, Andrei (Andrew) and Ivan (John). On a superficial level this is an allusion to Tarkovsky's first name, Andrei, and the first name of his protagonist from *Ivan's Childhood* (original title *My Name is Ivan*), the film to which *The Return* has been persistently compared. According to John's Gospel, Andrew was Christ's first follower. Ivan plays the role of the traitor, although John was the most devout of Jesus' disciples, a member of the inner circle of the three apostles (Peter, James and John) who witnessed all of His deeds. The name Ivan could also refer to John the Baptist, who was the first to recognize Christ and sacrificed his life for him. Strangely, though, this Ivan fears both heights and—water.

Religious imagery pervades the symbolism of water as a life-giving and life-taking force. The fishing trip draws on the image of Jesus telling his apostles to "fish for men," while also echoing the third apparition of Christ after his resurrection. The crossing of the sea to the island occurs in a boat, with the Father steering, assuming the role of Charon, the ferryman on the Styx. He takes the children to the (under)world where they encounter death, from

where the Father does not return, as his dead body disappears on to the bottom of the sea.

The image of the sea as a burial ground explains Ivan's fear of water when he fails to jump into the sea in the first frames of the film (entitled Sunday).[2] Indeed, the structure of the film suggests an inversion of the sequence of events: the day of creation (Saturday) becomes the day of destruction. In Holy Week Christ died on Friday and was resurrected on Sunday; the film places the Sunday of the resurrection before the death that occurs at the end of the film. The Father returns home on Monday and dies on Friday, and therefore Ivan expects the resurrection on Sunday. The Sunday at the beginning of the film effectively follows the Saturday at the end of the film. It is then clear why Ivan is afraid of water.

If the film represents a failed "second coming," it has to be read as beginning with the Father's death, not his return.[3] The Father died on Friday, the boys return home on Saturday. The life at home (Monday to Thursday) is a flashback, informed by the memory of the events shown in the film. Here the Father rests on the bed in the position of the Dead Christ, who is about to be resurrected and make His first apparition. His second apparition is at the dinner table, laid out like the Last Supper, where He met his apostles. Finally, Christ's third apparition to His disciples occurred on the shore, when He accompanied them on a fishing trip and helped them catch fish. Indeed, it is a fishing trip that the Father suggests during the supper scene. These three apparitions of Christ are represented in the film as if they were painted images, stressing their special and symbolical significance. After having appeared thrice, Christ ascends into heaven, but the Father disappears into the depths of the sea. Ivan fears the water because of a possible encounter with the image of the Father he doubted. The Father is absent from the family, which is held together by mother and grandmother, substituting for Mary and Mary Magdalene: the women immediately recognize Him. Seen in reverse, the film reviews the coming of Christ in a modern

2 Vladimir Garin (Andrei) drowned in an accident in the summer of 2003.

3 I am grateful to Lesley Milne for this suggestion.

context, but the Christ figure is far from benevolent, patient and understanding, and instead filled with hatred for his surroundings.

However, the interpretation of the Father's return as the return of Christ, who remains unrecognized, contradicts the character of the Father. If the Father is Christ, then his conduct offers no model to be followed. Ivan is right to doubt him and challenge his authority. If man were to follow any Father-figure without challenge and thought, then mankind would soon succumb to political dictatorships. Absolute and devout acceptance of a figure who neither inspires trust nor respect is, however, advocated in this film. Indeed, parallels to political leaders who called themselves "Fathers" of the nation (Stalin) spring to mind, and a reading of the film as a warning to follow a powerful Father-figure may be more fruitful than a Christian reading, but the film offers no guidance in this direction. [...]

On the everyday level, the boys never experienced what it is really like to have a father who cares and loves, who provides leadership and knowledge. The film continues the theme of father-lessness so prevalent in Soviet and Russian cinema. On a religious level, modern Russia fails to recognize the Savior. He sacrifices Himself to save the non-believer (Ivan), but faith vanishes neverthe-less. Instead, Ivan is frightened and fearful of His image. In the end, all that remains of the Father are the images captured on the photo-camera that the boys have taken on the trip. These pictures form the epilogue to the film, presented as a photo-album. [...]

The "return" to Tarkovsky is a return to cinematic traditions of the past without looking into the future. Zviagintsev thus offers a powerful vision of the absence of such a future for Russia both cinematically and more broadly, instead capturing the boys and the father in a circular structure that offers no escape, but only returns. In this cyclical structure lies also a viable political interpretation of the film: history repeats itself, but people still fail to recognize the true Father.

By tapping into the Tarkovsky tradition and dwelling on the significance of Christ's suffering that is so important for Russian culture, the film offers a view that foreign audiences will cherish. International acclaim, however, is no guarantee of popular domestic

success. The Russian box office thrives on slick blockbusters such as *Anti-Killer* and *Boomer*,[4] highlighting once again the divide between art-house and commercial cinema, between cinema for the intellectuals and for the masses, between films for a national and international market. By keeping the best traditions of Soviet cinema alive, Zviagintsev has already secured a devoted following abroad.

[4] *Anti-Killer* (2002) and *Anti-Killer 2* (2003) by Egor Konchalovskii and Petr Buslov's *Boomer* (2003) topped the box office charts in Russia over and above new American releases.

ARRESTED RETURNS

Meghan Vicks

Andrei Zviagintsev's *The Return* examines the arrested transition from Soviet to post-Soviet Russia by delegitimating a number of mythologies that have traditionally been part of Russian culture while showing, in the same stroke, how those delegitimated mythologies nevertheless continue to inform the post-Soviet condition (and, indeed, the film itself). Zviagintsev himself has stated that "the film is a mythological look at human life," and that "if you watch this movie from the standpoint of everyday life, it's a mistake, because it's much broader, and the mystery of the film won't reveal itself to you."[1] In *The Return*, Zviagintsev presents these mythologies via "filmic hieroglyphics"—that is, "sacred writings in picture form, a fusion of verbal and visual texts."[2] In another interview, Zviagintsev discussed his desire to turn text into images in *The Return*, and the importance of the visual over the written medium: "We were originally going to show a lot of text from the diary on-screen, but I think that can be a sign of a lack of imagination. Sometimes it works, […] but generally, if you can think of a way to turn text into visuals, you should do it. That's how we came up with the idea of the children taking black-and-white photos."[3]

Erica Abeel, "Return of the Prodigal Father; Andrey Zvyagintsev Talks About *The Return*," *indieWIRE*, 2 February 2004, http://www.indiewire.com/article/return_of_the_prodigal_father_andrey_zvyagintsev_talks_about_the_return (accessed 28 December 2012).

Nancy Condee, "Introduction," *Soviet Hieroglyphics: Visual Culture in Late Twentieth-Century Russia*, ed. Nancy Condee (Bloomington: Indiana University Press, 1995), xii.

"The Return: Interview with Andrey Zvyagintsev," http://az-film.com/en/Publications/23-The-Return-Interview-witn-Andrey-Zvyagintsev.html (accessed 28 December 2012).

These filmic hieroglyphics inform both the form and content of *The Return*: formally, because the film is the visual representation of journal entries, and in content, because discourses from various cultural mythologies—including folkloric and Christian—are presented as images. In effect, the film "returns" to and even resurrects these mythologies, while bearing witness to a number of additional "returns," including the return of the absent father, the return to the cinematic traditions of Andrei Tarkovsky, and the return of a Christ-like figure.[4] However, in returning to these various mythologies, the film reveals how they are no longer capable of producing the sacred in post-Soviet Russia. *The Return*, then, while it is about the mythologies that have shaped Russia from pre-Christian through Soviet times, is ultimately a film about contemporary post-Soviet Russia, and how the dying or dead past still informs, affects and even dominates the present.

Folkloric Hieroglyphics:
We Were Born to Make Fairytales Reality

Beginning in the early 1930s, Soviet party leaders decided to utilize Russian folklore as a vehicle to disseminate Marxist-Leninist ideology.[5] In a similar vein, *The Return* employs folkloric hieroglyphics to create a visual narrative that resurrects the rites of initiation that form the mythological basis of the Russian fairytale.

4 See Birgit Beumers' 2004 review of the film in *KinoKultura* for a discussion of these additional "returns," http://www.kinokultura.com/reviews/R14return. html (accessed 28 December 2012).

5 This official appropriation of fairytales and folklore began in the early 1930s, when Iurii Sokolov declared its efficacy as a means of disseminating and encouraging Soviet party ideology, arguing that "folklore is an echo of the past, but at the same time it is also the vigorous voice of the present." Reiterating Sokolov, Maksim Gorky notoriously highlighted the potentiality of folklore and fairytales as propaganda tools in his keynote address to the First Congress of Soviet Writers in 1934. Sokolov and Gorky's call did not go unanswered: Stalinist Russia made a cult of Russian folklore.

plot, and that were also adopted by the Soviet culture industry.[6] *The Return* therefore utilizes Russian folklore to illustrate the nature of post-Soviet culture—just as Soviet culture utilized folklore to illustrate an idealized Soviet reality.

We find elements of the folkloric tradition in the film's characterization of the younger brother Ivan, in the trials and tests that the two brothers face, and in the journey to a shadowy island to get a mysterious box (a visual quotation from Tarkovsky's *Stalker*). It has been said that of all folkloric figures, the Russian people especially love Ivan the Fool, who perpetually must tackle the same enigmatic quest: "to go nobody knows where to find nobody knows what."[7] The film's Ivan parallels this figure not only because they share the same given name, but also because they are the most lowly, untalented and ridiculed figures. At the beginning of Russian fairytales, we often find an immature hero who either spends his days lounging on the stove, being teased or abused by his family and neighbors, or failing to accomplish acts that his older brothers can. Similarly, at the start of *The Return* we meet Ivan, an adolescent who cries and is teased by others and, despite his strong resolve to imitate his older brother and jump off the tower, cannot muster the courage to do so.

Like his folkloric analogue, Ivan is sent off on a journey that, among other things, is a prolonged initiation ritual. As this mythological journey requires the relinquishing of the old self to make room for the new self, it often includes battles, a symbolic death and rebirth, and tests of wit, endurance and strength. In *The Return*, the journey that Ivan and Andrei undertake is similar to the fairytale quest: it marks a new phase in their lives, the beginning

6 The film's folkloric elements have previously been pointed out by Mark Lipovetsky and Tatiana Mikhailova in their 2010 *KinoKultura* review that compares Aleksei Popogrebskii's *How I Ended This Summer* with Zviagintsev's *The Return*: http://www.kinokultura.com/2010/30r-leto.shtml (accessed 28 December 2012).

7 See Svetlana Boym, "From the Russian Soul to Post-Communist Nostalgia," *Representations*, no. 49, Special Issue: Identifying Histories: Eastern Europe Before and After 1989 (Winter, 1995): 133-66.

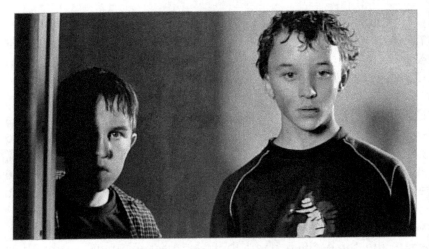

Fig. 106. Ivan and Andrei

of a transition; it takes place far away from home, in an unknown area; it includes battles (with the other boys who steal the father's wallet); it involves tests of endurance (Ivan must wait in the rain when his father leaves him on the bridge to fish); and it entails tests of strength (the boys must help push the car out of the mud, and also row the boat to the island). However, the boys ultimately fail a number of these tests (they refuse to fight the other boys; it is the father who gets the branches under the tire and pushes the car out of the mud), and moreover, if there is a transition in the film from boyhood to adulthood, it takes place only in Andrei and not in Ivan (Fig. 106). Arguably, Ivan is recreated into an obedient child by the end of the film.

The island, too, is reminiscent of the unnamed destination ubiquitous in Russian folklore. When the boys and their father cross the channel and step onto the island, they enter a realm where magic can happen. Whereas on the mainland the father's word is largely ineffectual, on the island his words become reality: the signified is matched up with the signifier. For instance, on the mainland when the father instructs his sons to use their "little hands" to put sticks under the tires, the boys fail; however, on the island, when Andrei echoes the father's "little hands," the boys are able to put sticks underneath their father's corpse. Also, Ivan's declared intention to kill his father becomes all too real on the island: his words dictate

reality. Most importantly, the island represents a magical space because it contains the mysterious object of the quest, the object that, in the fairytale tradition, helps to fulfill whatever is lacking in the hero's life.

The magical object, however, instead of bringing the boys fulfillment of any kind, is lost. It is in this way that the folkloric hieroglyphics of the film are arrested: yes, the magical object is present, but it is lost and thereby rendered ineffective; yes, the boys endure a long and trying quest, but their transition from boyhood to manhood is stunted, at least in Ivan, the supposed hero. Indeed, the film truly does invert the fairytale paradigm if we conclude that the older brother Andrei achieves transformation while the younger brother Ivan does not.

Two significant readings develop from this line of thought. On the one hand, as a comment on the use of folkloric themes by the Soviet culture industry, the film performs the inability of the Soviet regime to make fairytales reality. On the other hand, if we read *The Return* as a film about the nature of post-Soviet Russia, a story of an arrested development emerges: these rituals have not been abandoned, yet they no longer generate progress or transcendence. The shift from Soviet to post-Soviet Russia is therefore the shift from one unrealized fairytale to another—what remains are the husks of rituals that cannot bring about the sacred.

Christian Hieroglyphics

In an analysis of the film through its Christian hieroglyphics, the father signifies a Christ-like figure who is sent to save his children through his death. This reading is supported by a number of visuals that evoke Christian imagery: the boys' photo of the father is kept in the family bible, specifically on the page that depicts God's intervention in Abraham's sacrifice of his son; there are repeated references to fish and fishing in the film; as Beumers points out, Jesus' last supper is reenacted in the family dinner, during which the father shares wine and chicken (instead of bread) with his "disciples"; when the father falls to his death, his arms are outstretched in a gesture that mimics a cross, evoking the crucifixion; and the seven-

day organization of the film mirrors the structural arrangement of the creation story.[8] These Christian hieroglyphics suggest that the film may be read as a religious allegory; however, such a reading is problematized by the film's end.

Among these problematic Christian hieroglyphics are the shots in which the father's posture is purposely positioned to imitate the dead Christ of Andrea Mantegna's painting, *The Lamentation Over the Dead Christ* (c. 1480). These shots include the first and last shots in which the father is depicted: the shot of the father sleeping on the bed (Fig. 105), which is the first time that the boys see him, and the shot of the father dead in the boat, which, conversely, is the last time he is seen. Both of these shots are composed as in Mantegna's painting: the father lies supine, his head slouching over toward his left shoulder; the viewer perceives the figure from the position of his feet, which produces the effect of a foreshortened body. Furthermore, both Mantegna's painting and Zviagintsev's film heighten the corporeal nature of the Christ-like figure, emphasizing his genitals beneath the sheet.

Thus, the first and last shots of the father are structurally informed by a painting of a dead and fleshly Christ, which intimates that the father is doubly deceased: he is at least symbolically dead at the beginning of the film, and corporeally dead by the end. Because the father's appearance in the film is framed by visual markers of his death, if he does represent a Christ figure, then he is an ineffective one, whose being and sacred texts were dead all along. It follows that there cannot be a resurrection: one cannot restore to life what ultimately never lived, and the film does not present a final resurrection of the father. Instead, at the end of *The Return*, the father's body is literally and figuratively caught in a liminal space: literally, he is submerged under water, neither on the island nor on the mainland; figuratively, he is caught between non-Christian and Christian, or Soviet and post-Soviet cultures. Moreover, his image is

8 The Christian imagery has been widely discussed by viewers of *The Return*. See Vlad Strukov in Further Reading. I also recommend reading the "user comments" available through www.imdb.com.

erased by the film's final photographs, which do not contain a single image of the father from this recent journey.

The Journal: Structural Hieroglyphics

At a very basic level, *The Return* is the cinematic chronicle of the boys' chronicling, the visual representations of their written words. Much like journal entries, a label that designates the day that the subsequent events occurred punctuates the beginning of each of the film's seven segments. Moreover, because the boys take turns keeping the journal, the film alternates between their two perspectives. As such, the film may simply be read as the filmic journal of the boys' week with their father. However, this reading of the film is not without its complications. The journal hieroglyphics are problematized when we acknowledge that one of the film's most important events—the father's solitary journey to get the mysterious box—could not have been told by the boys. Moreover, this is the only scene in all of *The Return* that is *not* represented from the boys' perspective after they have made a pact to keep a journal. (There are, indeed, a few scenes prior to this pact that are not filmed from the boys' perspective.)

Because this scene exists, the validity of the journal interpretation is thrown into question. If the film does represent the visual narrative of the boys' chronicling, then the boys have obviously invented material, for they have told stories that they themselves have not witnessed. Their words do not necessarily match up with reality, but perhaps with a *reality they wished had been*; this, perhaps, positions the film in the vein of Socialist Realism, which sought not to present reality as it is, but as it ought to be. Furthermore, that the father is not depicted in the photographs displayed at the end of the film suggests a number of readings. First, should we read this as suggesting that the father has somehow purposely been left out or even erased from the photographs, then we immediately recall the Stalinist doctoring of photographs to eliminate those who were deemed enemies of the people. Are the boys engaging in their own rewriting of history, erasing any evidence of their own victim? After all, in a way they have indeed purged and executed

their own father. Second, if the father represents dead ideologies, then the inability to photograph him suggests the unreality of those ideologies. Third, because we cannot trust the validity of the boys' journal, perhaps we cannot believe that the father really returned: did the boys simply invent him because of some unsatisfied need? Does the film take place in the psyche rather than in reality? What is clear is that the film undermines its own journalistic structure, thereby itself figuring as another potential grand narrative that has lost its claim to transcendent truth in post-Soviet Russia.

The Return is a film about a plurality of returns. On its surface is the return of a father to his family after a long absence and the resulting family tragedy. On a number of symbolic planes, we have the return to Christianity and the return to folklore—both mythological systems that have shaped Russian culture in the past and, as the film reveals, continue to influence it in the post-Soviet present. However, the film problematizes each of these ideological systems, thereby denying their access to truth. As a postmodern film about post-Soviet Russia, *The Return's* brilliance lies in its portrayal of a realm that is constructed and influenced by narratives and ideological systems that have been delegitimated. It portrays a quandary that dominantly characterizes post-Soviet Russia: what to do with a debunked past that nonetheless informs what Russia is today?

Further Reading

Hashamova, Yana. "Resurrected Fathers and Resuscitated Sons: Homosocial Fantasies in *The Return* and *Koktebel'*." In *Cinepaternity: Fathers and Sons in Soviet and Post-Soviet Film*, edited by Helena Goscilo and Yana Hashamova, 169-88. Bloomington and Indianapolis: Indiana University Press, 2010.

Krasavina, Anna. "Vozvrashchenie. Popytka analiza." *Drugoe kino*, 20 Dec. 2004. http://az-film.com/ru/Publications/104-Vozvrashhenie-Popitka-analiza.html (accessed 5 September 2012).

Marco, Zakarias, A. Zviagintsev, K. Golubovich. *"Vozvrashchenie." Diptikhi. Doroga.* Moscow: Izdatel'stvo "Logos," 2007. Translation of Zacarías Marco. *DIPTICOS. Un studio sobre la idea de Padre en la pelicula El regreso de Andrey Zvyagintzev.* Madrid: Pastor, 2005.

Stishova, Elena. "Na glubine." *Iskusstvo kino* 1 (2004). http://kinoart.ru/2004/n1-article4.html (accessed 5 September 2012).

Strukov, Vlad. "The Return of Gods: Andrei Zviagintsev's *Vozvrashchenie* (*The Return*)." *Slavic and East European Journal* 51, no. 2 (2007): 331-56.

Surkova, Ol'ga. "Ostrov neizvestnykh sokrovishch." *Iskusstvo kino* 1 (2004). http://kinoart.ru/2004/n1-article6/Печать.html (accessed 5 September 2012).

Zviagintsev, Andrei. *Andrey Zvyagintsev.* http://az-film.com/ru/ (accessed 21 June 2013).

-----. *Master-klass.* 3rd ed. Moscow: ARTkino, 2012.

NIGHT WATCH

Nochnoi dozor

2004

114 minutes

Director: **Timur Bekmambetov**

Screenplay: **Sergei Luk'ianenko and Timur Bekmambetov**

Cinematography: **Sergei Trofimov**

Music: **Iurii Poteenko**

Leading Producers: **Aleksei Kublitskii and Varvara Avdiushenko**

Producers: **Anatolii Maksimov and Konstantin Ernst**

Production company: **Kinokompaniia TABBAK/Bazelevs-Prodakshn and Channel One (Pervyi kanal)**

Cast: **Konstantin Khabenskii (Anton Gorodetskii), Vladimir Men'shov (Geser, leader of the Light Forces), Viktor Verzhbitskii (Zavulon, leader of the Dark Forces), Rimma Markova (Dar'ia, sorceress), Il'ia Lagutenko (Andrei, vampire), Valerii Zolotukhin (vampire, Kostia's father), Mariia Poroshina (Svetlana, doctor and magician), Galina Tiunina (Ol'ga, magician), Aleksei Chadov (Kostia, vampire), Dmitrii Martynov (Egor, Anton's son), Mariia Mironova (Irina, Egor's mother)**

Timur Nuruakhmetovich Bekmambetov (1961—) is a prolific Russian filmmaker with a successful career in the Russian Federation as well as in the USA. Born and educated in the Kazakh Republic of the USSR,[1] he worked in Central Asia until moving to Moscow

[1] After the dissolution of the USSR in 1991, it became the independent state of Kazakhstan.

in the early 1990s. Bekmambetov's debut film *The Peshawar Waltz* (*Peshavarskii val's*, 1994, also known as *Escape from Afghanistan*), about the Soviet war in Afghanistan, won him a few international prizes. However, he was not directly involved in production of feature films for another decade, during which he focused on advertising for television and setting up his own film company, Bazelevs Prodakshn. In the 1990s, his series of commercials for Imperial Bank became a classic of Russian advertising and made him well known in television and film circles. In 2004 he directed *Night Watch*, which became a huge success in Russia, the former Soviet republics, and in the West. With a budget of $4.2 million, the film grossed over $32 million worldwide, which is outstanding for a film released in the category "foreign films." The distribution rights for the film were purchased by Twentieth Century Fox and the film was remastered to include all-English dialogue and released in the USA in 2006. In Russia, Bekmambetov released *Day Watch* (*Dnevnoi dozor*) in 2005, a sequel which also proved to be extremely popular, and his career took off internationally. At Universal Pictures, he directed *Wanted* (2008, starring James MacAvoy and Angelina Jolie); in collaboration with Tim Burton Productions, he directed *Abraham Lincoln: Vampire Hunter* (2012), and also produced Chris Gorak's *The Darkest Hour* (2011) and Shane Acker's animated feature *9* (2009). In Russia he scripted, directed and produced a number of feature and animated films, including *The Irony of Fate 2* (*Ironiia sud'by: prodolzhenie*, 2007) and *Black Lightning* (*Chernaia molniia*, 2009). His career exemplifies the success of a Soviet artist who became famous internationally in the post-Soviet period owing to the liberalization of the global film market and new creative opportunities in post-Soviet Russia.

Bekmambetov's cinematic output falls into three distinct categories. The first group comprises feature films that combine the genres of horror, fantasy, action and crime: *Night Watch*, *Day Watch*, *Black Lightning*, *Wanted* and *Abraham Lincoln*, films which share Bekmambetov's interest in the nature of history, the workings of fate or predestination and an individual's choice. These films utilize complex narrative structures and create fantastical worlds ruled by the laws of chance and destiny. These films also demonstrate

Bekmambetov's obsession with vampires who either inhabit present-day Russia (*Night Watch* and *Day Watch*) or historical America (*Abraham Lincoln*). By employing the myth of the vampire, the director presents his own interpretation of historical events and social crises.

The second group consists of remakes of Soviet cinematic classics: *The Irony of Fate 2* is a remake of El'dar Riazanov's 1975 comedy *The Irony of Fate* (*Ironiia Sud'by, ili s legkhim parom*), and *Gentlemen of Luck* (*Dzhentel'meny udachi*, 2012) is a remake of Aleksandr Seryi's 1971 film. These films are primarily aimed at the citizens of the former USSR and exploit their nostalgia for the past. They also trace the lives of characters from the Soviet films in the post-Soviet period, thus functioning as cinematic bio-pics. The ironic tonality of these films enables the director to combine accurate historical representation with fantastic situations. This is particularly evident in *Black Lightning*, which tells the story of a Soviet car that resurfaces in contemporary Moscow. As the car is able to fly, it takes its driver, a young man named Dima (Grigorii Dobrygin),[2] around Russia's capital on various rescue missions.

Bekmambetov's work as a producer of animated films—the third category—has resulted in films that continue the logic of his feature films: for example, *9* is the macabre story of a hand-stitched doll with the number 9 written on its back who comes to life in a world destroyed in a war between man and machine. As in *Night Watch*, the toy makes a journey in a dark, frightening world and discovers that he is not alone and that there are others like him, also with single digits written on their backs. The film is a complex cinematic puzzle that viewers need to assemble as they follow the characters. *Smeshariki: The Beginning* (*Smeshariki: Nachalo*, 2011, directed by Denis Chernov), on the other hand, is a light-hearted comedy about ball-shaped animated characters called *smeshariki* (the compound word in Russian means "laughing balloons") who

2 Dobrygin also appears in the leading role of *How I Ended This Summer*, discussed in this collection.

act like superheroes in a contemporary city. *Smeshariki* continues the "light," comedy-based strand in Bekmambetov's cinematic career.

Bekmambetov's focus on urban environments, original interpretations of history and the macabre have gained him a reputation in Russia and abroad. However, it was *Night Watch* that catapulted him to international fame. The film begins in 1992 Moscow, where Anton Gorodetskii seeks help from a sorceress, Dar'ia, in order to regain his unfaithful wife, Irina, only to learn that his wife carries another man's child—information that subsequently proves inaccurate. Anton's suspicions of Irina's infidelity and his desire to punish his wife prompt him to ask the sorceress to terminate Irina's pregnancy. Just as Dar'ia is about to act, she is attacked by some invisible forces that prevent her from completing her spell. Unexpectedly, Anton is able to see the attackers, who turn out to be representatives of the Light Forces. Thus, in the opening scene, the director introduces a new social order in which "Others,"[3] who possess supernatural powers, live among normal humans. The Others fall into two groups: the Dark ones, who gain their power by feeding on the blood of humans, and the Light ones, who are supposed to protect people from their Dark opponents. Although being one of the Others is biologically predetermined, a human being can be initiated, becoming a vampire, if s/he falls prey to another vampire.

Anton faces the dilemma of whether to join the Light or Dark forces, and throughout the film he straddles the divide, following his call—the desire to reconnect with the son that he initially thought was not his. In this way, the director introduces the main philosophical concern of the film—the logic of choice and predestination (fate). He also shows the origin of the conflict in the destruction of the family rather than in a conspiracy of the husband and

In Russian the term *"inye"* is used; this is more neutral than *"drugie,"* which conveys a stronger feeling of otherness. While *"inye"* emphasizes difference, *"drugie"* signifies alienation, opposition and even possible threat.

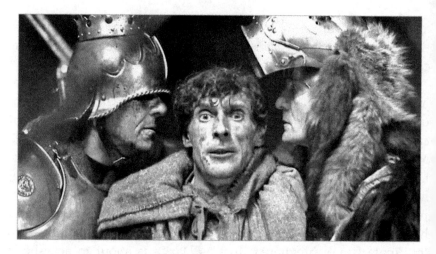

Fig. 107. Negotiating the Truce

wife to maintain their power.[4] Finally, Bekmambetov emphasizes the role of history in our understanding of contemporary problems and demonstrates their mythological connotations: we can read the opening scene as an interpretation of original sin, as well as a reference to the story of Oedipus, except that now it is the father who desires the death of his child. The principle of inversion governing the film's understanding of evil recalls Goethe's *Faust*: "'... who are you, then?'/ 'I am part of that power/ which eternally wills evil/ and eternally works good'" — a familiar reference for Russian audiences because of the citation from Goethe in the epigraph to Mikhail Bulgakov's *The Master and Margarita*, a text that provides *Night Watch* with a set of inspirational allusions.

As the action moves to contemporary Moscow in 2004, twelve years later, the viewer is reintroduced to Anton, who is no longer a neurotic young man but a conscientious member of the Light Forces. His objective is to exterminate vampires, governed by Zavulon, and to bring more "Others" to the realm of the Light Forces, commanded by Geser. However, his main aim is to reestablish contact with his son Egor, who lives with his mother, and as the viewer eventually learns, is destined to become the Great Other. No

[4] Vlad Strukov, 192, in Further Reading.

one knows whether he will join the Dark or Light forces, but it is certain that his choice will determine the balance of world power in the future. So, Anton's desire to reconnect with his son should be interpreted as an element of the monumental battle between Dark and Light Forces and therefore, motivation and causality are inverted in the film one more time. In fact, the conflict between the forces goes back to the Middle Ages, when the armies of Light and Dark Forces, under Geser and Zavulon, met in battle on an ancient arched bridge. When it became clear that the Dark and Light forces possessed equal powers and the clash was doomed to result in mutual extermination, Geser halted the fight and the forces of Light and Dark signed a truce ending the devastating battle (Fig. 107). Since then, the forces of Light govern the day, while nights belong to their Dark opponents, and the two sides establish watches to maintain peace.

The energy of the film is such that it enables the reading of the most mundane situations on a mythological level. For example, the apartment across from Anton's is occupied by a family of vampires, Kostia and his father. The two flats and their inhabitants represent the fragile truce between the Dark and Light Forces, and also illustrate Anton's yearning for a family of his own. In the absence of the mothers, the social and cultural conflict is shown as a male prerogative, i.e. the passing of knowledge from father to son. Kostia's father has managed to maintain control over his son only because he had "initiated" him, that is, turned him into a vampire; in other words, he has maintained control by establishing the law of the father by force. Thus, the director shows how the metaphysical conflict of good and evil is acted out in the private realm of the family, whereby one's experience is also a paradigm of destiny. Bekmambetov connects the opposed spheres—the private and the public, the real and the fantastic, the actual and the allegorical— through the myth of Oedipus, utilizing the matrix of the myth to unite the otherwise disjunctive structure of the film. With the help of implicit allusions, he reconstructs a complete chronology of events and renders the ancient myth's thematics. For example, Bekmambetov retains the metaphor of the road, where the father and the son meet for the first time, to convey the workings of fate,

as well as to suggest that his characters' search for identity is not achieved. Both Anton and Egor are nomads whose allegiance has not yet been determined.[5]

The conflict between Egor and Anton should be read in mythological and psychoanalytical terms—the Freudian introduction of the Oedipus complex and its Lacanian interpretation in the realm of culture and language[6]—as well as in sociocultural terms as a conflict between fathers and sons and Soviet and post-Soviet generations. Egor is a representative of the first post-Soviet generation: born in 1992, the film makes it explicit that he was conceived in 1991, the year the USSR was dissolved. Geser and Zavulon, the leaders of the Others, function as surrogate fathers for Anton and Egor, respectively. Both are shown as typical Soviet leaders—the oak panelling of Geser's office alludes to the business style of the late Brezhnev period, and Zavulon's outfits are similar to those worn by mafia bosses who made their fortunes in the Soviet period because they had uncontrolled access to national property. Moreover, Geser and Zavulon, as well as Dar'ia and Kostia's father, are played by actors who gained fame in the Soviet era. Thus, the conflict between Light and Dark forces is drawn not in terms of the "Soviet versus post-Soviet" opposition, but rather as an eternal divide between good and evil, and as a generational conflict. Anton falls out of this binary logic because he is neither a Soviet nor a post-Soviet character. His social identity can be determined as that of the perestroika period; as the Russian term suggests, he is forever doomed to pursue "rebuilding, remaking." In other words, his identity will always remain unstable and account simultaneously for destruction and innovation. Anton is a mediator between the two generations: "he is a communicator between the past and the present; between male and female; and between the Soviet and post-Soviet generations. Thus, the director shows how the radical political and social changes of the 1990s undermined parental authority, especially that of the father. The crisis of the father

5 Strukov, 193.

6 For a detailed analysis of the film from these perspectives, see Strukov.

systematically coincides with the crisis of masculinity. The director enables his protagonist to overcome both of these crises in the realm of the fantastic through the process of identification based on the Oedipus complex."[7]

While the fierce battle between the Dark and Light Forces continues on the streets of Moscow, "normal" humans, i.e. those who are not Others, receive little attention. "Muscovites are reduced to bare life, essentially the position of the vampires' cattle."[8] The disenchantment of "normal" humans can be interpreted as the social and political inertia of many Russians following two decades of intense political engagement. Alternatively, their limited function in the narrative signifies the trauma of post-Soviet transformation whereby the distinctions between social classes, cultural values, and good and evil were blurred. The instability of signs, cultural symbols and identities is rendered on many levels, including the so-called Gloom, the third, alternative space that the characters can inhabit temporarily. The Gloom allows characters to transcend such boundaries as walls and also to slow down and reverse time; however, the Gloom also saps their life energy and feeds on it in the same way vampires feed on their prey. As a result, the life cycle of *Night Watch* is completed: the film argues for a non-linear, cyclical structure of history, human experience and cultural value.

The transient spaces, characters and experiences of *Night Watch* are represented through award-winning special effects. Computer-generated imagery is used to emphasize the transformative power of magic and the experience of the uncanny. On one level, the story is rooted in ancient myths and historical contexts; on another it celebrates technological modernity, which is evident in the use of computer-generated imagery as well as various technologically advanced artifacts—computers, mobile phones, cars, etc. The celebration of the modern and contemporary is seen in the presence of Russian celebrities—musicians, television personalities and socialites. The film thus presents a complex matrix of cultural

[7] Strukov, 203.

[8] Alexander Etkind, 197, in Further Reading.

allusions that refer both to the Russian past and present and enhance the viewer's experience by injecting elements of comedy into an otherwise gruesome narrative about vampires and vampire-hunters.

Night Watch had a massive appeal to audiences in Russia and abroad because of its multilayered narrative construction, its entertaining and simultaneously deep exploration of life in the country and of the contemporary condition generally. Upon its release in the West, the film made its mark through the innovative use of subtitles. Subtitles are always a sign of (cultural) difference. Rather than masking them with the false pretence of making the viewing experience comprehensible for the spectator, *Night Watch* capitalized on subtitles as yet another level of story-telling. "We discussed with the studio [Fox Searchlight] how to make the movie more entertaining for English-speaking audiences," explained Bekmambetov, "we thought of the subtitles as another character in the film, another way to tell the story."[9] Indeed, subtitles in the English version of *Night Watch* convey the meaning of what is being said in Russian and also relate to the visual aspect of the film. For example, when Egor is swimming in the pool and begins to feel the vampire's call, the subtitles appear in red and pulsate, vibrate and "bleed," literally engaging with the theme of the film. As a result, "*Night Watch* uncovers the immanent corporeality of language and text."[10] The innovative use of subtitling in *Night Watch* also helped maintain its inner link with the original literary source.

Night Watch and its sequel *Day Watch* are based on the novels of Kazakhstani-born writer Sergei Luk'ianenko, who actively contributed to scripting the films. *Night Watch* is an example of "transmedia storytelling," the telling of a story using multiple media types.[11] Indeed, Bekmambetov's films contribute to the

9 Grant Rosenberg, "Rethinking the art of subtitles." *Time*, 15 May 2007, http://www.time.com/time/arts/article/0,8599,1621155,00.html (accessed 23 August 2012).

10 Giorgio Hadi Curti, 201–08, in Further Reading.

11 Henri Jenkins, "Transmedia Storytelling," *MIT Technology Review*, 15 January,

creation of the particular fantastical world originally conceived by Luk'ianenko. This world is extended in a series of computer games produced by the Russian developer Nival Interactive. (A single-player tactical game was released in 2006 and was followed by an online multi-player game released in collaboration with the news portal mail.ru.)[12] The novel-film-game franchise prompted the emergence of real life role-playing games which bring together young people who roam the streets of their cities in order to fulfil various tasks set by the game organizers. At one point the game was simultaneously played in 180 cities in Russia and abroad. Fans have produced numerous *Night Watch*-inspired artworks that have been used in the creation of the online game; they have also authored "fanfiction" that Luk'ianenko has incorporated into his work.[13] As a transmedial practice, *Night Watch* expands our understanding of non-linear production and hypertextual creativity, multi-platform environments, "synergizing with complex cross-promotional product marketing initiatives and the construction of citizen-spectators."[14]

Vlad Strukov

2003, http://www.technologyreview.com/biotech/13052 (accessed 25 August 2012).

2 The game is available here: http://dozory.ru/ (accessed 26 August 2012).

3 Sergei Luk'ianenko, "Obsuzhdeniia" [Blog post], 2009, http://forum.lukianenko.ru/index.php?showtopic=4650 (accessed 25 August 2012).

4 Vlad Strukov, "Editorial," *Digital Icons: Studies in Russian, Eurasian and Central European New Media* 5 (2011): i-iv, http://www,digitalicons.org/issue05/vlad-strukov/ (accessed 17 June 2013).

Further Reading

Curti, Giorgio Hadi. "Beating Words to Life: Subtitles, Assemblage-(s)capes, Expression." *GeoJournal* 74, no. 3 (2008): 201–208.

Etkind, Alexander. "Post-Soviet Hauntology: Cultural Memory of the Soviet Terror." *Constellations* 16, no. 1 (2009): 182-200.

Kupriianov, B. and M. Surkov. *Dozor kak symptom. Kul'turologicheskii sbornik.* Moscow: Falanster, 2006.

MacFadyen, David. "Timur Bekmambetov: *Night Watch (Nochnoi dozor)* (2004)." *KinoKultura* (2004). http://www.kinokultura.com/reviews/R104dozor.html (accessed 25 August 2012).

Matizen, Viktor. "Timur Bekmambetov: *Day Watch (Dnevnoi dozor,* 2006)." *KinoKultura* (2006). http://www.kinokultura.com/2006/13r-daywatch.shtmlhtml (accessed 25 August 2012).

Strukov, Vlad. "The Forces of Kinship: Timur Bekmambetov's *Night Watch* Cinematic Trilogy." In *Cinepaternity: Fathers and Sons in Soviet and Post-Soviet Film,* edited by Helena Goscilo and Yana Hashamova, 191-216. Bloomington: Indiana University Press, 2010.

THE TUNER

Nastroishchik

2004

154 minutes

Director: **Kira Muratova**

Screenplay: **Sergei Chetvertkov, with Evgenii Golubenko and Kira Muratova (based on themes from the works of Arkadii Koshko)**

Cinematography: **Gennadii Kariuk**

Art Design: **Evgenii Golubenko**

Sound: **Aleksei Shul'ga**

Production Company: **Pygmalion Production, Odessa Film Studio, Ministry of Culture and Art**

Cast: **Georgii Deliev (Andrei), Alla Demidova (Anna Sergeevna), Renata Litvinova (Lina), Nina Ruslanova (Liuba)**

Kira Muratova (born 1934) has directed eighteen full-length feature films. Her first two films, co-directed with her (then) husband, were followed by two solo works, *Brief Encounters* (*Korotkie vstrechi*, 1967) and *Long Farewells* (*Dolgie provody*, completed 1971; released 1987), films that she has affectionately called her "provincial melodramas." These two black-and-white films garnered both lasting critical attention and official opprobrium. The first (*Brief Encounters*) marked her as a risky filmmaker whose fragmented narrative line, flashbacks, and multiple points of view were incompatible with governing Soviet norms of socialist realism, which was then— at the end of the Thaw period—becoming more rigidly codified. A worse fate awaited *Long Farewells*: the film was banned entirely and, as a consequence of her "incompetence," the filmmaker was

downgraded in her professional status. During the Stagnation period, seven years after this banned film, Muratova was finally able to complete her next work, *Getting to Know the Wide World* (*Poznavaia belyi svet*, 1978), followed by *Among Grey Stones* (*Sredi serykh kamnei*, 1983). By now, Muratova had moved to color film, but continued her preference for an experimental search, evident here in impressionistic camera work and a vivid, mannered color scheme. Official reaction to *Among Grey Stones* was severe; substantial cuts were demanded before its authorized release. In response, Muratova removed her name from the film and substituted "Ivan Sidorov," Russian cinema's equivalent of "John Doe," as the director's name.

Perestroika was kinder to Muratova's work. The provincial melodramas began to gain the critical attention they had always deserved; in 1987 her *Long Farewells* was finally unshelved.[1] Her next two films, *A Change of Fate* (*Peremena uchasti*, 1987) and *Asthenic Syndrome* (*Astenicheskii sindrom*, 1989; released 1990), retained her love of narrative complexity. The latter work contained a notorious profanity scene that delayed the film's release, awarding it the honor of briefly being the last shelved Soviet film. In her immediate post-Soviet period, during which Muratova shot the more mellifluous *Sentimental Policeman* (*Chuvstvitel'nyi militsioner*, 1992) and *Passions* (*Uvlecheniia*, 1994), she also directed the almanac film *Three Stories* (*Tri istorii*, 1997) and *Minor People* (*Vtorostepennye liudi*, 2001). These two color films were followed by a return to black-and-white in *Chekhov's Motifs* (*Chekhovskie motivy*, 2002) and *The Tuner* (2004), which is the subject of this essay. After *The Tuner*, Muratova directed *Two in One* (*Dva v odnom*, 2007) and *Melody for a Street Organ* (*Melodiia dlia sharmanki*, 2009), both color films that retain many of Muratova's signature devices: mannered speech, verbal and visual repetitions, unpredictable narrative turns, and a heightened performance style.

[1] See Batchan in Further Reading; V. Fomin, *"Polka": Dokumenty. Svidetel'stva. Kommentarii* (Moscow: NIIK, 1992); J.M. Frodon, "Kira Muratova: l'oeuvre mutilée," *Le point* 818 (23 May 1988): 72; Nicholas Galichenko, *Glasnost—Soviet Cinema Responds*, ed. Robert Allington (Austin: University of Texas Press, 1991), 91-106.

Muratova's most recent work, *Eternal Return* (*Vechnoe vozvrashchenie*), appeared in 2013.

Since the late 1980s, alongside such Russian *auteurs* as Aleksei German and Aleksandr Sokurov, Muratova has held a well-recognized place among the lead Russian art-house directors. Resisting both contemporary Hollywood norms and more broadly accepted social convention, her artistic style has a distinct signature that challenges our expectations of Russian filmmaking, women's filmmaking, and even such larger categories as "civilized behavior." Her insistence upon a different way of watching films has produced a community of devoted spectators responsive to her idiosyncrasies. While her cinema appeals primarily to an educated, metropolitan audience accustomed to a quirky, art-house style, it is not an exaggeration to suggest that Muratova's films have had a lasting impact on viewer practices internationally at major festivals. Her work has shifted our expectations not only of such "natural" categories as character, dialogue, and setting, but also of "good film." As Zara Abdullaeva writes, "[Muratova] does not shoot (and incidentally has never filmed) 'the nice way of filming good cinema,' or even 'bad cinema,' but rather she works on a different playing field and by different rules."[2]

The film on which we focus here has been honored in both domestic and global competitions. *The Tuner* won three Nika 2005 awards from the Russian Academy of Cinema Arts (Best Director, Best Female Lead, Best Supporting Actress). International awards include the Grand Prix (Golden Lily) at the 2005 goEast Festival of Central and Eastern European Film (Wiesbaden) and three prizes (Grand Prix, Best Female Lead, Best Supporting Actress) at the 2005 Eurasian International Film Festival (Alma Aty).

In *The Tuner*, we encounter two pairs. The first pair is two older women, the former nurse Liuba and the wealthy Anna Sergeevna. The second pair is two scam artists, the protagonist Andrei, who befriends the two older women, and his lover Lina, played by cult actress Renata Litvinova, a worthy research topic in her own

2 Abdullaeva, "Zloumyshlenniki," in Further Reading.

right. Liuba seeks marriage through personal ads, but is bilked by a stranger whom she mistakes for her personal-ad date. Her friend Anna Sergeevna fares no better: in search of a piano tuner, she is charmed by Andrei, who is a "tuner" in two senses: he is both a real musician and a real scam artist who "tunes" his victims to his advantage. Liuba's troubles continue when her real personal-ad date, to whom she is newly married, escapes with her purse. Andrei takes it upon himself to track down her stolen cash, but—hardly a hero—he is motivated by a more ambitious scam to secure both women's available funds through an elaborate forgery scheme. Less a thriller than a portrait of human nature, Muratova's film alternates humor and brutality in its highly ornamented performance of social peccadillos.

Anna Sergeevna reminds us that "everyone needs a tuner." What, then, is a "tuner"? This is no metaphor for psychotherapy; it is Muratova's sly assertion of our voluntary, but unacknowledged availability to the marauder who will always "tune" the victim for his own benefit. Turning to the police for help, the two female victims find they have entirely different memories of Andrei's physical appearance. Each has produced her own individual tuner.

Even in the opening minutes of *The Tuner*, the viewer will notice Muratova's odd cinematic style, most evident in its mannered acting, closer to exaggerated performance than realistic drama: the characters' facial features, gestures, posing, and intonations are distorted, hyper-expressive, or unnaturally dramatic. What kind of cinema is this? Critics and scholars have compared it to Italian *commedia dell'arte* (Shilova), to the circus (Mikhail Aizenberg), and to farce (Beumers, Horton and Brashinsky, 106; Roberts, 148; Sheib). Muratova herself has described it as vaudeville (Muratova in Ramm). Her characters at times do not even appear human; critics have aptly described them as "happy and restless marionettes" (Mantsov, 9) or "simulated humans" (Berry, 449).[3]

[3] Shilova, Beumers, Horton and Brashinsky, Roberts, Scheib, Berry, in Further Reading; Mikhail Aizenberg, in "*Nastroishchik: Seansu* otvechaiut...," *Seans* 21/22 (Summer-Fall 2004), http://seance.ru/category/n/21-22/films2004/nastroyschik/mnenia/ (accessed 20 January 2013); Vita Ramm,

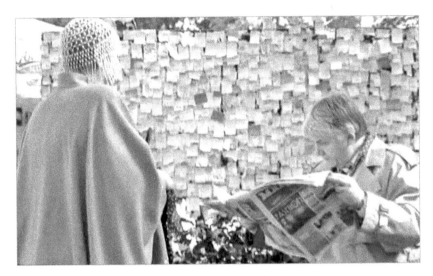

Fig. 108. Personal Ads

The film is rich in self-conscious and repetitive devices: its opening scene, for example, sets its characters against a backdrop of fluttering personal ads (Fig. 108). Soon paper of all kinds—posted ads, newspaper pages, fluttering strips on the portable fan, bank certificates, forged papers, fake love letters, currency—becomes the film's dominant sign of what might be described as the scripted self. But this scripted self is not necessarily a negative phenomenon in Muratova's universe. The scam artist, the musical artist, and the film artist—both the actor and the film director herself—are all variants of such a concocted self. Of these scripted selves, one kind is sublime: as Lina reminds us twice (quoting Lenin's dictum), "cinema is the most important art." As if to confirm cinema's place in the arts of deception, the newly-wed husband who had stolen Liuba's purse turns out to be a movie-theatre projectionist.

Muratova's core identification throughout this film is precisely with Andrei, the "double trickster," both artist and scammer. Towards the film's end, in a long take, Andrei stares directly out at

"Vtorostepennye liudi priekhali v Moskvu...," *Rossiiskaia gazeta* (4 October 2003), http://www.rg.ru/Anons/arc_2002/0518/6.shtm (accessed 20 January 2013); I. Mantsov, "Kollektivnoe telo kak romanticheskii geroi-liubovnik," *Iskusstvo kino* 8 (1994): 7-9.

us, accompanying himself on the (now) well-tuned piano. Finally, he gives us a knowing wink, the director's greeting to her (potential) confederates, whose creative streak is indistinguishable from social transgression.

Muratova's cinema had not always been so mannered. Her "provincial melodramas," mentioned above, were understated psychological portraits that captured complex emotions beneath the surface of quotidian dialogue. It was only in the late Stagnation period (the late 1970s and early 1980s), in response to both her ostracism and the influence of ornamentalist artist Rustam Khamdamov, that Muratova moved from psychological realism towards the playful, eccentric cinema for which she is better known today.[4] Saturating the screen with the kind of tasteless domestic clutter that conceptually corresponds to the actors' mincing affectations, Muratova provokes us to see such affectations as a symptom of high civilization, a category we might otherwise hold in high esteem.

Muratova's cinematic style, therefore, is not the familiar mimetic realism we are used to watching in "normal" Hollywood films. Instead, Muratova aims to distort "civilized" behavior and speech, staging it so as to call attention to the ways in which established social codes are always already fake, hypocritical, and manipulative. Despite our high regard for the achievements of social breeding, her cinema suggests, we remain predatory mammals. Under a veneer of philistine niceties, our normal intent is to bend others to our will. And so the extreme stylization that might irritate the first-time viewer is intended to do precisely that: alienate that viewer's conventional habits of looking. Whether the viewer chooses to take Muratova on her own terms—as an invaluable provocation—is a matter of choice. An appreciation of her work requires not only the suspension of traditional viewing norms, but also—beyond the boundaries of cinema—a skepticism toward social norms we have accepted as "polite," "refined," or "genteel."

[4] On Muratova's move toward ornamentalism and her contribution to what the scholar productively calls haptic cinema, see Widdis in Further Reading.

Hence, in the early moments of the film, when Liuba lunges to kiss the man whom she mistakes for her personal-ad date, it is not because she is a demented or aggressive person (in the usual sense of a "flesh-and-blood human"), but rather because Muratova is suddenly "somatizing"—acting out with a body—the meeting's unspoken contract. This somatization is one of Muratova's trademark devices: the director knows (and wants us to know) that higher-order impulse control is a difficult, unnatural practice (and not necessarily a good thing). In the next scene, as Andrei guzzles alcohol from the store's bottles, we are not invited to censure or to approve of him; we are presented instead with the irrepressible drive of living organisms to consume whatever resources are easily available. Hence, Liuba's aggressive kiss and Andrei's guzzling become normal, predatory activities. At stake is not the conventional character development of realist cinema, but a cinematic challenge to our own self-delusional gentility.

"Realism" is only one of the false yardsticks by which Muratova's critics have measured her work. Some (western critics in particular) include her work in a pantheon of feminist filmmakers, an honor Muratova has vigorously resisted.[5] Muratova operates at a much lower baseline: all human aspirations, as we have come to conceive them, are mendacious and predatory. Yet, for all this, Muratova is by no means a pessimistic director: she has a highly developed sense of play. Indeed, rather than normal narrative protocol, much of her convoluted cinema is exactly an enactment of that playfulness, deliberately confounding conventionally minded critics who would prefer a straightforward plot.

It is with this bemused distance we might best watch *The Tuner*: the director is quite happy to shock the snobbish, middle-brow viewer. In *The Tuner* and elsewhere, the target of Muratova's sharpest humor is the liberal intelligentsia, to which she, together

[5] Condee, "Kira Muratova," 115-40, in Further Reading; Taubman, 8-9, in Further Reading; Anna Lawton, *Imaging Russia 2000: Film and Facts* (Washington, DC: New Academia Publishing, 2004), 210.

with her most typical viewing public, also belongs. In the words of film scholar and director Oleg Kovalev:

> [Muratova] takes particular provocative pleasure in depicting the conceptually bankrupt, the mentors and idols of the liberal intelligentsia. The wandering 1960s types, resembling self-confident idiots, or "Chekhovian" *intelligenty* [members of the intelligentsia], expatiating tedious pablum to no good purpose, resemble here talking dolls in a farce that has come to bore you. It is clear that the external cynicism of the artist can be cleansing and constructive.[6]

If readers were to watch Muratova's other films, they would notice the recurrence of distinct visual patterns: twins, dolls, corpses, stray animals, are just some of these signature images. At the end of *The Tuner*, in the bank scene, we see two set of twins (one younger, one older), utterly unmotivated images except as Muratova's "double signature" at the film's end. Two additional devices deserve mention here: first, Muratova's eccentrics, who appear episodically in her films with no evident plot function. In *The Tuner* these eccentrics might (arguably) include three characters: the homeless deaf-mute woman whom Lina befriends; the toga-clad wine-seller; and the nameless blind man who is granted the film's final lines. What is the purpose of these interventions? Do they have common, key functions internal to the film, or should they be understood as signs linking together Muratova's cinematic style from one film to the next? Taking these queries one step further, Nina Tsyrkun has suggested that the director "films one endless 'Muratova film,' in which the people whom she has discovered live and act."[7] In this sense, Muratova's art has much closer ties, for example, to orchestral symphony (sustained by leitmotifs and formal patterns) than to narrative film.

A second characteristic device is Muratova's insertion of an "artistic intermezzo." In *The Tuner*, we see at least two examples:

6 Kovalev, in "*Nastroishchik.*"

7 Tsyrkun, in "*Nastroishchik.*"

first, the amateur rehearsal by the charmingly inept, elderly musicians; then (twice) the girl singer-songwriter, performing on public transport. These characters disrupt the narrative to provide us with examples of art within art, tiny episodes of amateur creativity that point sympathetically at the larger "amateur creativity" of the filmmaker herself. If this is so, could that device suggest that the entire film is, at a foundational level, art about art? Or is Muratova's film a more global manifesto about the potential of our daily lives for such improvisational, creative affirmations?

Taken together, Muratova's eccentrics and amateur artists are examples of what might be thought of as the director's creative game preserve, a mammalian community to which she devotes enormous visual affection. In the final analysis, Muratova holds such "deviant" species in higher regard than normal middle-brow citizens. For her, the human race as a whole is a project of dubious value, less worthy of her attention than wild animals, or even her recurrent dolls and corpses. As Muratova herself has said, "living people are very dangerous."[8]

Nancy Condee

[8] Muratova in Natal'ia Shiverskaia, "Zhivye liudi—eto ochen' opasno," *Vremia* 6 (June 2001).

Further Reading

The best comprehensive English-language volume on Muratova's work is by Jane Taubman. The best two Russian-language volumes on Muratova are those by Zara Abdullaeva and Mikhail Iampol'skii. Abdullaeva's book combines interpretation with memoirs and includes Muratova's creative writing; it provides an invaluable examination of Muratova's key signatures—her verbal repetitions, her doubles and twins, cameo performances—while offering the reader a dialogic, open-ended engagement with the key works. By contrast, Mikhail Iampol'skii offers a reading of Muratova's work as a kind of "cineanthropology," in which *homo sapiens* is perpetually pulled between his own feral nature and self-imposed philistine norms. For a review of *The Tuner*, screening notes, and a chapter on Muratova's work, see Condee. Irina Shilova provides an excellent portrait of cult actress Renata Litvinova that situates this phenomenon in Russian culture more broadly. (See also Sul'kin.) The interested reader will find that many of the field's most interesting cinema critics and journalists (only some of whom are listed here) have tried to make sense of this filmmaker's challenging work.

Abdullaeva, Zara. *Kira Muratova: Iskusstvo kino*. Kinoteksty series. Moscow: NLO, 2008.

------. "Zloumyshlenniki." *Iskusstvo kino* 1 (2005). http://kinoart.ru/2005/n1-article1.html (accessed 20 January 2013).

Batchan, Alexander. "Andrei Plakhov on the Work of the Conflicts Commission." *Wide Angle* 12, no. 4 (October 1990): 76-80.

Berry, Ellen E. "Grief and Simulation in Kira Muratova's *The Aesthenic Syndrome*." *Russian Review* (July 1988): 446-54.

Beumers, Birgit. "Kira Muratova: *Minor People*." *KinoKultura*, 2001. http://www.kinokultura.com/reviews/Rminor.html (accessed 20 January 2013).

Condee, Nancy. "Kira Muratova: The Zoological *Imperium*." In *The Imperial Trace: Recent Russian Cinema*, 115-40. New York: Oxford University Press, 2009.

Condee, Nancy. "Muratova's Well-Tempered Scam." Essay-review on Kira Muratova, dir. *Nastroishchik* (*The Tuner*). *KinoKultura* (January 2005). http://www.kinokultura.com/reviews/R1-05tuner.html (accessed 20 January 2013).

------. "*The Tuner.*" Program notes. *The Yellow House of Cinema* (Russian Film Symposium 2005). http://www.rusfilm.pitt.edu/2005/pn/tuner.htm (accessed 20 January 2013).

Galichenko, Nicholas. *Glasnost — Soviet Cinema Responds*. Edited by Robert Allington, 91-106. Austin: University of Texas Press, 1991.

Horton, Andrew, and Michael Brashinsky. Chapter 3 in *The Zero Hour: Glasnost and Soviet Cinema in Transition*, 105-08. Princeton: Princeton University Press, 1991.

Iampol'skii, Mikhail. *Muratova: opyt kinoantropologii*. St. Petersburg: Seans, 2008.

Roberts, Graham. "The Meaning of Death: Kira Muratova's Cinema of the Absurd." In *Russia on Reels: The Russian Idea in Post-Soviet Cinema*, edited by Birgit Beumers, 144-60. London: I.B. Tauris, 1999.

Scheib, Ronnie. "*Two in One.*" *Variety* (31 May 2007). http://www.variety.com/review/VE1117933807?refcatid=31&printerfriendly=true (accessed 20 January 2013).

Shilova, Irina. "Renata Litvinova: Actress and Persona." *KinoKultura* 19 (January 2008). http://www.kinokultura.com/index.html (accessed 20 January 2013).

Sul'kin, Oleg. "Renata Litvinova obozhaet dukhi 'Krasnaia Moskva': Portret russkoi divy na fone skuchnykh voprosov." *Novoe russkoe slovo* 16 (September 1997): 17.

Taubman, Jane A. *Kira Muratova*. KINOfiles Filmmakers' Companions 4. London: I.B. Tauris, 2005.

Widdis, Emma. "Muratova's Clothes, Muratova's Textures, Muratova's Skin." *KinoKultura* 8 (April 2005). http://www.kinokultura.com/articles/apr05-widdis.html (accessed 20 January 2013).

NINTH COMPANY

Deviataia rota

2005
126 minutes (Russian release), 133 minutes (British release)
Director: **Fedor Bondarchuk**
Screenplay: **Iurii Korotkov**
Cinematography: **Maksim Osadchii**
Art Design: **Grigorii Pushkin**
Composer: **Dato Evgenidze**
Sound: **Kirill Vasilenko**
Producers: **Elena Iatsura, Sergei Mel'kumov, Aleksandr
 Rodnianskii**
Production Company: **Art Pictures**
Cast: **Artur Smol'ianinov (Liutyi), Aleksei Chadov (Vorobei),
 Soslan Fidarov (Pinochet), Mikhail Evlanov (Riaba), Ivan
 Kokorin (Chugun), Konstantin Kriukov (Dzhokonda), Artem
 Mikhalkov (Stas), Ivan Nikolaev (Seryi), Fedor Bondarchuk
 (Khokhol), Mikhail Porechenkov (Warrant Officer Dygalo),
 Irina Rakhmanova (Belosnezhka), Aleksei Serebriakov
 (Captain, Intelligence), Svetlana Ivanova (Olia), Aleksandr
 Bashirov (Pomidor), Amadu Mamadakov (Kurbashi), Karen
 Martirosian (Ashot), Marat Gudiev (Akhmet), Mikhail Efremov
 (Dembel'), Aleksei Kravchenko (Captain Bystrov), Aleksandr
 Kucherenko (the barber), Stanislav Govorukhin (Commander
 of soldiers in training), Andrei Krasko (Commander in
 Afghanistan)**

Fedor Bondarchuk (1967—) is the son of the famous film directo:
and actor, Sergei Bondarchuk (1920-1994). He served in the army
at eighteen and is part of the generation of Russian men who were

involved in the Afghan war, although he himself was not sent to the front. Bondarchuk started acting in cinema in the late 1980s. After graduating from the State Film Institute in 1991, he co-founded the company "Art Pictures Studio" and began making music videos of rock and pop stars, such as Alla Pugacheva, Boris Grebenshchikov, Filipp Kirkorov, the groups "Rondo," "Alibi," "Smash" and others throughout the 1990s, and then moved into television as a TV host and director. *Ninth Company*, his directorial debut as a feature filmmaker in 2005, incorporates signature elements of his commercial beginnings with its rapid sequence short scenes, quick color and light changes, and visual humor. Its success has secured for him a notable place in contemporary Russian entertainment and media, where he has continued as an acclaimed actor, director and producer. Bondarchuk's work in all three capacities covers a wide range of genres, from action to comedy, historical epic and science fiction, and is also devoted to promoting and expanding the infrastructure of the video-film industry in Russia through the creation of advanced production studios and other such facilities. He has directed *The Inhabited Island* (*Obitaemyi ostrov*, 2008) and *The Inhabited Island: The Struggle* (*Obitaemyi ostrov. Skhvatka*, 2009). His most recent film, *Stalingrad*, will be released in late 2013.

Ninth Company (*Deviataia rota*) constitutes a landmark of post-Soviet Russian film, both as a box office success and cinematic-cultural achievement. Based loosely on real events, it follows the training, deployment and near-destruction of a paratrooper unit during the Soviet-Afghan War (1979-1989), and blends signature techniques of Hollywood war movies within a Russian tradition of military narratives. Meteoric ticket sales made *Ninth Company*, for its time, the highest grossing domestic movie since the fall of the Soviet Union, and critical acclaim at home, for the most part, followed suit. Hailed by some as a "masterpiece," for others it signaled a "renaissance of Russian cinema" following the plunge in production quantity and quality during the 1990s.[1] Numerous

[1] Boris Svetlov, writing for *Zhizn'* (October 6, 2005); Valery Kichin, writing for *Rossiiskaia Gazeta* (October 1, 2005). Both cited from the film's website: www.9thcompany.com (accessed 9 September 2012).

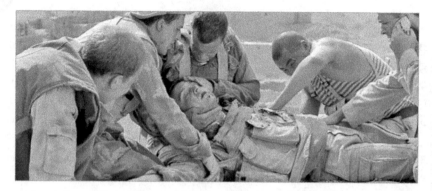

Fig. 109. Brothers

awards at Russian film festivals—particularly for directing, editing, screen writing, acting and musical score—were matched by a positive reception from the political elite following a private screening by President Vladimir Putin and the Minister of Defense with the cast of *Ninth Company* in attendance. While it failed to receive the Academy Award for Best Foreign-Language Film as the Russian nominee for 2006, as a sign of its domestic appeal and significance *Ninth Company* was shown that same year on state television on May 9, the anniversary of victory over Nazi Germany and the greatest secular-cum-military holiday in Russia today.

The film's focus is on five Russian young men, draftees who choose to serve in Afghanistan and who represent different social backgrounds and character types: an orphan (Lyutyi), an artist (Gioconda), a tough guy (Chugun), a sensitive one (Vorobei) and a new father (Stas). They are all ingénues when it comes to war and, with the exception of the last, yet to begin their adult lives and careers. Brutal training followed by the strain and horror of combat in a dangerous but exotic foreign land, relieves them of civilian naïveté and youthful innocence. Simultaneously, they grow together as their shared fate erases any initial differences or antagonisms. From beginning to end, the structuring motif of *Ninth Company* is their successive bonding, whether rendered in a comic, tragic, sexual, martial or patriotic light. Scenes typically end with a close-up of these five as metaphoric brothers, whether joined by laughter, tears, alcohol, sex or, ultimately, blood (Fig. 109). As fitting symbolic closure, each, with the exception of the orphan, who is the

unit's lone survivor, dies in character: the artist while sketching the mountainous landscape; the tough guy while swinging his machine gun; the sensitive one kills himself and numerous enemies with a hand grenade; and the new father is shot by an Afghan child.

Many have noted how Bondarchuk employs iconic structural, characterological and plot motifs of American cinema, particularly that of the Vietnam War. The film's division into training here and combat there, the drill sergeant as sadist and field sergeant as father figure (the latter played by Bondarchuk himself), the emphasis on the unit as a microcosm of the country's social and ethnic identity, the operatic and visually compelling village destruction scene, the indigenous child as killer, the natural environment as seductive yet deadly, the predominance of sex and alcohol, the apparent meaninglessness behind the slaughter, as well as the acknowledgment of command incompetence—all would seem to reprise the legacy bequeathed by such films like *Apocalypse Now* (Francis Ford Coppola, 1979), *Platoon* (Oliver Stone, 1986) and *Full Metal Jacket* (Stanley Kubrick, 1987).

Bondarchuk's recognized debt to others' work—for he has admitted to studying, inter alia, the above three films—has led to criticism that *Ninth Company* is a pastiche or retread of Hollywood conceits for a Russian audience. To a certain degree the charge would seem valid; it is difficult to escape a sense of déjà vu in certain scenes. Yet elsewhere Bondarchuk shows awareness of such precedents and consciously plays with viewers' expectations. In *Ninth Company* the drill sergeant, while a brute, turns out to have a sentimental side. There is sex but only with a Russian woman; rape, a common element of the Vietnam cinematic canon, is absent. While in the final battle scene the Afghan enemy or Mujahideen are shown as charging automatons, until that point their culture is presented with emphasized deference, especially in the orientation scene for the new soldiers. One does not feel the racism typically found in Vietnam films. The village destruction scene shows only buildings exploding with no civilian casualties, and its destruction is prompted by the disclosure of its use as an insurgent base, harboring the boy who shoots Stas, the father character, in the back. At the same time, recognition of Bondarchuk's desire to manipulate

viewers' expectations does not necessarily mitigate the controversy behind such intentions, particularly given the horrific nature of the Afghan war which included extensive atrocities on both sides and near-genocidal actions by the Soviet military.

Another problematic point in the reception of *Ninth Company*, especially for viewers unfamiliar with the tradition of Russian war narratives, is how to understand the resounding domestic popularity of a storyline in which all but one of the company's members are killed. Typically, such an ending would be the basis for tragedy. Yet in the Russian context, since medieval times death on the battlefield has often been rendered as an expected and thus positive outcome, be it for the Christian faith or, in secular terms, for nation and homeland. The tendency to foreground death as the logical end of soldier's duty has become re-emphasized in modern Russian literature and cinema following the millions of lives lost in the Second World War. In *Ninth Company*, Bondarchuk extends this tradition to a new historical setting, a shift made evident by his distortion of the facts on which the film is based: during the last major Soviet offensive of the war, for two days in January 1988 on Height 3234, Ninth Company, 345th Guards Parachute Regiment, beat off a dozen attacks by the Mujahideen. Of thirty-nine Soviet soldiers, six were killed. For Bondarchuk this number was insufficient — a decisive testament to the strength of symbolic tradition over reality.

Bondarchuk's choice of the Soviet-Afghan War to blend, reposition and experiment with cinematic and cultural legacies, both foreign and domestic, lies at the heart of the controversy and, to a certain degree, of the appeal behind *Ninth Company*. On one hand, as evidenced by many western reviews, it is distasteful at the least to treat the war in such light — in short, to attempt to make a "feel-good" movie about such a ghastly conflict. On the other hand, as evidenced by its domestic reception and influence over subsequent Russian war films, *Ninth Company*, albeit for the most part fiction, has served as a catalyst to consider the possibilities of reframing the worst Russian/Soviet defeat in living memory. Since the end of the war in 1989, in journalism, documentary, fiction and film, the dominant story of the Afghan invasion had been that of an army

sent on a disastrous mission that helped precipitate the breakup of the Soviet Union. Now, as a signature part of the resurgence of Russian nationalism in the twenty-first century, *Ninth Company* suggests ways for turning its history's tragic chapters into points of pride for a new, post-Soviet generation.

Gregory Carleton

FURTHER READING

Alexievich, Svetlana. *Zinky Boys: Soviet Voices from the Afghanistan War.* New York: Norton, 1990.

Borovik, Artyom. *The Hidden War: A Russian Journalist's Account of the Soviet War in Afghanistan.* New York: Grove, 1990.

Carleton, Gregory. "A Tale of Two Wars: Sex and Death in Ninth Company and Cargo 200." *Studies in Russian and Soviet Cinema* 3, no. 2 (2009): 215-28.

-------. "Victory in Death: Annihilation Narratives in Russia Today." *History and Memory* 22, no. 1 (2010): 135-68.

Kishkovsky, Sophia. "From a Bitter War Defeat Comes Russia's Latest Blockbuster Action Movie." *The New York Times,* 29 October 2005.

Norris, Stephen M. "Patriot Games: *The Ninth Company* and Russian Convergent Cultures after Communism." *Digital Icons,* no. 8 (2013). http://www.digitalicons.org/issue08/stephen-norris/ (accessed 16 June 2013).

Seckler, Dawn. "Fedor Bondarchuk: Company 9 (9-aia rota), 2005," http://www.kinokultura.com/2006/12r-company9.shtml. (accessed 15 September 2012).

Youngblood, Denise. *Russian War Films: On the Cinema Front, 1914-2005.* Lawrence: University of Kansas Press, 2007.

HOW I ENDED THIS SUMMER

Kak ia provel etim letom

2010

130 mins.

Director, Screenplay: **Aleksei Popogrebskii**

Cinematography: **Pavel Kostomarov**

Music: **Dmitrii Katkhanov**

Production company: **Koktebel' and Startfilm**

Producers: **Roman Borisevich, Aleksandr Kushaev**

Cast: **Grigorii Dobrygin (Pavel, intern), Sergei Puskepalis (Sergei, director of the polar station)**

Aleksei Petrovich Popogrebskii (1972—) represents a new wave of filmmakers in post-Soviet Russia. Born into the family of a Moscow-based scriptwriter, Popogrebskii received his degree from the Psychology Department of Moscow State University. In 1997 he made his first short film in collaboration with Boris Khlebnikov. In 2003 they released their debut feature *Roads to Koktebel* (*Koktebel'*), which received many international awards. Since then Popogrebskii has produced two feature films of his own, *Simple Things* (*Prostye veshchi*, 2007) and *How I Ended This Summer*, and has experimented with 3D video (a short film called *Blood Drop*, 2011). His cinematic style is characterized by the use of long shots, minimalist dialogue and intense emotions. At the same time, his films are interspersed with subtle, ironic humor, which produces a recognizable atmosphere of suspense, depth and psychological multimodality. Along with Andrei Zviagintsev, Aleksei German-Junior, Petr Buslov, Kirill Serebrennikov, Nikolai Khomeriki, Boris Khlebnikov and Igor' Voloshin, Popogrebskii is a representative of the Russian new

wave—informally known as "the new quiet ones" (*novye tikhie*)—a group of filmmakers that has emerged since 2000, who utilize a new cinematic language that draws upon the national and international filmic tradition, steers away from producing blockbusters[1] and celebrity and glamour culture, and focuses on niche arthouse films that have a dedicated audience world-wide.

In *How I Ended This Summer*, Popogrebskii exploits themes that he explored in his earlier films—the father-son relationship, the cultural memory of the (Soviet) past, male psychology—and he does so by using even more minimalist cinematic language. The film shows two meteorologists working on an island off the Chukotka peninsula. The younger character, Pavel, an intern, arrives at the station to assist Sergei, the older character, in modifying data-gathering techniques so that in the future the station can operate in the absence of people.[2] Sergei continues to collect data using traditional, well-tested techniques—thermometers, barometers, instruments that measure solar activity—while Pavel fully relies on computerized data collection. Therefore, from the very outset, the two characters are shown to represent two mentalities, one that values tradition and preservation, and the other that emphasizes modernity and progress. The film's setting accounts for two interpretations of the characters' differences: the generational, whereby the conflict between Sergei and Pavel is the eternal opposition between father and son, and the social, in which the characters of Sergei and Pavel stand for Soviet and post-Soviet values, respectively. Sergei values the historical past, as he always

[1] One of these, Timur Bekmambetov's *Night Watch* is discussed in the reader.

[2] The title of the film makes a complex cultural reference. On one level, it is a reference to an educational practice: every September students in Russian schools are asked to write a composition on "How I Spent My Summer." In this context Pavel is a student; however he is not a student of meteorology but rather of life. On another level, the verb "provesti" used in the title also means "to cheat, to con," thus hinting at the conflict between the two main characters. The title sounds incomplete, and this incompleteness is meant to attract viewers' attention. It is also an abrupt rhetorical change from one structure to another which denotes extreme emotion and confusion. Consequently, the title signals Pavel's traumatic experience both as perpetrator and victim.

speaks highly of his Soviet predecessors and their "heroic" actions. Pavel, on the other hand, is more concerned about his individual gain and displays no connection to his place of work (Fig. 110); instead, he withdraws into the world of computer games, awaiting the arrival of a ship that would bring him back to the mainland. It is no surprise that he loses some important meteorological data, and as a result, the value of the century-old scientific experiment may be undermined.

The film shows how Sergei and Pavel perform a range of scientific tasks and domestic chores. As they are the only inhabitants on the island, communication is limited; moreover, Sergei is naturally introverted, and this combination of factors creates tension between the characters. Their main task is to transmit meteorological data to the hub in mainland Russia, and these radio transmissions become their link to the wider world. On one occasion, while Sergei is absent—he goes on a fishing trip to another island—Pavel receives a telegram that informs Sergei of the death of his family in an accident. Because of Pavel's fear of Sergei's anger, his own irresponsibility, or even his desire to protect Sergei's psychological well-being—the film is never clear about the characters' motivations—Pavel fails to tell Sergei about the telegram. A series of ensuing misunderstandings and arguments brings Pavel and Sergei into an outright clash. Pavel is forced to abandon the station and tries to survive in sub-zero temperatures, escaping polar bears and other dangers. Their confrontation turns into violent fighting which brings out predatory instincts in both.

The heated confrontation between the characters is contrasted with the cold, serene landscape of the Far North. Arguably, the landscape is the third character in *How I Ended This Summer*, and the imagery of the bay where the station is located constantly changes, reflecting the transformations in Pavel and Sergei's relationship. In fact, the film highlights not only their confrontation but also amicable moments of male bonding. For example, Pavel teaches Sergei some basic computer-mediated communication skills, while Pavel learns about the hardships of living in complete isolation, as well as its few pleasures. (Thanks to Sergei he discovers the delights of the *bania*, a traditional Russian steam house.)

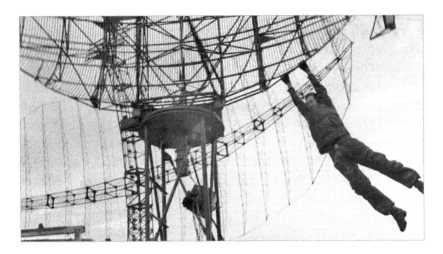

Fig. 110. Pavel

The austere landscape of the island also facilitates a more abstract, mythological interpretation of the story, with Sergei and Pavel representing two competing value systems, even two types of gods—a pagan god who lives in harmony with nature and a god of the new technological era. The film has a clear ecological stance, especially in that the fantastically beautiful imagery of the island is contrasted with scenes showing the effects of Soviet modernity on the Far North: hundreds of empty oil barrels have been dumped on the island and left to rust, polluting the ground; radiolocation antennas are now out of use but have not been dismantled and litter the landscape; and finally, a nuclear capsule, which was set on the island during Stalin's time to provide the station with energy, threatens to contaminate the whole region with radioactive waste. At the end of the film, Sergei decides to stay at the station; as he had been exposed to radiation and all his family are dead, he chooses to spend his last days on the island. Pavel leaves the island on a rescue ship; however, as he too had been exposed to radiation, he is perhaps doomed as well. Thus, the film does not "discriminate" against either Soviet or post-Soviet modernity.

The film ends with the capsule being removed, lifted onto a ship and transported away from the island, thus signalling the end of the Soviet modernity. Scheduled for decontamination, the capsule, however, has polluted the relationship between Sergei and

Pavel, which suggests that, even though the signs of the Soviet era have been removed, they have left permanent mental scars on its citizens. The traumatic memory of the USSR pervades the film and the lives of its characters in a number of ways—in the form of the nuclear capsule and actual radioactive contamination, in allusions to Soviet films and literature about the exploration of the Far North, and in more recent events: Pavel plays a popular computer game, S.T.A.L.K.E.R., that reproduces the Chernobyl' nuclear disaster. The trauma of Soviet technological modernity thus invades the screen of the computer and the cinematic screen, as well as the memory of viewers.

Vlad Strukov

Further Reading

Graffy, Julian. "Aleksei Popogrebskii: *Simple Things* (*Prostye veshchi*, 2007)." *KinoKultura* (2008). http://www.kinokultura.com/2008/19r-prostye.shtml (accessed 25 August 2012).

Lipovetsky, Mark, and Tatiana Mikhailova. "Aleksei Popogrebskii: How I Ended This Summer (Kak ia provel etim letom, 2010)." *KinoKultura* (2010). http://www.kinokultura.com/2010/30r-leto.shtml (accessed 25 August 2012).

Strukov, Vlad. "Ludic Digitality: A. Sokurov's *Russian Ark* and A. Popogrebskii's *How I Ended This Summer* as Cinegames." *Digital Icons: Studies in Russian, Eurasian and Central European New Media* 8 (2012): 19-45. http://www.digitalicons.org/issue08/vlad-strukov (accessed 22 March 2013).

Printed in the USA
CPSIA information can be obtained
at www.ICGtesting.com
LVHW021330210823
755836LV00010B/297